THE DAVID AND ALFRED SMART

MUSEUM OF ART

A Guide to the Collection

THE DAVID AND ALFRED SMART MUSEUM OF ART
A Guide to the Collection

EDITED BY SUE TAYLOR AND
RICHARD A. BORN

HUDSON HILLS PRESS · NEW YORK
IN ASSOCIATION WITH
THE DAVID AND ALFRED SMART MUSEUM OF ART
THE UNIVERSITY OF CHICAGO

Publication of this guide to the Smart Museum collection has been made possible by grants from the National Endowment for the Arts, a federal agency, and from the Women's Board of the University of Chicago. Indirect support has been received from the Institute of Museum Services, a federal agency offering general operating support to the nation's museums.

First Edition

Published in the United States by Hudson Hills Press, Inc., Suite 1308, 230 Fifth Avenue, New York, NY 10001-7704. Editor and Publisher: Paul Anbinder

Distributed in the United States, its territories and possessions, Canada, Mexico, and Central and South America by Rizzoli International Publications, Inc.

Distributed in Japan by Yohan (Western Publications Distribution Agency).

Design: Harvey Retzloff, Chicago
Typesetting: RT Associates, Inc., Hoffman Estates, Ill.
Copy editing: Sue Taylor
Color photography: Jerry Kobylecky Museum Photography, Chicago
Manufactured in Japan by Toppan Printing Co.

Black-and-white photography: fig. 1, Museo di Villa Giulia, Rome; fig. 2, Ampliaciones y Reproducciones Mas, Barcelona, © Patrimonio Nacional, Madrid (all rights reserved); fig. 3, Alinari/Art Resource; fig. 4, Courtesy of the Art Institute of Chicago; fig. 5, Metropolitan Museum of Art, all rights reserved; fig. 6, Cleveland Museum of Art; fig. 7, Minneapolis Institute of Arts.

Library of Congress Catalogue Card Number 89-82164

LIBRARY OF CONGRESS CATALOGUING IN PUBLICATION DATA

David and Alfred Smart Museum of Art.
 The David and Alfred Smart Museum of Art : a guide to the collection / edited by Sue Taylor and Richard A. Born.
 p. cm.
 Includes bibliographical references (p.)
 ISBN 0-935573-11-9 (Smart Museum of Art : pbk.)
 1. Art—Illinois—Chicago—Catalogues. 2. David and Alfred Smart Museum of Art—Catalogues. I. Taylor, Sue, 1949- . II. Born, Richard A. III. Title.
N531.D38D38 1990
708.173'11—dc20 89-82164
 CIP Rev

Contents

Foreword

Coinciding with the fifteenth anniversary of the David and Alfred Smart Museum of Art, the publication of this guide to the collection celebrates the strengths of scholarship at the University of Chicago in a number of ways. The catalogue entries that follow represent the efforts of faculty, alumni, and advanced graduate students in the Department of Art; in certain instances, we are fortunate to have the most eminent authorities in the field contributing entries in their particular areas of expertise. During the course of this research, much new information has come to light to increase our appreciation for the objects discussed here, and it is especially gratifying that the project has thus served one aspect of the Museum's charge to preserve, exhibit, and elucidate the works of art in its care.

The selections included in this catalogue are not intended to provide an encapsulated history of art nor even a comprehensive indication of the Museum's holdings; instead, we wish to offer an introduction to what we believe to be the special nature of a university study collection. Thus many of the works considered in the following pages effectively illustrate problems of connoisseurship, technique, reproduction and translation, stylistic influence and dissemination, and attribution. They are pedagogical aids, instructive and often challenging to amateur and expert alike. Above all, however, they are aesthetic objects, in many cases of the greatest significance and beauty. It is our hope, therefore, that the essays and illustrations contained in this book will enhance the enjoyment of all visitors to the Museum and inspire further inquiry from scholars the world over.

RICHARD A. BORN
Curator

Director's Preface

This publication marks the fifteenth anniversary of the David and Alfred Smart Museum of Art, established through the generosity of the Smart Family Foundation, yet it also records the collections of the University of Chicago dating back to its founding in 1891. Thus, the objects discussed in this book represent the donations of generations of alumni and friends of the University, and it seems fitting that this guide to the Smart Museum includes the research of so many distinguished scholars.

As the new director of the Museum, I am grateful for the privilege of thanking the donors who have formed our collection and the scholars who have so brilliantly explicated a representative selection of those objects in this publication. Chief among those scholars are its editors, Sue Taylor and Richard A. Born, whose knowledge and dedication have resulted in such an important book. The entire staff of the Smart Museum has contributed to its realization and also deserve thanks.

We are also very grateful to the Trustees of the University of Chicago and to the National Endowment for the Arts for making this publication possible, and for additional funding from the Institute of Museum Services and the Women's Board of the University, which helped to support its realization.

Of course, a publication of this size cannot encompass the depth of our collections nor the continuing complexity of scholarly discourse that surrounds them. We present it, not as a static record, but as a foundation for our future growth.

TERI J. EDELSTEIN
Director

Contributors to the Catalogue

Jeffrey Abt
Rolf Achilles
Ann Adams
Dennis Adrian
Julia Bernard
Frederick N. Bohrer
Richard A. Born
Russell Bowman
Louise Bross
Michael Camille
H. Rafael Chacón
Elena Ciletti
Charles E. Cohen
Marion W. Covey
Stephanie D'Alessandro
Holliday T. Day
Daphne Anderson Deeds
Mary Lackritz Gray
Mark A. Hall
Marla H. Hand

Mary Jackson Harvey
Adrienne Kochman
Sura Levine
Norma Lifton
Pamela Loos-Noji
Edward A. Maser
Naomi Maurer
Rita McCarthy
Dwight Miller
Warren G. Moon
David Morgan
Stanley Murashige
Deborah S. Neibel
Leslie Peet
Robert J. Poor
Erica Rand
Robin Reisenfeld
Daniel Robbins
Earl Rosenthal
Thomas F. Rugh
Leah Rutchick

Esther Saks
Laura Satersmoen
R. Stephen Sennott
Levi Smith
Timothy J. Standring
Laurie A. Stein
Robin Scribnick Stern
Sue Taylor
Judith Anne Testa
Katherine R. Tsiang
Harrie A. Vanderstappen
Dominique Vasseur
Naomi Vine
Louise Virgin
Cheryl Washer
Susan Weininger
Timothy N. Wittman
Michael Preston Worley
James Yarnall
James W. Yood

Acknowledgments

Many individuals have contributed to this publication over a period of several years; it is a pleasure here to thank each of them on behalf of the Smart Museum. The original conception of a handbook to the collection belongs to Richard A. Born, Smart Museum Curator, whose extensive knowledge of the objects in his care—from ancient Greek shards to contemporary American paintings—allowed him to make the appropriate selections for inclusion in this catalogue. After securing initial funding for research and then for publication, Richard supervised all aspects of the book's production. During the early stages of the project, former Smart Museum Director John Carswell provided necessary support; subsequently, Acting Director Jeffrey Abt, among his numerous other responsibilities, secured additional funding for publication and patiently guided continuing efforts towards the project's completion. We appreciate the experience and enthusiasm with which our newly appointed director, Teri J. Edelstein, has ushered the catalogue through its final stages.

Faculty of the Department of Art of the University of Chicago helped identify writers for individual catalogue entries and read portions of the manuscript; Professors Ann Adams, Michael Camille, Charles E. Cohen, Earl Rosenthal, and Harrie A. Vanderstappen generously contributed essays themselves, and for these we are especially grateful. All the authors of the catalogue entries merit the highest recognition for their scholarship and for their willingness to participate in the project, often despite the pressing demands of professional or academic life.

We appreciate, too, the expertise of scholars who rendered opinions on material of a problematic nature, from attributions to translations of dates and inscriptions: D. Scott Atkinson, Curator, Terra Museum of American Art, Chicago; Andrew Cohen, University of Chicago; Mary Anne Goley, Director, Fine Arts Program, Federal Reserve Board, Washington, D.C.; Reinhold Heller, Professor in the Departments of Art and Germanic Languages, University of Chicago; Michael

Quick, Curator of American Art, Los Angeles County Museum of Art; Martha Ward, Assistant Professor, Department of Art and the College, University of Chicago; Ian Wardropper, Eloise W. Martin Curator of European Decorative Arts and Sculpture and Classical Art, Art Institute of Chicago; and Harrie A. Vanderstappen, s.v.d.

For responding to inquiries of various kinds for factual information and for assistance in gathering comparative photographs, we are indebted to Karen Alexander and Mary Greuel, Department of European Decorative Arts and Sculpture and Classical Art, Art Institute of Chicago; Monserrat Blanch, Ampliaciones y Reproducciones Mas, Barcelona; Lela Hersch, Registrar, Museum of Contemporary Art, Chicago; Paula Pergament, Department of Photographic Rights and Reproductions, Art Institute of Chicago; Alice Piron, Director of Education, Museum of Contemporary Art, Chicago; Holley Sandlin, Archivist, Marlborough Galleries, New York; Patricia Tang, E. V. Thaw and Company, Inc., New York; Martha Tedeschi, Associate Curator of Prints and Drawings, Art Institute of Chicago; and Alice Westphal, Exhibit A, Chicago.

Special acknowledgment is due Smart Museum Curatorial Intern, Stephanie D'Alessandro, for her painstaking work on the bibliographies and exhibition histories that follow the catalogue section of the handbook. Scholars who have conducted similarly crucial but often tedious research will know how much effort is represented in this kind of documentation. Mary E. Braun, Smart Museum Registrar, deserves credit for her meticulous records and for personally verifying the dimensions of each object. Thanks are also due Glen K. Lafferty, Administrative Assistant, who provided his usual indispensable and good-natured support throughout the project.

For expertly photographing the works of art reproduced in the following pages, we thank Jerry Kobylecky Museum Photography. The challenge of unifying such diverse images and texts in a handsome and eminently

useful volume has been successfully met by the publication's designer, Harvey Retzloff, Chicago. All this endeavor was underwritten, directly or indirectly, by grants from the National Endowment for the Arts and the Institute of Museum Services, federal agencies, and from the Women's Board of the University of Chicago, for whose confidence and beneficence we are most appreciative.

Finally, it is with fondness and respect, mixed with sadness, that I recall afternoons spent with the late Edward A. Maser, Founding Director of the Smart Museum, discussing plans for the handbook, potential contributors, and fine points of particular essays as they were submitted for publication. Many of the objects elucidated in these pages owe their presence in the collection to the dedicated efforts of Professor Maser; many of the authors published here were, formally or informally, his students in years past. We are deeply grateful for his generosity and guidance, as well as for his work on Franz Anton Maulbertsch, presented in this catalogue with the gracious permission of Inge Maser, and representing one small aspect of his lasting legacy to the Smart Museum and its constituents.

SUE TAYLOR
Editor

A HISTORY OF THE COLLECTION

Though the David and Alfred Smart Gallery opened in 1974,[1] many of the works of art in its care were acquired in the earliest years of the University of Chicago, some even before the turn of the century. Later purchases and donations have given the University's collections a much-welcomed breadth and richness, but it is by examining those intense concentrations of objects amassed for research nearly a hundred years ago that one can appreciate the special character of the Smart Museum's holdings. In addition, the University's art collecting during the first several decades provides tangible evidence of the almost dizzying expansion and refinement of its disciplines as faculty began setting the course of this unique institution.

The University was incorporated in the summer of 1890; its first president, William Rainey Harper (1856–1906), was appointed in 1891, and students began classes the following year. Soon after his appointment, President Harper began to recruit faculty; departmental museums and libraries were also central to his plan.[2] He launched the University on a trajectory of growth and diversification that continued virtually unabated through the early 1930s. After the Depression and war years, the University began again to prosper, but the pace of its development never quite matched that of its first four decades.

The University's art collection followed a different course. Many objects now integral to the Smart Museum's permanent collection were acquired during the first half-century; however, many also came in the period immediately before and just after the Museum's opening. While earlier acquisitions had been made by individual faculty to enrich their own programs, the creation of the Smart Museum expanded both the institutional base and constituency for the University's art collecting. In particular, the Museum has accepted an educational responsibility to represent the broad sweep of art history for students first encountering the subject, as well as for the community surrounding the campus. Where solitary professors once sought materials to support focused disciplinary concerns, the Museum has built upon and integrated these objects into a more general historical survey.

THE EARLY YEARS

In fall of 1893, the Walker Museum was opened on East 58th Street, housing the University's natural history collections, including specimens transfered from nearby displays at the World's Columbian Exposition.[3] Objects belonging to the Departments of Anthropology, Botany, Comparative Religions, Geology, Geography, Mineralogy, Osteology, Petrography, Paleontology, and Semitic Archaeology were at first accommodated within the building.[4] The departmental orientation of the University's collections, however, including libraries, dictated that research materials be housed in proximity to the appropriate classrooms and faculty offices. Thus when the Haskell Oriental Museum was established in 1896, collections in Semitic Archaeology and Comparative Religions were relocated there; the following year, collections in Botany, Osteology, and Vertebrate Paleontology were removed to the new Hull Biological Laboratories.[5] By the early 1900s, the University had numerous departmental libraries and museums rather than single large repositories designed to serve the entire campus.

This policy guided the disposition of the University's research collections for many years. Because the art history department was not established until fall of 1902, there were no faculty advocates for an art museum during the early years when many buildings were erected and collections acquired. This is not to say, however, that the University did not already possess substantial collections of art. During the period of the University's founding, the purview of the relatively new discipline of art history differed markedly from that of today. For this reason, many of the objects that are now considered works of art were then acquired for their value to other scholarly fields. These facts, when viewed in the context of the University's disciplinary taxonomy, particularly

as it was expressed in the division of academic departments, had and continues to have a profound impact on the division of collections that could, under other circumstances, fall within the scope of an art museum. There are some notable examples.

The University's first significant acquisition of art came with President Harper's purchase of the book stock being liquidated by the Calvary Antiquariat, Berlin, in 1891. The collection boosted the University's library holdings from virtual nonexistence to the fifth largest in the United States a year before classes began. Many works of art in the form of illuminated manuscripts and prints were acquired in the purchase, including the nearly one thousand prints of the *Speculum Romanae Magnificentiae* (mid-sixteenth to eighteenth century).[6] Regarded as a library resource from the beginning, the prints may now be found in the special collections department in the Joseph Regenstein Library, along with other great works of book and graphic art.

The world-renowned collection of Middle Eastern art at the University is largely due to the efforts of James Henry Breasted (1865–1935). Professor Breasted was one of two faculty mainstays of the Department of Archaeology, which began in 1893 and was renamed the Department of the History of Art in 1902. Breasted remained in the latter department for a few years longer while continuing to hold a joint appointment in the Department of Semitic Languages and Literatures. He also became assistant director of the Haskell Oriental Museum in 1895 as it was nearing completion, and succeeded President Harper as director in 1901.[7] A man of enormous vision and energy, Breasted sought antiquities from the Middle East for teaching and research. In addition to purchases from dealers, acquisitions included yields from excavations conducted by the pioneering archaeologist William Mathews Flinders Petrie and those sponsored by Chicago groups and later by John D. Rockefeller, Sr., the University's founder. When the collapse of the Ottoman Empire opened numerous regions previously inaccessible to foreign scholars, Breasted successfully attracted funding for an expanded range of researches and excavations reaching from Chicago to many locations throughout the Middle East.

Though he continued to teach in the Department of the History of Art, it is clear from his courses and publications that Breasted favored an interdisciplinary approach to the study of Middle Eastern art, treating it as material evidence of the civilization's society and culture. He soon began arguing for an academic center to fulfill his cross-disciplinary goals and in the spring of 1919, John D. Rockefeller, Jr. authorized a gift to establish the program Breasted envisioned.[8] Named the Oriental Institute, it was first housed in the Haskell Oriental Museum. The collections proceeded to grow alongside the faculty and student body and in 1931, with a gift from the Rockefeller Foundation, Breasted was able to move the Oriental Institute to a new building designed specifically to house its faculty, collections, and research facilities, where they continue to thrive today.[9]

One of the first special exhibitions presented at the University consisted of a fascinating group of Shinto religious implements displayed in the Walker Museum in February 1894.[10] Edmund R. Buckley, a docent or adjunct lecturer in the Department of Comparative Religions, had collected the objects—phallic rocks, folded paper strips, magic wands, tiny mirrors—during a brief sojourn in Japan and, subsequent to their loan for exhibition at the Walker, left them to the University. The collection was moved to the Haskell Oriental Museum and exhibited there until the completion of the Oriental Institute. When the Middle Eastern holdings were relocated to the new building, leaving the East Asian collections behind, the Haskell Oriental Museum exhibition halls were converted to classrooms and offices, and the Buckley Collection, without a home and apparently lacking an academic constituency, was packed away. In 1988, the artifacts were discovered in storage at Swift Hall, home to the University's Divinity School, and transfered to the Smart Museum the following year.

The Case Collection of Early Christian and Byzantine artifacts was also housed until recently in Swift Hall, where in the 1930s a number of distinguished scholars specialized in Early Christian studies. Divinity School Dean Shirley Jackson Case (1872–1947) established a study collection including Syro-Palestinian bronze evil-eye charms, miscellaneous ivories, terracotta and bronze oil lamps, and terracotta ampullae from the Egyptian shrine of St. Menas. Although the program was carried on after Case's retirement in 1938 by Professor Harold Willoughby, the Divinity School's emphasis on Early Christian studies, particularly those centered on iconography and artifacts, has diminished in intervening years. The Case Collection gradually became a much-cherished adornment in Swift Hall, but with rising interest from art history circles, the collection was transfered to the Smart Museum in 1988.

Of the University's earliest art acquisitions, the best-known is the Tarbell Collection of classical antiquities,

begun in 1902 with a donation of over one hundred Greek and Roman objects from E. P. Warren of Lewes, England. This group was merged with the Stanley McCormick Collection of Antiquities (belonging to the School of Education) and placed on display in the Classics building after its completion in 1915.[11] The collection was expanded through gifts and purchases guided by Professor Frank Bigelow Tarbell (1853–1920), who taught a number of courses on the art of ancient Greece and Rome through his retirement in 1918. The Tarbell Collection began as a source for teaching and research and has been used continually for this purpose ever since (see cat. nos. 1–3).[12]

Another, more recent collection represented in the handbook is the Max Epstein Archive, founded in 1936 as a research tool for the Department of the History of Art.[13] The archive began in the wake of failed plans to found an Institute of Fine Arts with a $1–million gift for this purpose from Chicago businessman Max Epstein in 1929. For unknown reasons, the first pledge on the gift was diverted in 1930 to the University's medical clinics, and the proposed art center was never realized. The project as envisaged by Epstein, with the advice of Bernhard Berenson among others, had been to include "rooms for an extensive collection of photographs of art works, and . . . for the exhibition of original paintings and sculpture."[14] The Max Epstein Archive was a natural outgrowth of the earlier proposal. Composed predominantly of mounted photographs, the collection was enhanced by a number of original graphic works under the directorship of Professor Bertha Harris Wiles (1896–1987), who taught courses in the history of printmaking in the 1950s and 1960s.[15] The prints and drawings in the Epstein Archive were separated from photographs and photomechanical reproductions after the creation of the Smart Museum, and, since their transfers in 1973 and 1976, they form the core of the Museum's print and drawing collection.

THE FOUNDING OF THE SMART GALLERY

In October 1967, George Beadle, then president of the University, announced a gift of $1 million from the Smart Family Foundation for a fine arts gallery for the campus, to be named in memory of David and Alfred Smart, founders in 1931 of Esquire, Inc. and publishers of *Esquire Magazine*. The brothers had been serious art collectors, concerned also for art education; the museum would admirably "represent both interests."[16] Unlike institutions built around the personal collections of their

major benefactors, the projected museum would be free to develop its own pattern of acquisitions, according to its perceived needs and available resources.

A prospectus for an art museum had been prepared the previous year by a faculty committee of the Department of Art, in response to a request from the dean of the Division of Humanities for architectural guidelines regarding the department's "needs and preferences" for a new building.[17] The committee envisioned "space for the more or less permanent display of works of art" as well as for rotating exhibitions, which would serve not only the research purposes of faculty and art history students, but also students seeking a liberal education and the university community in general.[18] In February 1969, the art department faculty approved the report of their steering committee, and the acting chair submitted a memorandum to the dean, reiterating that "the principal function of the gallery is education—teaching and research," achieved by a permanent collection and temporary exhibitions that should "serve to illuminate the entire history of art."[19]

According to the terms of the gift, the Museum was to be designed by the Chicago-born architect Edward Larrabee Barnes, who, during his assessment and planning of the project, was also engaged in the commission for the Walker Art Center in Minneapolis. Plans for the David and Alfred Smart Gallery specified a modest space (7,200 square feet) for the flexible display of the collection in conjunction with the relatively frequent turnover of small loan exhibitions, within a single hall without permanent interior walls or detracting architectural detail. Display, storage, and attendant service areas were linked by a unified environmental control system. In a concrete way, the facilities served the evolving statement of purpose of the institution with the incorporation of the new art department quarters opposite a shared sculpture courtyard within the Cochrane-Woods Art Center complex.[20]

Groundbreaking ceremonies were held on 29 October 1971; the Museum's founding director, Edward A. Maser, was appointed in early 1973. As former director of the Helen Foresman Spencer Museum of Art at the University of Kansas in Lawrence, Professor Maser brought invaluable experience to the fledgling institution and a specific understanding of the special qualities of the university museum.[21] A member of the art department from 1961, he held an insider's knowledge of the University's aspirations for its newest resource. As a museum professional and an avid collector, he under-

stood the budgetary and physical conditions imposed on the development of a broad-based fine arts collection.

Nonetheless, there was a beginning, which Professor Maser gratefully inherited: works of art from the various departmental collections that, with time, had lost much or all of their original academic context and were now seen to be best used through their integration into the University's fine arts collection. The careful selection and transfer of these works began in 1973, in anticipation of the opening of the Museum, when the Smart Gallery's first curator, Katharine Lee Keefe, and a team of graduate art history students conducted a campus-wide survey of original works of art. A review of individual works accepted over the years by the University, dispersed in offices, lobbies, lounges, and reception halls, yielded substantial discoveries of museum-quality paintings, sculptures, and works of decorative art (cat. nos. 34, 37, 52). Certain collections on campus, moreover, were long-standing and well known: there were old-master prints from the Epstein Archive, for example, and, among the classical holdings, prehistoric shards given personally to Professor William G. Hale by the excavator of Troy, Heinrich Schliemann.

In addition, several cogent groupings had more recently entered the University collections, including much of the original furniture and fixtures from Frank Lloyd Wright's Frederick C. Robie Residence on the edge of campus (cat. no. 41). The Wright material had passed with the ownership of the famous Robie House to the University in 1967, after a concerted campaign to save the exemplar of Prairie School architecture from the wrecker's ball. Since the structure served as a functioning University office, many of the interior fitments, and other furnishings by Wright that had come to the University, were on deposit with the Chicago Architecture Foundation, where they were in storage. After an inventory, the entire group was accessioned into the Smart Gallery collection, immediately establishing a vital study center for Prairie School and Arts and Craft design when viewed in conjunction with several gifts from 1967, such as bronze fixtures from Louis H. Sullivan's demolished Chicago Stock Exchange and architectural fragments by Dankmar Adler and George Grant Elmslie.

Professor Maser sought and secured on behalf of the University the first major gift in the Chicago area from the New York based Samuel H. Kress Foundation—twenty-one medieval, Renaissance, and baroque paintings, sculptures, and works of applied art (cat. nos. 7, 8,

9, 12, 15). Along with the prints from the Epstein Archive, this group formed the core of the old-master collection. Announcing the Kress donation in November 1973, Professor Maser stressed the great artistic importance of a number of these superb objects, and noted that others, "while being works of fine quality, pose art historical problems" crucial to the training of art history students in methods of research on original works of art.[22]

Contributions by alumni and local collectors had begun auspiciously almost immediately after reports of the Smart Museum's construction. Among these early donors was Katharine Kuh, for many years a prominent dealer, curator, and critic in Chicago, who had championed avant-garde European and American art in her gallery in the 1930s and forties. Although living in New York by the late sixties, she presented several works from her collection to the new Museum, including a small painting on paper by the Abstract Expressionist Franz Kline (cat. no. 61). In Chicago, Joel and Celeste Starrels proposed the bequest of their extensive collection of late nineteenth- and twentieth-century European art, distinguished especially by modern sculpture and the specialist's enthusiasm for drawings by sculptors (see cat. nos. 38, 45, 48, 57a–b, 58, 59, 64). In 1974, the Starrels transfered title of nearly two hundred of these works to the Museum, establishing through their beneficence The Joel Starrels, Jr. Memorial Collection, named in memory of their son, who had been a student in the University's Law School. Selections from this important donation formed the Smart Gallery's inaugural exhibition in October and December 1974.[23]

With earlier departmental research collections as a model, the Museum inspired direct action by art department faculty, notably Father Harrie A. Vanderstappen, professor of Chinese and Japanese art. By May 1968, he formally proposed the creation of a "solid study collection" of later Chinese painting, when a group of Ming and Qing scrolls collected in Shanghai in the 1920s and thirties by the eminent Chinese painting expert Victoria Contag came on the New York art market.[24] Securing purchase funds from an anonymous patron and connoisseur of Chinese painting, Professor Vanderstappen acquired twelve scrolls by literati and professional painters of the sixteenth through early nineteenth centuries. Three years later, during a trip to Japan, he added eight more Ming and Qing paintings (see cat. no. 74), and established the beginnings of a research collection of Japanese painting. The latter focuses on the

Nanga School of the eighteenth and nineteenth centuries —an indigenous response to Chinese scholar-amateur painting traditions—but includes Buddhist subjects such as the *yamato-e*-derived narrative painting of *Nichiren's Nirvana* from the mid-Edo period (cat. no. 76). Again, Professor Vanderstappen personally sought contributions for these purchases, this time from Mr. and Mrs. Gaylord Donnelley, who also donated the Museum's first Japanese color woodblock prints in the *ukiyo-e* manner and who have continued their support of new acquisitions, both Western as well as East Asian (see cat. nos. 50, 73).

Under Professor Maser's directorship, these and other significant early accessions for the Museum—which was not yet a physical reality, for construction continued into the spring of 1974—were set into an overall guideline for the systematic development of the University's fine arts collection as a whole. Acknowledging the importance of previous departmental holdings and past and promised gifts to the University, he also perceived the necessity of on-going purchases which would respond to faculty research and teaching needs. In 1973, he conducted an art department survey to establish the sorts of objects that should be sought by the Gallery, and encouraged his peers to identify and recommend works of art for purchase.[25] Until his retirement from the directorship in 1983, Professor Maser steadfastly held in special regard, indeed as an article of faith, the planned growth and purposeful refinement of the collection, independent of personal taste or private patterns of collecting which inevitably characterize welcome donations from individuals. As a corollary, he understood faculty to be an inherent resource of any university museum, and if the art department were logically given first consideration, the needs of other disciplines as they relate to the visual arts were also to be taken seriously into account.

Working without an endowed purchase fund, by 1974 Professor Maser had secured contributions for an ad hoc acquisitions fund through individuals and organizations, either directly or through University channels such as the Women's Board and Alumni Fund. Among foundation support, a generous grant from the Woods Charitable Fund, augmented in 1975 and 1976, is especially significant for establishing the Cochrane-Woods Collection, which in less than a decade numbered over three dozen paintings, sculptures, and decorative-art objects (cat. nos. 4, 5a–b, 6, 10, 11a, 14a–b, 26, 28). Individual contributions by Mr. and Mrs. Eugene Davidson, to name

but two of the Museum's many generous early benefactors, resulted in purchases that set high standards, in terms of quality and suitability to the institution, for future acquisitions (see cat. nos. 16, 17, 18, 35, 36).

The Museum was thus poised at its opening to consider faculty and staff recommendations for purchase. Many of the works included in the present catalogue and selected checklist entered the collection through this informed avenue. Among them, two may be cited as representative examples. Pordenone's *Milo of Croton Attacked by Wild Beasts* (cat. no. 11a), a large-scale Renaissance history painting presumed lost, was discovered in a dealer's shop in London by Professor Charles Cohen, whose dissertation was a monographic study of the North Italian artist. Three rare twelfth-century architectural fragments associated with the influential Burgundian atelier of the School of Cluny III (cat. nos. 4, 5a–b) were found in an antiquarian dealer's personal collection in France by former faculty member C. Edson Armi, a specialist in the sculpture and architecture of the French Romanesque.

By the end of its second season, the Museum initiated the first in a continuing program of exhibitions from the collection organized by art department graduate students and faculty with the guidance of Museum staff.[26] Offering students first-hand experience with original works of art and focused museological practice, these exhibitions provide a public forum for scholarly research, as part of the Museum's mission to explicate as well as preserve and display the collections. Such exhibitions are thus accompanied by didactic wall texts, and checklists, brochures, or catalogues are published as funds permit. Another actualization of the educational potential of the collection has been the number of masters' theses and doctoral dissertations at the University of Chicago and elsewhere incorporating research on works from the Museum (cat. nos. 15, 16, 41), not to mention generations of undergraduate and graduate course and seminar papers. The publication of a scholarly journal was discussed from the earliest days of the Museum, and in 1988, the first annual bulletin appeared, incorporating articles on the collection and a complete list of new acquisitions.[27]

With this legacy of dedication to the goals of a university study collection, the Museum has witnessed significant additions to its holdings under Professor Maser's successors. During the tenure of Professor Reinhold Heller (1983–1985), a respected scholar of symbolist and expressionist art, the Marcia and Granvil Specks Collec-

tion was constituted and subsequently enriched with premier examples of German and Austrian expressionist and new-objectivity graphics. The collection is comprised of choice single sheets and pristine print portfolios, including Otto Dix's extraordinary masterpiece, *The War* (cat. no. 49). Under the directorship of John Carswell (1985–1987), the Museum received a major collection of over one hundred Chinese bronze-age ritual vessels, weapons, and artifacts of the Shang and Zhou dynasties (cat. no. 72).[28] The gift was due to the remarkable beneficence of the noted Sinologists Professor and Mrs. Herrlee G. Creel. Founder in 1936 of the University's Oriental studies program (today the Department of East Asian Languages and Civilizations), Professor Creel had assembled his own private research collection in China in the early 1930s, and had shared this material with generations of students of Chinese history and culture. The gift of such a significant and cohesive body of works marked the Creels' continuing faith in the utility of study collections at the University and the means for their suitable display and continuing scholarly investigation at the Smart Museum.

Today the Museum's collection numbers over six thousand works of art, almost triple the initial holdings fifteen years ago. Through a careful program of purchased acquisitions—an endowed acquisition fund is still a hope for the future—and solicited and accepted gifts, the Museum has built a collection providing a balanced survey of Western art from the classical period through the present, and East Asian art from antiquity to the modern period. The goal has also been to secure objects that illustrate the technical processes of sculpture, painting, and printmaking, through studies, states, and completed works. In other instances, transmission of style within artistic schools or across cultures can be traced through the comparison of original exemplars and subsequent copies of specific compositions (cat. nos. 11a–b, 13a–b, 14a–b). Unknown works or unconfirmed attributions have been acquired as advanced student and faculty research materials or as pedagogical aids in such areas as connoisseurship, materials and techniques, and conservation. For example, a damaged seventeenth-century Italian painting is retained in a partially conserved state to demonstrate the stages of cleaning from original condition, through varnish and earlier inpainting removals.

Though the Museum's collections are broadly representative, there are defined concentrations responsive to the various requirements of a study collection serving University and community alike. The historical factors at work in the origins of the Museum in 1967, and before that through a distinguished history of department research collections, continue to mold the growth and direction of the University's fine arts collection.

Jeffrey Abt
Acting Director (1987–1989)

Richard A. Born
Curator

1. The Museum was founded in 1967 as The David and Alfred Smart Gallery; in 1990, the name was officially changed to The David and Alfred Smart Museum of Art. Throughout this catalogue, references to the Smart Gallery have been retained in their historical context.

2. Thomas Wakefield Goodspeed, *A History of the University of Chicago: The First Quarter-Century* (Chicago: University of Chicago Press, 1972), 366.

3. From the beginning, large portions of the Walker Museum were given over to faculty offices, classrooms, and library facilities. Though the building still stands and retains its original name, it is now part of the Graduate School of Business complex.

4. *The President's Report, 1892–1902* (Chicago: University of Chicago Press, 1902), 440.

5. Ibid.

6. *The Berlin Collection* (Chicago: University of Chicago Library, 1979), 55.

7. The Haskell Oriental Museum ceased to be a museum after the completion in 1931 of the Oriental Institute building and the removal of the Middle East collections to the new site. Renamed Haskell Hall, the building now provides offices and classrooms for the Department of Anthropology.

8. James Henry Breasted, "The Place of the Near Orient in the Career of Man and the Task of the American Orientalist," *Journal of the American Oriental Society* 39 (1919): 159–184; idem, "The Oriental Institute of the University of Chicago," *American Journal of Semitic Languages and Literatures* 35 (July 1919): 196–204.

9. Breasted, *The Oriental Institute* (Chicago: University of Chicago Press, 1933), 27–128. For an introduction to the Oriental Institute Museum collection see *A Guide to the Oriental Institute Museum* (Chicago: Oriental Institute, University of Chicago, 1982).

10. Frederick Starr, *Circular Regarding Collections of Religious Objects* (Chicago: University of Chicago, 1894).

11. Goodspeed Hall, adjacent to the Classics Building, at the time housed the Department of the History of Art, which remained in that location until 1974, when it moved to new facilities in the Cochrane-Woods Art Center (the complex housing the Smart Museum). The Classics Building museum could be reached directly from Goodspeed Hall, providing ready access for art historians studying the collection there.

12. See also the exhibition catalogue by Lynn Stowell and Gregory Knight, *Earth, Fire, Water: Classical Mediterranean Ceramics* (Chicago: David and Alfred Smart Gallery, University of Chicago, 1976).

13. Originally housed with the Department's library in Goodspeed Hall, the Epstein Archive now can be found adjacent to the Department of Art's reserve collection in the Joseph Regenstein Library.

14. Minutes of the Board of Trustees, University of Chicago, 12 September 1929 and 8 January 1931, University of Chicago Archives.

15. The impact of Bertha Harris Wiles' scholarship and connoisseurship on generations of art history students has been recounted in the exhibition catalogue *Alumni Who Collect I: Drawings from the 16th Century to the Present* (Chicago: David and Alfred Smart Gallery, University of Chicago, 1982), 4, 17.

16. John Smart as quoted in the *Chicago Sun-Times*, 26 October 1967. In 1971, at the groundbreaking ceremonies for the Cochrane-Woods Art Center, John Smart repeated these sentiments about his brothers: "David and Alfred Smart were workers in the labor force of the arts. I am using

the term in its broadest sense, to include magazines and films which help to spread the art of appreciation, which is, after all, the foundation for the appreciation of art." *The Cochrane-Woods Art Center/The David and Alfred Smart Gallery: Groundbreaking October 29, 1971* (Chicago: University of Chicago, 1971), 9.

17. Originally under the purview of the Dean of the Division of Humanities, the Museum was moved administratively to the office of the Provost of the University in 1985.

18. Unpublished letter from Acting Chairman of the Department of Art, Robert L. Scranton, to the Dean of the Division of Humanities, Robert Streeter, 5 October 1968.

19. The department's vote was reported in a memorandum from Scranton to Streeter, 23 March 1971.

20. In 1980, an additional grant from the Smart Family Foundation provided for the refurbishing of the preparator's workshop adjacent to the exhibition hall into a special exhibition gallery, thereby freeing the entire original gallery space for the reorganization and display of the permanent collection. In honor of the sister and brother-in-law of David and Alfred Smart, the sculpture courtyard was renamed the Vera and A. D. Elden Sculpture Court in October 1987.

21. Maser's years at the Spencer Museum are fondly remembered in a personal recollection by Marilyn Stokstad in "Edward A. Maser, 1924–1988," *The Register of the Spencer Museum of Art* 6:5 (1988): 41–43.

22. Quoted from "Art Gift for University," *The University of Chicago Bulletins* 1:5 (1–5 November 1973): 1.

23. For the Starrels collection, see also Richard A. Born, "The Collection," *Great Sculpture at Laumeier* (St. Louis: Laumeier Sculpture Park, 1983), n.p.

24. Victoria Contag's catalogue of artists' and collectors' seals is the standard reference. See Contag and Wang Chi-ch'üan, *Seals of Chinese Painters and Collectors of the Ming and Ch'ing Periods* (Shanghai: Commercial Press, 1940; rev. ed., Hong Kong: Hong Kong University Press, 1966). For a more detailed account of the formation of the Smart Museum's Chinese paint-

ing study collection, see Born, "Introduction," *Ritual and Reverence: Chinese Art at The University of Chicago* (Chicago: David and Alfred Smart Gallery, 1989), 8–10.

25. Supporting documentation included in a memorandum of 22 January 1973 from Maser to Michael J. Claffey of the University's development office.

26. Already in 1975 small exhibitions of prints and drawings from the collection (including some loans) were mounted by graduate students in the Museum's graphic arts study room. Following the inaugural exhibition of The Joel Starrels, Jr. Memorial Collection, the earliest exhibition was *Earth, Water, Fire: Classical Mediterranean Ceramics* (31 March–3 May 1976), see n. 12 above. Notable later exhibitions drawn from the permanent collection include *A New Acquisition: Milo of Croton by Il Pordenone* (21 January–15 March 1976), *A New Acquisition by Mark Rothko* (March 1977), *Alderman Boydell's Shakespeare Gallery* (4 October–26 November 1978), *Master Prints from Landfall Press* (13 March–27 April 1980), *Concentrations in the Collection: European and American Decorative Arts* (10 January–17 March 1985), *Henry Moore: Drawings, Prints, Sculpture* and *Modern British Sculpture: Moore's Contemporaries* (21 May–29 June 1986), *The Charged Image: Political Satire in the Age of Daumier* (4 October–4 December 1988), and *Ritual and Reverence: Chinese Art at The University of Chicago* (10 October–3 December 1989).

27. From 1976 to 1984, the Museum published *Gallery*, a newsletter which included notices and short articles on new acquisitions. The *Bulletin of the David and Alfred Smart Gallery*, initiated by Acting Director Jeffrey Abt in 1988, serves as the Museum's annual report as well as a venue for studies in the permanent collection.

28. For the Creel collection, see *Ritual and Reverence*, 7–8. Professor Creel's pioneering study, *The Birth of China: A Survey of the Formative Period of Chinese Civilization* (London: Jonathan Cape, 1936; New York: John Day, 1937, Frederick Ungar Publishing Co., 1954, 1964), remains the fundamental work in English on the origins of Chinese civilization in the prehistoric period and Bronze Age.

CATALOGUE

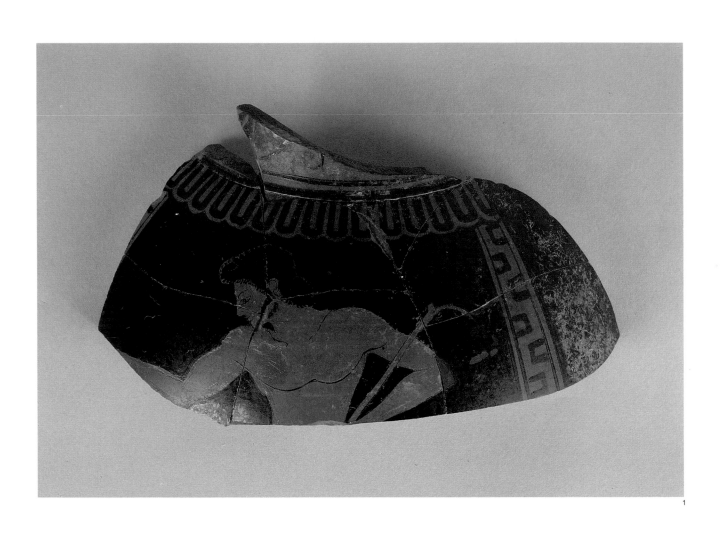

1

Euphronios
Greek, Attic

1 *Red-figure Neck-pelike Fragment: Ephebe (Youth) with a
Walking Stick*, circa 510 B.C.
Slip-painted earthenware, l. 7¼ in. (18.4 cm.)
The F. B. Tarbell Collection
1967.115.287

One of the pioneering studies of Euphronios, the most gifted
of the early red-figure vase painters, was in part stimulated by
this seemingly unprepossessing fragment in the Smart
Museum collection.[1] In 1937, Franklin Plotinus Johnson,
Professor of Ancient Art at the University of Chicago from
1930 to 1961, remarked a curious twist in the artistic relationship
between an older cup painter, Oltos, and the younger vase
decorator Euphronios, with regard to certain seated figures.[2]
Euphronios drew these figures particularly successfully, and
his older master seems to have borrowed their design and
learned much about the expressiveness of painting from the
genius of his young pupil.

Euphronios is the first vase draftsman effectively to record
the intricate turnings and twistings of the human body.
Contemporary advances in Greek sculpture, in fact, are often
less convincing than his two-dimensional renderings. Moreover,
the quality of his output is outstandingly high: his subjects
are not repetitive; they are often dramatic, especially
painterly, and possess unusual pictorial monumentality. Because
of his tremendous advances in drawing and composition,
Euphronios has been called a pioneer of Greek red-figure vase
painting, along with his contemporaries Euthymides and
Phintias, who clearly knew each other's work; their short
careers and brilliant production merit much more discussion
in the scholarly literature.[3]

Any curator would consider a vase or vase fragment by Euphronios
of the utmost desirability; however, for many years
the Chicago piece was one of the few works ascribed to his
hand in the United States.[4] Besides the Chicago piece, there
are now in American collections a number of vases and fragments
painted or drawn by Euphronios.[5] Indeed, the painter
signed his vases as decorator at least seven or eight times. Euphronios
also signed vases as potter; he was equally innovative
in this quite separate profession, and had here a lengthy career
(as opposed to the brevity of his activity as a painter). Some
of the most famous cup painters, well into the fifth century,
decorated his fine kylixes.[6] We can deduce something about
his financial success and social status in Athens from the fact
that he was allowed to set up a sculptural dedication on the
Acropolis. The inscription on it begs for good health, probably
for improved eyesight, which was doubtless failing because
of the rigors of his exacting, detailed style of painting.
A stamnos in Leipzig shows signs of the artist's presbyopia.[7]

The Chicago fragment is from a vase called a pelike (neck-
pelike), which is best remembered for its squat pear shape and

open mouth. The piece belongs to the reverse side of a vase
the rest of which, with the foot and the obverse side, is in the
Museum of the Villa Giulia, Rome. It is clear from the reverse
fragment in Rome (fig. 1) that the young man represented is
seated on a folding stool and is playing with a pet, perhaps a
marten, otter, or ferret. The other side of the vase depicts a
boy fastening the sandal of a seated youth. Seated figures, parenthetically,
are also featured on another neck-pelike in the
Villa Giulia painted by Euphronios. The disc foot of the restored
Chicago vase has a graffito in Etruscan script. Some
Greek vases seem to have been intended for the Etruscan market;[8]
several calyx-kraters painted by Euphronios are thought
by one scholar to have been part of a single shipment destined
for this foreign clientele.[9]

The painting style on both neck-pelikai just mentioned is
very early in Euphronios's career. The offset neck on these
"early" vases may also represent the initial stage of what will
become a popular vase shape.[10] The Chicago fragment, in fact,
again might have been a catalyst for an important study of the
pelike's development, which was written by Dietrich von
Bothmer, Chair of the Greek and Roman Department at the
Metropolitan Museum, not long after he had studied with
Johnson at Chicago in 1942 and 1943. Bothmer observed that
the offset neck would eventually merge with the vase body,
becoming a continuous gentle curve with the canonical pelike
amphora. One cannot help but think that Euphronios was influential
in the invention of this shape, as he had been with
several other vase types.

J. D. Beazley, the distinguished Oxford scholar of Greek vase
painting, did not see the Chicago piece on his first visit to the

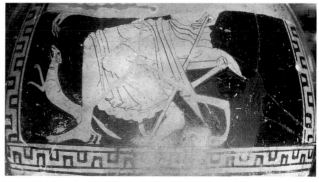

Fig. 1. Euphronios, *Red-figure Neck-pelike Fragment*, circa 510 B.C., slip-
painted earthenware, Rome, Museo di Villa Giulia.

United States in 1914, but examined it in February of 1949, on his second transatlantic voyage. The fragment had come, by the late 1890s, into the hands of Frank Tarbell, Professor of Classical Archaeology and Greek Epigraphy at the University of Chicago from 1892 to 1900. Tarbell had strong and influential ties at the Boston Museum of Fine Arts, and the Chicago fragment, one suspects, may have been seen first by E. P. Warren, who directed other vase fragments to Chicago's Classics Department and who helped build the vase collections at Boston and elsewhere.

<div align="right">Warren G. Moon</div>

1. Description: Max. width, 18.5 cm.; thickness of wall, 0.35 to 0.45 cm.; thickness of neck, 0.6 cm. Reconstructed from seven pieces. There are obvious chips, nicks, surface pitting, and encrustation; the surface is scratched and abraded. The tip of the figure's left elbow seems to have endured different conditions of archaeological preservation. The reserved parts and the biscuit are quite red, strengthened by an orange wash. The fragment is reserved inside; the orange clay is dark in the break. There remains a small part of the neck and shoulder of the neck-pelike. A red ring molding separates the neck and body. There are traces of black handle palmette and tendril, bordered below by a black line. Large tongues just below the join of the neck and body border the picture above; a battlement pattern serves as frame at the side. The upper part of the young man is preserved, facing left, a red-painted wreath around his hair, a walking stick in the crook of his left arm. His hair is outlined in reserve; thick raised dots of paint about the head indicate curls. Thin glaze is used for the sideburns, nostril, and possibly for markings of the abdomen. These appear to have been relief-outlined everywhere; it would seem that the lips and the tip of the nose are not outlined, but traces of relief show in strong light (much is worn away). The relief line varies in thickness and quality. Sketch marks are visible for arms and chest.

At the right, behind the figure, reading left to right and down, inscribed in neat red paint: LEAG[ROS]; at the left, in front of the figure, similarly: KALOS. For *leagros kalos* (homosexual love names), see D. M. Robinson and E. J. Fluck, *A Study of the Greek Love Names* (Baltimore: Johns Hopkins Press, 1937) and K. J. Dover, *Greek Homosexuality* (Cambridge, Mass.: Harvard University Press, 1978). (Description by Louise Berge, in Warren G. Moon and Berge, *Greek Vase-Painting in Midwestern Collections* [Chicago: Art Institute of Chicago, 1979], 137.)

2. Franklin Plotinus Johnson, "Oltos and Euphronios," *Art Bulletin* 19 (1937): 559.

3. More discussion will certainly be stimulated by an exhibition, in preparation at this writing, of the work of Euphronios to be presented at the Museo Archeologico di Arezzo from May through July, and which will travel to the Louvre from October through December 1990.

4. A second red-figure shard by Euphronios, formerly in the University's collection, was returned in 1952 to the National Museum in Athens, where it was joined with a fragmentary kylix. See Eleanor Svatik, "A Euphronios Kylix," *Art Bulletin* 21 (March 1939): 251–257.

5. These are the Sarpedon krater and some unpublished fragments by Euphronios at the Metropolitan Museum (1972.11.10); the Sarpedon cup and Kyknos krater in the Hunt collection in Dallas; a psykter (not restored) in the Boston Museum (ARV², 16, no. 14); and, in the J. Paul Getty Museum, three krater fragments (77.AE.86), one of which, depicting a back-turned Athena, suggests Perseus and the Gorgons (Bothmer), the Achilles cup (77.AE.20), another fragment of a red-figure cup (83.AE.429), and seven fragments of a white-ground cup formerly in the Bareiss collection (86.AR.313).

6. A small covered pot, for example, in the Getty Museum (81.AE.195), spouted like a tea pot, was painted by Onesimos and potted by Euphronios. As far as I can tell, the shape (circa 475 B.C.) is unique and is perhaps the latest example of this master's boundless creativity as potter. See J. Frel, "Euphronios and His Fellows," in *Ancient Greek Art and Iconography*, ed. Warren G. Moon (Madison, Wisc.: University of Wisconsin Press, 1983), 158, ill. 10.19.

7. See J. Maxim, "Euphronios Epoiesen: Portrait of the Artist as a Presbyopic Potter," *Greece and Rome* 21 (1974): 178–180 and J. Frel, "Euphronios and His Fellows," 158, n. 17.

8. Moon, "The Priam Painter, Some Iconographic and Stylistic Considerations," in *Ancient Greek Art*, 109–118.

9. Frel, "Euphronios and His Fellows," 157.

10. Dietrich von Bothmer, "Attic Black-Figured Pelikai," *Journal of Hellenic Studies* 71 (1951): 47.

Greek, Attic, Group of Polygnotos

2 *Red-figure Calyx-krater Fragment: Battle of Kaineus and
Centaur, Departure of a Youth*, circa 440–430 B.C.
Slip-painted earthenware, h. 5¹¹/₁₆ in. (14.4 cm.)
The F. B. Tarbell Collection
1967.115.294

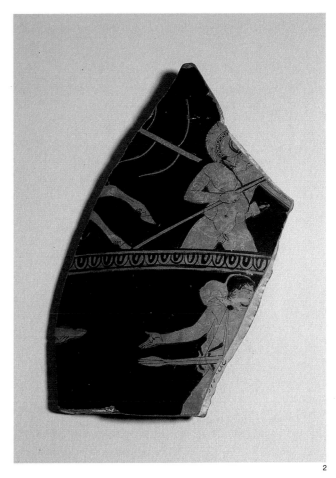

2

This fragment of an Attic red-figure calyx-krater is assigned to the circle of the vase painter Polygnotos, who flourished from around 450 to 420 B.C. Calyx-kraters, one of four types of krater (a vessel for mixing wine with water), had been produced in Athens since about 530 B.C., but did not become common until the following century. The shape is that of a wide-mouthed pot which tends to narrow slightly toward the bottom: the body of the upper two-thirds of the vase is a tall cylinder with a flaring profile, while at the level of the handles, marking the lower third of the vase, the body bulges outward slightly, then curves sharply inward to a short, thick stem, and widens again at the foot. The flaring body of the vase provides the main decorative field, which can be treated either as a single decorative unit running around the whole pot, or as two separate units with the handles marking the division between the two sides of the vase.

Before the third quarter of the fifth century B.C., decoration of Attic vases emphasized two-dimensional design. In the early classical period, from approximately 475 to 450 B.C., some artists began to experiment with the suggestion of spatial depth: figures are more radically foreshortened and placed one above the other on the surface of the vase.[1] These experiments were inspired by illusionistic effects created in murals and panel pictures by painters such as Polygnotos of Thasos and Mikon of Athens, who were active in Athens during these years. Although the illusionism of large-scale painting remained influential during the high classical period, from about 450 to 420 B.C., some vase painters were unaffected by this "Polygnotan" style. The calyx-kraters with two registers of decoration, which first appeared toward the end of the 450s and became common in the following two decades, are products of this conservative tradition.[2] By embellishing the pot with two rows of figures, the artist emphasized the decorative surface of the vase and the two-dimensionality of the design.

The upper row of decoration on these calyx-kraters, although not larger than the lower, tends to be dominant: the field is not interrupted by the handles, and the artist usually places the more interesting or important scenes in this register, concentrating more effort on the figures that appear there. On the Smart Museum fragment, the top register includes a nude armed man, Kaineus, wearing a helmet and sheathed sword and holding a lance. Also visible are the front legs of a centaur and the branch of a tree. The scene is from the Battle of Lapiths and Centaurs, in which Kaineus, otherwise invulnerable, is hammered into the ground by centaurs using stones and tree trunks. Separated from this scene by a decorative band, the lower register of the fragment shows a male figure wearing traveling clothes and carrying two spears. To the left, a hand appears holding a phial; the motif is all that remains of the person toward whom the youth is moving. While the meaning of this departure scene is unclear, the struggle of Kaineus, like all centauromachies, surely represents the conflict between civilization and barbarism which was a central theme in Greek thought.[3]

Leslie Peet

1. G. Richter, *Attic Red-Figure Vases*, 2d ed. (New Haven: Yale University Press, 1958), 90.
2. P. Jacobsthal, "The Nekyia Krater in New York," *Metropolitan Museum Studies* 5 (1934–1936): 120.
3. Yvonne Korshak, "Attic Red-Figure Calyx Krater Fragment," in Warren G. Moon and Louise Berge, *Greek Vase Painting in Midwestern Collections* (Chicago: Art Institute of Chicago, 1979), 211.

Greek, Boeotian, Workshop of the Kabiros Painter

3 *Kabiric Bowl: Odysseus's Men before Circe, Two Combatants*, circa 430–420 B.C.
Slip-painted earthenware; h. (restored) 5⁹⁄₁₆ in. (14.1 cm.)
The F. B. Tarbell Collection, Gift of E. P. Warren, 1902
1967.115.276

In 1887, near Thebes in Boeotia, German archaeologists discovered an ancient cult site which yielded the remains of many vessels decorated with grapevine motifs and scenes of drunken silenes, satyrs, and pygmies.[1] The iconography of these vessels suggests that rituals performed at the site pertained to the protection of vineyards and animal fertility. The principal deity worshiped was Kabiros, believed to be a permutation of Dionysos, the Greek god of the vine. Pausanias recorded the presence of an active Kabiron near Thebes in the fifth and sixth centuries B.C., and indeed archaeological investigations have shown that the location, with its nearby spring for ritual cleansing, continued to function as a religious site well into Hellenistic times.

Despite its reputation as a cultural backwater of the Athenian empire, Boeotia in the fifth century was a center of much artistic activity. Boeotian vase painting is technically less developed than its Athenian counterpart, but it is exceptionally notable for the levity of its imagery. The fragmentary vessel in the Smart Museum collection, with particularly fine and complex though incomplete decoration, typifies some of the issues associated with vase painting of the Kabiric cult. The bowl, a rare form resembling a stamnos without handles, is composed of three large pieces, united at some point in the twentieth century before its accession by the Smart Museum. The largest of the fragments depicts two figures in profile beneath a grapevine. Clearly caricatures, the figures have short, stubby bodies, large wrinkled faces with exaggerated features, and long, spindly limbs. The figure on the left, a woman in a loose, belted chiton, extends a small bowl towards the second figure with her left hand; with her right hand she touches his forehead. As if mesmerized, the male figure leans forward, drawn to her. A third figure, also in profile, approaches behind the second; just his feet are visible, and the edge of his chiton. A small remnant of a fourth figure approaching from the right includes only the front half of his foot.

3a

3b

The scene is accepted as an episode in the *Odyssey*, in which Odysseus's men encounter the witch Circe who offers a potion that will turn them into swine.[2] The identification of Circe is thus based on the skyphos she holds; the identification of the first male figure is more problematic. Odette Touchefeu-Meynier has accepted him as Odysseus because of the gnarled stick he holds, perhaps the magical moly, an herb given Odysseus by Hermes, which prevented his falling under the witch's spell.[3] Homer, however, clearly states that Odysseus visited Circe alone, and the gnarled twig could be a walking stick often associated with wanderers. Other Kabiric representations of the myth usually portray Odysseus with an unsheathed sword; there were no set compositional rules for illustrating the scene.[4] If in fact this is a depiction of the procession of Odysseus's men towards Circe, it must be the beginning of the tale, before the men were transformed into swine.

The smallest fragment in the Smart Museum bowl seems to be a continuation of the narrative, for it depicts the upper body of a male figure almost identical to the Odysseus of the first fragment. Missing, though, is the grapevine linking this scene to the one mentioned above. Even if the grapevine did not originally continue around the entire circumference, as is sometimes the case in these bowls, the figure is still located too high, almost a full head higher than the others, to be a part of the procession of Odysseus's men. The possibility should therefore be noted that this piece may be from a different bowl by the same artist.

The third fragment depicts two battling pygmies. One of these, naked except for the pilos hat falling off his head, is almost intact. With a bulging belly, and genitals dangling between skinny legs, he holds a large round shield in his left hand. His right arm, now lost, may have carried a sword. Only the right foot and black shield of his foe are present. Such scenes of pygmies are common on Kabiric vessels, but their relationship to Homeric myths is unclear. Apparently

not directly linked to the procession of Odysseus's men, this image may represent another episode from the *Odyssey*, and the pygmy Odysseus himself, whose popularity in Kabiric vase painting was perhaps connected with his initiation in the rites of the Kabiroi.[5]

Why did these painters parody the Homeric myths? Along with satires of mortal heroes are fragments showing that the entire pantheon of Athenian gods were targets of these visual jokes. Noting that the gods were treated with similar irreverence in Greek Middle Comedy, Gerda Bruns has proposed that these images are representations of what actually occurred on the stage, "visual illustration of a little-detailed literary tradition."[6] Thea Elizabeth Haevernick, on the other hand, believes that these paintings are not so much specific illustrations as "remembrances" of the plays.[7] In either case, the compositional and expressive creativity demonstrated by the Kabiric vase painters reflects the improvisational character of the farces or satyr plays common at the site.[8] The Smart Museum bowl is a fine example of the popularity of the *Odyssey* on Kabiric vases and of visual satires of the Homeric myths. The quality of the painting, stylistically more detailed and meticulously executed than most Kabiric vases depicting similar subjects, reveals the diversity of hands and styles, as well as a variety of compositions and modes within Kabiric vase decoration.

H. Rafael Chacón

1. For a history and catalogue of the dig, see Karin Braun and Thea Elizabeth Haevernick, *Bemalte Keramik und Glas aus dem Kabirenheiligtum bei Theben* (Berlin: Walter de Gruyter and Co., 1981) and Paul Wolters and Gerda Bruns, *Das Kabirenheiligtum bei Theben*, vol. 1 (Berlin: Walter de Gruyter and Co., 1940).

2. The two main interpretations are given by Karl Kilinsky II in Warren G. Moon and Louise Berge, *Greek Vase-Painting in Midwestern Collections* (Chicago: Art Institute of Chicago, 1979), 215–216, and Odette Touchefeu-Meynier, "Ulysse et Circé: Notes sur le Chant X de l'*Odyssée*," *Revue des Etudes Anciennes* 62 (1961): 263–271, pls. 15–17.

3. Touchefeu-Meynier, "Ulysse et Circé," 269. In addition, a late eighth-century fragment from Ithaca showing a male and female figure facing each other, the male carrying a leafy branch, has been interpreted as the earliest depiction of the confrontation between Circe and Odysseus. See Frank Brommer, *Odysseus, die Taten und Leiden des Helden in antike Kunst und Literatur* (Darmstadt: Wissenschaftliche Buchgesellschaft, 1983), 70–71.

4. Other vases illustrating the Odysseus-Circe myth include: London, British Museum (Wolters K19); Baltimore (Wolters K20); Harvard, Hoppin Collection, 1925.30.127 (Wolters K21); Oxford 262 (Wolters M16); Robinson Collection, present whereabouts unknown; Nauplia, Archaeological Museum, 144; Bonn, Akademisches Kunstmuseum (Wolters K18); and another in the Smart Museum, 1967.115.276.

5. See Brommer, *Odysseus*, 15–17.

6. Wolters and Bruns, *Das Kabirenheiligtum*, 127.

7. Braun and Haevernick, *Bemalte Keramik und Glas*, 27. Although Odysseus played a considerably smaller role in Greek comedy than in tragedy, he is mentioned in various of Aristophanes' comedies; *Pluto*, for example, mentions the confrontation between the hero and Circe. There are only six comedies on the *Odyssey* recorded—by Anaxilas, Ephippos, Anaxandrides, Alexis, Amphis, and Eubolos—and these are fragmentary (see J. M. Edmonds, *The Fragments of Attic Comedy after Meineke, Bergk, and Kockу*, vol. 2 [Leiden: E. J. Brill, 1957]). Other Middle Comedy playwrights such as Theopompos and Kratinos are associated with comedies about Circe. None of the fragments of comedy, as Haevernick asserts, illustrate the scene depicted on vases.

8. Braun and Haevernick, *Bemalte Keramik und Glas*, 27.

3c

French, Burgundy, School of Cluny III

4 *Architectural Fragment: Head (of an Angel?)*, circa 1120
Limestone, h. 7¼ in. (18.4 cm.)
Purchase, The Cochrane-Woods Collection
1977.2

Romanesque sculpture in Burgundy entered its most vigorous phase during the first quarter of the twelfth century in connection with the third and largest rebuilding of the abbey church at Cluny, one of the most powerful Benedictine monasteries in Europe. This church, known as Cluny III, was almost completely destroyed at the time of the French Revolution; its fragmentary sculptural remains, with only a few exceptions, are housed in the Musée Ochier at Cluny. These fragments attest to at least two major ateliers working in the area of the choir and on the west portal, respectively.[1] Their influence can be seen at other churches in the region, most notably at Vézelay where, it is now believed, the narthex tympana and some capitals in the nave were carved by sculptors from the atelier responsible for the hemicycle of eight capitals in the Cluny ambulatory.[2] The Smart Museum's limestone head of an angel also compares in style with the Cluny ambulatory capitals, though its provenance cannot be established with certainty.

Once part of a figure carved in relief, the head, which appears to have been sculpted "so that it looked downwards to the left,"[3] has sustained damage to its nose and chin. Deep scratches on the left side mark where it was torn from a wall or flat surface. The stone is also broken at the neck, where part of a collar, decorated with drill holes, and the folds of a garment can still be seen. The size of this head, approximately six inches, indicates the body to which it belonged was between three and one-half to four feet in length.

A figure of this size would not fit even on an oversize capital, such as those in the Vézelay nave, nor does it match the size of figures usually carved on lintels in the area.[4] While it may have been created for a tympanum, the facial features do not show the weathering usually associated with sculpture in exterior locations.[5] Nor does this head agree stylistically with fragments from the west portal of Cluny.[6] Instead, the large round eyes with straight upper lids and teardrop-shaped lower lids, the straight nose, slight facial contouring, and straight lips with parentheses at the corners parallel the facial features of figures on the eight capitals in the Cluny hemicycle.[7] The delicate yet insistent manner of carving testifies not only to a high level of technical competence, but to such confidence with these motifs that the head can be considered the work of a sculptor from the Cluny ambulatory atelier.

These considerations suggest that the Smart Museum head was originally located in the church at Cluny, yet it is difficult to integrate with known sculptural sites within the church:

there is no published evidence for relief figures on the walls of the ambulatory or its chapels; the Tomb of St. Hugh, once located at the east end of the nave, appears to have been too small to have accommodated such a figure; and the proposed reconstruction of a choir screen from fragments in the Musée Ochier and elsewhere would seem to involve only geometric and floral decoration.[8] Under these conditions, the possibility must at least be considered that the Smart Museum's fragment was carved by a Cluny sculptor working elsewhere, perhaps on the portals sheltered by the Vézelay narthex. While there are few opportunities for an angel in the iconographic programs of these portals, the identification of this figure as an angel is only hypothetical and may need revision.[9] It is more likely that the Smart Museum head was located somewhere in the Cluny church, probably in conjunction with other sculptural remains that have not yet come to light.[10]

Leah Rutchick

1. The major work on Cluny remains that of John Kenneth Conant, *Cluny: Les Eglises et la maison du chef d'ordre* (Mâcon: Imprimerie Protat Frères, 1968).
2. Francis Salet, *La Madeleine de Vézelay* (Melun: Librairie d'Argences, 1948). Salet first posited the migration of some sculptors from the Cluny ambulatory workshop to Vézelay, and this argument is now widely accepted.
3. Neil Stratford, Keeper of Medieval and Later Antiquities, British Museum, London, in a letter dated 25 January [1983], to Richard A. Born, Curator, David and Alfred Smart Gallery.
4. An important exception is the large figure of Eve, carved horizontally on the lintel over the north door to Autun Cathedral. See Denis Grivot and George Zarnecki, *Gislebertus, Sculptor of Autun* (New York: Orion Press, 1961). The Autun Eve, however, is both different in style and later in date than the Cluny capitals; nor is there other evidence that a lintel with figures of this size was carved for Cluny or any other Romanesque lintel.
5. The possibility of the original location of the fragment on a tympanum was suggested by Prof. C. Edson Armi, who discovered and recommended the acquisition of this and the other Cluny III pieces in the Museum's collection, in a letter dated 15 August 1977 to Katharine Lee Keefe, then curator of the David and Alfred Smart Gallery.—Ed.
6. Sculpture fragments from the west portal have been published by Conant, *Cluny*, pls. 82–92, especially figs. 192, 196, 203.
7. Ibid., figs. 129–133, 138–141 for the hemicycle capitals, and fig. 174 for additional fragments from the ambulatory. The stylistic closeness to the Cluny hemicycle/Vézelay narthex group was proposed originally by Armi in an undated memorandum on file at the Smart Museum, and in the letter mentioned in n. 5 above.—Ed.
8. Ibid., figs. 35 and 176 for the Tomb of St. Hugh; p. 120 and fig. 184 for the choir screen. The most recent proposal for a choir screen is Armi and Elizabeth Bradford Smith, "The Choir Screen of Cluny III," *Art Bulletin* 66 (December 1984): 563; see also the next entry in this catalogue.
9. The voussoirs of the central tympanum are deeply recessed compartments with prominent relief figures, some of which are now without heads, but the overall size of the figures seems too small to relate to this particular fragment.
10. A further study of the identification, provenance, and function of the Smart Museum fragment will benefit from a comprehensive publication of sculpture in the Musée Ochier, currently in preparation under the direction of Neil Stratford and David Walsh. In addition, petrographic analyses are now being carried out on the Cluny sculptures in the Musée Ochier. This kind of analysis compares the mineralogical content of stone found in different quarries or in different areas of a single quarry with that of the stone used for a given sculpture or group of sculptures.

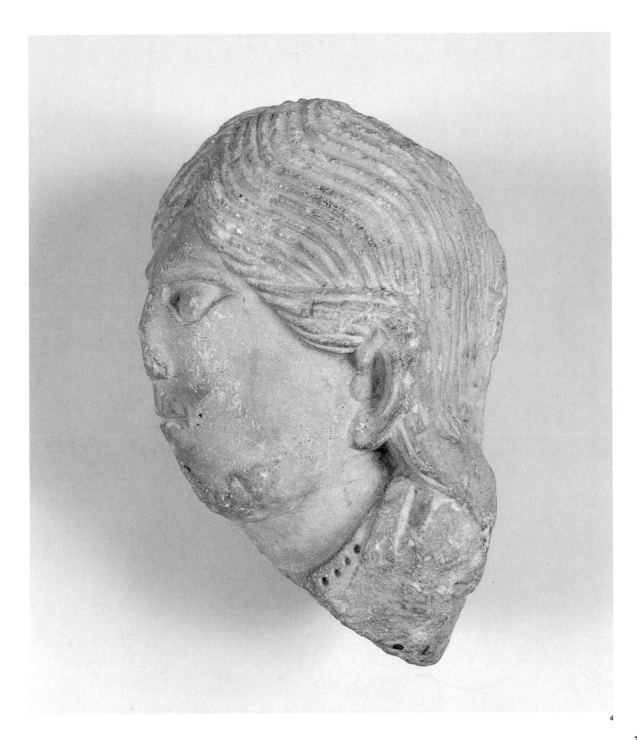

French, Burgundy, School of Cluny III

5a *Architectural Fragment: Section of an Arcade*, circa 1120
Limestone, 15¾ x 9⁷⁄₁₆ x 4½ in. (40 x 24 x 11.4 cm.)
Purchase, The Cochrane-Woods Collection
1977.3

5b *Architectural Fragment: Capital*, circa 1120
Limestone, 6¾ x 11 x 6 in. (17.1 x 27.9 x 15.2 cm.)
Purchase, The Cochrane-Woods Collection
1977.4

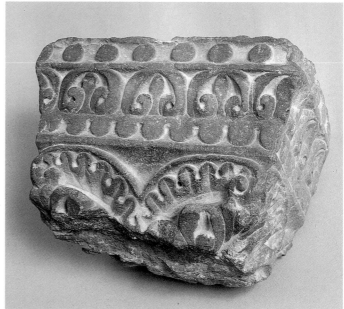

5b

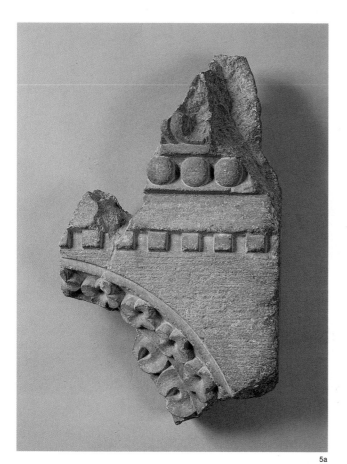

5a

Architecture provided one of the most important settings for sculpture in the Middle Ages. Working on interior and exterior surfaces, medieval sculptors articulated the structural elements themselves, including piers, columns, and pilasters, as well as capitals, arches, corbels, and cornices. With often intricate geometric motifs, foliate and floral forms, and figural representations, sculptors also elaborated tombs, altars, pulpits, or ambos and choir screens, carved on a smaller scale and with greater refinement of formal detailing. The Smart Museum's section of an arcade and capital represent this tradition of small-scale architectural sculpture in the Romanesque style of the twelfth century, and can be considered among the finest examples of carving from the abbey of Cluny.

The arcade fragment preserves portions of an arch, spandrel, and entablature with acanthus frieze above. It is crisply and deeply carved with leaf and flower motifs in the soffit of the arch and a classically derived system of dentils, fillet, and beads in the entablature. The quality of carving, proportions, and order of motifs match a larger arcade section in The Cloisters, Metropolitan Museum, New York, where it is possible to observe the acanthus frieze in more detail. Recent scholarship has identified these sections as "two pieces from the same arcade."[1] They join a large group of fragments in the Musée Ochier at Cluny which, it is argued, would have formed a low, arcaded choir screen for Cluny III.[2] The date proposed for this choir screen is around 1120.[3]

The Cluny screen would have stretched across the nave at the western end of the choir and probably extended eastward along the side aisles,[4] providing a barrier between the space reserved for the monastic liturgy, in the eastern parts of the church, and the nave itself, where visitors would hear Mass and receive communion. In its proposed reconstruction, the screen would consist of segments, each with three arches supported by pilasters and capitals in an open-closed-open sequence, with a single rosette in each spandrel.[5] In this system, the open arches of one segment join with those in the next by matching half-pilasters and half-rosettes on the outer sides. This suggested format is based in part on a section of the arcade reconstructed from two fragments by John Kenneth Conant.[6] Conant's section shows a rosette between one open and one closed arch. The arches carry a band of checkered billets and a single row of leaves, and spring from a fluted pilaster and capital, also carved with a single row of leaves. Although a rosette does not seem to have been carved in the spandrel of the Smart Museum fragment, the distribution of motifs over the length of the screen is far from certain; the typical segment does not account for those areas where the decoration may have been more elaborate.

That such areas did in fact exist is shown by the treatment of both the Smart Museum and Cloisters pieces, which may have fitted together in a sequence of open arches; in addition to this open sequence, each arch displays different types of leaf and flower motifs, and the capital on the Cloisters piece is larger than usual and carries a scroll and rosette combination instead of a single row of leaves.[7] Yet these distinctions do not resolve the problem of the absent rosette in the Smart Museum fragment. This variation in the decorative format might have occurred at either extremity of the west front or at the western entrance to the choir, probably in the center of the arcade. At these points, pier supports or frames might reasonably appropriate the space otherwise filled by a rosette.

The capital fragment is more difficult to place in the context of the screen. Broken horizontally at mid-point, this capital was carved on three sides in the same style and small scale as the arcade section, but it is substantially larger and deeper than any of the engaged capitals carved on the published fragments. It must have been detached from the surface of the screen in some way; perhaps it originally rested on a column in front of an opening, or belonged to an associated structure such as an ambo or shrine. Further study of surviving Cluniac sculpture may resolve the problem of its location.[8]

The capital is an outstanding example of chisel work and ornamental composition. The sculptor has created a lively play of volumes across the surface, and it is especially regrettable that so little remains of the vigorously projecting acanthus (?) forms under the arches. This capital and the section of an arcade provide one of the few opportunities to view Cluniac architectural sculpture outside France.[9] They offer a glimpse, however incomplete, of the formal concerns and physical context this type of sculpture involved.

Leah Rutchick

1. C. Edson Armi and Elizabeth Bradford Smith, "The Choir Screen of Cluny III," *Art Bulletin* 66 (December 1984): 563.

2. Ibid. This idea was first offered, but not developed, by John Kenneth Conant in *Cluny: Les Eglises et la maison du chef d'ordre* (Mâcon: Imprimerie Protat Frères, 1968).

3. Armi and Smith, "The Choir Screen," 556. According to the current position of French archaeologists, this date would place the screen within the final years of construction of the church itself.

4. Ibid., 560.

5. Ibid., 557 for the scheme of a typical section.

6. Conant, *Cluny*, 120 and fig. 184. Conant's assembled section remains in the Musée Ochier.

7. Armi and Smith propose that these two pieces belong to an "area of focus of particularly high quality and elaboration," which would include at least four open arches, "The Choir Screen," 563.

8. A second hypothesis for the original placement and function of the screen is offered by Charles T. Little in notes on the Cloisters arcade fragment, *Gesta* 26 (1987): 160–161. Little points out that none of the screen fragments were found in the nave; rather, some were excavated "in the area occupied by monastic buildings," 160. He indicates their formal analogies to arcaded screens that decorate surviving medieval houses in the town of Cluny, and in particular to an unpublished complete arcade once enwalled in such a house, but now kept in the Musée Ochier, 161. While his proposal is provocative, it should be tested in greater detail than it has been to date.

9. For other examples of architectural sculpture in American museums attributed to Cluny III, see Linda Seidel, "Romanesque Sculpture in American Collections IV: The William Hayes Fogg Museum," *Gesta* 11 (1972): 72–73; Marilyn Stokstad, "Romanesque Sculpture in American Collections XV: The William Rockhill Nelson Gallery and Mary Atkins Museum of Art, Kansas City, Mo.," *Gesta* 16 (1977): 51; and Charles T. Little, "Romanesque Sculpture in North American Collections XXVI: The Metropolitan Museum of Art. Part VI. Auvergne, Burgundy, Central France, Meuse Valley, Germany," *Gesta* 26 (1987): 159–163.

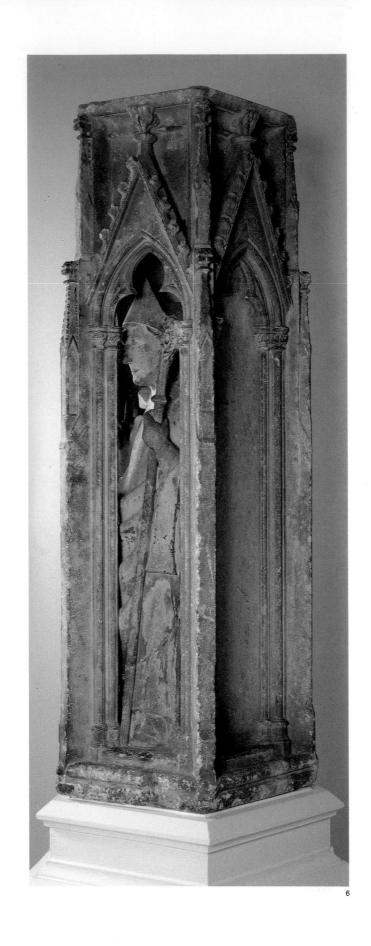

6

French, School of Burgundy

6 *Architectural Fragment: Bishop*, circa 1350–1400
Sandstone, traces of polychromy, h. 55⅛ in. (140 cm.)
Purchase, The Cochrane-Woods Collection
1974.122

This architectural fragment depicting a bishop standing in a niche is shaped like a column flattened on five sides; its base forms a regular pentagon. Each column face repeats the motif of a trilobed arch surmounted by a cusped gable with flanking pinnacles. The two front sides of the pentagon form the apertures of the bishop's niche, while the two lateral sides are treated as blind arches. Pierced by a smaller arched niche, the rear face of the column bears a metal fixture and indentations which probably accommodated hinges and a latch; it is thus likely that the niche was enclosed by a small door, of wood or grill-work. A horizontal groove within the niche may have supported a wooden or metal shelf.

The figure holds a bishop's crozier and wears a bishop's vestments, although they are unusually plain ones. Traces of polychromy indicate that his miter was originally red, his chasuble blue, and his crozier gray. Although blue is no longer permitted bishops, it was used in the Middle Ages.[1] Gray gloves, one easily seen on the hand raised in blessing, complete his attire. Gloves, not common in medieval representations of bishops, were indeed part of a bishop's regalia; they were to be worn only during the celebration of Mass.[2]

The niche in the sculpture's rear face is characteristic of an aumbry, which holds vessels used at the altar, or of a tabernacle for reservation of the Host. A groove for a shelf as well as the remains of hinges, like those in this piece, can be seen in an aumbry at Rattlesden, Suffolk.[3] Moreover, aumbries are mentioned in connection with solemn Masses such as those celebrated by bishops, and an aumbry at Souvigny exhibits traces of a bishop's image on its door.[4] The niche, the references to the Mass made by the bishop's gloves, the pentagonal shape of the object (five was symbolic of the wounds of Christ, the basis of the Eucharist), and the sculpture's excellent state of preservation support the conjecture that the piece was used in the choir as an aumbry or tabernacle.

Aumbries were either cut into the wall or incorporated into freestanding complexes near the altar. Before sacristies became common, aumbries were often used in conjunction with credence tables, where Mass was prepared before presentation at the altar. English aumbries remained rather plain until the fifteenth century, while German *Sakramentshausen*, common from the mid-fourteenth century, were heavily ornamented, incorporating figural sculpture.[5] Because of large-scale destruction following the Revolution in the eighteenth century, few French aumbries or tabernacles still exist; however, documents confirm their placement on or near altars in the Middle Ages. They may have been created in conjunction with the many *clôtures* and *jubés* (rood screens) popular in France through the fourteenth century. Marks on the top and base of the Smart Museum fragment indicate that, whether placed behind or near the altar or connected to a credence table, the column was mounted on and surmounted by additional pieces of stone. Clearly, the piece must have been approachable from at least two sides, and the finished nature of all five sides suggests it may have been freestanding or at least visible from all directions.

Stylistically, the bishop compares well with works by André Beauneveu, such as the effigy of Charles V from 1364 and the tomb figures of Philippe VI and Jean II of similar date, all at St. Denis.[6] A date for the sculpture between 1350 and 1400 coincides with both the style of the work and a period of French interest in the sculptural elaboration of the choir. Unfortunately, the lack of surviving monuments makes it difficult to imagine the exact nature of the complex to which this bishop belonged.

Pamela Loos-Noji

1. Ludwig Eisenhofer and Joseph Lechner, *The Liturgy of the Roman Rite*, trans. A. J. and E. F. Peeler (New York: Herder and Herder, 1961), 146.

2. Ibid., 157.

3. Francis Bond, *The Chancel of English Churches* (London: Oxford University Press, 1916), 210.

4. E. E. Viollet-le-Duc, *Dictionnaire de l'architecture raisonné*, vol. 1 (Paris, 1859), 466.

5. Bond, *The Chancel of English Churches*, 204–219. See also Wim Swann, *The Late Middle Ages: Art and Architecture from 1350 to the Advent of the Renaissance* (Ithaca, N.Y.: Cornell University Press, 1977) for images of *Sakramentshausen* at St. Sebaldus, Nuremburg (1370–1380), fig. 237, and St. Lorenz, Nuremburg (circa 1450), fig. 231.

6. See Arthur Gardner, *Medieval Sculpture in France* (Cambridge: University Press, 1931; New York: Kraus, 1969), figs. 408, 411, 413, 414.

Ugolino Lorenzetti
Italian, active circa 1320–1360

7 *The Crucifixion*, circa 1350
Tempera and gilding on wood panel, 19¾ x 8⅝ in.
(50.2 x 21.9 cm.)
Gift of the Samuel H. Kress Foundation
1973.40

The name "Ugolino Lorenzetti" refers to an anonymous artist active in Siena from about 1320 to 1360, whose style derives from Ugolino da Siena and Pietro Lorenzetti.[1] The previous identification of the artist as the Master of the Ovile Madonna has not found general acceptance among scholars; the same is true of Millard Meiss's linking paintings in this style with a documented artist, Bartolommeo Bulgarini.[2]

We know that the Smart Museum panel was once the right wing of a diptych, since the half-length figure of the Virgin Annunciate with an open book in the roundel of the pinnacle would have faced a pendant Gabriel on the left wing. The main scene on this lost wing may have represented the Madonna and Child, creating a devotional contrast between Mary's joy at the Savior's birth and her sorrow at his death. Or, the scene may have been a Pietà, with the cross repeated in both compositions, as occurs in a number of Sienese diptychs of the same date. The composition with flanking angels is close to that in a triptych in the Siena Accademia and to another in a Florentine private collection, dated circa 1335 and attributed to Pietro Lorenzetti himself.[3] Although no evidence exists of the patron or original site of this work, its eucharistic focus points to its function on a small altar.

The eucharistic piety of late medieval devotion and the notion of *imitatio Christi* popularized by the Franciscans are expressed in our panel in the emphasis on Christ's blood, which spurts from his side and drips down the cross onto the ground. This red is echoed in the blood of the symbolic pelican surmounting the cross, piercing her own breast to feed her young in an allegory of Christ's sacrifice. Another emotive motif commonly found in Sienese passion iconography of this period is Mary Magdalene, who hugs the foot of the cross. Like the Virgin, she provided, in her penitence, a channel through which the viewer might empathize with Christ's human suffering. Another crucifixion by this artist in the Vatican collection, identical in shape, shares this feature as well as the polygonal halo of the centurion with his shield inscribed S.P.Q.R.[4] The expressive figure of Longinus, who looks up at the cross in his orientalizing costume, may remind the viewer of the miracle in which his blindness was healed when he witnessed the Passion. Longinus and the centurion, regarded as converted heathens, were placed on a par with the saints, but they are distinguished here on the scale of sanctity from the holy women on the left by their unusual nimbuses.

The group on the left side of the cross is different from that in both the Vatican panel and a closely related crucifixion scene by the same hand in a predella in the Louvre.[5] Both these latter works show the Virgin swooning in the arms of the other women. In the Smart Museum crucifixion, instead of fainting, the Mother of God, dressed in dark ultramarine blue, looks up from the left. St. John stands beside her, clutches his garment, and turns away in grief. It is the facial type of this figure, with upturned brows and watery eyes, that distinguishes the work of this master and is very close to the saint who stands more isolated and to the right of the cross in the Louvre predella. Our panel and the Louvre crucifixion must date from the same period, when the artist was working strongly under the influence of Pietro Lorenzetti, who died in the plague of 1348. Both the Louvre and Chicago panels have recently been described as "certainly later" than the Vatican panel dated circa 1335, thus placing our picture towards the middle of the century.[6]

The panel is in excellent condition apart from the placard of the cross and the banner on the right. It is most especially splendid in the punched gold decoration, which frames the composition in a minute pattern of cusped trefoils and rosettes.[7] This aspect of the painter's art, which made such objects shine like metalwork reliquaries as they reflected the flickering candlelight of side chapels, is just as important as the painted image. The translucent effects of the tempera pigments, especially the blue of the angels and the green underpaint of Christ's body, together with the tender emotions on the faces of the onlookers, make this one of the most important Italian trecento panels in the Midwest and the jewel of the Smart Museum's collection.

Michael Camille

1. Bernhard Berenson, "'Ugolino Lorenzetti': Part One," *Art in America* 5 (October 1917): 259–275, was the first to use the designation "Ugolino Lorenzetti," anticipated by F. M. Perkins in "Appunti sulla Mostra Duciana a Siena," *Rassegna d'Arte* 13 (January 1913): 9.

2. Fern Rusk Shapley, *Paintings from the Samuel H. Kress Collection, Italian Schools XIII–XV Century* (New York: Phaidon Press, 1966), 55. W. E. Suida refers to the panel as by an artist "called the 'Master of S. Pietro in Ovile' by Ernest T. DeWald," in Honolulu Academy of Arts, *The Samuel H. Kress Collection in the Honolulu Academy of Arts* (Honolulu: Honolulu Academy of Arts, 1952), 10. Millard Meiss, "Bartolommeo Bulgarini Altrimento detto 'Ugolino Lorenzetti,'" *Rivista d'Arte* 18 (1936): 113–136, proposed the Bulgarini identification, although not referring specifically to our picture.

3. For the Siena painting see Millard Meiss, "Ugolino Lorenzetti," *Art Bulletin* 13 (September 1931): 376–397, fig. 24 (attributed to the shop of "Ugolino Lorenzetti"). The Pietro Lorenzetti triptych was exhibited and discussed in *Il gotico a Siena: Miniature pitture oreficerie oggetti d'arte* (Siena: Centro Di, 1982), 147, no. 49.

4. Rome, Pinacoteca Vaticana, no. 152 is described as "Bottega di Pietro Lorenzetti: 'Ugolino Lorenzetti,' c. 1335" in *Il gotico a Siena*, 253, no. 92.

5. The Louvre predella is reproduced in Millard Meiss, "Nuovi dipinti e vecchi problemi," *Rivista d'Arte* 30 (1955): 135, fig. 20. Meiss cites this as by Bulgarini but recent scholarship totally separates this documented artist's work from our Ugolino Lorenzetti (*Il gotico a Siena*, 251, no. 91).

6. Giulietta Chelazzi Dini in *Il gotico a Siena*, 254.

7. These motifs are comparable to the punch-marks on the related panels as well as on the beautiful *Saint Catherine of Alexandria* in the National Gallery, Washington, also attributed to Ugolino Lorenzetti. See Shapley, *Catalogue of the Italian Paintings [in the National Gallery of Art, Washington, D.C.]* (Washington, D.C.: National Gallery of Art, 1979), no. 521, vol. 1, p. 270, vol. 2, pl. 186.

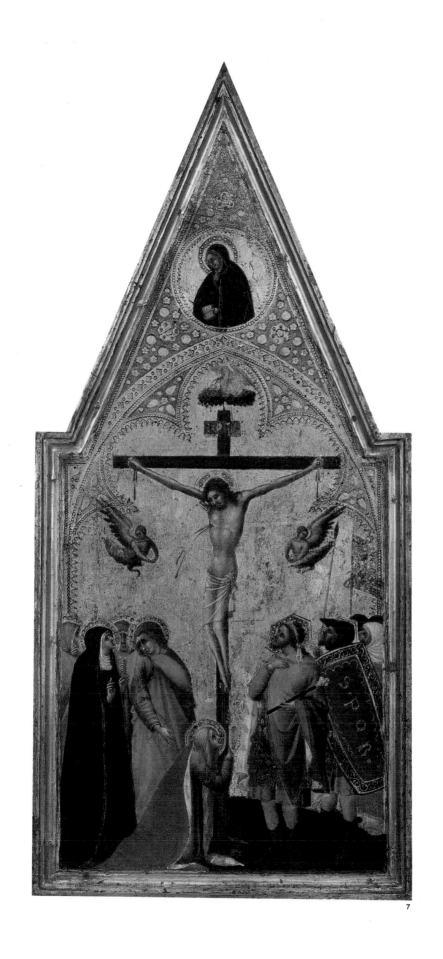

7

Italian, Padua, Workshop of Severo Calzetta da Ravenna

8 *Candlestick and Inkwell (or Sandbox): Kneeling Satyr,*
circa 1500–1509
Cast bronze, h. with base 9¾ in. (24.8 cm.)
Gift of the Samuel H. Kress Foundation
1973.58

The seat of a major university renowned for classical literature and Aristotelian philosophy, Padua around 1500 supported an eminent humanist circle. Its scholars were familiar with texts by Pliny, Virgil, and Martius, among others, ecstatically describing Roman connoisseurship of small-scale bronze sculptures.[1] Stimulated by excavations throughout Italy that were bringing to light ever greater numbers of ancient statues and ornamented utensils, Padua's antiquarians enthusiastically vied for the insufficient supply of rare Greek and more common Roman originals. Eventually creating a market for avowed copies and outright forgeries, they also encouraged artists to improve upon antique models with free variations and inventions. These statuettes, plaquettes, and medals were destined for private use rather than municipal or ecclesiastical decoration; they formed in their extreme the "cabinet of curiosities" or *Wunderkammer* of the princely collector, merchant, statesman, or scholar, in which contemporary bronzes were displayed side by side with antique statuary and natural curiosities such as ostrich eggs.

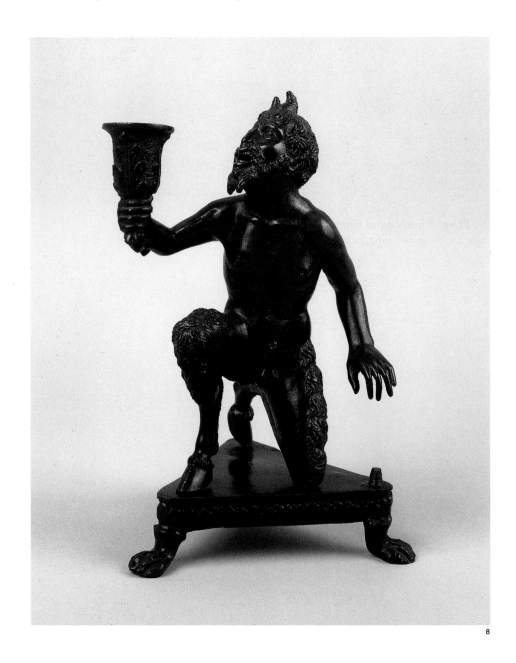

8

The Smart Museum's writing desk implement exemplifies the assimilation of classical forms espoused by learned Renaissance humanists. Kneeling on an original triangular base with animal-paw supports, the ithyphallic satyr—half-human, half goat—gazes awestruck with mouth agape at the floriate, vase-like candle socket with cornucopia-shaped terminal grasped in his right hand; his open left hand extends above an integrally cast threaded screw which originally secured a container for ink or sand, probably the ubiquitous seashell cast from nature that adorns similar bronze desk accessories.[2] The frequent woodland companion of Dionysos and his wine-flushed train of revelers, the satyr in this ensemble, otherwise infamous for his mischievous, even lascivious nature, is set into the service of higher intellect as the mute aide of the solitary man of letters in his study.

The great number of such small-scale Renaissance bronzes from Padua testifies to the renown and commercial success of the city's metalworking industry. In 1443, Donatello had been summoned from Florence to create the high altar complex of the Church of St. Anthony in Padua, called the Santo. The program of statuettes and reliefs he completed by 1454 established a local tradition of bronze sculptures and decorated utilitarian objects imbued with the artistic vocabulary of antiquity, and the fabrication of his altarpiece spawned a well-organized bronze-casting industry supplying the workshops of individual master sculptors. A local treatise, *De Sculptura* (1504), by the Neapolitan-born theorist Pomponius Gauricus, praises Paduan sculptors in metal and stone, but following the example of the Elder Pliny in his *Natural History*, Gauricus reserves highest praise for those working in bronze.[3] Three artists are singled out: Donatello's pupil Bartolommeo Bellano; Bellano's pupil Andrea Briosco, called Riccio; and Severo da Ravenna, described as an outstanding sculptor, "sculptor . . . egregius," in bronze.

The kneeling satyr motif has been traditionally ascribed to Riccio, in large part because of the fame of his *Pascal Candlestick* installed in the Santo in 1516, which includes groups of bound satyrs among the elaborate classically inspired grotesque embellishments. The model for the Smart Museum's *Kneeling Satyr* is now understood to have been invented by Severo, whose artistic identity has only recently emerged through the study of newly recovered archival documents, two signed bronzes, and a marble John the Baptist, signed and dated, commissioned for the Santo.[4] Thought to have been from a Paduan[5] or Ferrarese family, but possibly born in Ravenna, Severo is cited in a Ravennate notarized act dated 1496 as a "magistro" or mature sculptor, and by June 1500, assuming the Santo commission, he had established himself in Padua. Documents record his activity in Ravenna in 1511, which suggests that he left Padua two years earlier, when the imperial army of Charles V of Spain advanced on the city during the war of the League of Cambrai.

One of Severo's two autograph bronze statuettes is a kneeling satyr, inscribed SE in the presumed wax model before cast-ing. This is the exemplar of the Smart Museum figurine,

although the satyr's right hand is altered in the replica so as to grasp the candle socket rather than support it with open palm. The Museum's variant form is listed in the 1542 inventory of Isabella d'Este of Mantua, one of the premier collector-connoisseurs of the age.[6] Indeed, the kneeling satyr type remained in vogue in Italy late into the sixteenth century. The different levels of quality in modeling, casting, and chasing of the many surviving examples reflect the degrees of proximity to the original model and suggest that copies were produced for a long time in the workshop of the master sculptor and by members of his artistic circle.

Technically, such replication had been possible in Padua since the end of the fifteenth century with the perfection of piece-mold casting by Antico in nearby Mantua, and the facture of bronzes given to Severo on the basis of style is consistent with this process.[7] The Museum's *Kneeling Satyr* is closest in figuration and style to bronzes in Munich (Bayerisches Nationalmuseum) and the former Adda Collection. Despite close correspondences with the signed kneeling satyr, the emaciated torso, linear anatomic detailing, and schematic facial features of the satyrs in this group betray the intervention of assistants. Nonetheless, the conceptual fidelity to the original and the quality of the chasing indicate an early date, most likely before Severo fled Padua and re-established his workshop in Ravenna, and possibly later in Ferrara.

Richard A. Born

1. There is a famous passage by the Domitianic court poet Statius, for instance, describing a small Greek bronze Hercules reputedly by Lysippus in the collection of Novius Vindex: "I fell deeply in love; nor, though long I gazed, were my eyes sated with it; such dignity had the work, such majesty, despite its narrow limits. A god was he . . . small to the eye, yet a giant to the mind! . . . What preciseness of touch, what daring imagination the cunning master had, at once to model an ornament for the table and to conceive in his mind mighty colossal forms!" (*Silvae* 4.6). This translation quoted in Manfred Leithe-Jasper, *Renaissance Master Bronzes from the Collection of the Kunsthistorisches Museum, Vienna* (London: Scala Publications in association with Smithsonian Institution Traveling Exhibition Service, Washington, D.C., 1986), 23.

2. See, for example, the kneeling satyr on a triangular base in the former Adda Collection, reproduced in Charles Avery and Anthony Radcliffe, "Severo Calzetta da Ravenna: New Discoveries," in *Studien zum Europäischen Kunsthandwerk: Festschrift Yvonne Hackenbroch*, ed. Jörg Rasmussen (Munich: Klinkhardt and Biermann, 1983), figs. 9, 11.

3. Book 34, in *Selections from The History of the World, commonly called The Natural History of C. Plinius Secundus*, trans. Paul Turner (Carbondale, Ill.: Southern Illinois University Press, 1962), 373–390, esp. 380 and 384.

4. Significant discussions include ibid., 107–122, and Patrick M. de Winter, "Recent Accessions of Italian Renaissance Decorative Arts, Part I: Incorporating Notes on the Sculptor Severo da Ravenna," *Bulletin of the Cleveland Museum of Art* 73:3 (March 1986): 89–118.

5. K. Corey Keeble, catalogue entry in Art Gallery of Ontario, *The Arts of Italy in Toronto Collections 1300–1800* (Toronto: Art Gallery of Ontario, 1981), 141, cat. no. 164.

6. De Winter, "Recent Accessions," 136, n. 68.

7. A thorough account of the technical characteristics of bronzes by Antico, with reference to Severo, is provided in Richard E. Stone, "Antico and the Development of Bronze Casting in Italy at the End of the Quattrocento," *Metropolitan Museum Journal* 16 (1981): 87–116.

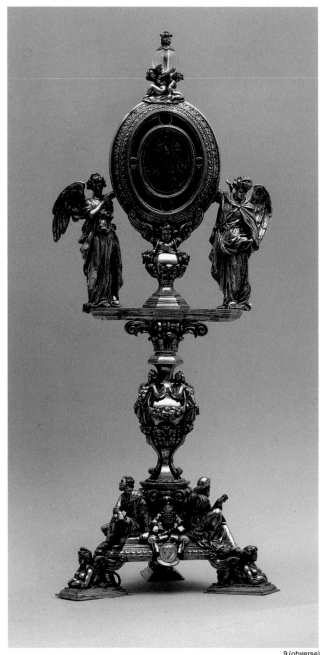

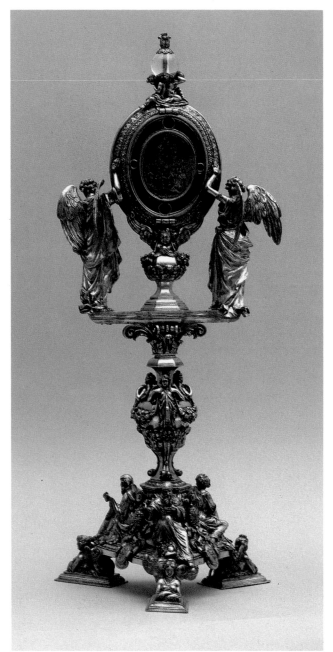

9 (obverse)

9 (reverse)

Italian, Rome

9 *Reliquary*, circa 1534–1549
 Cast silver gilt, lapis lazuli, crystal, enamel, *eglomisé*,
 h. 23 ½ in. (59.7 cm.)
 Gift of the Samuel H. Kress Foundation
 1973.54

The reliquary functions in Catholic ritual as a receptacle for some sacred object associated with a saint or martyr. Because of the venerable remains it encases, the container itself, generally of precious materials, has traditionally been crafted with great finesse, frequently mirroring in its form the relic it houses—a head, hand, crown. The silver-gilt, monstrance-shaped reliquary in the Smart Museum collection affords no such clues to the nature of its one-time contents, nor to the saint with whom they were associated. On each side of the triangular foot, however, is the gold coat of arms of the Farnese family, ornamented with blue and red enamel, and crowned with the papal insignia of tiara and keys. From this we deduce that the reliquary was commissioned by the sole sixteenth-century Farnese pope, Paul III, who headed the church from 1534 until his death on 10 November 1549.

Paul III's papacy coincides with turbulent years in the Protestant Reformation. The outstanding achievement of this advocate of reform, and of those orders, such as the Jesuits, who worked to spread Catholic doctrine, was the convening of the Council of Trent in 1545. In the arts, Paul was a vigorous and discriminating patron; while the most notable artistic monument of his reign is Michelangelo's *Last Judgment* in the Sistine Chapel, city improvement projects, church restorations, important decorative cycles, and quantities of metalwork reveal the extent of his commissions. The superb craftsmanship of this reliquary is testament to Paul's taste.

Portraits by Titian, numerous medals, and sculpted busts by Guglielmo della Porta all record the image of Paul III. Exceptionally, we also find the pope, left hand drawn to his breast, right extended, among the three seated figures on the foot of the Smart Museum's reliquary. To Paul's left is Saint Peter, identified by the keys held in his right hand; at the third corner sits an unidentified prophet, his left hand holding an un-furled scroll, his right extended in a rhetorical gesture. Peter's presence is explained by the dignity of the patron; the significance of the prophet, however, is less obvious. Two large angels stand on either side of the medallion, hinged at the back, which held the relic. Lapis-lazuli bands frame two *eglomisés* or paintings on the back of the rock crystal: on the front, the Coronation of the Virgin, on the rear, the Virgin bestowing a crown and palms on a group of kneeling saints. In both cases, the identity of many of the saints can be determined from their attributes. But, since we know neither whose relics were here enshrined nor for what church the piece was intended, it is difficult to ascertain the precise implication of these scenes.

The reliquary, adorned with classical grotesque ornament including scrolls, garlands, cherub heads, and various moldings, is further enhanced by a variety of humanistically inspired anthropomorphic motifs—sphinges supporting the feet, three highly individualized terms arching across the central baluster, and two putti struggling under the weight of the crystal ball. The finesse of treatment, fecundity of ornamental invention, elegance of the individual figures, as well as the pleasing proportions of the piece, represent the epitome of sixteenth-century metalwork. Though no archival records document the designer or sculptor of the reliquary, we presume that it is the work of the finest artists in the papal circle. The name of Manno di Bastiano Sbarri, who is known to have worked from designs of both Perino del Vaga and Salviati, has been ascribed to the piece. Despite Ulrich Middeldorf's refutation of this attribution,[1] a comparison with Manno's famous Farnese casket (1548–1561) in Naples reveals strong affinities:[2] the liberal use of the volute motif on the casket, the general figural style and the variation in the scale of figures, the pose of the crowning figure of Hercules which strongly recalls that of Saint Peter on the Smart Museum reliquary, and the nearly identical sphinges used as feet all support the traditional association of the object with the style of Manno.

Mary Jackson Harvey

1. Ulrich Middeldorf, *Sculptures from the Samuel H. Kress Collection: European Schools XIV-XIX Century* (London: Phaidon Press, 1976), 79.
2. The casket is illustrated in detail in Aldo de Rinaldis, "Il Cofanetto Farnesiano del Museo di Napoli," *Bollettino d'Arte del Ministero della Pubblica Istruzione* 2 (October 1923): 145–165.

Hans Reinhart the Elder
German, circa 1517–1561

10 *The Fall of Man* (obverse)
 The Crucifixion (reverse), 1536
 Cast silver medallion, diam. 2¹¹/₁₆ in. (6.8 cm.)
 Purchase, The Cochrane-Woods Collection
 1977.100

Hans Reinhart the Elder was one of the most important medalists in Saxony in the first half of the sixteenth century. The strong influence of Lucas Cranach on his compositions suggests that he may have been born in Wittenberg, where Cranach, Albrecht Dürer, and the Venetian Jacopo de' Barbari were employed by the Electors of Saxony. Reinhart's works include both portraits and religious images and, like Cranach, he seems to have had no difficulty in serving Catholic and Protestant patrons simultaneously. Among his medallions, for example, which range in date from 1535 to 1574, are portraits of Cardinal Albrecht of Brandenburg and Emperor Charles V as well as the Protestant Duke Johann Friedrich of Saxony and Martin Luther himself.

The Smart Museum medal is typical of works produced in northern Germany during the early years of the Reformation, evincing in both style and content the theological concerns and ardent faith of the first generation of reformers. Duke Johann Friedrich, who commissioned the medal, was among Luther's earliest supporters; he was the one to offer Luther asylum after the latter's confrontation with Charles V and the Catholic Church at the Diet of Worms in 1521. Cranach was court painter to Johann Friedrich at the time Reinhart cast this medal, and its compositions and iconographic program owe much to Cranach's art. Cranach treated the subject similarly, for instance, in his design for the title page of Luther's translation of the Bible; this particular work of Reinhart's can thus be seen as a clear affirmation of Protestant beliefs.

The obverse of the medal shows the Fall of Man in a setting that resembles several paintings of the subject by Cranach.[1] As in Cranach's Vienna panel, *The Garden of Eden* (1530), scenes of the Creation of Eve and the Expulsion appear in the background. In Cranach's *Adam and Eve* (1526), on the other hand, the deer, lamb, and lion surrounding the central figures of Adam and Eve suggest the harmonious, unspoiled nature of Eden before the Fall, while in Reinhart's conception the animals appear to be part of a more specific symbolic pro-

gram. Reinhart's Tree of Life holds not only the serpent, but also a monkey, fox, and cock. On the ground next to Adam are a unicorn, ox, and ass; an elk, pig, and rabbit appear to the right of Eve. A swan stands at the foot of the tree.

The monkey, fox, serpent, and pig are obvious references to sin and impurity, while the elk and rabbit may symbolize the melancholic and sanguine temperaments, as in Dürer's famous engraving of 1504.[2] Other animals may allude to New Testament events: the ox and ass refer to the Nativity, the cock perhaps to Peter's denial of Christ. The unicorn, which according to legend can only be captured by a virgin, often symbolizes purity and here may point to Eve's lost innocence and to her anti-type, the Virgin Mary. The swan is more difficult to interpret; however, because of its beautiful death-song, it sometimes symbolizes the death and Resurrection of Christ.[3] The beasts assembled in Reinhart's garden thus reflect the idea contained in the surrounding inscription, St. Paul's famous antithesis of Adam and Christ: certain animals denote mankind's sinful nature and inevitable mortality, others symbolize redemption and eternal life.

The Crucifixion side of the medal also shows the influence of Cranach in the twisted postures of the thieves and the arrangement of the figures at the foot of the cross.[4] Young St. John supports the fainting Mary; Longinus thrusts his spear towards Christ's side, and on the right a Roman soldier brandishing a club prepares to break the legs of one of the thieves. In the background, a modest (anachronistic) church rises on the left, and opposite, the Savior emerges victorious from an open tomb. The text encircling the ensemble compares Moses' lifting up of the brazen serpent to Christ's death on the cross for the salvation of mankind. Both textual and visual imagery here have the directness and simplicity of early Lutheranism: the believer is saved not through the intervention of priests or saints, but only through faith in the reality of Christ's sacrifice and Resurrection. The theme of redemption through faith alone lies at the core of Luther's theology and it is this idea that informs the imagery of Reinhart's medallion.

Judith Anne Testa

1. Max J. Friedländer and Jakob Rosenberg, *The Paintings of Lucas Cranach*, rev. ed., trans. Heinz Norden (Ithaca, N.Y.: Cornell University Press, 1987), pls. 191, 201.
2. Erwin Panofsky, *The Life and Art of Albrecht Dürer* (Princeton, N.J.: Princeton University Press, 1967), 85.
3. C. L. Kuhn, *German and Netherlandish Sculpture 1280–1800. The Harvard Collections* (Cambridge, Mass.: Harvard University Press, 1965), 81.
4. Friedländer and Rosenberg, *Cranach*, pl. 1.

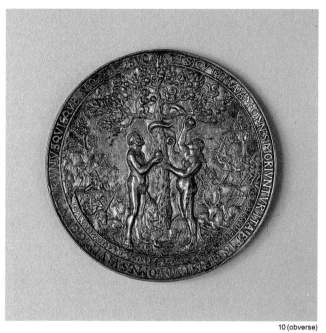

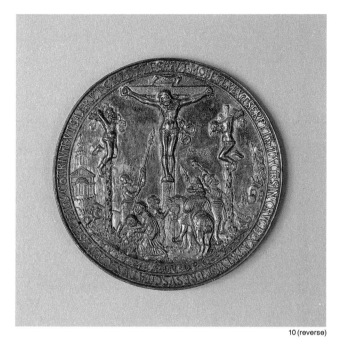

10 (obverse)

10 (reverse)

Il Pordenone (Giovanni Antonio de Sacchi)
Italian, 1483/4–1539

11a *Milo of Croton Attacked by Wild Beasts*, 1534–1536
Oil on canvas, 80½ x 93¾ in. (204.5 x 238.1 cm.)
Purchase, The Cochrane-Woods Collection
1975.31

Niccolò Boldrini
Italian, 1510–after 1566

11b *Milo of Croton Attacked by Wild Beasts*,
after Il Pordenone, mid 16th century
Chiaroscuro woodcut (key block only),
image 11⅝ x 16¼ (29.5 x 41.3 cm.)
Gift of Mr. and Mrs. H. W. Janson
1977.109

Pordenone's *Milo of Croton Attacked by Wild Beasts* sheds light on a poorly understood aspect of the artist's career and on a critical moment in the history of Venetian art. The painting represents the comparatively rare Renaissance subject of Milo of the Greek city of Croton in southern Italy, who was devoured by wild beasts in the sixth century B.C.[1] It is a story of overweening pride and its punishment in which the great athlete, while walking in the forest, comes upon a tree trunk partially split and held apart by wedges. Too confident of his strength, Milo attempts to pull the trunk apart, causing the wedges to fall out. But he is not strong enough to split the two halves of the tree, which trap him when they snap together, leaving Milo helpless, prey to animals, including the rather unconvincing lion gnawing at his leg in Pordenone's painting.

Easel pictures, especially of such non-religious subjects, are extremely rare in the extant oeuvre of Pordenone, since he

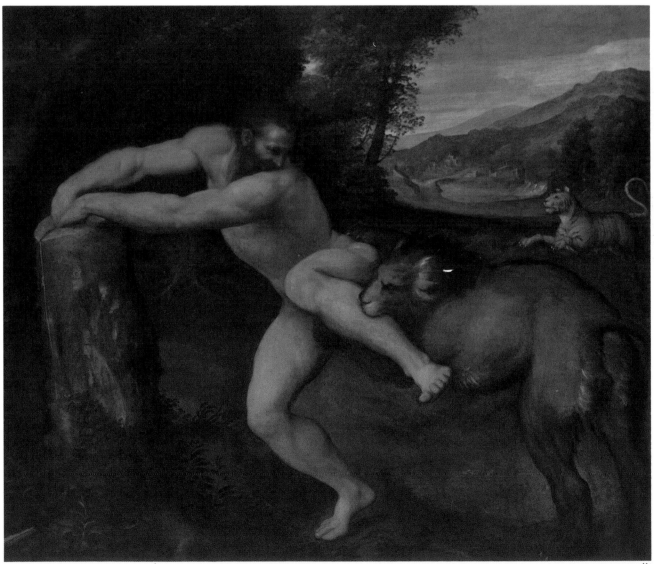

11a

42

mainly painted altarpieces and large fresco cycles. The importance of *Milo of Croton* derives from the fact that, although undocumented, it certainly dates to the influential late phase of Pordenone's career, much of which was spent in Venice. Stylistic evidence points to a date in the 1530s and to the sophisticated patronage of a great cultural center like Venice (or Genoa, where Pordenone also worked during that decade) rather than his more typical provincial clientele.

The plastic strength, expressive power, and heightened emotional atmosphere in Pordenone's painting, all characteristics of his mature style, appealed to Venetians as they became more receptive to non-Venetian art during the second quarter of the sixteenth century. Something of the same violence, vigorous yet idealized muscularity, and incipient illusionism are visible in remains or reflections of lost Venetian works by Pordenone from the early 1530s.[2] Even if not actually painted in Venice, *Milo of Croton* is a valuable indication of what Pordenone's great secular, public commissions must have been like in the fourth decade, such as his work in the Palazzo Ducale and for Andrea Doria in Genoa, as well as many painted house façades, almost all of which have been destroyed.

Moreover, *Milo of Croton* reveals Pordenone's profound assimilation of Roman artistic ideas, especially those of Michelangelo—breadth of form, use of complex anatomy under stress, and even a certain ferocity of expression. It was probably those aspects of Pordenone's art, inspired by central Italian ideas and developed during one or more trips to Rome, that particularly impressed the Venetians; he thus became the most important early carrier of the Roman High Renaissance to northern Italy. It was, however, typical of Pordenone's carefully calculated response to very diverse patronage that, while working in Venice, he modulated the violence and pathos in his art, compared at least with some of his famous earlier works,[3] to make his style palatable to a more sophisticated clientele. Perhaps for the same reason there is, in the *Milo of Croton*, a distinctly Giorgionesque landscape as well as unusually rich chiaroscuro and facture—in short, deliberately Venetianizing qualities.

Pordenone's paintings had great influence in Venice. Modern writers have stressed Pordenone's impact on the young Tintoretto, on Jacopo Bassano, Bonifazio dei Pitati, Paris Bordone, and Lorenzo Lotto. But the most important relationship *Milo of Croton* helps us reconstruct is the painter's almost legendary rivalry with Titian, which was already cited in the sixteenth century by Vasari and which became a major theme in later discussions of Pordenone's career. Titian's works of the early 1540s, such as his Old Testament scenes now in Santa Maria della Salute, the period of his so-called mannerist crisis, derive major impetus from Pordenone's Venetian pictures.

For whom *Milo of Croton* was painted and where it originally hung is unknown.[4] But one of the fascinating aspects of the painting is its fame as an historical image which can be traced through a series of distinguished collections,[5] including, in the seventeenth century, that of Queen Christina of Sweden, and through numerous graphic reproductions. The renown of Pordenone's composition is reflected, for example, in the powerful single-block woodcut reproduced here, attributed to Niccolò Boldrini but also assigned to Ugo da Carpi (cat. no. 11b). A chiaroscuro version of the same design in the British Museum closely follows Pordenone's figural invention, although it simplifies and freely adapts the landscape. Even more faithful to Pordenone's original conception, a fine but pedantic and polished drawing in the Louvre (inv. no. 5445) is surely a sixteenth-century record of the painting, which it transcribes quite literally, including many details in the landscape. On the other hand, much weaker in quality, with a number of misunderstood passages, is a drawing recently sold at Christie's, which may be another sixteenth-century record of the Smart composition.[6] All these various reflections of *Milo of Croton* demonstrate that Pordenone, who left no important followers when he died in Ferrara in 1539, nevertheless impressed and influenced numerous artists, from Titian to Rubens.

Charles E. Cohen

1. Valerius Maximus 9.12.

2. Examples of such remains and reflections include an almost totally destroyed fresco cycle in the Cloister of Santo Stefano known today only in a few fragments and engravings after Pordenone's compositions (circa 1532), and a highly finished drawing of the *Conversion of St. Paul* in the J. Pierpont Morgan Library, which was probably the *modello* for a famous lost easel painting (circa 1532). A relatively early date of about 1532 is also supported by Milo's relation to the great muscular semi-nude prophets (Samson, for example) in the central cupola of S. M. di Campagna in Piacenza, though continuing connections with works like the figure of Sacripante in Pordenone's design for Ludovico Dolce's *Il primo libro di Sacripante* of 1536 demonstrate that he continued to work in this athletic style far into the decade.

3. Examples of such early works would include the frescoes in the Malchiostro Chapel, Treviso (1519–1520) and the Cremona Passion cycle (1520–1522).

4. The author Count di Maniago recorded a painting of this theme in a palace of Girolamo Rorario in the artist's home town of Pordenone, but this was almost certainly a fresco. See Fabrio di Maniago, *Storia delle belle arti friulane*, 2d ed. (Udine, 1823), 189.

5. See provenance, p. 180.

6. The graphic reproductions of *Milo of Croton* enumerated here are illustrated in Charles E. Cohen, "The Fame and Influence of Pordenone's *Milo of Croton,*" *Bulletin of the David and Alfred Smart Gallery* 1 (1987–1988): 17–18.

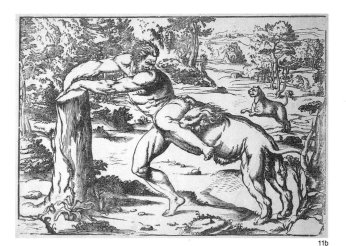

11b

Luca Cambiaso
Italian, 1527–1585

12 *Madonna and Child with St. John the Baptist and
St. Benedict*, circa 1562
Oil on wood panel, 55 x 40⅝ in. (139.7 x 103.2 cm.)
Gift of the Samuel H. Kress Foundation
1973.50

When Luca Cambiaso was coming of age in the 1540s in Genoa, his home city was little more than a provincial backwater. Genoa's major families imported artists from elsewhere in Italy when need arose; local artists, including Luca's father, Giovanni, did little more than work and rework styles from elsewhere into dull pastiches. Genoa was not to change much during Luca's lifetime, but with his own talent and drive—a drive that would propel him to Madrid to become court painter to Philip II—the artist single-handedly brought to Genoa an interesting and rather significant episode of late mannerist art. Much of his agenda is pictorialized in the Smart Museum's *Madonna and Child with St. John the Baptist and St. Benedict*, a mid-sixteenth-century reformulation of the early Renaissance *sacra conversazione*.

Convincingly dated to the early 1560s by the pioneering research of Bertina Suida Manning,[1] the painting indicates Cambiaso turning away from the influences of Perino del Vaga and Pordenone (both of whom had worked in Genoa), towards a reconciliation with tendencies from nearby Milan and Emilia. The long shadow cast by Leonardo da Vinci over North Italian painting for much of the sixteenth century has paused here, directly through his own work, and indirectly through his innumerable followers. There is more than a passing resemblance (in reverse!) between Luca's Madonna and Child and St. John the Baptist, and the Madonna and Child and elder king in Leonardo's *Adoration of the Magi* (1481), done in Florence but widely copied and circulated throughout Italy. It is a resemblance extending beyond figuration to the sense of urgency these characters portray—heightened in Cambiaso, but known elsewhere in Leonardo's oeuvre.

That urgency also seems to have filtered to Cambiaso through the Emilian Correggio, particularly in the latter's works of the 1520s. Luca's St. John, seeking an intimacy with the Christ Child that borders on the sensual, plays a role more commonly associated with St. Catherine or the Magdalene, as in Correggio's *Il Giorno* (1527–1528). Correggio's superb *Madonna of the Basket* (1523–1524) depicts the Christ Child in a remarkably similar pose. (Curiously enough, Cambiaso recycled that pose for the Cupid in his *Venus and Cupid* [circa 1570] at the Art Institute of Chicago.) The placement of the Madonna and Child in the Smart Museum painting against a tree reflects both these works, as well as Correggio's *Allegory of Vice* (1532–1533)—but on what exactly is our Madonna sitting?

As is often the case with provincial artists of exceptional talent, Cambiaso subsumed these influences into an image that is simultaneously less cosmopolitan and more frank than any of its sources. The S-curve that runs through St. John in this painting is energized by the passion of an ascetic. A rather sinister lamb at his feet does not vitiate the force of the Baptist's feeling or the sweet complicity and acceptance given him by Christ and Mary. And St. Benedict? He stands austere and erect like some figure from a fourteenth-century altarpiece, draped in deepest black, iconic and hieratic, not part of the scene he inhabits, but part of our space, solemnly trying to remind us of the seriousness of his activity. His eyes are not on those around him, but are fixed on the viewer; like the Holy Church he represents, St. Benedict is here the keeper of the mystery, the rather forbidding intercessor through whom salvation must be approached.

As such, Cambiaso's Benedict and the other figures fully breathe the time of their creation, a moment exactly contemporaneous with the counter-reformation concepts coming into being at the Council of Trent, occurring some two hundred miles away. A chastened and redetermined Catholic Church, while remembering the glories of the High Renaissance just a few decades earlier—Michelangelo was still alive when this picture was painted—was perhaps more conscious still of its need for a reassertion of dogma. Cambiaso's picture is evidence of this convergence of two divergent strains. Precariously balanced between the sensuous and the severe, the flesh and the spirit, the world we inhabit and the world we believe might be, the painting is a portrait of a world in crisis, a crisis tantalizingly unresolved.

James W. Yood

1. Bertina Suida Manning and W. E. Suida, *Luca Cambiaso: Le Vite e le opere* (Milan: Casa editrice Ceschina, 1958), 160.

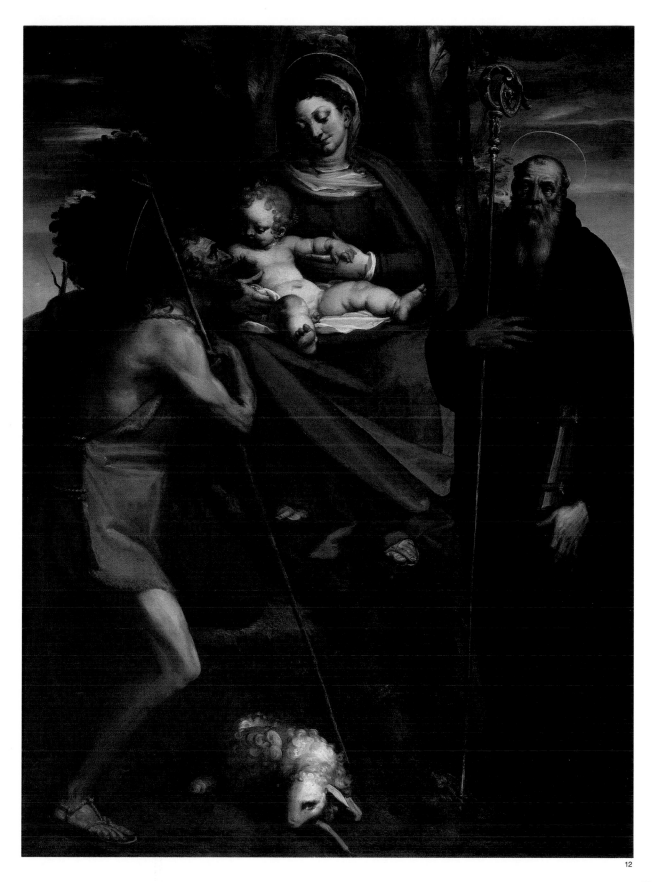

Hendrik Goudt
Dutch, 1573–1648

13a *The Mocking of Ceres*, after Adam Elsheimer, 1610
Engraving, second state; plate 12⅜ x 9⅝ in.
(31.4 x 24.4 cm.)
Dutuit 6, Hollstein 5, Reitlinger 6
University transfer from Max Epstein Archive,
Gift of Max Epstein, 1937
1976.145.197

Wenceslaus Hollar
Dutch, 1607–1677

13b *The Mocking of Ceres*, after Hendrik Goudt, 1646
Etching, plate 11¾ x 9 in. (29.8 x 22.9 cm.)
Parthey 273, Pennington 273
University transfer from Max Epstein Archive,
Gift of Max Epstein, 1937
1976.145.200

13a

13b

Hendrik Goudt is known primarily for seven striking engravings after paintings by the German artist Adam Elsheimer, of which *The Mocking of Ceres* is the second. The son of a steward in the privileged household of Louise von Coligny, widow of Prince Willem I of Orange, Goudt probably studied printmaking in his native city, The Hague, before moving to Rome in 1604. There he met Elsheimer, five years his junior, and moved into Elsheimer's house as pupil and patron, apparently keeping the impoverished German solvent by buying his paintings. But Goudt's abrasive personality led contemporaries to insinuate that he hastened Elsheimer's untimely death. They record that as Elsheimer's patron, Goudt had the artist thrown into debtor's prison, shortly after which Elsheimer died. Documents have not yet been discovered to substantiate this. Goudt had, however, moved to a neighboring street by the time of Elsheimer's death in 1610. Furthermore, Goudt's drawings show a violent streak, and his later mental derangement may have made itself felt at this earlier date.

Goudt's *Mocking of Ceres* is dedicated to Cardinal Scipione Borghese, a leading collector who patronized Dutch and German artists working in Rome. The Latin verses at the bottom of the print, by poet and diplomat Janus Rutgers, paraphrase an episode from the fifth book of Ovid's *Metamorphoses* (446–461), in which Ceres, the goddess of the earth and fertility, searched for her daughter, Proserpina, who had been abducted by Pluto, lord of the underworld. Bearing a torch lit from the fires of Mount Aetna, Ceres grew thirsty and stopped at the hut of an old peasant whom she asked for a drink. When the boy Stellio mocked the greedy way in which she drank, Ceres angrily transformed him into a spotted lizard.

Elsheimer's original painting is now lost; the best surviving version is that once owned by Peter Paul Rubens and now in the Prado, Madrid.[1] Elsheimer himself tried to make an etching after his painting, very likely under Goudt's tutelage, but the result was unsatisfactory.[2] Both Goudt's etching and Elsheimer's engraving show Stellio looking out at the viewer, while the painting in Madrid depicts him in profile. Keith Andrews convincingly argues that the Madrid painting represents either a copyist's variant on Elsheimer's original or another version by Elsheimer himself.

Of the seven engravings Goudt produced after Elsheimer's paintings, the first two were executed under Elsheimer's supervision: one dates to 1608, and this one to 1610, the year of Elsheimer's death. Andrews notes that a manuscript by Friedrich Noack in the Bibliotheca Herziana, Rome, states that Goudt began the engraving in January of that year. Andrews also cites a hitherto unknown first state of the print, sold in London in 1973,[3] which makes the Smart Museum's engraving technically a second state.

After Elsheimer's death, Goudt returned to Holland and engraved five more plates after the master's paintings. Most of Goudt's prints are night scenes; all exploit the effects of dramatic light. In *The Mocking of Ceres*, Goudt evokes a rich variety of nocturnal tones through a dense web of fine crosshatching and closely laid parallel lines. A characteristic variety of light sources pick out the outlines of the scene: the light through the door of the hut, the candle held by the old woman, the small fire beside the group in the background, Ceres' torch, the moon, and the stars. As Clifford Ackley has poetically observed, the light from Ceres' torch ripples like ascending flames on her garments, lending a sense of latent power to the figure of the goddess.

Goudt's seven engravings after Elsheimer's paintings were instrumental in the diffusion of the latter's imagery and dramatic chiaroscuro. Among the many printmakers inspired by his work was Wenceslaus Hollar.[4] Although he is said to have had a defect in his left eye, Hollar produced nearly three thousand etchings, the best known of which are topographical views of European cities. Born in Prague, he entered the service of Thomas Howard, Earl of Arundel, as a printmaker and followed him to London. In 1644, Hollar moved to Antwerp, where he lived until 1656. During his intensely productive years in Antwerp, he produced topographical views, animal and costume studies, and prints after drawings and paintings, for at least eleven different publishers.

Of the more than twenty-eight printmakers who worked after Elsheimer, Hollar etched by far the largest number of plates: eighteen of these name Elsheimer as his model.[5] These were probably all published during his Antwerp sojourn, as the thirteen dated prints fall within this period.[6] In 1646, the year he finished his *Mocking of Ceres*, Hollar was working at the phenomenal rate of a plate nearly every five days—sixty-nine plates in all. Six of these were prints after Elsheimer; one also utilizes a print by Goudt after Elsheimer's original.[7]

Hollar's *Mocking of Ceres*, the same size as Goudt's print, reverses the image; Hollar probably transfered Goudt's engraving directly to his own prepared etching plate. Hollar was capable of producing prints of great delicacy and charm, and the cost of this literal reproduction is in part a loss of subtlety. In spite of the nearly line-for-line transcription, Hollar's etching is much less striking than Goudt's original. The volume, textures, and velvety tones of Goudt's original are lost, and the contrasts between light and dark in Hollar's work are more strident and less nuanced.

Ann Adams

1. Illustrated in Keith Andrews, *Adam Elsheimer: Paintings, Drawings, Prints* (New York: Rizzoli International Publications, 1977), no. 23.

2. Ibid., no. 56, pl. 85.

3. Craddock & Barnard, London, December 1973, cat. 128, no. 74.

4. For other printmakers inspired by Elsheimer, see Clifford Ackley, *Printmaking in the Age of Rembrandt* (Boston: Museum of Fine Arts, 1981), no. 45, and Willi Drost, *Adam Elsheimer und sein Kreis* (Potsdam: Akademische Verlagsgesellschaft Athenaion m.b.h., 1933), 189–190.

5. Richard Pennington, *A Descriptive Catalogue of the Etched Work of Wenceslaus Hollar 1607–1677* (New York: Cambridge University Press, 1982), nos. 75, 98–100, 114, 168, 170, 268–273, 278, 279, 424, 1221, 1222. As early as the 1640s when these plates were produced, some were already misattributed to Elsheimer. See Andrews, *Adam Elsheimer*, 9.

6. The first plate was apparently etched in England, and only published in Antwerp.

7. *Salome Receiving the Head of St. John*, Andrews, *Adam Elsheimer*, no. 48. An undated third plate, *Tobias and the Angel*, also utilizes a print by Goudt.

14a

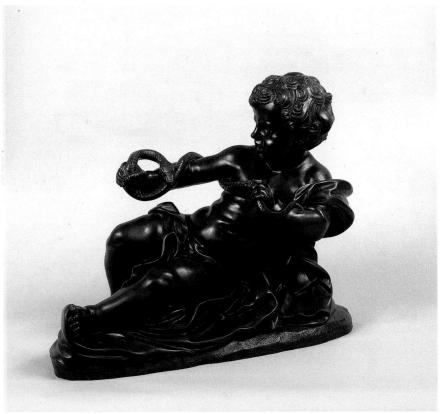

14b

48

Alessandro Algardi
Italian, 1598–1654

14a *The Infant Hercules Subduing the Serpent*, after circa 1635
Cast bronze, l. 17 in. (43.2 cm.)
Montagu 127.c.5
Purchase, The Cochrane-Woods Collection
1977.103

Attributed to **Michel Anguier**
French, 1612–1686

14b *The Infant Hercules Subduing the Serpent*, after
Alessandro Algardi, circa 1641
Cast bronze, l. 18½ in. (47 cm.)
Montagu 127.c.6
Purchase, The Cochrane-Woods Collection
1977.101

From the mid-1630s until his death in 1654, Alessandro Algardi was recognized as a major proponent of baroque sculpture in Rome, rivaling the great Giovanni Bernini during the pontificate of Innocent X. Algardi was born in Bologna in 1598 and trained in the Academy of Lodovico Carracci, where he was apprenticed to the sculptor Giulio Cesare Conventi. Around 1625, after working for the Gonzaga family in Mantua, he went to Rome, where he worked as a restorer of antiques and received his greatest commissions—the tomb of Leo XI in St. Peter's and the statue of San Filippo Neri in Santa Maria in Vallicella—during Innocent's reign. Algardi also produced small-scale sculptures in marble and bronze.

The energetic bronze *Infant Hercules Subduing the Serpent* in the Smart Museum collection, cast during Algardi's lifetime or shortly thereafter,[1] reveals a number of stylistic values inherited from the High Renaissance through the Carracci workshop—attention to structure, classicizing anatomical proportions, precise description of details, and intensity of expression. While Algardi rejected the stylistic exaggerations and contortions of Bernini's figures, opting for a more restrained and classicistic style, he did adopt the emotive, graceful, elegant, and decorative linearity of the Roman Baroque.

The subject of the bronze is an ancient Greek myth from Homer's *Iliad*, in which the infant Hercules fights with a snake placed in his crib by the goddess Hera. The child of an illicit union between Hera's husband, Zeus, and the mortal Alcmene, Hercules was able to thwart Hera's jealous attempts to destroy him. Endowed with supernatural strength, he eventually gained immortality through a series of determined labors. Pagan myths like the labors of Hercules had been ap-propriated by neoplatonist thinkers and interpreted by Italian artists since the mid-fifteenth century as moralizing allegories paralleling Christian aspirations.

Algardi's design is undocumented, although there are references to this composition by the artist as early as 1719 in Italian collections. The Franzoni family of Florence, who owned a cast of this design, were patrons of Algardi in his lifetime; their collection of bronzes stems from the mid-seventeenth century. Other versions of this design by Algardi are now in the Louvre as well as in the collections of the Marquess of Exeter at Burghley House and the Duke of Devonshire at Chatsworth. One of these shows the snake rearing its head instead of biting itself as in the Smart Museum's cast.

There is a second, nearly identical bronze in the Smart Museum collection, attributed to Algardi's French pupil Michel Anguier. Later in date, and clearly derivative of Algardi's design, the sculpture nevertheless reveals a subtle yet significant difference in sensibility. In this second version, a deliberate reinterpretation of Algardi's, there is a greater emphasis on pictorial elements such as mellifluous lines and a glossing of the anatomy and descriptive details. There is no differentiation of textures in the treatment of the cloth or flesh, for example, and particulars such as Hercules' hair, the pupils of his eyes, or the scales of the snake are abbreviatory. Such general traits are distinguishing marks of later French baroque bronzes.

The attribution of the second bronze to Anguier, however, is a matter of debate. It is possible that Anguier copied his teacher's design upon returning to France from his apprenticeship in Rome; in hopes of winning commissions, he might have taken advantage of his association with the famous Algardi.[2] On the other hand, the pupil may have hesitated to cast his teacher's designs since Anguier, through most of his artistic maturity, showed little respect for his master's classicizing restraint or his more structural approach.[3] It is possible that the work was cast by a French sculptor other than Anguier. Regardless of attribution, the piece stands as an important example of French baroque metalwork. In comparison with Algardi's sculpture, which still adheres to the values of the High Renaissance and the Carracci, this version is closer to the work of Bernini and the spirit of the Baroque.

H. Rafael Chacón

1. Jennifer Montagu is not convinced that Algardi actually cast any of his own designs. In correspondence with former Smart Gallery director Edward A. Maser (27 January 1977), Montagu suggests Guidi or Girolamo Lucenti, or even one of the latter's sons as possible founders.
2. Ian Wardropper, "Michel Anguier's Series of Bronze Gods and Goddesses: A Re-examination," *Marsyas* 18 (1976): 24 and 38, n. 18.
3. Montagu, in correspondence with the author, 23 December 1986.

Cecco Bravo (Francesco Montelatici)
Italian, 1607–1661

15 *Angelica and Ruggiero*, circa 1640–1645
Oil on canvas, 12¾ x 17½ in. (32.4 x 44.5 cm.)
Gift of the Samuel H. Kress Foundation
1973.42

Known as a spirited creator of bizarre frescoes, easel pictures, and fantastic, visionary drawings, Francesco Montelatici, called Cecco Bravo (Capable Francesco),[1] spent most of his career in Florence until he left in 1659 to become court painter to Archduke Ferdinand Carlo of Innsbruck. He had entered the Florentine Accademia del Disegno in 1629, where he learned much from the Flemish artist Giovanni Biliverti (1576–1644), but soon fell under the influence of the Florentine High Renaissance painter Andrea del Sarto and of some of the later Florentine Mannerists. During the 1630s, Cecco Bravo began to chart his own artistic course, primarily by emphasizing lively color and virtuoso brushwork, the hallmarks of his style.

The relative obscurity of information about Cecco Bravo's life and the paucity of published works by him were, perhaps, the principal reasons past scholars mistakenly ascribed the Smart Museum picture to Francesco Furini, Sebastiano Mazzoni, and even to an anonymous sixteenth-century Ferrarese artist, before Gerhard Ewald correctly identified the artist as Cecco Bravo in 1960.[2] Dating *Angelica and Ruggiero* in Cecco Bravo's oeuvre has also been a problem, largely because so few of his known works are documented. While the majority of scholars have suggested a late date in the 1660s for the picture, current thinking, including this author's, holds that Cecco Bravo executed the work sometime during the early to mid-1640s when his style—as the picture's former attributions suggest—was much closer to Francesco Furini's. Moreover, although two studies in the Uffizi (nos. 10625F and 10737) can be connected with the figures of Angelica and Ruggiero, they offer little additional evidence for dating the composition, since Cecco Bravo's graphic style changed little throughout his career. Assigning a precise date to the picture at this time is thus still premature.

Cecco Bravo's conception of the comic and unexpected tryst between Angelica and Ruggiero is taken from Cantos X and XI of the *Orlando Furioso* by Ludovico Ariosto (1474–1533), who dedicated his first edition of forty cantos in 1516 to Cardinal Hippolytus (d'Este), but managed to publish his final revised edition of forty-six cantos in 1532. The *Orlando Furioso* is a chivalric romance in verse involving numerous complex plots among the major characters of the wars between Christians and Saracens in the time of Charlemagne. The text's popularity during the second half of the sixteenth century and later is probably owed to Ariosto's virtues as a skillful poet and narrator: he reveals profundities without being moralistic or pedantic and expresses sublimities without becoming overly abstract.

Cecco Bravo captures the moment shortly after Angelica, the ravishing Princess of Cathay, has been saved from the monstrous Orca by the paladin Ruggiero. As Ruggiero's winged steed, the hippogriff, flies off to the left, the champion rushes to undress to receive his imagined reward of a thousand kisses for his bravery. Yet, little does Ruggiero know that his fair companion is about to disappear. Angelica, modeled after an antique Doidalses-type or "Crouching Venus" (perhaps influenced by one of Giambologna's bronzes Cecco Bravo could have seen in the Tribune of the Uffizi),[3] calmly displays her small finger from which her magic ring is clearly missing. It is the ring that will enable Angelica to disappear if she places it in her mouth. By excluding the ring from view, and thus allowing the viewer's imagination to take full command, Cecco Bravo makes the princess's imminent departure more poignant than in the prosaic sources upon which he may have based his composition. Any one of the many illustrated editions of the *Orlando Furioso*, of which the 1572 Valgrisi edition appears to be the closest, or a similar composition of the subject painted by his mentor Biliverti during the early 1630s for the Medici Villa at Petraia[4] could have inspired him. But in both instances, Angelica's ring is prominently displayed.

Stressing the imminence of events in this particular narrative as he does, Cecco Bravo reveals his sensitivity to the poetic nature and meaning of Ariosto's charming text. Since Angelica's disappearance *is* indeed near, she becomes an Ariostian "symbol of the elusiveness of things desired."[5] And because Ruggiero foolishly continues to concentrate on the fulfillment of his lustful desires, he emerges as a figure of misfortune who, failing constancy to his lady Bradamant of Clairmont, receives his comic, and perhaps just, punishment: not only the disappearance of Angelica, but also the loss of his fantastic winged horse, which vanishes like a fleeing phantom into the distant sky. The moral theme of the episode thus revealed makes one think that the painting may have been appropriate for a newly wed couple.

Timothy J. Standring

1. Perhaps Cecco Bravo's sobriquet was applied in the spirit of "*ceccofurio*," or one who executes something in a hurry. For a recent catalogue entry on this picture, with additional bibliography on Cecco Bravo, see Anna Barsanti, in *Il Seicento Fiorentino* (Florence: Palazzo Strozzi, 1986), cat. no. 1.193.

2. Gerhard Ewald, "Hitherto Unknown Works by Cecco Bravo," *Burlington Magazine* 102 (August 1960): 343–352.

3. Barsanti in *Il Seicento Fiorentino*, cat. no. 1.193; see also Phyllis Pray Bober and Ruth Rubinstein, *Renaissance Artists and Antique Sculpture* (London: Oxford University Press, 1987), 62–63, with additional bibliography.

4. Illustrated in Pierre Granville, "Contribution à la connaissance de l'oeuvre de Giovanni Biliverti," in *Revue du Louvre et des Musées de France* 32:5/6 (December 1982): 347, fig. 3.

5. Rensselaer W. Lee, *Names on Trees: Ariosto into Art* (Princeton, N.J.: Princeton University Press, 1977), 13ff.

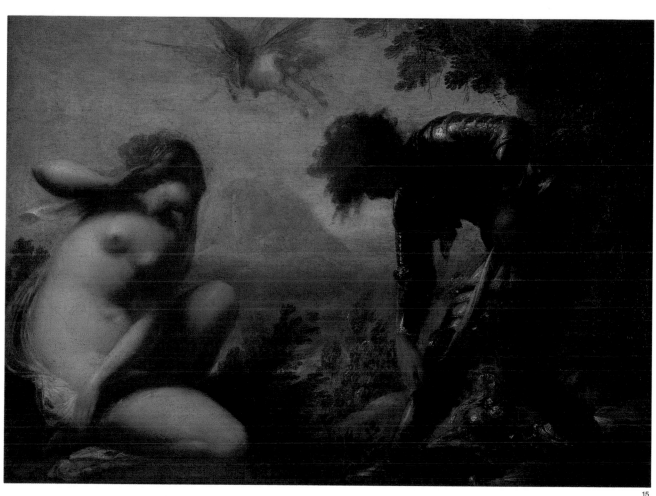

15

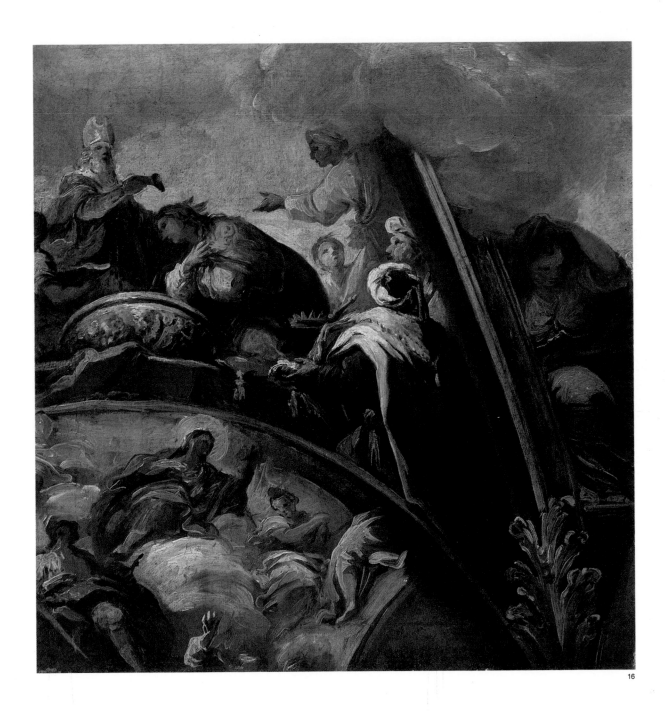

16

Luca Giordano
Italian, 1634–1702

16 *The Anointment of King Solomon*, 1692–1694
Oil on paper mounted on canvas, 14¾ x 14¼ in.
(37.5 x 36.2 cm.)
Purchase, Gift of Mr. and Mrs. Eugene Davidson
1976.69

Luca Giordano frequently made quick oil sketches of this sort in preparation for fresco cycles, and perhaps they best reveal his extraordinary touch and facility as a painter. His prodigious talent was already evident in his eighth year when the Spanish viceroy arranged for an apprenticeship in the studio of José de Ribera in Naples. In less than five years, Luca had mastered Ribera's manner and, at the age of thirteen, he set out on an artistic peregrination to the major art centers of Italy. Along the way, he made obligatory studies of the art of Raphael, Michelangelo, and Titian, but the painters he most admired were Veronese, for his vivid color, and Pietro da Cortona, with whom he worked in Rome at mid-century. Because of his natural talent for chiaroscuro, vigorous movement, and compositional invention, Luca quickly assimilated Pietro's high-baroque style; it was that lively manner he brought back to Naples in 1653. Although he remained in Naples most of the rest of his life, he worked several years in Florence for Cosimo III de' Medici and spent his last decade in Spain in the service of King Charles II.

Because "Luca fa presto" was famous for the speed with which he designed and executed frescoes, he was recommended to the king by the viceroy for the completion of the remaining vaults of the gigantic royal palace known as the Escorial. (Decorations for the palace had begun in the late sixteenth century, but because few indigenous artists had learned the fresco technique, the work was not continuous, depending on Italian fresco painters who could be persuaded to come to Spain.) Luca's first and most spectacular work at the Escorial, on the huge vault of the main staircase, is a depiction of the famous Spanish victory over the French at San Quintín in 1557, in the dispute over the former's claim to the Lowlands. One of the last frescoes Luca produced in the palace represents the biblical story of Solomon (fig. 2), for which the little painting in the Smart Museum was a preparatory sketch.

Apparently only two-thirds of the original composition is preserved in our sketch, which includes the anointment of King Solomon in the triangular severy and a less readily identifiable event in the lunette below. This design for a lunette and severy must have been made for a different part of the church, because the story of Solomon was eventually painted on an oblong and truncated vault located over the passage into the foot of the church from the college of the Escorial. A comparable vault over the passage from the monastery on the opposite side is devoted to the story of David and, between them, under the raised choir, is the main entry to the church from the Court of Kings. The scene of the anointment was painted on the end of the oblong vault confronting the portal from the college: this readily visible location may account for the repetition of Luca's composition by lesser artists in several oil paintings and a series of tapestries now in the Royal Palace in Madrid. The fresco includes the figure of young Solomon kneeling before the priest Zadok, who holds a horn containing the oil from the tabernacle, and to the left the prophet Nathan (missing in the sketch), as described in 1 Kings 1:32–45.

The Smart Museum sketch is accepted as Luca's by Dawson Carr in his recent study of the artist's work at the Escorial,[1] though he would restrict the master's hand to the scene of the anointment, characterized by more vigorous and telling brushstrokes. Assigning the ambiguous scene in the lunette to another hand may also explain the incongruously large leaf over the molding in the lower left, a feature not found in the lunette and severy sections of the vaults at the Escorial. Because the fresco itself was badly restored in the nineteenth century, there has been some question about its attribution to Luca. Carr, however, used our sketch to confirm the bungling of the restorer in the delineation of the foreshortened laver or basin and also the headdress of Zadok. Uncertainty about the authorship of the fresco of the anointment of King Solomon in the Escorial is thus dispelled by the evident authenticity of the Smart Museum sketch.

Earl Rosenthal

Fig. 2. Luca Giordano, *The Anointment of King Solomon*, 1692–1694, fresco, Escorial, Spain.

1. Dawson W. Carr, "Luca Giordano at the Escorial: The Frescoes for Charles II" (Ph.D. diss., New York University, 1987), vol. I, 284–287.

Noël Hallé
French, 1711–1781

17 *Joseph Accused by Potiphar's Wife*, circa 1740–1744
Oil on canvas, 55¾ x 65⅝ in. (141.7 x 166.5 cm.)
Purchase, Gift of The Mark Morton Memorial Fund
and Mr. and Mrs. Eugene Davidson
1974.116

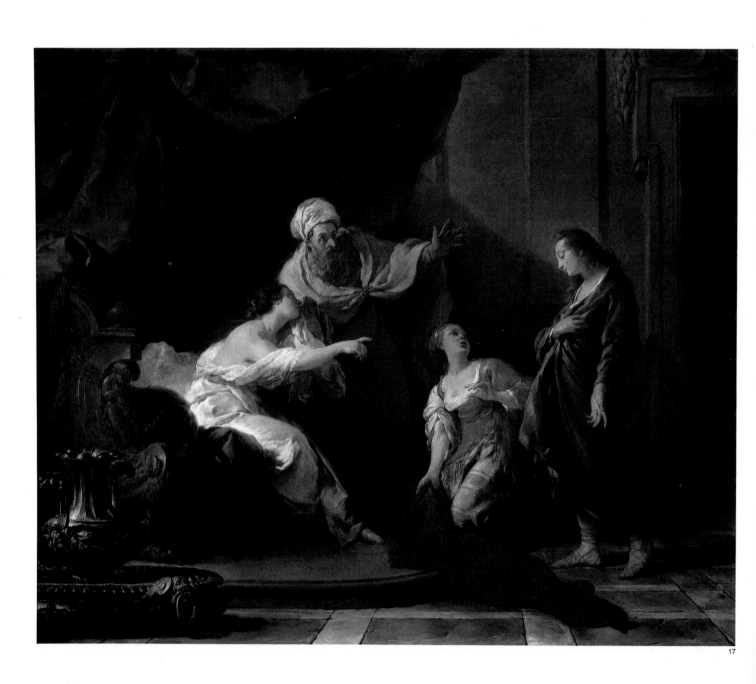

17

Noël Hallé studied with his father, Claude-Guy Hallé, also the son of a painter, and with his brother-in-law Jean Restout. He spent the years 1737 through 1744 in Rome, where he copied Raphael's *Expulsion of Heliodorus* in the Vatican and sketched after works by the Carracci, Domenichino, and Tiepolo. In 1746, Hallé was *agrée* into the French Academy and was received two years later with *The Dispute of Minerva and Neptune*, now in the Louvre. This painting appeared in the Salon of 1748 along with four other works by Hallé, including *Joseph Accused by Potiphar's Wife*. Thus, the Smart Museum's painting comes at the very beginning of Hallé's career, when he would have been under the influence of Restout and contemporary Italian painters, as well as Jean-François de Troy, then director of the French Academy in Rome.

Although genre and portraiture are more characteristic of the age of François Boucher and the Rococo during the reign of Louis XV, painters of history, mythology, and religious themes were still greatly esteemed for their moral edification, intellect, and imaginative scope. Hallé's depiction of this Old Testament subject was therefore highly prized within the Academy's hierarchy of genres. Indeed, the years 1747 and 1748 marked the beginning of a revival of history painting, in which late seventeenth-century traditions became especially important.[1]

The subject of Hallé's painting was rendered far less frequently than the preceding episode in which Joseph flees the advances of Potiphar's wife (Gen. 39). The many versions of the more famous scene generally feature two struggling figures, often in half length, and focus on Joseph's escape and the procuring of his garment. The best-known precedent for Hallé's theme is by Rembrandt,[2] who depicts Potiphar listening to his wife's accusations as Joseph looks on from the other side of the bed. Hallé places the figures on one side of the bed in a well-defined space in which the drama is clearly presented. His Potiphar shows astonishment at his wife's announcement. Hallé added a servant who holds Joseph's cloak, acting as an accomplice. The dramatic chiaroscuro, the turban and bearded head of Potiphar may come from a Dutch source, if not from Rembrandt himself.[3] Like many eighteenth-century French painters, Hallé was attracted to Rembrandt's genrelike renderings of religious themes.[4]

Apparently, Hallé felt that the understated ornament and severity of the architecture were appropriate for Old Testament scenes. In Hallé's *Joseph Interpreting the Dreams of the Pharaoh's Officers* (London, Heim Gallery), exhibited in the Salon of 1747, the extremely severe neoclassical interior forecasts those in the works of Joseph-Marie Vien and Jacques-Louis David. In the Smart Museum painting, the accessories—the rococo bed, Italianate basin and ewer—have something of the flair of De Troy's more ample style. Hallé was also indebted to Charles-Antoine Coypel's version of the subject dated circa 1737 (whereabouts unknown), in which the artist used a similar platform before the bed and dramatic curtains.[5] The color and certain painterly passages in Hallé's costumes seem Venetian-inspired. One interesting detail is the little cupid on the bedpost who seems to be hiding his nudity. It may be a gesture of innocence, in reference to Joseph; or perhaps Love is ashamed by the false accusation taking place. Hallé would be following Watteau's practice of animating sculptural figures that interact symbolically with the painted figures.[6]

Hallé's painting was well received in critical pamphlets of the Salon. The writer of the *Mercure de France* said it was "très beau d'effet et de composition."[7] Another anonymous author admired the novel treatment of the subject and especially the range of expression: " . . . the credulous old man is torn between anger and astonishment All the various passions in this painting form the happiest contrasts. It is assuredly the most successful work that Hallé has put before us."[8] Baillet de Saint-Julien praised Hallé's taste, drawing, and color, claiming that this "bon tableau" would earn him a name, though he warned the artist to beware of "la manière."[9] In the eyes of the critics, Hallé was destined to become a distinguished and important painter. In fact, he was highly esteemed by his colleagues and enjoyed a successful career within the Academy. His works, like those of his contemporary J.-B.-M. Pierre, show a combination of the graceful rococo style and the new seriousness of tone around mid-century when Neoclassicism was in its initial stages.

Michael Preston Worley

1. The revival was initiated in part by the Surintendant des Bâtiments, Lenormant de Tournehem, who in 1747 reinstated a history painting competition that had been abandoned for twenty years. See Jean Locquin, *La peinture d'histoire en France de 1747 à 1785* (Paris: Henri Laurens, 1912).

2. There are two versions of this painting by Rembrandt, one in the Gemäldegalerie, West Berlin, the other in the National Gallery, Washington, D.C. Both are dated 1655.

3. David Lomax, "The Early Career of Noël Hallé," *Apollo* 117 (February 1983): 106, suggests De Troy as the source for this type of bearded figure. The dramatic chiaroscuro was most likely an experiment by the young Hallé; it is not characteristic of his Roman works. See *Portraits and Figures in Paintings & Sculpture 1570–1870* (London: Heim Gallery, 1983), cat. no. 16. Hallé's earliest known work, *Antiochus Falling from His Chariot* (circa 1738, Richmond, Virginia Museum of Fine Arts), exhibits the bright sunny palette typical of both French and Italian painting of the early eighteenth century.

4. See Jean Cailleux, "Les artistes français du dix-huitième siècle et Rembrandt," *Etudes d'art français offertes à Charles Sterling. Réunies et publiées par Albert Châtelet et Nicole Reynaud* (Paris: Presses Universitaires de France, 1975), 287–305. Rembrandt was especially admired by Alexis Grimou (1678–1733), Charles Coypel (1694–1752), and Hallé's teacher Restout (1692–1769). Later, Chardin showed an interest in Rembrandt, whose works were in the collections of Crozat and others.

5. Lomax, "The Early Career of Noël Hallé," 108, fig. 6, and Antoine Schnapper, " 'Le Chef d'oeuvre d'un muet,' ou la tentative de Charles Coypel," *Revue du Louvre et des Musées de France* 18 (1968): 259, fig. 5.

6. A. P. de Mirimonde, "Statues et emblèmes dans l'oeuvre d'Antoine Watteau," *Revue du Louvre et des Musées de France* 12 (1962): 11–20.

7. "Very beautiful in effect and in composition," *Mercure de France*, September 1748, 172.

8. *Lettre sur la peinture, sculpture et architecture. A M.*** par une Société d'Amateurs* ([Paris], 1748), 104–105.

9. Louis-Guillaume Baillet de Saint-Julian, *Réflexions sur quelques circonstances présentes. Contenant deux lettres sur l'Exposition des Tableaux au Louvre cette année 1748. A M. le Comte de R.*** et une autre Lettre à Monsieur de Voltaire au sujet de sa Tragédie de Semiramis*, n.d. [1748], 11–12.

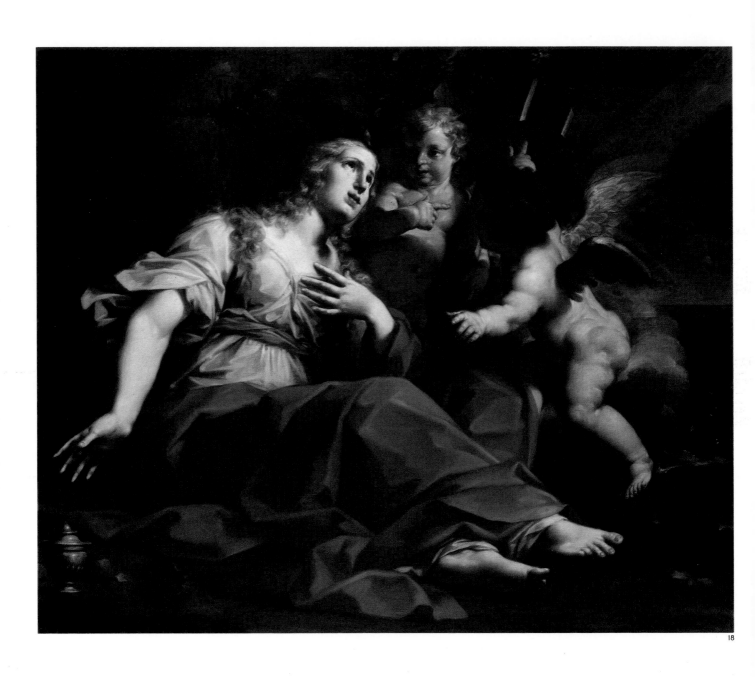

18

Il Sansone (Giuseppe Marchesi)
Italian, 1699–1771

18 *The Magdalene Attended by Two Angels*, circa 1740–1750
Oil on canvas, 57¼ x 66⅜ in. (146 x 168.4 cm.)
Purchase, Gift of Mrs. Eugene Davidson
1977.104

Giuseppe Marchesi had not come into sufficient prominence at the time of Giampietro Zanotti's *Storia dell'Accademia Clementina*, published in two volumes in 1739, to receive the full-fledged discussion Zanotti dedicated to older members of the Academy. Rather, he was given a short accolade as a promising pupil in the biography of his master, Aureliano Milani: "He has developed a firm and excellent mode of painting to the delight of all and a good reputation and fame are sure to be his. He has painted in fresco in the church of the Oratorian Fathers and is now at work on a very large painting for the metropolitan church of the city."[1] Subsequently, Marchesi entered the studio of Marcantonio Franceschini, a very prestigious older master in Bologna and one of the founding members of the Accademia Clementina. This training had a more permanent influence on Marchesi's style.

Although there has yet to appear a monograph on Marchesi, his artistic "profile" was presented in 1971 by Renato Roli of the University of Bologna in an essay rehearsing the principal features of his art and career.[2] His activity was auspiciously initiated in 1725 with a huge history painting, nearly three meters in length, the *Abduction of Helen* for the *salone* of the Palazzo Metasti in Bologna. (The companion decoration on the opposite wall, *Jove and Semele*, was painted by Marchesi's gifted colleague Vittorio Bigari). Marchesi's career continued in full tide through the 1760s, as he painted numerous altarpieces for churches in Bologna and environs and undertook ambitious fresco projects, most notably the extensive scenes in the vaults of the Bolognese church of Santa Maria di Galliera (circa 1740). He also served a private clientele, illustrating with some frequency and sophistication of taste pastoral fables from Ovid's *Metamorphoses*. Judging from the number of such pictures found in English country-house collections, they must have had a special appeal for English connoisseurs of the time. In these interpretations, as befitted their later date

in the 1740s and fifties, Marchesi's cultivated classical manner inspired by Franceschini took on a lighter, fancier character, one attuned to the general drift of the late-baroque style in northern Italy, with its rococo overtones.

As for the picture under discussion, Marchesi's approach was of a more serious character, in keeping with the visionary nature of the subject. The Magdalene's inspired glance to heaven (conventional for the age of the Counter-Reformation) and her gesture evoke the pathos of this moment of ineffable bliss. The little angels who present the cross for her contemplation, both exhorting and comforting, are bearers of God's tidings, a token of his favor. Marchesi's style is distinctive, especially recognizable in his facial types, so that his authorship of this work is quickly resolved. However, one senses reminiscences of older Bolognese masters, most clearly of Franceschini in the rendering of the drapery in crisply breaking folds, rather flat and angular, and in the coloration of the Magdalene's mantle, a deep russet that was one of the older painter's favorite hues. There is also some resemblance to the manner of Franceschini's friend and colleague, the Bolognese Gian Gioseffo dal Sole; indeed, the picture was formerly attributed to him. In the closed, compact arrangement of the Magdalene and angels, large figures brought to the front of their setting and allowing only side views of foliage and distant shoreline, one observes a characteristic Bolognese compositional mode. The method stems ultimately from the work of Franceschini's teacher, *caposcuolo* of his epoch of Bolognese painting, Carlo Cignani. As for the date of the picture, the writer concurs with the opinion of Professor Roli, who would place it in the 1740s.[3]

Dwight Miller

1. Giampietro Zanotti, *Storia dell'Accademia Clementina*, vol. 2 (1739), 167: ". . . furono suoi scolari, cioè Giuseppe Marchesi detto Sansone, che passato poi dopo l'andata a Roma del Milani, alla scuola del cavalier Franceschini, si è fatto un modo di dipingere così bello, e così forte che tutti delitta e buona, e gran fama glie ne viene. Ha pinto a fresco tutta la chiesa de' padri dell'Oratorio, e ora sta facendo una gran tavola per questa nostra chiesa Metropolitana." The metropolitan church to which Zanotti refers is S. Pietro.
2. Renato Roli, "Per la Pittura del Settecento a Bologna: Giuseppe Marchesini," *Paragone*, n. 261 (November 1971): 15–30; see also the same author's account of Marchesi's career in *Pittura Bolognese, 1650–1800: Dal Cignani ai Gandolfi* (Bologna, 1977).
3. "Siamo negli anni quaranta del Settecento," according to a letter from Renato Roli in the Smart Museum documentary files, 9 January 1977.

French, Chantilly Factory

19 *Shell-form Bowl with Platter*, circa 1750
Soft-paste porcelain, bowl 4½ x 10½ in.
(11.4 x 26.7 cm.), platter l. 13½ in. (34.3 cm.)
Gift of Mrs. Helen Regenstein
1976.10

The veristic shell form, artful reverse curves, and determined asymmetry of this bowl and platter are hallmarks of the mature rococo style in French decorative arts. These characteristics and the white body of this Chantilly soft-paste ensemble are extremely rare among the productions of the factory. There is only one other known example of this form, which is, however, polychromed (Musée de Sèvres).[1] The modeler of these two extraordinary pieces was clearly inspired by the engraved designs for salt cellars and tureens, published since the late 1720s, by one of the most influential creators of the rococo aesthetic, Juste-Aurèle Meissonier (1693–1750). Though Meissonier's original design specified that the bowl was a salt cellar, the Chantilly piece was probably not meant to be used in this manner. The bowl and platter are not large, but their scale is monumental; they may have been intended to be part of a large, impressive table garniture.[2]

The Chantilly porcelain factory was founded in 1725 by Louis Henri de Bourbon, Prince of Condé, an avid collector of oriental porcelain, particularly elegant Japanese Kakiemon ware. Early factory productions reflected the prince's desire to emulate the serene shapes and exotic decoration of Japanese ceramics. Though his death in 1740 deprived the factory of important financial support, it allowed the proprietor, Ciquaire Cirou, a wider range of response to varied and contemporary decorative tastes.

The Chantilly decorators and modelers would likely have looked for inspiration to the porcelain factory of Vincennes-Sèvres, favored with royal patronage and unquestionably the most important French porcelain manufacturer in the second half of the eighteenth century. Its decorators, chemists, and modelers provided new colored grounds, decorative motifs, and forms which set standards for porcelain production not only in France but for the rest of Europe as well. In 1747, the royal goldsmith, Jacques Duplessis, was brought to Vincennes to create new porcelain models and to oversee their execution. Like many of the great silver- and goldsmiths of the period, Duplessis used Meissonier's readily available engravings as a design source for marvelous models of rococo fantasy which were immensely popular at the time.

Many of Duplessis's forms were executed with polychrome decoration and in the white. White porcelain made in emulation of the Chinese ware called "blanc de chine" was popular both at St. Cloud and Mennency, for not only did the pure white body have the authority of an oriental prototype but it was also easier and less costly to manufacture than polychrome ware. The great Swan Service made at Meissen in 1745 provided a noble predecessor for white ware, and at Sèvres unglazed or "biscuit" (and therefore white) figures became popular in the 1750s and 1760s.[3]

The style of the Smart Museum bowl and platter indicates a date after 1740. It is possible that the ensemble was made between 1740 and 1750, in which case it would predate the great Duplessis pieces made at Vincennes. The financial instability of the factory after the death of the Prince of Condé, however, and the essentially conservative nature of its documented productions during this period argue against such a bold and innovative stylistic step. It seems more probable that the piece dates to the 1750s. Encouraged by the successes of Duplessis designs, the modeler might have wished to introduce the "goût moderne" to Chantilly. Like Duplessis, he sought his inspiration in Meissonier's engravings. He must also have understood the innate qualities of the beautiful Chantilly paste and glaze, for he integrated his design with the material to make an object of great originality.

Louise Bross

1. Serge Gauthier, *Les Porcelainiers du XVIIIe siècle français* (Paris: Hachette, 1964), 103-105.

2. For an illustration of Meissonier's design for a large silver centerpiece with two tureens, remarkably like the Smart Museum bowl and platter, see Victor Carlson, John W. Ittmann, et al., *Regency to Empire: French Printmaking 1715–1814* (Minneapolis: Minneapolis Institute of Arts in association with the Baltimore Museum of Art, 1984), 91.—Ed.

3. Despite the predominance of polychromed ware at Chantilly at this time, other complex sculptural white ware pieces are known. See, for example, the eighteen-inch *Bust of Louis XV* (circa 1745) illustrated in Sandra LaWall Lipshultz, *Selected Works: The Minneapolis Institute of Arts* (Minneapolis: Minneapolis Institute of Arts, 1988), 116.—Ed.

19

19

20 (left)

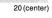

20 (center)

Fig. 3. Tintoretto, *The Crucifixion*,
1566–1567, oil on canvas,
211 x 482 in. (535 x 1224.3 cm.),
Venice, Scuola di San Rocco.

60

John Baptist Jackson
English, 1701(?)–1777(?)

20 *The Crucifixion*, after Tintoretto, 1740 (dated 1741)
 Four-color chiaroscuro woodcut, left sheet 23⅞ x 18½
 (60.6 x 47 cm.), center 24¾ x 18¼ (62.9 x 46.3 cm.),
 right 23⅞ x 18½ (60.6 x 47 cm.)
 Kainen 22 (undescribed state)
 University transfer from Max Epstein Archive
 1967.116.144–146

20 (right)

If relatively little is known of the details of John Baptist Jackson's life, the few documented facts show that he fits the mold of the printer-innovator-entrepreneur.[1] Jackson sought to create new technical and aesthetic approaches to the chiaroscuro woodcut, and to make a living thereby. Although he was never able to convert his artistic achievements into financial success, his work was indeed recognized, and received the ultimate compliment—several of his printing blocks were preserved and used by contemporaries to reissue his prints, including the blocks Jackson cut for this *Crucifixion*. The more than eighty prints attributed to Jackson today have assured him a place in the history of printing as an original and gifted practitioner.

At a time when etching and engraving on metal plates were the preferred techniques for artists' prints, Jackson saw in the woodcut possibilities for creating richer and more vibrant reproductions and original images. Because woodcuts were used almost exclusively for book illustrations, ornaments, and decorated initials, Jackson found the commercial potential of advancing woodcut techniques for book publishing irresistible. Realizing the relatively poor quality of book printing and the small audience for fine books in his English homeland, he moved to Paris in 1725, where he worked with Jean M. Papillon, one of the city's masters of the woodcut, and advanced his personal reputation and knowledge. By 1731, he had moved to Venice, where he earned renown for his craftsmanship.

About 1738, Jackson made the acquaintance of John Smith, an English merchant who would later become British Consul to Venice.[2] Smith commissioned Jackson to make this *Crucifixion* after Tintoretto's great mural in the Scuola di San Rocco (fig. 3), as part of a larger project to reproduce seventeen large-scale paintings by Venetian masters. The endeavor was financed through subscriptions to a bound volume of the completed collection,[3] published by Giambattista Pasquali, a Venetian printer Smith had set up in business in the early 1730s.[4] Though the *Crucifixion* was finished in 1741, the remaining twenty-one prints in the collection (some paintings, such as the Tintoretto, required more than one sheet to capture the entire image) were not printed and bound until 1745.[5] That year, Jackson returned to England, where he attempted to bring innovations to the wallpaper business. He remained in England until his death, never quite achieving the financial success he sought.

Jackson's *Crucifixion* is a chiaroscuro woodcut, a type of print made in multiple hues, nearly always limited to a monochromatic scale ranging from pale beiges to brownish

blacks. The chiaroscuro woodcut originated in attempts by early sixteenth-century artists, such as Hans Burgkmair and Lucas Cranach in Germany and Ugo da Carpi in Italy, to capture the tonal gradations of contemporary wash drawings in the reproducible medium of printing. The term "chiaroscuro," derived from the Italian for "bright-dark," was first coined in the late seventeenth century to characterize increasingly popular, mainly monochromatic paintings that contained brilliantly illuminated details against predominantly dark, though warmly colored backgrounds—Rembrandt's oeuvre provides the most familiar examples. The first practitioners of the chiaroscuro woodcut generally incised a "key block" which contained the crucial linear elements of the design, and then transfered this design, via inked sheets, to second, third, and sometimes fourth blocks. These additional blocks, "keyed" to the master block to assure they would all align or register perfectly, would then be incised with patterns necessary for printing a range of tones, from faint background tints, to the more distinctive tones of a middle distance, to the strong black of the foreground and primary subject of the composition. The key block, with black ink, was printed last.

The Crucifixion typifies a number of Jackson's innovations. Because it does not employ a black-printed key block, there is a softer overall tonal quality than one finds in early chiaroscuro woodcuts. The print reproduces a painting, and a very large one at that, rather than a wash drawing. To join the three individual sheets into one long image, certain crucial details of the scene are lapped into the print borders. When fitting the prints together, one could trim along these edges, removing the dark frames but carefully cutting around the overlapped details. The prints would then be aligned and the details pasted over the adjacent sheet to minimize the visual disruption of the seam.

There is a certain awkwardness to the rendering of expressions, draperies, and textures in this composition; clearly, Jackson is more concerned with reproducing Tintoretto's design than with using it as a springboard for his own artistic statement. Indeed, Jackson actually traced the image from an earlier copy by Agostino Carracci.[6] However, a comparison of Carracci's prints and those by Jackson indicates that the latter must have closely studied Tintoretto's composition as well. For example, the stone deleted in the lower left-hand corner of Carracci's rendition is restored in Jackson's print.[7] Despite its artistic limitations, Jackson's *Crucifixion* remains a noteworthy example of the sporadic development of the woodcut in the lean years between the medium's nascence and its flowering in the hands of modern artists such as Paul Gau-

guin, Edvard Munch, and Ernst Ludwig Kirchner. A more definitive study of Jackson's influence among contemporary and subsequent printmakers awaits completion, as does a study of the evidence Jackson's work provides for the growing English appetite for collecting and knowing about the art of continental Europe in the eighteenth century.[8]

Jeffrey Abt

1. Jacob Kainen, *John Baptist Jackson: 18th-Century Master of the Color Woodcut* (Washington, D.C.: United States Government Printing Office, 1962).

2. Francis Haskell, *Patrons and Painters: A Study in the Relations between Italian Art and Society in the Age of the Baroque* (New Haven, Conn.: Yale University Press, 1980), 299ff.

3. [John Baptist Jackson], *An Enquiry into the Origins of Printing in Europe* (London: N. Gibson, 1752), 45–51; Mr. [John Baptist] Jackson, *An Essay on the Invention of Engraving and Printing in Chiaro Oscuro, as Practiced by Albert Durer [sic], Hugo Di Carpi, & c. and the Application of It to the Making [of] Paper Hangings of Taste, Duration, and Elegance* (London: A. Miller [et al.], 1754), 7.

4. Haskell, *Painters and Patrons*, 299ff, 336ff. The volume appears to have been printed in a very small edition, perhaps owing to the complexity of the printing process. There are two copies in the Chicago area, one in the University of Chicago Library, the other in the Ryerson and Burnham Libraries, Art Institute of Chicago (though the latter copy lacks the right-hand sheet).

5. Jackson, *Titiani Vecelii, Pauli Caliarii, Jacobi Robusti et Jacobi de Ponte, opera selectiora* (Venice: Jo. Baptistam Pasquali, 1745).

6. Kainen, *John Baptist Jackson*, 32. For the Carracci, see Diane DeGrazia Bohlin, *Prints and Related Drawings by the Carracci Family* (Washington, D.C.: National Gallery of Art, 1979), 254–257. Jackson closely follows several of Carracci's reductions and stylistic interpolations, such as the distinctive treatment of the crossed trees in the upper left-hand corner of the left print. He also divides the Tintoretto into three panels (with the central section slightly wider than the other two), as does Carracci. Finally, the dimensions of Jackson's images and those of Carracci's are nearly identical.

7. The Smart Museum print bears an inscription on this stone which is not present in the copies reproduced in Kainen's book (*John Baptist Jackson*, 64–65, 116–17) or in either of the copies of the Pasquali volume in Chicago (see n. 4 above). The inscription, "Tintor[et]to pinxit Jackson delin sculp," (painting by Tintoretto, copied and engraved by Jackson), along with substantial and rather crude reworkings throughout the print, indicate that the Smart Museum print is a subsequent manifestation of the print listed in the Le Blanc (9), Nagler (13), and Kainen (22) inventories. Apparently some of Jackson's blocks were acquired by the Venetian printer Remondini and later by the Typografia Pozzato in Bassano. The former house used the blocks to issue subsequent printings; perhaps Remondini or the Typografia Pozzato recut the blocks to extend their commercial life. See Rodolfo Gallo, *L'Incisione nel '700 a Venezia e a Bassano* (Venice: Libreria Serenissima Depositaria, 1941) 22–23.

8. An additional question concerns the dedication of the print to Richard Boyle (1694–1753), fourth Earl of Cork and third Earl of Burlington, a prominent patron of the arts in his day. See, for example, *Apollo of the Arts: Lord Burlington and His Circle* (Nottingham: Nottingham University Art Gallery, 1973). Boyle may have been the principal subscriber of the project, although available sources contain no evidence to confirm this.

Silesian, Warmbrunn
In the manner of Christian Gottfried Schneider, engraver

21 *Goblet with Lid* (*Pokal*), 1760
Clear glass, gilt decoration, with 19th-century brass
finial, h. with lid 8½ in. (21.6 cm.)
Gift of Mrs. Else Felber
1981.75

21

This covered goblet is dated 1760. The date, the engraving and
cutting techniques employing both stone and diamond
wheels, the style of ornamentation, gilding, and overall shape
associate this goblet with Silesia (now Poland). Moreover, Sile-
sian goblets with and without covers, cut in the same style and
technique and in the same shape as the Smart Museum's gob-
let suggest Warmbrunn (Cieplice Slaskie Zdroj), a popular spa
in the eighteenth century, as the center of production for the
Museum's goblet.[1] Only one piece of eighteenth-century Sile-
sian glass, however, presently in the Stadtmuseum of Leipzig,
is fully signed and dated.

The fine engraving and cutting of the rococo sea creatures
and the emblem indicate a highly skilled craftsman. Inscribed
Sommer, the emblem provides an allegory of one of the four
seasons and implies three other goblets forming the original
set. Most goblets show a single scene, carry specific inscrip-
tions, or depict a particular city panorama. Such glasses were
produced in volume. In 1742, there were forty-two registered
glass engravers in Warmbrunn alone, and many more came to
the city for the "season." Individual pieces sold as gifts and sou-
venirs to visitors to Warmbrunn's spa and the Leipzig fair. Sel-
dom were sets created, except by the most renowned craftsmen
who would have little trouble obtaining a fair price for more
than one piece at a time.

One of these craftsmen, Christian Gottfried Schneider
(1710– 1763), who is among the best-documented artists (with
seventy paper prints of his later engravings preserved), uses the
same ornamentation and allegories as those on the Smart
Museum goblet, but not in the same combination. This gob-
let, which is beautifully cut though of modest form, proba-
bly originated in the hands of a craftsman very familiar with
Schneider's style and technique.

The coronet over a vine-stem monogram PS has not been
identified. Coronets were a common symbol of status and so-
cial ambitions by 1760, and did not necessarily symbolize no-
ble rank. Around the middle of the eighteenth century, rococo
ornament appeared on Silesian glass, framing allegorical, gal-
lant scenes, working scenes (as on the cover of the goblet), por-
traits, town panoramas, and chinoiserie. Many of these scenes
were taken from the Augsburg engravers J. W. Baumgartner,
G. Hertel, E. Nilson, and J. Rumpf, or from earlier engrav-
ings, such as those of M. Küssel from the middle of the seven-
teenth century. The cup and cover are an original pair, with
the cover's original finial having been replaced by a brass knob
in the mid-nineteenth century. This knob reproduces the

function of the glass finial, but is distinctly different in detail
from a Silesian cut-glass finial.

For relief cut, particularly thick and perfect glass is required.
Such glass was developed in Bohemia in the seventeenth cen-
tury, based on Venetian *cristallo* and English lead crystal. The
new Bohemian glass had properties closer to natural rock crys-
tal in that it was thick, shining, and hard, making it a perfect
glyptic material. Throughout the eighteenth century, this glass
was exported for cutting and engraving to Silesia. But by the
end of the eighteenth century, popular demand for cut glass,
generally regardless of quality, had ruined the high craft of
crystal cutting and engraving.

Rolf Achilles

1. Such goblets can be found in the collections of the British Museum
and the Victoria and Albert Museum, London; the Kunstgewer-
bemuseum, Cologne; the Württembergisches Landesmuseum, Stuttgart;
and the Kunstmuseum, Düsseldorf.

22

Italian, Doccia Factory

Gaspero Bruschi, modeler (active at Doccia 1742–1780)

22 *Portrait Medallion with Bust of Marchese Carlo Ginori,*
 circa 1757
 Hard-paste porcelain, h. 6¾ in. (17.1 cm.)
 Purchase, The Harold T. Martin Fund
 1979.54

A pupil of the sculptor Girolamo Ticciati and member of the Florentine Accademia del Disegno, Gaspero Bruschi came into prominence in the late 1730s. Recorded from that period are a terracotta portrait bust of Gian Gastone (1737), the last Medici Grand Duke, and a marble *Mercury* (1739) for the Triumphal Arch erected at the Porta San Gallo for the entry into Florence of the Medici successor, Francis Stephen of Lorraine. Bruschi's subsequent working life was dedicated exclusively to the porcelain factory established at Doccia in 1737 by Marchese Carlo Ginori, whose portrait is seen in this plaque. As head of the porcelain modelers from 1742 until his death, Bruschi oversaw the entire range of Doccia productions, from table services to life-sized sculptures. He is particularly associated with its celebrated porcelain reproductions of marbles and bronzes by major Florentine baroque sculptors such as Giovanni Battista Foggini, Massimiliano Soldani, and Giuseppe Piamontini.

The porcelain works at Doccia, where this plaque was produced, made Marchese Ginori a leading figure in the economic and cultural life of Tuscany from 1740 until his death in 1757. His scientific curiosity and inventive creativity earned him no small victory at Doccia, which became not merely the most successful Italian porcelain establishment of the eighteenth century but the only one to maintain operations since then (from 1896 under the name Richard-Ginori). For Tuscany, Ginori's achievement at Doccia, with its special emphasis on sculpture, offered the only large-scale exception to the general rule of artistic decline associated with the demise of the Medici dynasty. Indeed, an aura of specifically Medici nostalgia lingers over the Marchese's entire Doccia enterprise, since it can be seen as his conscious revival of the very first European successes in this medium, the famous sixteenth-century porcelain experiments sponsored by Grand Duke Francesco I. Similar patriotic overtones mark Ginori's commitment to late Florentine baroque sculpture, seen in his lifelong attempts to translate its glories into porcelain and in his choice of Bruschi to direct this work.[1]

Bruschi's white-glazed, hard-paste plaque displays the restrained rococo elegance typical of much of the sculptor's original work at Doccia. In this regard, he expresses some independence from the more decidedly baroque effusions of the local sculptors whose works he reproduced. It may be that the lighter touch exhibited here owes something to contemporary porcelain styles north of the Alps. The closest source for this kind of image is the cast-metal profile portrait medallion, much diffused in this period. Bruschi and Ginori were more than casually interested in porcelain variants of this more familiar medium. Their correspondence from 1747, for instance, records their efforts over a pair of large vases composed primarily of small porcelain portrait medallions—thirty-two each—of the new Grand Duke's family, the House of Lorraine.[2]

The Smart Museum portrait represents Ginori in the robes of a Florentine senator, a reminder of the political and diplomatic dimensions of his wide-ranging career. It seems to be based on Bruschi's large portrait bust of about 1750 to 1755 (Florence, Collection Ginori Lisci), which accords with the date of around 1757 assigned to the Smart Museum medallion. Ginori died in that year; Bruschi continued on as first master of the factory until 1780. This porcelain plaque, therefore, may well be Bruschi's memorial to his enlightened patron and mentor.

Elena Ciletti

1. The history of the factory's productions is enshrined in the modern Museo delle Porcellane at Doccia, where another example of this portrait medallion is recorded. A third example exists in the collection of the Museo Civico, Turin.
2. One of these vases survives, at Capodimonte, Naples.

Jean-Baptiste Le Prince
French, 1734–1781

23 *The Russian Dance* (*La Danse Russe*), 1769
Etching, aquatint; plate 15⅛ x 12⅛ in. (38.4 x 30.7 cm.)
Hédou 137
University transfer from Max Epstein Archive
1976.145.391

As a young man, Le Prince, a native of Metz, studied with François Boucher and Joseph-Marie Vien in Paris before visiting Italy in 1754. Four years later, he traveled to St. Petersburg (Leningrad) where he remained until 1763, producing studies of Russian costumes and peasant life which would serve as subjects for his oil paintings, drawings, and prints, as well as material for reproduction by printmakers such as Gilles Demarteau and Louis Marin Bonnet.

During the middle of the eighteenth century, a new market emerged for reproductive prints as well as for graphic work in general. A wealthy middle class arose, demanding affordable works of art to decorate their private homes and apartments, and a heightened respect for graphic arts developed among intelligent collectors. As a result, printmakers sought new ways to reproduce works of art, not merely in the black and white of conventional intaglio techniques but in full color. Among the most important technical advances to come from these experiments, yet ironically one of the least often used, was the aquatint process, traditionally considered to have been invented by Le Prince.[1] While it is now accepted that resin aquatint was discovered by the Dutch printmaker Jan van de Velde in 1653,[2] the practical application of the technique had been forgotten and not revived until over a century later, when Le Prince began to prepare his print plates with a resin dustbox and flywheel or bellows, much as is still done by aquatint printmakers today.

Le Prince's first experiments with the process appear to have been made in 1768, after the publication of three suites of line etchings depicting Russian and foreign costumes.[3] His efforts bore fruit with the publication that same year of the *2e Suite d'habillement de diverses nations* and the *1e Suite de coiffures dessinées d'après nature*, both of which utilized the newly perfected technique. These early aquatints, with their liberal use of line etching, are usually printed in either black or brown ink, the latter successfully imitating the appearance of drawings done in bistre wash. The *manière de lavis* (wash manner) was first presented to the French Royal Academy in 1769 by Le Prince and was finally published as the *Découverte du procédé de graver au lavis* (1780). This manual by Le Prince gave printmakers various tested recipes for toning their printing plates with resin aquatint to achieve effects akin to those of wash or watercolor, thereby eliminating the need for time-consuming procedures required with engraving tools such as the roulette. Strangely though, Le Prince's process was not widely used by French printmakers, who continued to favor other intaglio processes. It remained for the Spanish master Francisco Goya to utilize the process in all its potentials.

In 1769, Le Prince exhibited twenty-nine of his aquatints along with several oils at the official Salon. *The Russian Dance*, one of these prints, was accompanied by an oval oil painting of the same subject.[4] Several other known studies of the theme attest to its popularity and to Le Prince's own fondness for it.[5] Certainly its charm is immediately apparent. The composition derives in large part from François Boucher, although the disposition of couples and musicians in a landscape brings to mind similar *fêtes galantes* by Nicolas Lancret, Jean-Baptiste Pater, or even Antoine Watteau. Le Prince's composition seems especially successful on account of the repetition of pairs scattered throughout—the two massive diagonal tent poles, for example, echoed by the diagonals of the balalaikas, or the various couples involved more or less with the dance about to occur. Most interesting, perhaps, is Le Prince's ingenious creation of a tension-filled void between the outstretched arms of the central dancers, beyond which one sees a mysterious couple, a woman in a fez-like hat with a male companion who leans against her as if to whisper in her ear. As with the majority of Le Prince's aquatints, most of the tonal effects are handled with relative conservatism and restraint yet not without a certain delicacy appropriate to the subject.

While Western Europe since the seventeenth century had been fascinated with things oriental, the eighteenth century brought a new wave of fervor for the exotic East. Le Prince's works helped to stir an interest in the fashion and culture of Russia, a country whose own mysterious aspects and eastern flavor were of growing interest to the French court. High fashion and fashionable trends often were generated by just such prints as *The Russian Dance*, which served not only to document the whims of society but also to disseminate them to the culturally less advanced provinces and more distant corners of the European continent eagerly awaiting the next stylish tendency from the French capital.

Dominique Vasseur

1. Arthur M. Hind, *A History of Engraving and Etching from the 15th Century to the Year 1914* (New York: Dover Publications, 1963), 300.
2. A. Hyatt Mayor, *Prints and People: A Social History of Printed Pictures* (New York: Metropolitan Museum of Art, 1971), 229–280.
3. Hind, *A History of Engraving and Etching*, 301.
4. Victor Carlson, John W. Ittmann, et al. *Regency to Empire: French Printmaking 1715–1814* (Minneapolis: Minneapolis Institute of Arts in association with the Baltimore Museum of Art, 1984), 190.
5. Ibid., 190, n. 8, refers to a drawing in oval format which is related to the same theme and was exhibited in 1975 at the Galerie Cailleux, Paris, and a rectangular wash drawing in the collection of the Albertina Museum, Vienna (inv. 12341).

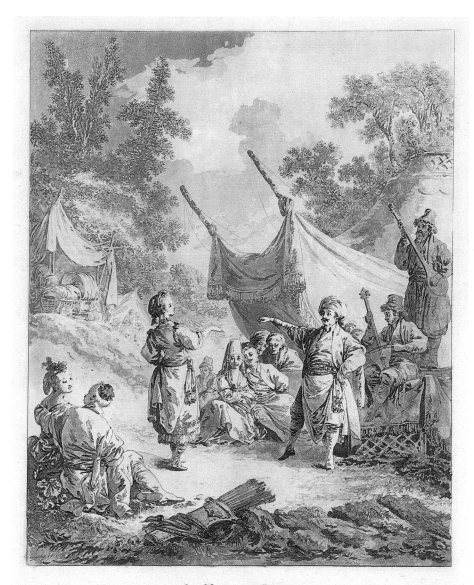

La Danse Russe

23

Franz Anton Maulbertsch
Austrian, 1724–1796

24a *The Sausage Woman (Die Würstelbräterin)*,
circa 1785–1790
Oil on wood panel, 12¹⁄₁₆ x 14¹⁄₁₆ in. (30.7 x 35.8 cm.)
Purchase, Gift of Viola Manderfeld
1978.184

24b *The Pancake Woman (Das Krapfenweib)*, circa 1785–1790
Oil on wood panel, 12¹⁄₁₆ x 14¹⁄₁₆ in. (30.7 x 35.8 cm.)
Purchase, Gift of Viola Manderfeld
1978.185

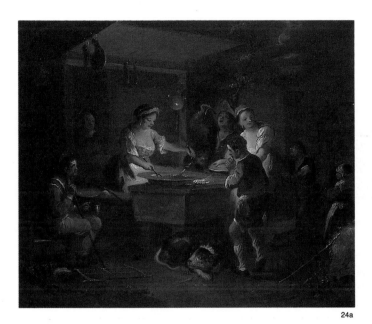

24a

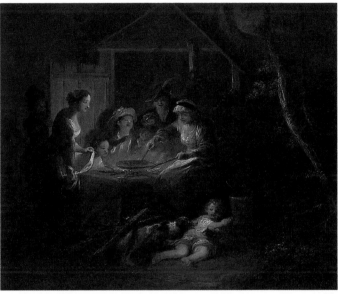

24b

The great fame of Franz Anton Maulbertsch has always rested on his monumental frescoes and paintings and on his brilliant preliminary oil sketches for them. Although he is still known for his phosphorescent glorifications of the wonders of faith and the glamour of power, recent study has found in the work of his later years significant exceptions to hitherto accepted generalizations about his style and subject matter. These two genre scenes from Maulbertsch's late period represent a noteworthy addition to the relatively small number of such works in his total production. Painted in oil on oak panels of almost identical size, *The Sausage Woman* and *The Pancake Woman* are clearly autonomous works rather than studies for larger compositions. The pictures must have been intended as a pair, such as were regularly sold to hang in the best room of some middle-class apartment in Vienna, one on either side of a fireplace or doorway. Filled with well-observed details from late eighteenth-century Viennese life in the less affluent levels of society, the scenes reveal a new side of Maulbertsch's personality as an artist, and, although related to other paint-

ings and prints produced around 1785, represent a unique example in his oeuvre.

In scale and subject, the two paintings indicate the artist's adjustment to the radical shift in taste that occurred during his lifetime—the gradual rejection of the values of the Rococo for the rational and classicizing ideals of the Enlightenment. Among the social and economic changes taking place was, of course, the rise of the middle class, who looked for other forms of art than the grandiloquent allegories and portraits of the aristocracy. The emerging Austrian bourgeoisie repeated, one might even say imitated, the artistic preferences of the first great middle-class society, that of the Dutch Netherlands of the seventeenth century. Among these new middle-class patrons, portraiture, landscapes, still life, and genre subjects became increasingly in demand—art, in short, that mirrored the world in which they lived.

Particularly popular among such subjects from everyday life were the so-called "street cries" of the cities. These were representations of poor peddlers who wandered through the streets, advertising their wares, often with very characteristic cries, or who at best established themselves in a market square or on the edge of town in primitive shelters or booths. Perhaps the most famous and important among the engravings depicting these colorful characters on the fringes of commerce were the *Cris de Paris* produced by Edmé Bouchardon in Paris between 1737 and 1746.[1] In Austria in 1773, Johann Christian Brand began his famous *Kaufrufe in Wien* (*Vienna Street Cries*), thirty drawings of street vendors, engraved and published in 1775 and 1776. Brand took his idea for the series from *Cris de Paris*, and modeled his character types on those of Bouchardon.

Maulbertsch undoubtedly knew the *Kaufrufe in Wien*, especially since he and Brand were close personal friends as well as colleagues at the Viennese Academy. Even more directly related to Maulbertsch's paintings, however, are several engravings by Jakob Adam from a series titled *Kleine Kaufrufe* (*Little Street Cries*) published in 1777, the year following Brand's first edition. Specifically, Adam's types include a sausage cook and a pancake vendor which inspired Maulbertsch's images. Most of the elements found in Maulbertsch's *Sausage Woman*, for example, are present in Adam's print of the same subject: the woman working at her tablelike hearth, the typical cap she wears, the broad pan in which the sausages cook, and the sausages hanging on the wall. The important difference between the two images lies in Maulbertsch's transformation of Adam's lean cook into an abundantly endowed, rosy-cheeked matron—a cheerful metamorphosis suggestive of Maulbertsch's temperament in his declining years when, newly married to a young wife and the father of two sons, he appears to have been enjoying his role as a respected academy professor experimenting with popular etchings as a substitute for major commissions.

In the pendant *Pancake Woman*, there is a specific borrowing that reveals an additional and much more distinguished source of inspiration for Maulbertsch than Adam's *Kaufrufe*.

Fig. 4. Rembrandt Harmensz van Rijn, *The Pancake Woman*, 1635, etching, plate 4¼ x 3¹/₁₆ in. (10.8 x 7.8 cm.), The Art Institute of Chicago, Clarence Buckingham Collection, 1938.1818.

Although the muted color of the painting and the simple, commonplace setting and personages could point to a score of seventeenth-century Dutch artists, the blond child in the foreground is taken directly, but in reverse, from an etching by Rembrandt (fig. 4).[2] There are a number of other points of similarity between the panel and this Rembrandt print, *The Pancake Woman* of 1635, but the motif of the child protecting his cake from an aggressive little dog is by far the most striking. That Maulbertsch was often inspired by Rembrandt has been noted before; indeed, he was only one of a number of late eighteenth-century painters who, departing from the Rococo, participated in a "Rembrandt Renaissance" emphasizing dark tonalities, chiaroscuro, and realistic types.[3]

The two Smart Museum panels provide then, not only excellent examples of Maulbertsch's late style, but also evidence of his ability to keep abreast of the new and incorporate it in his work. His Rembrandtism and his concern with the folktypes of the *Kaufrufe*—both matters of some immediacy and popularity during the late eighteenth century—reveal something of his character as an artist and as a man. The obviously sympathetic treatment of the humble, hungry people gathered around these food vendors also suggests the old man's benevolent nature: although a famous and successful member of Vienna's artistic community, Maulbertsch looked at his subjects with gentleness and even affection, remembering perhaps how some fifty-odd years earlier, as a poor young student, he too must have frequented their booths and savored their plebian but delicious wares.

Edward A. Maser

1. A second edition appeared in 1748.

2. The Rembrandt etching (Bartsch 124, Hind 141) was certainly available to Maulbertsch in Vienna, either in the original or in such a work as Pierre François Basan's first catalogue of Rembrandt's prints (published sometime after 1786 when Basan had acquired seventy-eight of Rembrandt's plates from the estate of Claude Henri Watelet) or in Basan's *Dictionnaire des Graveurs* (Paris, 1789), in which the *Pancake Woman* is number 122. Since we know, moreover, from the inventory of Maulbertsch's estate that he owned a large collection of prints, it is possible that he may even have owned Rembrandt's etching himself.

3. Among the artists of this "Rembrandt Renaissance" were Christian Wilhelm Ernst Dietrich (called Dietricy, 1712–1771), Januarius Zick (1730–1797), Johann Georg Trautmann (1713–1769), and Johann Andreas Nothnagel (1729–1804).

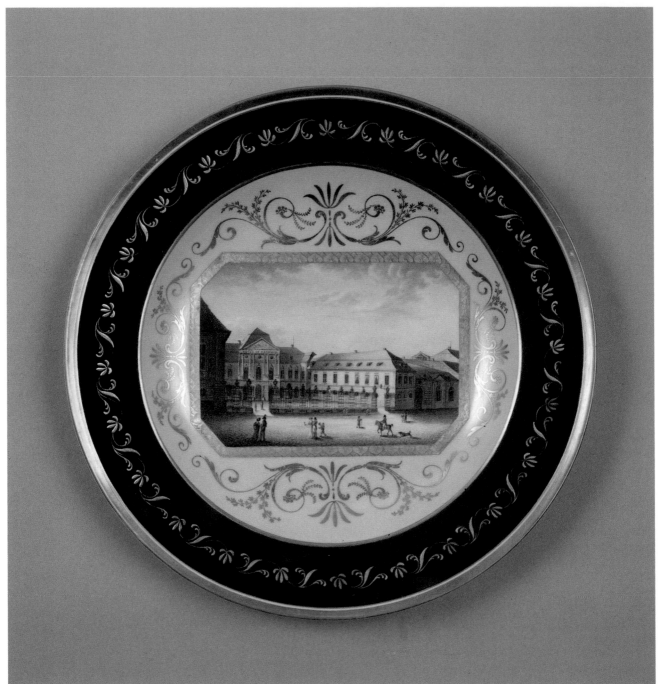

German, Berlin, Royal Porcelain Manufactory

25 *Plate*, circa 1810–1815
Hard-paste porcelain, overglaze enamel, gilt
decoration; diam. 9⁷⁄₁₆ in. (24 cm.)
Purchase, Gift of Mrs. Louis Bader Adelman
1979.51

As early as 1751, a porcelain factory was founded in Berlin by
the industrialist Wilhelm Caspar Wegely. Another factory, es-
tablished a decade later, was acquired in 1763 by Frederick the
Great, and has remained a state-operated concern to the pres-
ent day as the *Königliche Porzellanmanufactur* or Royal Por-
celain Manufactory. With this royal support, which the
famous Meissen and Sèvres factories also enjoyed, Berlin
would become one of the chief producers of European
porcelain.[1]

During the early years of production, Berlin wares were
strongly influenced by the designs of Meissen and Vincennes.
Frederick became so enamored of Meissen porcelain during
the Seven Years War that he even attempted to transfer the
Meissen manufactory to Berlin, but was successful only to the
extent that he lured a number of its outstanding artists. By the
third quarter of the century, Berlin porcelains were highly in-
fluenced by popular French neoclassical designs. The Empire
style as developed at Sèvres was introduced in Berlin as early
as 1800, that is, before the time of the French occupation of
Prussia in 1806. Antique forms and motifs were adopted, along
with ground colors that sometimes imitated semiprecious
stones. The matte blue border of the Smart Museum plate, for
example, is painted to simulate lapis lazuli. This effect was
achieved by mottling the cobalt pigment and leaving the rim
unglazed, in a bisque state.

A view of a famous city palace is painted in the center of
the cavetto of the plate. Such *Ansichtsporzellane*, or view por-
celains, were produced from about 1810 in Berlin. These views
were often enframed as if they were paintings. At first, roman-
tic and fanciful landscapes and buildings were depicted, but
later accurate renderings, views of Berlin and Potsdam became
fashionable. Noted Berlin buildings such as Karl Friedrich
Schinkel's Theater and the monumental Brandenburg Gate
were illustrated, along with important residences, such as this
example.

It is clear from the inscription on the underside of the Smart
Museum plate that the grisaille decoration depicts Hôtel Rad-
ziwill, considered one of the finest Berlin residences in its day.
The main building, without its attendant wings, dates to 1736
when it was built in the French style for General Graften von
der Schulenburg-Wolffsburg. It was renamed "Hôtel" Rad-
ziwill after the French fashion of the day, when it was pur-
chased in 1795 by the Polish Prince Michel Radziwill,[2] who
had been living in Dresden during the revolution and Prus-
sian occupation in his homeland. Prince Michel was Castel-
lan of Vilna and as a Senator of the Polish Republic he was
named Prince Palatine in 1790. Although not from a reigning
house, this wealthy and magnificent Polish family was well
known and was a source of frequent conversation in the Prus-
sian court. In 1796, Michel's son Prince Anton was married to
Princess Luise of Prussia, niece of Frederick the Great, at
which time the Hôtel was presented to the young couple. This
suggests that its purchase the prior year may have been part
of the marital negotiations.[3]

The style of the painting and the unusual format of the
framing device closely imitate Sèvres examples before 1815. The
delicate treatment of the gilding on the Smart Museum plate
would also indicate a date prior to 1815, since it was around that
time that the Berlin factory began to embellish their wares
with heavily tooled gilded ornament, such as that found on
a service ordered by King Frederick William II for the Duke
of Wellington and produced between 1815 and 1819. The view
on this "Hôtel Radziwill" plate is an early example of what
was to become a frequent motif on Berlin wares throughout
the 1830s. Such *Ansichtsporzellane* began to be considered a
medium of artistic expression; series of "picture plates" were
issued to be hung as paintings on walls of smaller rooms
within palaces.

Rita McCarthy

1. For a complete review of the factory's production, see Erich Köllman,
Berliner Porzellan 1763–1963, 2 vols. (Braunschweig: Klinkhardt & Bier-
mann, 1966), and Günter Schade, *Berliner Porzellan zur Kunst- und Kul-
turgeschichte der Berliner Porzellanmanufakturen im 18. und 19. Jahrhundert*
(Leipzig: Koehler & Amelang, 1978). A useful English catalogue is Win-
fried Baer, *Berlin Porcelain*, trans. Erika D. Passantino (Washington,
D.C.: Smithsonian Institution Traveling Exhibition Service, 1980).
2. R. Borrmann, *Die Bau- und Kunstdenkmaler von Berlin* (Berlin: J.
Springer, 1893), 369.
3. Biographical information on the Radziwill family was derived from
Princess Luise of Prussia, *Forty-Five Years of My Life (1770–1815)*, trans. A.
R. Allinson (New York: McBride, Nast & Co., 1912).

Pierre-Henri de Valenciennes
French, 1750–1819

26 *Cloud Study*, circa 1817
Oil on paper mounted on paperboard, 9¼ x 14⅛ in.
(23.5 x 35.9 cm.)
Purchase, The Cochrane-Woods Collection
1982.19

Valenciennes, the "David of Landscape," began his artistic career in Toulouse before becoming a pupil of the history painter G. F. Doyen in Paris. In 1777, he traveled to Rome where, except for a sojourn to Paris from 1780 to 1781, he remained until 1785, when he returned to the French capital. In March 1787, Valenciennes was made an associate of the Royal Academy of Painting and in July of the same year was accepted as an academician with the *morceau de réception, Ciceron qui fait abbatre les arbres qui cachaient le tombeau d'Archimède* (now in Toulouse).

Valenciennes exhibited regularly at the Salons from 1791 until his death, and taught courses in perspective from 1796 to 1800. His lectures would form the basis for a publication titled *Eléments de perspective pratique à l'usage des artistes; suivis de réflexions et conseils à un élève sur la peinture et particulièrement sur le genre de paysage* (1799–1800, issued in an enlarged edition in 1820). Valenciennes's efforts to ennoble the landscape genre and raise it to a level close to that of history painting greatly contributed to the decision of the Ecole des Beaux-Arts to establish a Prix de Rome category for landscapes, a prize first awarded to one of Valenciennes's pupils, A. E. Michallon, later the master of Camille Corot. Two years before his death, Valenciennes visited Rome for the last time and there produced many small oil sketches.

This handsome *Cloud Study* has been attributed to Valenciennes on stylistic grounds as well as for similarities of scale and facture with other sketches by the artist.[1] The painting compares well, for example, with others from a series of studies presented to the Louvre in 1930 by the Princesse de Cröy, whose grandfather, the Comte de l'Espine, had purchased them from Valenciennes's estate sale in 1819,[2] along with others gleaned from the posthumous sale of A. L. Girodet, another of Valenciennes's pupils.[3]

The strong resemblance between Valenciennes's sketches and those done *sur le motif* by his spiritual heir Corot is worth noting. Nevertheless, the practice of making such small studies from nature had been established before Valenciennes. F. Desportes, for instance, is recorded as having executed his oil-on-paper studies of landscapes and skies from nature,[4] and J. Vernet is said to have done studies in the same manner while in Rome during the 1740s.[5] It must be stressed in each of these cases, and particularly in that of Valenciennes, that such oil studies were not considered finished paintings, worthy of exhibition or sale, but rather as studio reference materials for use in the creation of large-scale Salon paintings and as teaching devices for classes in perspective and landscape painting. The vast difference between Valenciennes's highly finished paintings and his freely executed studies underscores the personal nature of the latter.

Valenciennes's interest in the transient effects of light and atmosphere can be supported by this study of clouds. Although a sloping hill and small villa occupy the lower right corner, the composition is above all an atmospheric study concerned with the effects of light as it strikes and filters through a semiopaque low-hanging cloud. The painting would seem to have been done *en plein air*. A most intriguing matter, however, has been raised by a sketchbook by Valenciennes in the Bibliothèque Nationale in Paris of detailed pencil with pen-and-ink contour drawings complete with appropriate color notations. These have been directly linked with some of the small oil studies in the Louvre, previously thought to have been done from nature.[6] Whether Valenciennes's oil sketches such as this *Cloud Study* are actually studio translations of yet unlocated skeletal, preliminary studies made outdoors has not yet been conclusively proven, but the possibility does exist. Valenciennes may indeed have painted some of his studies in the atelier or from memory as has been suggested;[7] however, the fact remains that such direct or near-direct studies were the foundation for his success as a painter of the *paysage historique* and the product of both keen observation and a deep love of the earthly world. Certainly the same mid-nineteenth century vision, valuing spontaneity and immediacy, that made Barbizon painting and Impressionism possible is applicable today and allows us to appreciate the freshness and palpable effects of light and atmosphere evident in this small painting.

Dominique Vasseur

1. Traditionally, the work had been indirectly linked to Corot, without, however, much foundation. This study's stylistic affinities to other works by Valenciennes were recognized by Richard R. Brettell, then Curator of European Painting and Sculpture at the Art Institute of Chicago, in a letter of 14 September 1981 (curatorial files, David and Alfred Smart Museum). For further discussion of Valenciennes's landscapes, see Paula Rea Radisich, *Eighteenth-Century Landscape Theory and the Work of Pierre-Henri de Valenciennes* (Ann Arbor, Mich.: UMI Research Press, 1981).

2. Wheelock Whitney, "Pierre-Henri de Valenciennes: An Unpublished Document," *Burlington Magazine* 118:877 (April 1976): 225–227. For further information on this subject see Philip Conisbee, "Pierre-Henri de Valenciennes at the Louvre," *Burlington Magazine* 118:878 (May 1976): 336–337.

3. Roseline Bacou et al., *French Landscape Drawings and Sketches of the Eighteenth Century* (London: British Museum Publications, 1977), 99–100.

4. Pierre Rosenberg, *The Age of Louis XV: French Painting 1710–1774* (Toledo: Toledo Museum of Art, 1975), 34–35, color pl. II.

5. Bacou, *French Landscape Drawings*, 100.

6. Conisbee, "Valenciennes at the Louvre," 336.

7. Pierre Rosenberg et al., *French Painting 1774–1830: The Age of Revolution* (Detroit: Detroit Institute of Arts, 1975), 636.

26

27

Louis Dupré
French, 1789–1837

27 *Portrait of M. Fauvel, the French Consul,
with View of the Acropolis*, 1819
Oil on canvas, 20½ x 25¼ in. (52.1 x 64.1 cm.)
Gift of Mr. and Mrs. Frank H. Woods
1980.33

Born the year of the French Revolution, the history painter and lithographer Louis Dupré studied under Jacques-Louis David. In 1811, Dupré became court painter to Jerome, King of Westphalia and brother of Napoleon Bonaparte. In 1814, Dupré went to Italy, which became his primary residence until 1830, when he returned to Paris. From 1817 to 1837, he exhibited at the Paris Salon, winning the gold medal for his ambitious *Camillus Expelling the Gauls from Rome* in 1824. He exhibited the *Portrait of M. Fauvel* in 1827 and again in 1833.

Stylistically, the clarity and stagelike foreground of *Portrait of M. Fauvel* epitomize the Neoclassicism championed by Dupré's teacher David. The subject reflects the broader early nineteenth-century fascination with Athens that Dupré shared with many of his contemporaries, most notably the English Lords Elgin and Byron. With its commanding view of the Acropolis, this picture is part of a series of works embodying Dupré's preoccupation with the ancient monuments he sketched and painted in Greece in 1819. Indeed, along with forty other scenes, he included a colored lithograph of the Smart Museum painting in his travel book *Voyage à Athènes et à Constantinople*, published in Paris in 1825. This lithograph was reproduced several times, and in this century appears in publications investigating the European intellectual community in Athens during the early nineteenth century.[1]

Dupré's subject, Louis-François-Sébastien Fauvel, the French consul who served as guide and host to European intelligentsia in Athens from 1780 to 1822, is here attended by his Armenian servant on the veranda of his home on the site of the ancient Athenian marketplace, the agora. Among his many admirers, Byron commended Fauvel's "talents as an artist, and manners as a gentleman."[2] In this sensitive and penetrating portrait, Dupré captures the many aspects of Fauvel's interests by showing him with the attributes and acquisitions of artist and antiquarian. Fauvel sits at his easel with paintbrush in hand, surrounded by some of the antiquities in his collection. On the garden wall behind the loggia are some relief sculptures, either casts of ancient objects or the originals themselves. A cast of one of the metopes from the Parthenon depicting the battle of the Lapiths and Centaurs—the original of which is one of the Elgin Marbles in the British Museum—occupies a place of honor on the veranda. To the right of the metope stand a cuirass and the tall, narrow Stele of Theron. These select objects announce Fauvel as an avid collector-connoisseur and a knowledgeable and experienced archaeologist.

With this work, Dupré has not only given us a telling portrait of the humanist Fauvel; he has also provided a record of some ancient monuments that no longer exist. For example, Dupré's depiction of the Stele of Theron, along with drawings by L. Vuillamy, are the only visual records of the stele's lost finial that scholars of classical antiquity can consult today.

Deborah S. Neibel

1. One example is Catherina Philippa Bracken, *Antiquities Acquired: The Spoliation of Greece* (London: David and Charles, 1975).
2. Quoted by Joan Rosasco, "Princes, Peasants and Heavy-Eyed Beauties," in *A Romantic Vision of Greece and Turkey: Louis Dupré's Voyage of 1819 to Athens and Constantinople* (New York: Michael Ward, Inc., n.d. [1988]), n.p.

Julius Veit Hans Schnorr von Carolsfeld
German, 1794–1872

28 *The Sleep of Emperor Frederick Barbarossa*, circa 1835–1837
Oil on wood panel, 18¾ x 14 in. (47.6 x 35.6 cm.)
Purchase, The Cochrane-Woods Collection
1980.3

After studying in Vienna for several years, Julius Schnorr von Carolsfeld moved to Rome, where he worked with the Nazarenes, a group of German painters who sought to revive traditions of late medieval and Renaissance art. In Rome, Schnorr met the Bavarian Crown Prince Ludwig I, an enthusiast of the arts and future transformer of the Munich cityscape. Upon accession to the throne in 1825, Ludwig called Schnorr to the Bavarian capital to undertake a series of large state paintings that would occupy the embattled artist until 1867.

Schnorr came to Munich in 1827 and was soon faced with the commission of patriotic and secular projects calculated to glorify Ludwig's nationalistic designs. In 1835, Schnorr was given the task of decorating three state rooms in the palatial Residenz with scenes from the lives of three pre-eminent figures in Germanic history: Charlemagne, Rudolf von Habsburg, and the Emperor Frederick Barbarossa.[1] *The Sleep of Emperor Frederick Barbarossa* probably originated in this project. From 1835 to 1837, Schnorr struggled to satisfy Ludwig's taste for the strictly historical, an attitude the artist deeply lamented since he believed it deprived art of its symbolic dimension. In the original program, Schnorr attempted to stress the unity of church and state under imperial rule. Ludwig, however, was not impressed with Schnorr's conception of an elaborate correspondence of biblical and secular figures, calling it "too theosophical and mystical."[2]

Since the legendary image of Barbarossa asleep does not exist in the finished cycle of Barbarossa's life, it may be that the scene belonged to the initial program rejected by Ludwig. The degree of finish in the figure, the minute and exquisite ornamental details in the chalice, crown, shoes, and sword hilt suggest the picture was created for a purpose other than as a studio aid. Yet the painting's cursorily sketched background indicates that it was not a "finished" painting. Possibly it was presented to Ludwig as a model for the proposed cycle. If this is so, the painting would date between 1835 and 1837. The placement of the chalice and sword on either side of the seated Barbarossa (so named because of his red beard) might be taken as reference to the Church and state joined in the imperial person of the Holy Roman Emperor. This interpretation is supported by the fact that Barbarossa wears Schnorr's free variation of the imperial crown long reputed to have been worn by Charlemagne himself.

The theme of the Emperor Barbarossa dormant in the Kyffhäuser, a mountain in central Germany, awaiting Germany's time of need, first appeared during the Reformation in folk literature and became quite popular in the romantic era when German nationalistic hopes were stirred by the Napoleonic occupation.[3] Literary sources of the theme were plentiful in the first half of the nineteenth century, but none seems to have served as a precise model for Schnorr. The popular poet Friedrich Rueckert published his poem "Barbarossa" in 1817.[4] Rueckert treated the tale picturesquely, describing a sleeping Emperor whose long beard has grown through the table upon which he rests his head. Attended by a dwarf, Barbarossa awakens every hundred years to determine if Germany requires him. This depiction, clearly courting the contemporary taste for fairy tale, contrasts with Schnorr's severe and historicizing treatment. Similarly out of character with the painting are two later poems on the subject, Ferdinand Freiligrath's "Barbarossa's First Awakening" (1829) and Emanuel Geibel's "Frederick Redbeard" (1838).[5]

Another contemporary account seems closer to the Smart Museum picture. Richard Wagner, with whom Schnorr was on close terms in the second half of the 1840s in Dresden,[6] provided at the close of one of his many prose forays into the mythical German past, a fleeting image of Barbarossa seated in the Kyffhäuser, with his sword at his side.[7] It is unlikely, however, that Schnorr's painting was directly inspired by Wagner's text. If Schnorr had based his image on the composer's account, it is logical to presume that he would have included iconographical elements essential to Wagner's treatment of the scene, such as the all-important (for Wagner) manuscript of the *Nibelungenlieder*, which the composer wrote was the only remnant from the heroic days of the Nibelung "hoard." Wagner also referred to the riches of the Nibelungen that surrounded the entombed emperor and to Barbarossa's sword as the blade that "slew the dreaded Dragon," neither of which feature is indicated in Schnorr's picture.

David Morgan

1. For a discussion of the commission and reproductions of the major Barbarossa images, see H. W. Singer, *Julius Schnorr von Carolsfeld*, Künstler Monographien 103 (Bielefeld-Leipzig, 1911).
2. Quoted in Donat de Chapeaurouge, "Die deutsche Geschichtsmalerei von 1800 bis 1850 und ihre politische Signifikanz," *Zeitschrift des deutschen Vereins für Kunstwissenschaft*, vol. 31 (Berlin: Deutscher Verein für Kunstwissenschaft, 1977), 128.
3. For a discussion of the political uses of the theme in nineteenth-century German architecture and literature, see Michael Stuhr, "Das Kyffhäuser-Denkmal: Symbol und Gestalt," in Karl-Heinz Klingenburg, ed., *Historismus—Aspekte zur Kunst im 19. Jahrhundert* (Leipzig: YEB E. A. Seemann Verlag, 1985), 157–182; see also Albrecht Timm, "Der Kyffhäuser im deutschen Geschichtsbild," in *Historisch-Politische Hefte der Ranke-Gesellschaft*, vol. 3 (Göttingen: Musterschmidt Verlag, 1964), 23ff.
4. Friedrich Rueckert, *Gedichte* (Frankfurt am Main: J. D. Sauerlander, 1868), 104–105.
5. Ferdinand Freiligrath, *Sämmtliche Werke*, vol. 2, ed. Ludwig Schröder (Leipzig: Max Hesse, 1906), 55–57; Emanuel Geibel, *Gesammelte Werke*, vol. 1 (Stuttgart: J. G. Cotta, 1883), 91–93.
6. Schnorr was present in the fall of 1845 when Wagner read the text of *Lohengrin* to a Dresden literary circle. See Ronald Taylor, *Richard Wagner. His Life, Art and Thought* (New York: Crescendo Books, Taplinger Publishing Co., 1979), 77–78.
7. Richard Wagner, "The Wibelungen [*sic*]," in *Richard Wagner's Prose Works*, vol. 7, trans. William Ashton Ellis (New York: Broude Brothers, 1966), 298; this writing dates to the summer of 1848.

29 (obverse)

29 (reverse)

Jean-Auguste Barre
French, 1811–1896

29 *Louis-Philippe I and Marie-Amelie,*
 King and Queen of the French (obverse)
 The Royal Family (reverse), circa 1832
 Cast bronze medallion, diam. 2¹⁵⁄₁₆ in. (7.5 cm.)
 Purchase, Gift of Mr. and Mrs. Richard Elden,
 Mr. and Mrs. Robert Feitler, and Mr. and Mrs.
 John Smart in honor of Mrs. Florence Richards
 1983.5

Known for his portrait medallions, busts, and statues, Jean-Auguste Barre was the son and pupil of the medalist Jean-Jacques Barre. The younger Barre's style, as recently noted by Peter Fusco, ranges from the bold romantic realism of his early works to the academic classicism of his official commissions, such as his busts of Napoleon III and his medals, as illustrated here.[1] Despite Barre's major Salon successes, election to the Legion of Honor in 1852, and many government commissions, his work has not been studied in depth or widely published to date.

The Smart Museum medal, which documents the visit of the royal family to the mint as recorded in the inscription on the obverse, may have been issued after Louis-Philippe ordered a merger of the Monnaie des Medailles with the Administration des Monnaies in 1832.[2] While medallic portraits such as this one commemorated historic events, they also preserved the likenesses of members of royal families and served to glorify, publicize, and immortalize them in a propagandistic fashion. In this case, the medal may also have been intended to legitimize the reign of the ruler. The power and position of the patron was often asserted by representing him in the guise of a hero of antiquity. Thus the rendering of Louis-Philippe on the obverse of the Smart Museum medal and in several known single portrait medals is fashioned after coins of the Roman emperor Augustus, that is, as a profile relief bust crowned with a laurel wreath with flowing ribbons. In this instance, Barre depicts the Citizen King in one of two oval medallions, the other enframing a profile portrait relief of Louis-Philippe's queen, Marie-Amelie. It is interesting to note that while medals of Napoleon also follow the classical prototype, subsequently those of Charles X, Louis-Philippe's predecessor, portray the king in his contemporary coronation robes—crowned and wearing a mantle of ermine.

The interpretation of the obverse of the medal is somewhat ambiguous. An unusual winged victory is shown in the center of the composition holding an olive branch in one hand and flowers in the other, as if offering peace and bounty. She stands on a mask of a lion's face surmounting a crown, which is in turn supported by the charter of 1830, presented by two putti. The prominence here of the constitutional charter which placed Louis-Philippe on the throne is significant: in early portraits of the Citizen King, the charter is a conspicuous attribute, but in later portraits, dating from about 1840 when the July Monarchy became increasingly *dynastique à l'ancien*, the charter recedes until almost hidden from view.[3] The lion, which universally engenders royal associations, in this context may well refer to the new regime, for the July Monarchy used the lion's skin of Hercules as both a symbol of strength and as an allusion to the zodiacal sign of the date of the 1830 revolution.[4] Barre's grouping of motifs, then, celebrates the victory of the constitutional monarchy over the Bourbon crown.

The reverse of the medal depicts four classical personifications presenting classicizing cameo portraits of Louis-Philippe's sister and his eight children, all of whom visited the royal mint with their parents. In the top center of the composition, two winged victories support an ovoid medallion portraying the King's sister Eugénie Adelaide Louise in a manner reminiscent of the portrait heads found on Roman triumphal arches and sarcophagi, Renaissance façades, and Renaissance-revival monuments of the nineteenth century. Winged victories of this type are found, for example, on the Arc de Triomphe de l'Etoile (1806–1837) in Paris. The scrolled relief decoration enframing the medallions on both sides of the medal is drawn from French Renaissance strapwork ornament which originated at the Court of Fontainebleau in the sixteenth century and was popularized in the printed designs of Jacques Ducerceau. However, it should be noted that the style and overall design of Barre's medal differ significantly from true Renaissance examples. Renaissance medals would typically portray a single portrait bust, usually in profile, without strapwork ornament on the obverse, and a single commemorative or allegorical scene on the reverse, while this example presents eleven portraits and a number of allegorical figures as well as some ornamentation. The amount of specific information and the delicacy of workmanship of this relief suggest that there may first have been a large model in plaster which was then reduced in size and cast in bronze.

Rita McCarthy

1. Peter Fusco, "Jean-Auguste Barre," in Fusco and H. W. Janson, *The Romantics to Rodin: French Nineteenth-Century Sculpture from North American Collections* (Los Angeles: Los Angeles County Museum of Art, 1980), 111.
2. J. Babelon, *La Médaille en France* (Paris: Larousse, 1948), 101.
3. M. Maarinan, "Painting Politics for Louis Philippe: Issues and Instruments of Propaganda in French Official Art, 1830–1848" (Ph.D. diss., New York University, 1983), vol. 1, 44.
4. Ibid., 433.

Princess Marie-Christine d'Orléans
French, 1813–1839

30 *Joan of Arc*, after 1835
Cast silvered bronze, h. 11⅝ in. (29.5 cm.)
Purchase, Gift of the Friends of the Smart Gallery, 1983
1983.4

Princess Marie-Christine d'Orléans was the daughter of Louis-Philippe, King of the French, as he was called, who reigned from 1830 to 1848. As a girl, Marie studied with the painter Ary Scheffer, and it is thanks to his recollections that we have some idea of her short life as an artist.[1] The *Joan of Arc* was among the first figures executed in the round by Marie; her earlier works, quite few in number, were almost entirely bas-relief. Despite this relative inexperience, Marie received the commission for a statue of St. Joan to be placed in the chateau at Versailles when Louis-Philippe was displeased with a sketch by the sculptor Jean-Jacques Pradier. Scheffer, who assisted his student with the sculpture, had no doubt influenced the king's decision.[2] The technical problems faced by Marie and her teacher, neither of whom had any formal training in sculpture, were recorded by Scheffer, along with his admiration for the final piece and for the talent of its young creator.[3]

The commission for a sculpture of the Maid of Orléans was probably intended to coincide with Louis-Philippe's 1837 consecration of Versailles after its abuse during the revolutionary years. General Lafayette had wanted to place invalids in the chateau; Louis-Philippe transformed it into a state museum. A statue of Joan in this setting was surely calculated to suggest an underlying national identity, one impervious to the tumult and upheaval experienced over the last generation in French society. Louis-Philippe found an excellent national symbol in the young peasant woman who saved the monarchy by leading a beleaguered France to victory over the English at Orléans in 1429. This greatest of French heroines, identified with the seat of Louis-Philippe's dukedom, appealed both to commoner and royalty alike.[4]

Marie portrayed Joan in prayer, her helmet and gauntlets removed, embracing her inverted sword. One contemporary viewer approvingly noted that "this sword possesses the form of a cross, a symbol of pious humility which must serve as auxiliary to force; indeed, courage united with piety—is not the story of Joan in these two words?"[5] According to Joan's own testimony at her trial in 1431, the sword came from the church of St. Catherine at Fierbois, its concealed resting place there revealed to her by the "voices" that had led and inspired her entire venture.[6] Article 20 of her condemnation charged her with having laid a charm on the sword.[7] It was this charge, among a host of others pertaining to witchcraft, that led to her execution at English hands.

Marie's wax model was transformed into a life-size marble and placed at Versailles.[8] Although contemporaries attributed the marble to Marie's "chisel,"[9] it was the *practicien* Auguste Trouchaud who actually carved the sculpture;[10] Marie's lack of training and her delicate health would hardly have allowed her to execute the marble version. The original model was probably near the scale of the Smart Museum bronze. A comparison of several known versions of the sculpture in various media reveals a great variety in detail and aspects of composition.[11] For instance, when compared with the Smart Museum statue, the marble at Versailles, which may be regarded as the exemplar for numerous subsequent translations, bears a number of differences in ornament, armor, placement of helmet and gauntlets, and the design of the sword. These differences indicate the degree of license nineteenth-century technicians employed in the work of making copies as well as transfering models to other media. While this variance contrasts with modernist notions of originality, it serves to remind one that the concept of a copy is a changing and historically defined one. Marie's wax model cannot be considered the "original" per se, but merely an embodiment of the idea to be executed by mechanical processes in marble. The superaddition of anatomical and costume detail were not understood to violate her conception. Likewise, subsequent copies, reductions, enlargements, and reproductions in other media were not confined to the "letter" of any original, but to the "spirit" of the exemplar at Versailles.

David Morgan

1. See Harriet Grote, *Memoir of the Life of Ary Scheffer* (London: John Murray, 1860), 38–48. In 1839, the year of Marie's early death, Scheffer wrote a brief biography of the princess, which focused on her artistic career and specifically discussed the *Joan of Arc*.
2. Ibid., 67. Grote points out that Scheffer later differed with the king's preference for Pradier on another sculptural project.
3. Ibid., 45. "Instead of moulding the form in clay, we took it into our heads to model it in wax. It fell to pieces more than once, then it bent down at a third attempt; furthermore, living models were unattainable."
4. Ibid., 46. Scheffer remarked that Marie's sculpture was most popular among French soldiers. The number of sculptures, paintings, and plays devoted to Joan of Arc during the nineteenth century is remarkable. Several sculptures in France were well known in Salons and as public monuments. The most familiar, which date to the aftermath of the humiliating Franco-Prussian War, are those by Louis-Ernst Barrias, Henri Chapu, Paul Dubois, and Emmanuel Fremiet. (Examples of the former two are represented in the Smart Museum collection; for Barrias, see cat. nos. 39a and 39b, pp. 98–99). See Peter Fusco and H. W. Janson, *The Romantics to Rodin: French Nineteenth-Century Sculpture from North American Collections* (Los Angeles: Los Angeles County Museum of Art, 1980), cat. nos. 8, 9, 121, and 141; also, Régine Pernoud and Marie-Véronique Clin, *Jeanne d'Arc* (Paris: Fayard, 1986), 366.
5. J. Chaudes-Aigues, "Statue de Jeanne d'Arc," *L'Artiste* 1 (1838): 252.
6. See Albert Bigelow Pain, *Joan of Arc*, vol. 2 (New York: Macmillan Co., 1925), 134; and the more recent Pierre de Sermoise, *Joan of Arc and Her Secret Missions* (London: Robert Hale, 1970), 69.
7. Pain, *Joan of Arc*, 2:233.
8. Illustrated in Mrs. Oliphant, *Jeanne d'Arc: Her Life and Death* (Garden City, N.Y.: Garden City Publishing Co., 1926), frontispiece.
9. See A.-Z., "Nouvelle statue de la princesse Marie," *L'Artiste* 1 (1838): 432.
10. Marie Busco, "Princess Marie-Christine d'Orléans," in Fusco and Janson, *Romantics to Rodin*, 311.
11. In 1843, a bronze reduction was authorized for Joan of Arc's home in Domrémy. In 1851, a bronze copy of the Versailles version was erected in Orléans. Yet another bronze version is illustrated in Fusco and Janson, *Romantics to Rodin*, no. 173.

30

31a

31b

Jean-Baptiste Clésinger
French, 1814–1883

31a *Seated Faun*, after 1862
 Cast bronze, h. 16 in. (40.6 cm.)
 Gift of Mr. and Mrs. Edward A. Maser
 1982.11

31b *Seated Faun*, after 1862
 Cast bronze, h. 12¾ in. (32.4 cm.)
 Gift of Ann Englander
 1985.80

The son of a sculptor, Jean-Baptiste Clésinger, called Auguste, studied in Rome with the great neoclassical master, Bertel Thorwaldsen, and later with David d'Angers in Paris. From the beginning, Clésinger enhanced his career through important friendships—with the critic Théophile Gautier, for example—and through an advantageous but brief marriage to the daughter of George Sand. Clésinger's work is characterized by an unabashed but generally fashionable sensuality; critical controversy sometimes surrounded the exhibition of his more provocative works, such as the erotic nude *Woman Bitten by a Snake*, shown in the Salon of 1847. His career was further marked by highly publicized litigation over reproduction and ownership rights with his founder, Ferdinand Barbedienne, among others.[1]

The two versions of the *Seated Faun* in the Smart Museum collection are reproductions of an original marble carved by Clésinger himself (in contrast to standard nineteenth-century practice) in 1862 and exhibited in the Salon of the next year.[2] The intense gaze—one might even say sexual leer—and the twist of the upper body give the *Seated Faun* the appearance of an antique fragment separated from its original compositional context. Yet possible narrative allusions were only faintly substantiated in a later marble of 1869 (now in the Minneapolis Institute of Arts), which combined the faun with a seated bacchante Clésinger had also exhibited in the Salon of 1863.[3] In the 1869 *Bacchante and Faun*, the sculptor raised the faun's right arm to embrace his companion and remove her drapery amidst the festival of wine they celebrate. This erotic component, the small scale, soft forms, and polished surface—anticipated particularly in the larger Smart Museum bronze—do not suggest the antique so much as the mid-century French revival of the Rococo, a revival Clésinger himself helped establish with works such as the *Seated Faun*.

Both Smart Museum statues were produced by the founder Barbedienne, presumably from a plaster model of the 1862 marble.[4] The relatively inexpensive bronze editions issued by Barbedienne made the work of many sculptors available to middle-class patrons during the Second Empire and after, patrons who bought small bronzes (as well as zinc, wax, plaster, and terracotta reproductions) to decorate tabletops and mantels. This change in the means of production, wrought through improved methods of casting and new industrial technologies and materials, resulted in legal debates over the control and quality of reproduction.[5] It was not until late in the nineteenth century that the thought or intent of a work of art was protected against distortion in the reproductive process. Previously, the producer had exercised unique judgment over artistic quality in multiple or serial reproductions.[6]

The Smart Museum's two versions of the *Seated Faun* provide an outstanding opportunity to examine the phenomenon of reproduction in nineteenth-century French sculpture. The improvement of reproductive processes and new devices such as Achille Collas's machine for reducing sculpture led to a controversial court decision in 1861, which established that what a worker did to retouch a mechanically reproduced sculpture did not alone make for a new work of art.[7] Charles Blanc, the academic writer, compared the reproduction to a translation of Virgil, which remains an "*oeuvre littéraire.*"[8] This legal precedent facilitated the entrepreneurship of the founder by allowing for variety in workmanship, which was entirely a function of the time, material, and ability invested in an edition. Furthermore, it legitimized changes an artist or founder might wish to introduce in the treatment of detail, surface texture, size, and patination—all aspects influenced by fashion and market value. For instance, a close examination of Clésinger's two *Seated Fauns* reveals that the larger statuette possesses a warmer patina, glossier surface, and less crisply defined ridges and furrows in such details as the hair on the legs, chest, and top of the head. In the smaller version, details are generally sharper. The grapes on the faun's head, for example, are individually rendered. While the smaller version may have been intended as a closer approximation of the antique with its older-looking patina and less luster, the larger bronze appealed to the contemporary taste for the Rococo, with more softly modeled forms and a sensuous glow reminiscent of François Boucher.

David Morgan

1. See Jacques de Caso, "Serial Sculpture in Nineteenth-Century France," in *Metamorphoses in Nineteenth-Century Sculpture*, ed. Jeanne L. Wasserman (Cambridge, Mass.: William Hayes Fogg Art Museum, Harvard University, 1975), 7, 10, 13, and notes 64 and 93.

2. Reproduced in Alexandre Estignard, *Auguste Clésinger, sa vie et ses oeuvres* (Paris, 1899), 56; also in June Hargrove, "Carrier-Belleuse, Clésinger, and Dalou: French Nineteenth Century Sculptors," *Minneapolis Institute of Arts Bulletin* 11 (1974): 32.

3. See Hargrove, "Carrier-Belleuse, Clésinger, and Dalou," 30.

4. The Smart Museum bronzes are inscribed "Rome," with the date 1862, in reference to the original marble, but were probably not created until after Clésinger's return to Paris in 1864. The sculptures may even have been cast much later, depending upon Barbedienne's rights over their reproduction.

5. The few excellent studies of such largely unresearched problems in nineteenth-century sculpture include: *Metamorphoses in Nineteenth-Century Sculpture*; Peter Fusco and H. W. Janson, *The Romantics to Rodin: French Nineteenth-Century Sculpture from North American Collections* (Los Angeles: Los Angeles County Museum of Art, 1980); an introductory essay by H. W. Janson in *The Other Nineteenth Century*, ed. Louise d'Argencourt and Douglas Druick (Ottawa: National Gallery of Canada, 1978), 198–201; and *Nineteenth-Century French and Western European Sculpture in Bronze and Other Media*, ed. Elisabeth and Robert Kashey (New York: Shepherd Gallery Associates, 1985).

6. De Caso, "Serial Sculpture," 11.

7. Ibid., 10.

8. Ibid., n. 64; Charles Blanc, "Le procès Barbedienne," *Gazette des Beaux-Arts* 12 (April 1862): 384–389.

Margaret F. Foley
American, 1827–1877

32 *Portrait of Jenny Lind*, 1865
 Marble, diam. 16½ in. (41.9 cm.)
 Gift of Dr. and Mrs. Isadore Isoe
 1973.35

The handsome pure-white marble medallion of Swedish-born soprano Jenny Lind (1820–1887) depicts her around the age of forty. At the time of this portrait, Lind had established her reputation on the European opera stage, and won even wider acclaim in the United States where she had spent two years from 1850 to 1852 touring the country under the sponsorship of impresario P. T. Barnum. Known as the "Swedish Nightingale," the singer married her accompanist at the end of the tour, returned to England where she had settled in 1847, and limited her singing to the concert hall, primarily in England and Germany, often under the baton of her husband.

Sculptor Margaret Foley, born in New England, was at the peak of her career when she carved this image. Approaching the age of forty, she had realized her dream of setting up a studio in Rome, and was busy filling portrait commissions, especially from visiting Americans. Although she generally modeled her relief images and busts from life, there is no evidence that she ever met Lind; the portrait bears a strong resemblance, however, to a photograph of the singer taken in 1860.[1]

The bas-relief tondo is signed and dated "M. F. Foley. Roma. 1865. sc." in an inscription under the bust. The nearly life-size head is depicted in profile, facing left, and the sitter's long, wavy hair is held back with a ribbon in a style that is both classically inspired and true to photographs and written descriptions of Lind. She wears a dangling triglyph earring, in the antique Roman mode, and a necklace with a six-pointed star-shaped pendant on which is inscribed the word "Roma." Such careful attention to details of hair and jewelry, as well as the left-facing profile, are typical of Foley's portrait style.[2]

The sculptured portrait medallion represents the neoclassical style which developed in the mid-eighteenth century when the nearly forgotten cities of Pompeii and Herculaneum were rediscovered. Sculptors such as Antonio Canova and Bertel Thorvaldsen journeyed to Italy to see the newly excavated artifacts and used Greco-Roman artworks as their models. In the nineteenth century, many European and American sculptors moved to Rome to study antique statuary and to be near the source of the white marble they had chosen as the ideal classical material. Such eminent artists as William Story and Harriet Hosmer, the leader of a group of women sculptors dubbed "the white, marmorean flock" by the novelist Henry James,[3] were already working in Rome when Foley joined the expatriates.

Foley's natural talent had first shown itself in the little figurines she whittled and modeled as a poor schoolgirl in Vergennes, Vermont. Determined to become an artist, she later supported herself by teaching school, giving art lessons, and working in a textile mill in Lowell, Massachusetts. In Boston, she learned the art of cameo-cutting and practiced it there for seven years. Moving to Rome in 1860, she expanded the scale of her work from miniature cameos to the life-size medallions and busts that became her specialty. The *Portrait of Jenny Lind* was carved in Rome in 1865, the year the sculptor made her only trip back to the United States. That summer, she set up a studio in Boston and executed portraits of Henry Wadsworth Longfellow and Senator Charles Sumner, among others. These plaster casts were then taken back to Rome and rendered in marble. Foley's most ambitious project, originally conceived for a Chicago park before the disastrous 1871 fire, was executed for the 1876 Philadelphia Centennial Fair.[4] Foley was plagued by neurological ailments, and died at the age of fifty, in the Tyrolean spa of Merano, Italy, where she had gone to seek a cure.

Mary Lackritz Gray

1. See Moses Pergament, *Jenny Lind* (Stockholm: P. A. Norstedt and Söners Förlag, 1945), photograph opposite p. 306.
2. Eleanor Tufts, *American Women Artists 1830–1930* (Washington, D.C.: National Museum of Women in the Arts, 1987), cat. no. 104.
3. Henry James, *William Wetmore Story and His Friends* (Boston: Houghton Mifflin and Co., 1903), 257.
4. Philip Sandhurst, *The Great Centennial Exhibition* (Philadelphia and Chicago: P. W. Ziegler and Co.), 497.

William Merritt Chase
American, 1849–1916

33 *Portrait of a Man*, circa 1875
 Oil on wood panel, 45½ x 30½ in. (115.6 x 77.5 cm.)
 Gift of Mrs. Robert B. Mayer
 1974.49

Nothing in the family background or early education of William Merritt Chase presages his successful career as a painter and teacher. His father, an Indianapolis businessman, grudgingly allowed his son at eighteen to study with a local painter, Barton C. Hays, who soon convinced the elder Chase to send his son to the National Academy of Design in New York. In less than two years there, Chase set up a studio and was exhibiting and selling still-life paintings. In 1871, he moved to St. Louis, where his family had settled, and began immediately to attract both buyers and financial backers. Several of his St. Louis patrons sent Chase to the Royal Academy in Munich in 1872, in exchange for work and for purchases of European paintings for their collections.

Portrait of a Man was probably painted during the early years of Chase's Munich period. Munich had succeeded Düsseldorf as Germany's major art center, so that between 1870 and 1885 there were 275 American art students documented there. The Neoclassicism practiced by the Nazarene Brotherhood and still admired in the fifties and sixties was being challenged by more advanced styles introduced to Munich by the International Art Exhibition of 1869. That exhibition included works by the two leading French Realists of the time, Edouard Manet and Gustave Courbet. The German painter Wilhelm Leibl, especially encouraged by Courbet's example, developed his own realist practice based on free brushwork and unidealized subject matter.

This experimentation with technique and content in Leibl's circle influenced the younger professors at the Royal Academy, among them Karl von Piloty, who became director in 1874 and, in that same year, Chase's teacher. With Piloty, Chase explored both the new Realism and the realist tendencies of seventeenth-century baroque painters such as José de Ribera and Francisco de Zurburán, Frans Hals and Peter Paul Rubens. This combination of experimentation and old-master study was a hallmark of the Munich Academy in the seventies and eighties. By 1878, Chase had won medals in Royal Academy exhibitions, and in the Philadelphia Centennial Exhibition with *Keyed Up, Court Jester*. As a result of these successes, he was offered teaching positions both at the Munich Academy and at the Art Students League in New York. Chase chose New York, which became the center of his prodigious activity from 1878 until his death.

The sitter for the Smart Museum portrait has been tentatively identified as either John White Alexander or Walter Shirlaw, both American painter friends of Chase in Munich. An Alexander scholar has rejected the first and this writer rejects the second on the strength of comparisons with Shirlaw self-portraits.[1] What makes identification a difficult problem here, if indeed this is a fellow student, is the fact that American artists in Munich (who, along with the two mentioned above, included Frank Duveneck, J. Frank Currier, and many others), were a close-knit group, socializing as well as working together. Painting each other's portraits, experimenting with each other's styles, were among the ways they grew technically. Moreover, when the paintings are unsigned, as ours is, the situation becomes more complex.

Portrait of a Man has all the attributes of a Munich work.[2] Painted on panel in emulation of the old-master tradition, the portrait is so dark that the black-suited sitter merges with the chair and background, making the contrast of sharp white at collar and cuff extreme. The man's face, the hand that holds the front paws of the boxer dog at his knee, and the dog's coat all show the typical Munich brushstroke. (The presence of the dog argues against the subject being a painter, given the student's itinerant life.) The most arresting section of the panel is the sitter's face, with its bushy mustache, narrow bony nose, protruding ear, and intensely penetrating eyes.

As an example of a significant genre embraced by a generation of Americans trained in Munich in the late nineteenth century, *Portrait of a Man* deserves attention. In the 1880s, Chase's paintings became lighter in both palette and mood, and he began to move outdoors to find his subjects as he became increasingly affected by the color and light of James McNeill Whistler and the Impressionists.

Norma Lifton

1. The Alexander scholar to whom the writer here refers is Mary Anne Goley, Director, Fine Arts Program, Federal Reserve Board, Washington, D.C.—Ed.
2. For reproductions of both German and American examples, see the exhibition catalogue *Munich and American Realism in the 19th Century* (Sacramento: E. B. Crocker Gallery, 1978).

Auguste Rodin
French, 1840–1917

34 *The Thinker* (*Le Penseur*), circa 1880 (model)
 Cast bronze, h. 28 in. (71.1 cm.)
 The Harold H. Swift Bequest, 1962
 1967.30

Auguste Rodin received his early training from Lecoq de Bois-bondran at La Petite Ecole in Paris, where he developed an interest in the arts of ancient Greece and Rome. Denied admission to the Ecole des Beaux-Arts, Rodin continued his studies independently with the sculptors Antoine-Louis Barye and Albert-Ernest Carrier-Belleuse. The exhibition of Rodin's life-size male nude, *The Age of Bronze*, at the Salon of 1877 brought the artist widespread attention. To his chagrin, critics responding to the sculpture's anatomical realism suggested that it was a life cast rather than a true modeled work.

Rodin's sculpture deviated from guidelines set by the French Academy which advocated a neoclassical standard in its demand for heroic subjects and godlike representations of human figures. This ideal of perfection was expressed in smooth, uniform surfaces and generally static yet graceful poses. In the nude, the figure reached a state of physiognomic superiority as a flawless and eternally youthful being. Rodin's desire to individualize his figures through modeled and irregular surfaces and dynamic poses, as well as his interest in the tactile qualities of the sculpting medium, conflicted with the Academy's dictates. At the time *The Thinker* was produced, about 1880 or 1881, Rodin stood in the vanguard of Modernism; he combined the traditional use of the human figure to personify such universal concepts as time, love, and beauty, with a new sense of the primacy of the individual.

The Thinker dates to a period in Rodin's oeuvre in which the influence of Michelangelo is particularly apparent. Rodin had traveled to Italy in 1875 to study the example of the Renais-sance artist, and was inspired by such works as the carved figures for the Medici tombs in San Lorenzo, Florence and the painted nudes in the Sistine Chapel, Rome. It is also believed that Rodin was influenced by the famous *Belvedere Torso* by Apollonius, of which he had designed a stone copy in 1874 for the Palais des Académies in Brussels; he probably viewed the antique fragment at the Vatican in 1875.[1] Although the resemblance of Rodin's work to Jean-Baptiste Carpeaux's *Ugolino and His Sons* (1857–1861) has been acknowledged by numerous scholars, who have suggested it as a possible source for *The Thinker*, recent evidence indicates that the primacy of this relationship has been likely overestimated, for it undermines the importance of Rodin's interest in Michelangelo and the *Belvedere Torso*.[2]

The Thinker was conceived as the frontispiece for the tympanum to the great *Gates of Hell*, a set of portals commissioned in 1880 by the Fine Arts Committee of the French Ministry of Education for the projected Museum of Decorative Arts in Paris. The iconographical program of the doors was based on Dante's *Divine Comedy*; *The Thinker* was identified as Dante himself until 1889, when the sculpture, in its original size, was shown at the Exposition Monet-Rodin at the Galerie Georges Petit under the title *The Thinker: The Poet, Fragment of a Door*. The idea of *The Thinker*, as it is now called, changed from an ascetic representation of Dante to a massive, solid symbol of thinking man as creator. The version of the sculpture originally planned for the *Gates of Hell* and exhibited in 1889 was of the same dimensions as the cast now belonging to the Smart Museum, produced by the foundry of Alexis Rudier. Enlargements and reductions of *The Thinker* were also made as independent works.

Adrienne Kochman

1. Albert E. Elsen, *'The Gates of Hell' by Auguste Rodin* (Stanford: Stanford University Press, 1985), 19.
2. Elsen, *Rodin's 'Thinker' and the Dilemmas of Modern Public Sculpture* (New Haven and London: Yale University Press, 1985), 36, states that "Rodin owned a bronze cast of a sketch for Carpeaux's group, which shows that he admired it, but he did not acquire the cast until 1911."

Emile René Ménard
French, 1862–1930

35 *Homer*, circa 1885
Oil on canvas, 51 x 62 in. (129.5 x 157.5 cm.)
Purchase, Gift of Mr. and Mrs. Eugene Davidson
1980.4

Born in 1862 to a family of distinguished artist intellectuals, Marie Auguste Emile René Ménard trained under the academic painter Paul Baudry, and studied at the Académie Julian in his native Paris. His lyrical landscape paintings, populated by timeless nudes or, as in this case, classical or mythological figures, reflect the early influence of Camille Corot, a friend of Ménard's father, himself a painter and director of the Ecole des Arts Décoratifs. The younger Ménard first exhibited at the Salon of 1883, but became associated with the anti-academic Société Nationale des Beaux-Arts, founded by Ernest Meissonier, Pierre Puvis de Chavannes, and Auguste Rodin as a rival exhibition society to the officially organized Salon. In addition, Ménard was a member of the informal anti-impressionist group, known as "*la bande noire*," surrounding the painter Charles Cottet, a protégé of Puvis.[1] Rejecting the Impressionists' contemporary subject matter and their focus on ephemeral phenomena, Cottet and his circle valued, most of all, the moral content of a work of art.

35

Ménard's *Homer* is a reprise of Corot's painting of the same subject, *Homère et les bergers*, exhibited in the Salon of 1845 and subsequently presented to the Musée des Beaux-Arts in Saint-Lô.[2] Corot's inspiration for the 1845 canvas was a verse by the eighteenth-century poet André Chénier, which Ménard reprinted in the Salon catalogue of 1885 to accompany his own version of the venerable bard reciting poetry to three shepherd boys.[3] The antique theme, though hardly unusual during the century and a half following the rediscovery of Herculaneum and Pompeii in the mid-1700s, recalls the Parnassian poets' continuing fascination with the ancient Mediterranean world. Opposed to the emotionalism of the romantic movement, Parnassians favored classical harmony, balance, and calm, qualities clearly in evidence in Ménard's painting. Significantly, Charles Leconte de Lisle, leader of the Parnassian school and author of *Poèmes antiques* (1852), was influenced by Ménard's paternal uncle Louis, a passionate Hellenist and man of letters. Louis Ménard, whose archaeological investigations inspired both his *Poèmes* (1855) and *Rêveries d'un païen mystique* (1876), was the subject of at least one portrait by his talented nephew.[4]

The iconography of the Smart Museum painting is of course consistent with such antiquarian interests and classicizing ideals; at the same time, the image of the aged poet imparting his wisdom to a group of enrapt youths provides an allegory of artistic authority and grateful discipleship, echoed in the motif of the shepherd with his flock approaching in the background. More specifically, Reinhold Heller, discerning a physiognomic similarity between Ménard's Homer and Puvis, has posited that Ménard meant his picture as an homage to the revered exemplar of symbolist painting.[5] The attentive young men at the poet's feet could then be understood to embody followers of Puvis, artists such as Cottet, Ménard himself, and a whole generation of Symbolists who held the painter of dreamy poetic idylls in the highest regard.

Although Ménard's canvas bears no date, we know that it was exhibited in 1885, associated with Chénier's poem, and again in the Salon of 1896, when it was purchased by a British collector in Paris.[6] It is interesting to note that the preceding year had been marked by grand celebrations of Puvis by many of his admirers. On one occasion in 1895, for example, the aging painter was honored by a dinner at the Hotel Continental attended by more than five hundred artists, critics, poets, and writers. Rodin presided, and other Symbolists present included Edmond Aman-Jean, Eugène Carrière, Paul Gauguin, Gustave Kahn, Stéphane Mallarmé, and Georges Rodenbach.[7] Ménard's decision to exhibit *Homer* a second time may have coincided with a series of such commemorations of Puvis, when, according to Robert Goldwater, "in further homage several symbolist periodicals joined to publish an *Album des Poètes* dedicated to the master, made up almost exclusively of contributions by the spokesmen of *l'art idéaliste*."[8]

An important principle linking all these proponents of *l'art idéaliste* was the theory of correspondences—the notion that a feeling or idea could be variously evoked and reinforced through sight, sound, taste, touch, and smell. This concept and its concomitant emphasis on synaesthetic experience also find expression in Ménard's *Homer*. As a visual evocation of a literary recitation with musical accompaniment, the painting alludes to the interaction of all the arts. That Ménard might associate an epic poet with Puvis, rather than a painter such as Zeuxis or Apelles, for instance, is thus perfectly in keeping with his symbolist orientation. Equally important to his choice of ancient models, moreover, is the fact of Homer's blindness, since closed or sightless eyes constituted a favorite symbolist motif, indicative of an inward focus, privileging the spiritual realm over a shifting, illusive material reality.[9]

Sue Taylor

1. Ménard exhibited a portrait of Cottet in the Salon of 1896. See *Exposition Nationale des Beaux-Arts: Catalogue Illustré des ouvrages de peinture, sculpture et gravure exposés au Champ-de-Mars le 25 Avril 1896* (Paris: E. Bernard et Cie., 1896), xxii, cat. no. 885.

2. Etienne Moreau-Nélaton, *Histoire de Corot et de ses oeuvres* (Paris: H. Floury, 1905), fig. 94.

3. "Ansi le grand vieillard, en images hardies/Déployait le tissu des saintes mélodies/Les trois enfants, émus à son auguste aspect/Admiraient d'un regard de joie et de respect/De sa bouche abonder les paroles divines/Comme en hiver la neige au sommet des collines.—André Chénier" *Explication des ouvrages de peinture, sculpture, architecture, gravure et lithographie des artistes vivants exposés au Palais des Champs-Elysées le 1er mai 1885* (Paris: E. Bernard et Cie., 1885), 151.

4. A portrait of Louis Ménard by Emile René is illustrated, undated, in Achille Segard, "René Ménard, Painter of Classical Landscape," *International Studio* 37 (May 1909): 183.

5. Reinhold Heller in correspondence with Edward A. Maser, 26 January 1980 (Smart Museum documentary files). My thanks to Professor Heller for discussing his hypothesis with me and for considering the problem of assigning a date to the painting.

6. For the Salon of 1885, see *Explication des ouvrages de peinture* (cited in n. 3 above), 151, cat. no. 1731, and F.-G. Dumas, ed., *Catalogue illustré du Salon* (Paris: Librairie d'Art L. Baschet, 1885), xxxix, cat. no. 1731; for the Salon of 1896, see *Exposition Nationale des Beaux-Arts*, xxii, cat. no. 882. The collector who purchased the painting is identified as Sir Andrew Noble of Newcastle-upon-Tyne; see Sotheby Parke Bernet & Co., *Fine Eighteenth, Nineteenth and Twentieth Century European Paintings and Works of Islamic Interest* (London: Sotheby Parke Bernet & Co., 19 April 1978), cat. no. 161. For the Salon references, I am indebted to Professor Martha Ward who also alerted me to the recent illustration of *Homer* in Neil McWilliam, "Limited Revisions: Academic Art History Confronts Academic Art," *Oxford Art Journal* 12:2 (1989): 73, fig. 2.

7. Robert Goldwater, *Symbolism* (New York: Harper and Row, 1979), 154.

8. Ibid.

9. This attribution of great powers of insight to the blind belongs to a long tradition that includes the Theban seer Tiresias of Greek myth and culminates in the twentieth century in Pablo Picasso's cruel hyperbole that "they should put out the eyes of artists as they do goldfinches to make them sing better." (E. Tériade, "En causant avec Picasso," *L'Intransigeant*, 15 June 1932, 1.) Ménard's *Homer*, in fact, is a relative in classical garb of Picasso's own blind bard of the Blue Period, the *Old Guitarist* (1903, Art Institute of Chicago). See Ronald W. Johnson, "Picasso's 'Old Guitarist' and the Symbolist Sensibility," *Artforum* 13 (December 1974): 56–62, and Mary Mathews Gedo, "A Youthful Genius Confronts His Destiny: Picasso's *Old Guitarist* in The Art Institute of Chicago," *Art Institute of Chicago Museum Studies* 12 (1986): 152–165, especially p. 162 for the symbolic implications of the theme of blindness.

Jean-Léon Gérôme
French, 1824–1904

36 *Pygmalion and Galatea*, circa 1890
 Oil on canvas, 17⅜ x 13¼ in. (44.1 x 33.6 cm.)
 Purchase, Gift of Mr. and Mrs. Eugene Davidson
 1980.73

Throughout most of the second half of the nineteenth century, Jean-Léon Gérôme's highly polished, detailed paintings of picturesque subjects won him critical acclaim and lucrative public and private commissions in both Europe and America. An ardent champion of the French Academy's idealized themes and refined techniques, he argued against any official recognition for the unconventional, controversial works of realist and impressionist artists right up to the end of the century, when a gradual acceptance of the avant garde marked the waning of Gérôme's own status.

During the eighteenth and nineteenth centuries, nearly all artistic training, exhibitions, and commissions in France were dominated by the Académie des Beaux-Arts, established in the seventeenth century by Louis XIV to control and codify artistic production in accordance with the much-admired values of classical antiquity and the Italian High Renaissance. The Academy held that art should depict only ennobling or picturesque subjects in a scrupulously illusionistic and elegant manner; vulgar, unpleasant, or even ordinary aspects of life were deemed unworthy of art's spiritual purpose of conveying only "important" truths, while any indication of the painter's working process in rendering forms was deplored as inferior manual labor that degraded the conceptual content

36

of the work. Maintaining strict categories and hierarchies of subject matter, as well as standards of beauty and rules governing composition and facture, the Academy preferred mythological, historical, and exotic genre themes presented in a graceful and decorous fashion. Only in the preliminary oil sketch, which had its own purposes and aesthetic conventions, was the artist allowed to indulge some individualism, to exhibit that idiosyncratic or expressive brushwork so revered in modern art. Freed from the constraints of meticulous finish, the academic sketch not only reveals more of the artist's working methods, but often communicates a greater sense of vitality than the perfected painting.

Gérôme executed this oil sketch of *Pygmalion and Galatea* preparatory to a larger painting, a work of his old age, which he completed in the summer or fall of 1890 (fig. 5). The subject of Pygmalion and Galatea was one he found particularly compelling for several reasons. Always enamored of antique sculpture, Gérôme had been fascinated by the discoveries in the 1870s of the Tanagra figurines of Boeotia—small Hellenistic statuettes of genre figures painted in bright colors.[1] In addition to providing retrospective justification for his own neoclassical figural style, palette, and preference for genre motifs, these figurines also inspired him to begin making polychromed sculpture. His first major sculptural work was exhibited in 1878, and he continued to work in plaster and marble throughout the remainder of the century. In 1890, the year he painted *Pygmalion and Galatea*, he exhibited a tinted marble called *Tanagra*, a seated nude in the antique style holding a painted figure of a hoop-dancer which Gérôme himself had executed in gilded bronze. In 1893, he produced a picture titled *Sculpturae vitam insufflat pictura* (*Painting Breathes Life into Sculpture*) in which a girl wearing classical garb colors figurines of the hoop-dancer in an ancient studio whose shelves are anachronistically filled with other works by Gérôme. Finally, in *Working on the Marble*, also known as *The Artist and His Model* (1895, Stockton, California, Haggin Museum),[2] Gérôme painted himself in his studio working from a live model on the plaster version of his 1890 *Tanagra*. Hanging conspicuously on the rear wall in this picture is Gérôme's painting *Pygmalion and Galatea*, and it is especially significant that in January of 1891, shortly after he completed the latter, he had executed a large painted marble group of the figures of Pygmalion and Galatea, now in the Hearst San Simeon State Historical Monument, California.[3]

These indications of Gérôme's preoccupations with classical statuary, the relationship between painting and sculpture, and giving life to sculpted form through color all provide us with the philosophical context in which his *Pygmalion and Galatea* was created. Pygmalion was a sculptor of Greek legend who fell so deeply in love with his own idealized marble of a woman that Aphrodite, taking pity on him, caused the statue to come to life. In Gérôme's painted rendition of the event, the process of metamorphosis from dead stone to living flesh is depicted through color transitions as well as gesture. Galatea's immobile lower legs, with feet still embedded in

Fig. 5. Jean-Léon Gérôme, *Pygmalion and Galatea*, 1890, oil on canvas, 35 x 27 in. (88.9 x 68.6 cm.), New York, Metropolitan Museum of Art, Gift of Louis C. Raegner, 1927 (27.200).

the unfinished marble base, are painted in cold, bluish-white tones. As these melt just below her knees into the rosy flush that suffuses her upper body, she bends gracefully around to return the sculptor's embrace, as if thanking him for endowing her with life. Gérôme's identification with Pygmalion is overt: Pygmalion's studio cabinets, model's dais, stool, and mounting box are identical to the furnishings of Gérôme's own studio as represented five years later in *Working on the Marble*, and on the cabinet at the left we find a vaguely articulated sculpture that closely resembles the seated *Tanagra* figure he produced the same year as this oil sketch.

Technically, this preliminary version of *Pygmalion and Galatea* exhibits the relative freedom associated with the academic sketch. Only the principal figures and foreground elements are fully delineated, and even they reveal a looser handling than do Gérôme's finished pictures. The objects of the background as well as the marble base of the statue are only crudely defined with broad, rough strokes, and both the rear wall and floor are painted with strong, directional applications of pigment which lend the work a greater sense of vigor and immediacy than we find in the completed version. In accordance with academic regulations, the strongest color is restricted to the main figures: Pygmalion's vivid blue tunic and Galatea's radiantly lit pink skin and ruddy blond hair make them the major focus in the dim studio ambiance of dark earth tones, a contrast that again suggests Gérôme's views about color as a vehicle of vitality. It was precisely because of their desire to expand this quality of life and dramatic intensity to all parts of the painted surface as well as to the portrayal of modern subjects that the Impressionists and Post-Impressionists were at this very date engaged in undermining the moribund academic dicta of limited color, invisible brushwork, and traditional themes on which Gérôme had founded and pursued his long career.

Naomi Maurer

1. See Gerald M. Ackerman, *Jean-Léon Gérôme (1824–1904)* (Dayton: Dayton Art Institute, 1972), 93.

2. Illustrated in Naomi Maurer, "Breathing Life into Sculpture: *Pygmalion and Galatea* by Jean-Léon Gérôme," *Bulletin of the David and Alfred Smart Gallery* 1 (1987–1988): 13.

3. Illustrated ibid.

Childe Hassam
American, 1859–1935

37 *On the Lake Front Promenade,*
Columbian World Exposition, 1893
Oil on canvas, 17⅝ x 23⅝ in. (44.8 x 60 cm.)
The Harold H. Swift Bequest, 1962
1976.146

A leader of American Impressionists, Childe Hassam had apprenticed to a Boston wood engraver in 1876 and worked as a magazine illustrator while enrolled at the Boston Art Club. After brief training at the Lowell Institute, Hassam studied with the German-born painter Ignaz Gaugengigl, who specialized in accurately rendered figure groups. While in Paris from 1886 to 1889, Hassam continued his studies at the important Académie Julian, during the peak of impressionist success and influence. After returning to New York to set up his own studio, he cofounded the Ten American Painters group in 1897 with Paris-trained American Impressionists J. Alden Weir and John Twachtman. Hassam exhibited in the 1913 Armory Show and, after 1915, received wide recognition for his etchings and lithographs.[1]

Throughout the 1890s and early 1900s, Hassam painted scenes of urban leisure, composed asymmetrically along receding axes of buildings or tree-lined avenues. He had been awarded a bronze medal at the 1889 Universal Exposition in Paris, but his reputation grew when he received another at the World's Columbian Exposition in Chicago.[2] During the summer of 1893, Hassam visited Chicago and completed several spacious and colorful views in oil of the Exposition.[3] He chose a typical impressionist subject when he composed *On the Lake Front Promenade, Columbian World Exposition,* depicting stylishly dressed visitors to the White City strolling along the terraced waterfront, many clutching guidebooks to the Fair. Judging from the agitation of the lake's surface, the fluttering flags atop the distant Columbus Portico or adjacent Liberal Arts building,[4] and people holding onto their hats, Hassam selected a windy and hazy Chicago day.

On the Lake Front Promenade exemplifies the artist's dedication to the problems of plein-air painting he had studied in Paris, most notably his interest in capturing effects of motion, color, and atmosphere in rainy or overcast weather. Hassam had mastered the techniques of Claude Monet more successfully than most of his American contemporaries; his investigation of light on rippling water, his convincing suggestion of movement by means of assured and spirited brushwork, and his arrangements of figures and architecture in a sweeping urban space bring to mind precedents such as Monet's *Boulevard des Capucines, Paris* (1873) or Camille Pissarro's cityscapes of the 1890s. Within Hassam's own oeuvre, *On the Lake Front Promenade* represents a relatively early example of the painter's adaptation of impressionist subject, style, and composition. The deep perspective and asymmetrical composition are similar in earlier city scenes such as *Rainy Day, Boston* (1885).[5] In the Exposition views, the palette is brighter, the facture more apparently spontaneous and painterly, reflecting all that he had learned during his years in Paris. Beginning in 1890, furthermore, Hassam visited New England seaside towns where he refined the spirited qualities of plein-air painting. Lastly, the prominent woman in the foreground of the Smart Museum picture, seized in motion with rapid brushstrokes, is a figural type common in many of Hassam's sidewalk scenes, including his important painting of 1890, *Washington Arch in Spring.*[6]

Hassam elaborated his ideas about modern history painting, aiming to catch truthfully "his own time and the scenes of everyday life around him":

I select my point of view and set up my canvas, or wooden panel, on the little seat in front of me I wait until I see picturesque groups, and those that compose well in relation to the whole Of course all those people and horses and vehicles didn't arrange themselves and stand still in those groupings for my especial benefit. I had to catch them, bit by bit, as they flitted by.[7]

Although consisting of only temporary structures, the World's Columbian Exposition permanently captured the imagination of American and foreign visitors, who turned homeward with dreams of ideally beautiful cities. With an appropriately fleeting view in *On the Lake Front Promenade,* Hassam seized the dreamy and misty atmosphere of the White City as the fashionable visitors walked along the shore, alone and looking inward.

R. Stephen Sennot

1. For a complete chronology, see the recent monograph by Donelson F. Hoopes, *Childe Hassam* (New York: Watson-Guptill Publications, 1979).

2. Hassam exhibited six oils and four watercolors. In addition, along with many American painters, sculptors, and architects directed by Chicago architect Daniel Burnham, Hassam made several architectural wash renderings of the proposed exposition buildings to suggest what the lakefront site might look like. See Hoopes, *Childe Hassam,* 36.

3. In addition to the paintings, Hassam also composed a limited set of chromolithographs, *Gems of the White City,* depicting many of the Exposition's buildings. See Guild Hall of East Hampton, *Childe Hassam 1859–1935* (East Hampton: Guild Hall Museum, 1981), 20.

4. According to maps of the grounds for the World's Columbian Exposition as well as contemporary photographs, Hassam has probably depicted either the Columbus Portico or a portion of the Liberal Arts Building at the far right side of the painting. Extending along the horizon at the left is the steamboat pier, equipped with a movable sidewalk.

5. Illustrated in Hoopes, *Childe Hassam,* 23.

6. Illustrated in ibid., 35.

7. A. E. Ives, "Talks with Artists: Mr. Childe Hassam on Painting Street Scenes," *The Art Amateur* 27 (October 1892): 116–117.

37

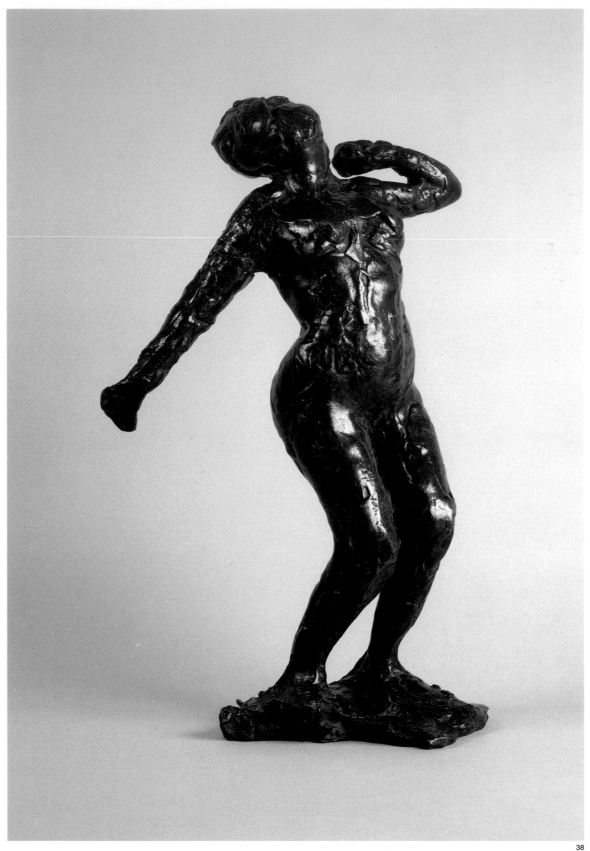

Hilaire Edgar Germain Degas
French, 1834–1917

38 *Woman Stretching (Femme s'étirant)*, 1896–1917
 (cast 1919–1921)
 Cast bronze, ed. 53/D, h. 14⅜ in. (36.5 cm.)
 Rewald LXIV
 The Joel Starrels, Jr. Memorial Collection
 1974.147

Among the greatest artists of the past two centuries, Edgar Degas produced a body of works resolutely modern, both for their contemporary subject matter and experimental, innovative approach to materials. With Camille Pissarro, Degas was a bulwark of the eight impressionist group exhibitions between 1874 and 1886. However, Degas's choice of urban subjects, often interiors, and rigorous linear exactitude in rendering distinguish his work from the open-air landscapes of Impressionists like Pissarro, Claude Monet, and Alfred Sisley. It is Degas's further distinction to have extended his approach to many different media—painting, drawing, printmaking, sculpture, and photography.

From the 1890s, Degas began to limit his work almost exclusively to sculpture. This change may be related to the growing deterioration of his eyesight, yet it must be noted that this choice is concordant also with the artist's desire to achieve an art of utmost realism and tangibility. In 1897, Degas discussed his sculpture with precisely this latter aspect in mind:

Draw a dancing figure; with a little skill, you should be able to create an illusion for a short time. But however painstakingly you study your adaptation, you will achieve nothing more than an insubstantial silhouette, lacking all notion of mass and of volume and devoid of precision. You will achieve mass only through modeling because sculpture is an art which puts the artist under an obligation to neglect none of the essentials.[1]

Thus Degas's shift to sculpture is perhaps best understood as the confluence of both physical and conceptual necessity.

Woman Stretching belongs to the final portion of the artist's career.[2] Two features connect it with Degas's characteristic concerns of the period. First is the choice of a completely anonymous, "generic" subject. The figure is identified no longer even as a dancer or schoolgirl, as in earlier work, and the activity chosen is one of similarly universal acquaintance. Second, the pose is an elaborate array of curves and straight lines, a complex interplay of muscular exertion and skeletal structure. It is an ephemeral moment of dynamic equipoise, a stillness that is the sum of motions. Both aspects of this sort of conception accentuate a tendency that can be found throughout Degas's works: to uncover the myriad complexity of everyday existence.

Degas's sculptures were never cast in bronze during his lifetime. The works remained as wax models with which a sculptor begins the lost-wax process, and were only ushered through the entire lengthy process by the master founder Adrien Hébrard between 1919 and 1921. In this period, Hébrard cast some seventy-two waxes by Degas, making at least twenty-two bronze examples of each piece. The first twenty examples were offered for sale and differentiated by the letters A through T. *Woman Stretching* is the fifty-third of the waxes cast by Hébrard, and the Smart Museum's piece, which is stamped D, is the fourth example created.[3] It is thus an especially early casting, which implies optimal reproduction of the intricate surface created by the artist. The sculpture is the product of a complex and arduous collaboration—between people as between materials—yet it presents with immediate clarity Degas's art and thought.

Frederick N. Bohrer

1. The artist quoted by François Thiebault-Sisson, "Degas Sculpteur," *Le Temps*, 23 May 1921, cited in translation in *Degas: Form and Space* (Paris: Centre Culturel du Marais, 1984), 179.

2. John Rewald, *Degas Sculpture*, rev. ed. (New York: Abrams, 1956), places the work (LXIV) in the group corresponding to the last part of Degas's career, 1896–1917. Charles W. Millard, *The Sculptures of Edgar Degas* (Princeton: Princeton University Press, 1976), 83, n. 56, dates the work "from the very end of Degas' career." The alternative proposal to date the sculpture to 1882–1884 is based solely on a superficial resemblance to Degas's *Repasseuse* images of 1882 and circa 1884 and cannot be maintained by any rigorous stylistic or documentary analysis. For this view, see Michele Beaulieu, "Les Sculptures de Degas: Essai de Chronologie," *Revue du Louvre et des Musées de France* 19 (1969): 378, and *Degas: Oeuvres du Musée du Louvre* (Paris: Orangerie des Tuileries, 1969), no. 282.

3. Degas's original wax figure is in the collection of the National Gallery of Art, Washington, D.C., accession no. 1985.64.55.

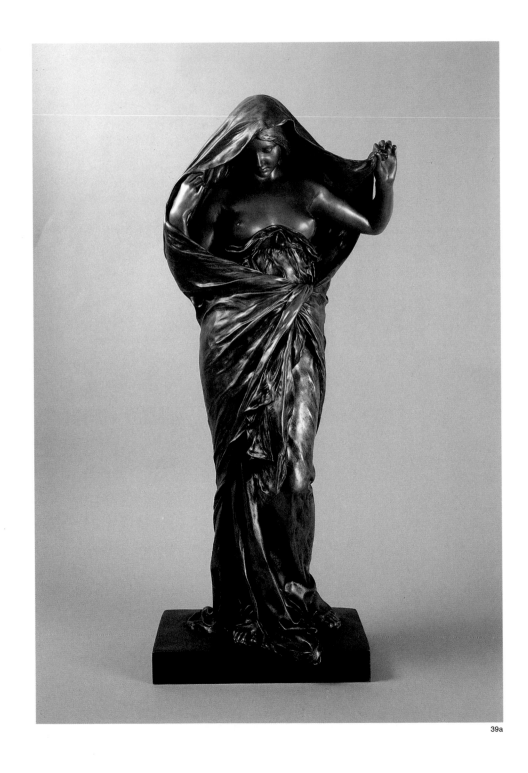

39a

Louis-Ernest Barrias
French, 1841–1905

39a *Nature Unveiling Herself to Science*, after 1899
Cast bronze, partial *doré* patination, h. 28½ in. (72.4 cm.)
Gift of John N. Stern
1984.6

39b *Nature Unveiling Herself to Science*, after 1899
Cast bronze, partial *doré* patination, h. 16¾ in. (42.5 cm.)
Gift of Mr. and Mrs. John N. Stern
1987.15

After being apprenticed to the painter Léon Cogniet and the sculptor Pierre-Jules Jouffroy, Barrias entered the Ecole des Beaux-Arts in 1858, and won the Prix de Rome in 1865. By the next decade, he was recognized as a talented proponent of academic doctrine: he won the Salon's Medal of Honor in 1878, was made officer in the Legion of Honor in 1881, became a professor at the Ecole in 1884, and continued to receive many honors and public commissions throughout his career.

Barrias made several versions of this allegory. The first, a marble statue shown at the Salon of 1893 (no. 2543) under the longer title *Mysterious and Veiled, Nature Uncovers Herself before Science*, portrays Nature as a voluptuous female nude discarding a long veil that drapes behind her to the floor. In the second, which Barrias exhibited in polychrome stone materials at the Salon of 1899 (no. 3186), Nature, wearing a garment that falls from beneath her breasts, begins to free herself from the veil that envelops her from behind and ties over her hip.[1] This piece was probably the model for the Smart Museum statues, which represent two of six sizes edited by the foundry of Susse Frères. The latter were worked in various materials to create the rich, exotic contrasts in texture and tone that characterize art-nouveau sculpture: one version, for example, was produced in marble and gilt bronze; another, in ivory with gilt and silvered bronze, malachite, and aquamarine detailing; several more, including ours, were fashioned in bronze with gold decoration applied to the veils.

The title chosen by Barrias reflects the late-nineteenth-century interest in scientific and technological progress, an interest that yielded the artist several public commissions, including a monument to electricity for the Gallery of Machines at the Universal Exposition of 1889 and, in 1900, a monument to the eighteenth-century French chemist Antoine-Laurent Lavoisier. Here, however, as contemporaries noted, Barrias uses the theme less to pay homage to science than to depict another object of current fascination—Woman. The ample, emphasized breasts, the self-absorbed expression, and the scarab that cinches the garment, symbolic of mystery, transform a traditional allegory into a distinctly fin-de-siècle female. She is not the maternal and bounteous Nature popularized during the French Revolution, nor Truth being stripped of her mystifying garb, although she alludes to both. Instead, she is the complex and contradictory creature who captured the imagination of Symbolists such as Gustave Moreau and Stéphane Mallarmé, and whose sinuous form and evocative richness provided the basis for many art-nouveau works. Barrias portrays her both forbidding and inviting, armored and penetrable: as the agent of her own unveiling, she has the power to withhold her secrets from the man who seeks them; yet her gesture and seminude state indicate that she will comply with his desires and reveal herself to the scrutiny of his mastering gaze.

If Barrias's image is less Nature than Woman, it does not render the artist's reference to science irrelevant, and it is particularly appropriate that several versions of the sculpture were acquired by schools of medicine.[2] In the nineteenth century, with the suppression of midwives and the development of gynecology, the medical treatment of women increasingly became a male practice as the female body and mind became the subject of intense study by male professionals. Barrias's *Nature*, who must be coaxed to yield her secrets, is also the Woman Sigmund Freud was investigating in Vienna during the same period.

Erica Rand

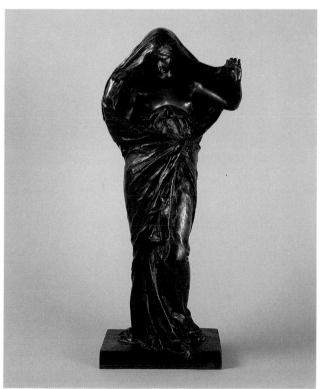

39b

1. For an illustration of the 1893 marble version and a concise discussion of the 1899 and later versions, see Richard H. Randall, Jr., *Masterpieces of Ivory from the Walters Art Gallery* (New York and Baltimore: Hudson Hills Press in association with the Walters Art Gallery, 1985), 302–303, cat. no. 445.
2. For example, the final rendition of *Nature*, carved in white marble and exhibited in the Salon of 1902 (no. 2229), was purchased by the Ecole de Médicine in Paris. Ibid.

Gustave Serrurier-Bovy, designer
Belgian, 1858–1910

40 *Fireplace Surround*, circa 1902–1905
 Brass, copper, wrought iron, mahogany, mirror,
 glazed porcelain tile, 98 x 56 in. (249 x 142.2 cm.)
 Gift of Seymour Stein
 1984.20

Gustave Serrurier-Bovy, a Belgian designer based in Liège, came from a family of cabinetmakers and trained as an architect. In recent years, his works have become better known and appreciated; in Europe, particularly, he is a subject of new research and reappraisal, recognized as one of a small group of influential Belgian architect/designers, including Henry van de Velde, Paul Hankar, and Victor Horta, who worked in the art-nouveau style. Unlike his colleagues, however, Serrurier-Bovy rarely engaged in the typical practice of designing an entire building and its contents. In fact, he would eventually abandon architecture altogether for furniture production, and is known primarily for his interiors.

While traveling in Britain in 1884, Serrurier-Bovy was inspired by John Ruskin, William Morris, and the principles of honest and functional design advocated by members of the British Arts and Crafts movement. Serrurier-Bovy helped bring these ideas to Liège through a shop he opened upon his return, selling goods from Liberty's of London, the company noted for oriental imports, and from Japan. In 1899, he established a large factory in Liège to produce his own furniture designs, with salesrooms in Paris, Nice, and The Hague.

Serrurier-Bovy exhibited his work widely. In Belgium, at the invitation of Van de Velde, he showed several furnished interiors at the salons of the Libre Esthétique, including an important *Chambre d'artisan* in 1895. He was a principal organizer of the 1895 L'Oeuvre Artistique international decorative arts exhibition in Liège, and designed a hall for the Tervuren colonial exhibition, a feature of the Brussels Exposition International in 1897. Internationally, he presented work at the 1896 Arts and Crafts Exhibition Society in London, designed the fanciful and highly successful *Pavillon bleu* restaurant at the 1900 Paris Exposition Universelle, and sent work to the 1904 Louisiana Purchase Exhibition in St. Louis. His last major endeavor was a pavilion at the Brussels Exposition International in 1910, the year of his death.

Serrurier-Bovy's design conception was shaped by several notable influences. In the mid-1890s, numerous sketches and the *Chambre d'artisan* reveal a preoccupation with the Arts and Crafts idea of affordable handcrafted design for middle- and working-class homes.[1] Like other Belgian artists, particularly those associated with the progressive exhibition society Les Vingt (The Twenty), Serrurier-Bovy believed that art should not be limited to the elite. The Art Section of the Belgian Worker's Party, for instance, had declared in 1891 the hope that in the future art would not only formulate an ideal, but would "come down to the ordinary things of daily life and [would] accompany all human activity."[2] That same year, examples of applied art were included in the salon organized by Les Vingt; this interest in decorative arts would be transmitted to the group's successor in the Libre Esthétique. Thus in the introductory brochure for the salon of the Libre Esthétique in 1895, Serrurier-Bovy wrote about the audience for his *Chambre d'artisan*:

I want to show the category of workers . . . we call artisans, that art is by no means reserved for the wealthy alone. On the contrary, taste has more to fear from luxury than from modesty, and the demands of simplicity are less dangerous to it than the facilities of opulence The masses must participate in artistic life We must believe in, and work for the future.[3]

From around 1897 to 1901, Serrurier-Bovy's close association with Van de Velde and his fascination with French Art Nouveau became apparent, especially in the elaborate, curvilinear, and organic forms of his designs for Tervuren and for furnishings from his factory. In 1901, he visited Darmstadt in southern Germany, the site of an active artists' colony, and attended the exhibition Ein Dokument Deutscher Kunst. This experience had a profound impact on the artist, and his works became infused with the geometric, abstract, and rectilinear aspects of German and Austrian Jugendstil. The Silex ensemble of furniture, which he produced around 1905, was a mature fusion of all Serrurier-Bovy's tendencies, combining strong geometric forms with discrete curvilinear and organic detailing, and constructed along simple and functional Arts and Crafts principles. Approaching the ideal of *"mobilier social"* even more completely than the *Chambre d'artisan* ten years earlier, the Silex ensemble featured designs for curtains that could be sewn at home by workers' wives, in the spirit of art for and by the people.[4]

Serrurier-Bovy designed the Smart Museum fireplace surround between 1902 and 1905, undoubtedly as part of a suite of furnishings. The dominant vertical pattern, enhanced by geometric reticulations and occasional horizontal elements, reflects the Darmstadt style. The use of prefabricated parts, an emphasis on construction seen in the prominence of the bolts, the subtle horizontal double-line wood inlays, and the relatively small scale of the surround, are similar to aspects of the Silex ensemble. Fireplace surrounds were an important area of interest for art-nouveau designers, and this one, combining a variety of materials and incorporating a clock and large mirror, typifies this tendency.

Laurie A. Stein

1. Henry van de Velde, "G. Serrurier-Bovy—Luttich," *Innen-Dekoration* 13 (February 1902): 41–68.
2. Quoted in Jacques-Grégoire Watelet, "Art Nouveau and the Applied Arts in Belgium," in Yvonne Brunhammer et al., *Art Nouveau Belgium/France* (Houston: Institute for the Arts, Rice University, 1976), 121.
3. Gustave Serrurier-Bovy quoted in Watelet, *Serrurier-Bovy: From Art Nouveau to Art Deco*, trans. A. Williams and N. Carlton (London: Lund Humphries, 1987), 19.
4. Lieven Daenens, "Des Meubles et des hommes," in *Art Nouveau Belgique* (Brussels: Palais des Beaux-Arts, 1980), 137.

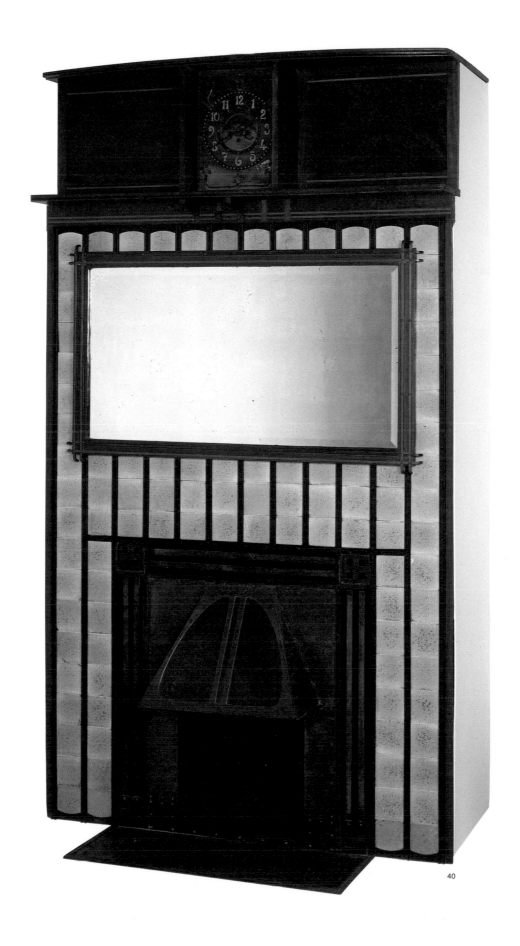

40

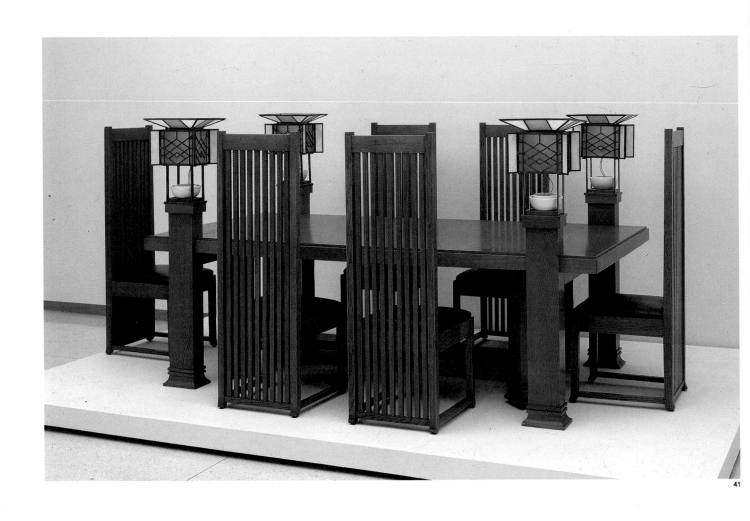

Frank Lloyd Wright, designer
American, 1867–1959

41 *Dining Table and Six Chairs*, 1907–1910
 Table: oak, leaded glass, ceramic, 55⅝ x 96¼ x 53½ in.
 (140 x 244.5 x 135.9 cm.)
 Chairs: oak, leather, h. 52⅜ in. (132.8 cm.)
 University transfer
 1967.73–79

Frank Lloyd Wright was born in Richland Center, Wisconsin, and spent the early part of his career in the Midwest. From the turn of the century until around 1915, he led a group of midwestern architects in developing what is now known as the Prairie School of architecture. The style is characterized by open interiors, an appreciation for natural materials, and an emphasis on horizontal forms which echo the flat midwestern landscape. For Wright and his colleagues, the prairie metaphor was bound up with ideas of American democracy, Walt Whitman, and liberation from moribund European and East Coast traditions. Although Prairie School architecture was largely a regional style, with the greatest number of examples concentrated in and around Chicago, it exerted influence throughout America and much of Europe.

A member of the Chicago Arts and Crafts Society, founded in 1897, Wright had long been impressed by the artistic and social philosophy of William Morris and the English Arts and Crafts movement. The rectilinear plainness of much of Wright's prairie-style work, for example, found confirmation in Morris's earlier plea "for simplicity as the basis of all true art."[1] Moreover, in his architectural conceptions, Wright sought to create not just the shell of a house but also many additional features, bringing exterior and interior in harmony within an overall aesthetic scheme. He designed chairs, tables, sofas, lighting fixtures, leaded-glass windows, and even rugs to complement or extend the structure itself. In the influential publication of his early projects, the *Ausgeführte Bauten* (1910), Wright explained:

It is quite impossible to consider the building as one thing and its furnishings another, its setting and environment still another. In the spirit in which these buildings were conceived, these are all one thing, to be foreseen and provided for in the nature of the structure. They are mere structural details of its character and completeness the very chairs and tables . . . are of the building itself.[2]

In 1906, Wright was commissioned to design a residence in Chicago for Frederick C. Robie, an engineer and assistant manager of the Excelsior Supply Company, a manufacturer of bicycles. The house Wright conceived for Robie and his young family between 1907 and 1909 embodies the ideal of unified design; it represents one of Wright's most comprehensive plans in terms of the variety and number of designs he created for the interior. Wright planned furnishings for many rooms in the house, but devoted most attention to the living and dining areas, which he considered to be at the core of family life. The focus of these interconnected rooms was the handsome oak dining table and chairs, surely among the architect's greatest achievements in furniture design.

The grouping was designed either contemporaneously or very soon after the house itself, therefore between 1907 and 1910, and was manufactured during the first half of 1910. The attached lamps, restored from vintage photographs, on the vertical supports at the corners of the table are an important feature, characteristic of Wright's designs from the period. The device developed out of his desire to reduce the clutter of the conventional turn-of-the-century interior by combining two pieces of furniture in one unit. Integrated into the overarching decorative theme, the pattern of the leaded-glass lamps repeats the stylized wheat motif found in the windows throughout the house. The unadorned geometric forms of the furniture allow the grain of the red oak to emerge, adding emphasis to the verticality of the chairs and the sweeping horizontality of the table. Wright further dramatized the horizontal forms in his design for the table by exaggerating the thickness of the tabletop and the sharpness of the outline, and by extending the tabletop well beyond its vertical supports.

These formal and material aspects of the dining table and chairs echo the design of the larger structure. Analogies might be made, for example, between the extended tabletop and the striking overhang of the Robie House's long cantilevered roof, between the table lamps on their corner posts and the exterior flower urns on their brick piers. Moreover, the dining furniture served an architectural function within the open interior of the house, dividing the long stretch of interior space, forming a room within a room. The tall backs of the chairs grouped around the table acted as a partition to define the area used for dining, while still allowing for a view through to other areas of the house. The attached lamps further defined the dining area by forming an ethereal boundary of light, providing warmth and illumination to one of the central rituals of family activity.

Laura Satersmoen

1. Frank Lloyd Wright quoted by Richard Guy Wilson, "Chicago and Arts and Crafts Movements," in John Zukowsky, ed., *Chicago Architecture, 1872–1922: Birth of a Metropolis* (Munich: Prestel-Verlag, 1987), 214.
2. Wright, *Ausgeführte Bauten und Entwürfe von Frank Lloyd Wright* (Berlin: Ernst Wasmuth, 1910); facsimile edition, *Drawings and Plans of Frank Lloyd Wright: The Early Period (1893–1909)* (New York: Dover Publications, 1983), 4.

Erich Heckel
German, 1887–1956

42 *East Baltic Seacoast* (*Ostseeküste*), 1911
 Pencil, watercolor on wove paper; sheet 10⁹⁄₁₆ x 13¼ in.
 (26.8 x 33.6 cm.)
 Bequest of Joseph Halle Schaffner in memory
 of his beloved mother, Sara H. Schaffner
 1973.93

This fresh, exuberant watercolor by one of the founders of German Expressionism represents the bath resort of Prerow, located on the little finger of land known as Darss that juts out into the Baltic Sea. It is similar in mood and execution to the many watercolors Heckel painted during his stay there in the summer of 1911. For Heckel and the artists associated with him, the country and seaside provided relief from the corruption and artificiality of the city, and also allowed the possibility of rediscovering the inner self. Because he believed deeply in the spiritual value that nature held for humanity, landscape became an important theme in Heckel's work. Prerow, a serenely beautiful retreat, offered him both a suitable subject for art and a haven from the hectic pace of modern urban life.

Chronologically and stylistically, *Ostseeküste* marks a special place in the artist's oeuvre, falling between his departure from Dresden in the spring and his move to Berlin in the autumn of that year. As in his other landscapes of the period, light and color are the chief expressive components of *Ostseeküste*. Abandoning the violent, nervous, and forceful lines

that characterized his works of the preceding years, and not yet influenced by the cubist geometries evident in his work shortly after 1911, Heckel here demonstrates a tenderness towards his subject matter, lyrically rendering the tranquility of the sea, sky, and sand. The expansiveness of the image separates it from the later cubist-inspired landscapes in which one often feels locked inside a bell jar.

Heckel uses the landscape to extend traditional definitions of watercolor drawing. For example, in *Ostseeküste* he draws with a light pencil in order merely to notate the forms of the chairs dotting the white beach and the flags flanking the pier. He releases color from line, allowing the bright flecks of orange and red to spill out over the outlines of the chairs. In his treatment of sea and sky, Heckel liberates color completely from form by eliminating outline altogether and permitting the blue water to dissolve into the heavens at the horizon line. Using the white of the paper as a reflective surface which serves as both sandy beach and clouds in the sky, the artist blurs the distinction between paint and ground, while also conveying the quality of light at the seashore.

Like other works of *Brücke* school, *Ostseeküste* expresses an inner mood; portraying the world "accurately" becomes secondary to this emotive concern. Ideologically anti-naturalistic, the Expressionists challenged the conventional notion of art as the imitation of nature. Instead, Heckel wishes to convey feelings engendered by the scenery: the quick notations and generalized landscape forms record his joyous outpouring of spontaneous enjoyment on a sunny, summer day.

Robin Reisenfeld

Helen Saunders
British, 1885–1963

43 *Island of Laputa*, 1915
Pen and ink, collage on wove paper, 10⅝ x 9⅛
(26.9 x 23.1 cm.)
The Joel Starrels, Jr. Memorial Collection
1974.275

After formal training at the Slade School of Fine Arts and the Central School in London, Helen Saunders rejected many of the principles fostered by traditional academies in Edwardian England. In eschewing recognizable subject matter rendered in approved naturalistic styles, Saunders joined a small coterie of younger English artists enthusiastic about the French avant garde. The 1910 exhibition organized by Roger Fry, *Manet and Post-Impressionism*, which featured paintings by Edouard Manet, Vincent van Gogh, Paul Gauguin, Henri Matisse, and Pablo Picasso, inspired united attacks against the conservative London art world. Pilloried in the press, scorned by academicians, and ridiculed by the public, this and similar exhibitions in London in 1912 and 1913 spawned such artist associations as the Camden Town Group and the Bloomsbury Group, aligned with the Neo-Impressionism of Georges Seurat and the color harmonies and simplified forms of Matisse and the Fauves, respectively.

In 1914, Saunders enlisted in the most controversial and experimental new English art and literary union. Led by the writer and painter Wyndham Lewis, and naming their movement Vorticism, the half-dozen members established their own salon and showroom, the Rebel Art Centre. Saunders signed the vorticist manifesto and contributed poems and illustrations to the group's aggressively polemical journal, *Blast*. Influenced by French Cubism, Italian Futurism, and, to a lesser extent, German Expressionism, Vorticism represented the most extreme English response to avant-garde developments in continental Europe, advocating a style that often appeared wholly nonrepresentational. Although the movement lasted barely two years, its members mounted a strident campaign of exhibitions, lectures, and publications designed to shock or "blast" London society out of the complacent legacy of the Victorian empire. Vorticists sought to forge an up-to-date view of England as a major industrial nation governed by the unsentimental dynamics of the modern machine age.

Most vorticist compositions begin with references to the physical world, but individual elements are so reduced to fundamental forms that the final image appears abstract. Mature vorticist works, such as Saunders's collage-drawing *Island of Laputa*, are characterized by precise geometric shapes, unmodulated color, and bold diagonal structures. The lines, rectangles, arcs, and triangles that establish this image are splintered fragments isolated from each other by stark, unshaded white ground or by severe, thick outlines circumscribing the separate parts. Individual units are, nonetheless, locked together by a linear grid overlaying the surface, and pressed firmly against each other by dense, impacted juxtaposition. The combination of lancing oblique composition, asymmetrical balance, and immobile, interlocking forms contributes to a characteristic vorticist tension between movement and stasis. Avoiding illustration, Saunders evokes the levers and forces of an engine by means of mechanistic shapes and dynamic compositional devices.

Customarily appended only after the fact, vorticist titles are not descriptive of subject matter; *Island of Laputa*, nevertheless, brilliantly asserts vorticist theory. Laputa is the kingdom in Jonathan Swift's satiric eighteenth-century novel, *Gulliver's Travels*, where geometry, mathematics, and music inflexibly govern life.[1] The diagrammatic logic of Saunders's drawing, akin to the irrevocability of a draftsman's blueprint, establishes a pictorial parallel to Swift's mythical island, brutally and methodically ruled by the absolute principles of science.

Island of Laputa was reproduced as a black xylograph in the second (and last) issue of *Blast* in 1915. Saunders is usually identified as a close follower of Lewis, her style heavily indebted to his dominating presence. She was, however, an original and outstanding colorist. The restricted, black-and-gray palette of this collage-drawing is uncharacteristic and suggests that the image may have been executed from the start for monochromatic reproduction as a wood engraving in the war issue of *Blast*.[2] Alternatively, Saunders's rare departure from her inventive chroma may have been an experiment, recommended by her mentor, with the possibilities of the expressionist print. In 1914, Lewis had praised the contemporary German woodcut as "disciplined, blunt, thick and brutal, with a black simple skeleton of organic emotion," and described its bold interplay of lights and darks as "surgery of the senses."[3]

In 1915, shortly after the outbreak of World War I, *Island of Laputa* was included in the first—and, as it turned out, the only—vorticist group exhibition in London, and subsequently, in 1917, in a vorticist exhibition at the Penguin Club in New York. The organizer of the American show, John Quinn, pioneering patron of avant-garde art, purchased the work for his own collection. Presumed lost after many years,[4] the drawing is a rare surviving witness to the important English contribution to the theory and language of abstract art in Europe, Russia, and even America before the dispersal of its energy in the aftermath of the fateful war years.

Richard A. Born

1. Richard Cork, *Vorticism and Abstract Art in the First Machine Age* (Los Angeles and Berkeley: University of California Press, 1976), 2:424.
2. The rare occurrence among Saunders's extant oeuvre of a preparatory drawing for *Island of Laputa* may reflect the special circumstances of its execution for monochromatic reproduction. The study is reproduced in Cork, *Vorticism*, 424–425.
3. Wyndham Lewis, "Notes on Some German Woodcuts," *Blast: Review of the Great English Vortex* 1 (1914): 136.
4. See, for example, Hayward Gallery, *Vorticism and Its Allies* (London: Hayward Gallery, 1974), cat. no. 415; and Cork, *Vorticism*, 562, n. 51.

43

Jean Metzinger
French, 1883–1956

44 *Soldier at a Game of Chess* (*Le Soldat à la partie
 d'échecs*), circa 1915–1916
 Oil on canvas, 32 x 24 in. (81.3 x 61 cm.)
 Gift of John L. Strauss, Jr. in memory of his
 father, John L. Strauss
 1985.21

44

Jean Metzinger was born in Nantes on 24 June 1883 to a prominent family of Palatinate origins. His great grandfather Nicholas Metzinger had been an artillery captain under Napoleon, the first of many Metzingers to serve as French military officers. Following the early death of his father, Metzinger resented the influence of one such relative, a maternal uncle whom he loathed. As a youth, he was interested in mathematics, music, painting, and in leaving Nantes, which he did at the age of twenty by selling the paintings he sent to the 1903 Salon des Indépendants.[1]

By the end of that year, Metzinger was living in Paris. He was represented in a 1904 exhibition that also included works by Raoul Dufy, and in 1906 he was elected to the hanging committee of the Indépendants. Unfortunately, because he did not date his pictures, we are not sure what his style was like during those early years. By 1906, he was a divisionist, like his friend Robert Delaunay, using large mosaiclike "cubes" to construct his symbolic compositions. His circle of friends grew; he met the poet Max Jacob, and through him Guillaume Apollinaire and Pablo Picasso. It was probably in 1909 that he became acquainted with Albert Gleizes. In 1910, he and Gleizes, Delaunay, Henri Le Fauconnier, and Fernand Léger were identified as a group, soon to be dubbed Cubists, and Metzinger became notorious as "the Prince of Cubism," the creator of *Le Goûter* or *Tea Time* (Philadelphia Museum of Art, Louise and Walter Arensberg Collection) popularly referred to as "the Mona Lisa of Cubism." Metzinger's style developed confidently and independently across these prewar years, during which he wrote *Du Cubisme* (1912) with Gleizes. He exulted in the exoticism of Parisian life, frequently joining visual references drawn from the moment to themes from tradition or from different cultures.

From the outbreak of World War I, Metzinger was horrified at the probability of conscription, not only because he was something of a pacifist, but also because he sensed that it would destroy the momentum of his art, as the war would disrupt modern European art as a whole. On 15 March 1915, his auxiliary service was joined to the Fifth Section of the military ambulance corps. He served as a stretcher bearer, later being attached to the Twenty-second Section of the same corps. On leave in Paris, he signed a contract that granted the dealer Léonce Rosenberg exclusive rights to his production in return for a monthly stipend.

In the army for a year and a half, Metzinger kept a sketchbook and found time to paint, probably during fairly long periods when his corps was bivouacked behind the front.[2] In the sketches as in the surviving oils, Metzinger only rarely made specific reference to the carnage he was witnessing, especially during the second trimester of 1916 when he was with a surgical automobile. Pages from the sketchbook are almost serene: landscapes that show a deep attachment to the French countryside, occasional heads, a still life. All are constructed according to the golden section, a pencil drawing of which appears on the verso of one of the gouaches. One rare oil of November 1917 (especially rare because it is dated), shows a chateau with a rifle poking out the window, but this was executed after Metzinger was provisionally mustered out on 5 October 1916. Another slightly earlier landscape of about 1915 to 1916, in the Guggenheim Museum, New York, shows a military notice juxtaposed with a cross, a church on the horizon, and trees ominously conflated with cannon barrels (camouflage). Generally, Metzinger pursued what he described in a letter to Gleizes as "this new kind of perspective I have talked about so much . . . a metaphysical perspective—I take full responsibility for the word The geometry of the fourth space has no more secrets for me."[3]

The Smart Museum's *Soldier at a Game of Chess* is one of these few war paintings by Metzinger. The painting illustrates Metzinger's statement to Gleizes in the 1916 letter that "everything is number. The mind hates what cannot be measured" In this work, every major geometric relationship is determined by golden section triangles as the soldier moves to solve a problem on his board. The actual soldier is to his shadow self as mind is to matter, as the rules of the game are to the exigencies of reality.

This picture may be contrasted with two portraits of 1913 to 1914, one in the Shapiro Collection (Oak Park, Illinois) entitled *Portrait of Max Jacob* and the other a variation, *Man with a Pipe* (Pittsburgh, Museum of Art, Carnegie Institute), where the idea of substance and shadow is also enunciated, but surrounded with a wealth of detail.[4] The angles of the heads, mouths, and the smoking apparatus are almost identical in the three pictures. What makes the *Soldier* so calm and assured is the simplification Metzinger had developed "since the beginning of the war, working outside painting but for painting." What he meant, of course, was the control to concentrate on art in the middle of chaos—to achieve what? "A new harmony. Don't take this word harmony in its ordinary, everyday sense, take it in its original sense." We see this not merely in the painting's rich color, but in its references to Pythagoras and Plato, in its assertion of the ideal of perfection in the face of the grim reality of life during the great war.

Daniel Robbins

1. Whether because he was an intensely private man, or because his papers were destroyed in his Nazi-occupied Bandol house during World War II, or because his reputation waned from the 1930s until recently, details about the life of this artist, one of the first Cubists, are difficult to recover. See Jean Metzinger, *Le Cubisme était né: Souvenirs par Jean Metzinger* (Chambéry: Editions Présence, 1972), and University of Iowa Museum of Art, *Jean Metzinger in Retrospect* (Iowa City: University of Iowa Museum of Art, 1985).

2. I have extrapolated details of Metzinger's military service from records at the Archives de Paris; of his corps's movements from the Service Historique de l'Armée de Terre, Château de Vincennes.

3. Letter of 4 July 1916. Cf. Daniel Robbins, "Jean Metzinger: At the Center of Cubism," in University of Iowa Museum of Art, *Jean Metzinger in Retrospect*, 21. Subsequent quotations from Metzinger are from this same letter.

4. Joann Moser put forth the tempting suggestion that, because of the cigarette, *Soldier at a Game of Chess* might be a self-portrait (University of Iowa Museum of Art, *Jean Metzinger in Retrospect*, 44). The corps affiliation on the tunic, number 24, makes this untenable because Metzinger served in the Sixth and the Twenty-second.

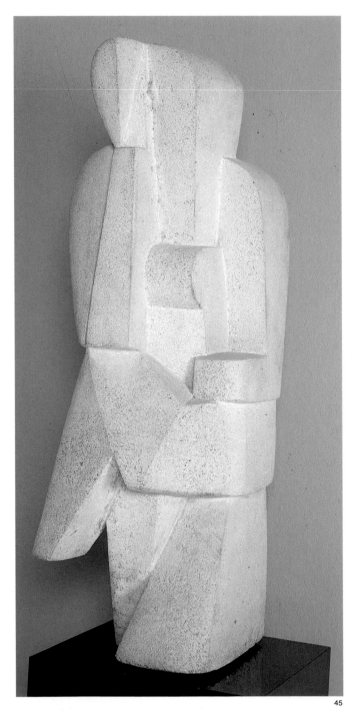

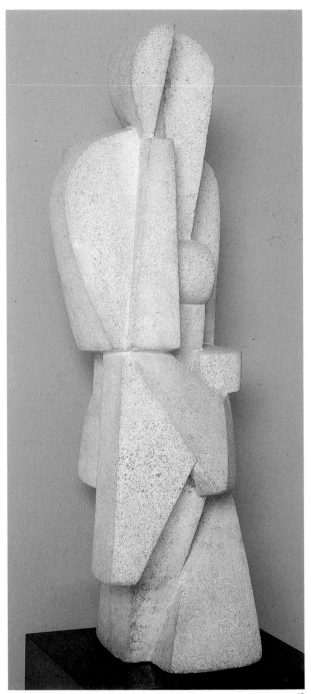

45

45

Jacques Lipchitz
Lithuanian, 1891–1973

45 *Seated Bather*, 1916–1917
 Limestone, h. 33 in. (83.8 cm.)
 The Joel Starrels, Jr. Memorial Collection
 1974.177

Born at Druskieniki, Lithuania, Chaim Jacob Lipchitz was the son of a building contractor from an affluent banking family. He was attracted to drawing and modeling from an early age, and while in high school at Vilna showed some of his work to a visiting lecturer, the sculptor Ilja Ginzburg. With Ginzburg's encouragement, but against his father's wishes, Lipchitz convinced his mother to finance his travel to Paris. Upon his arrival in October 1909, he began his studies under Jean Antoine Ingalbert at the Ecole des Beaux-Arts, and later continued under Raoul Verlet at the Académie Julian.

Lipchitz found early inspiration in the thirteenth-century architectural drawings of Villard de Honnecourt and in medieval, archaic Greek, Egyptian, and African sculpture. By 1913, he had exhibited at the Salon National des Beaux-Arts and the Salon d'Automne and had met, through his friend Diego Rivera, many of the cubist painters, including Pablo Picasso. He shared the Cubists' attitude, conservative in technique, employing traditional materials and methods, yet revolutionary with regard to the formal problems of expression. His first experiments beyond academic limits were geometric reductions of the human figure; however, the drawings and models he produced on a trip to Spain with Rivera in 1914 led to a new synthesis. He abandoned simplification in favor of a constructive process wherein the volume of the assembled mass is revealed through sharply contrasting areas of light and shade established by angular penetrations.

Lipchitz produced the majority of his work in bronze rather than stone, in part because bursitis made carving a painful procedure for him.[1] But in the winter of 1916 he signed a contract with the art dealer Léonce Rosenberg, and for the first time was able to hire a stonecutter to assist in translating his clay and plaster models into stone.[2] *Seated Bather* is one of a series executed between 1916 and 1919 in stone to emphasize the architectonic qualities of the figure. The blocky composition is rectangular and somewhat frontal with a vertical emphasis, and "seems to have been constructed from the background forward, an approach that Lipchitz adopted quite often."[3] Light and shadow animate the matte, slightly pitted surface to evince a female nude in a contemplative posture, with legs crossed, elbow resting on one knee, and head supported on one hand in a manner reminiscent of Auguste Rodin's *Thinker* (cat. no. 34). The restrained gesture contributes to the sense of compact weight conveyed by the geometric clarity and proportions of the mass. The piece is unusual among those of this period in that a triangular nose, rather than a circular eye, is the single defined facial feature. Although *Seated Bather* was previously dated to 1917, the sculpture's frontality places it before a number of spiral compositions of the same theme executed that year.

Timothy N. Wittman

1. Jacques Lipchitz with H. H. Arnason, "My Life in Sculpture," in *Documents in 20th-Century Art*, ed. Robert Motherwell, Bernard Karpel, and Arthur A. Cohen (New York: Viking Press, 1972), 42.

2. According to the artist, none of the maquettes from this period have survived. Although Lipchitz cast versions of a number of his works in stone after 1946, this *Seated Bather* has not been exhibited or documented in a bronze rendition. See Arnason, *Jacques Lipchitz: Sketches in Bronze* (New York: Praeger, 1969), 7.

3. Deborah A. Stott, "Jacques Lipchitz and Cubism" (Ph.D. diss., Columbia University, 1975), 132.

46 *Amalie*, 1922
Gouache, ink, graphite on wove paper;
sheet 20¾ x 16¼ in. (52.7 x 41.2 cm.)
The Joel Starrels, Jr. Memorial Collection
1974.140

46

George Grosz is best known for his early paintings and graphic works satirizing the German military and bourgeoisie. Disgusted by World War I and its consequences, Grosz joined the German Communist Party in 1918, and abandoned the legacy of Expressionism in favor of the anti-aesthetic antics of Dada. Along with John Heartfield, Wieland Herzefelde, and Richard Huelsenbeck, Grosz staged outrageous performances and exhibitions and published satirical journals, bent on exposing the hypocrisies of the established order.

Grosz's political stance and his desire to reach a wide audience—through print portfolios, for example, periodicals, and theater—dovetailed perfectly with a commission for set and costume designs for Yvan Goll's *Methusalem*. Written in 1921, the drama pokes fun at a wealthy shoe-manufacturer, Methusalem, the embodiment of capitalist greed. His plump wife, Amalie, cooks goulash, worries about the price of carrots, and schemes for her daughter, the romantic Ida, to marry a rich man. In a parody of the traditional conflict between young love and parental authority, Ida becomes enamored with the radical Student (fig. 6) who leads a strike against Methusalem's company. Student assassinates Methusalem, but the victim reappears, with dreams of new marketing successes, at the end of the play, the undaunted and eternal bourgeois.

Despite Goll's devastating characterization of the German middle class, the playwright had no illusions about the virtue of the revolutionary masses: Student is no less lustful nor self-serving than his hated capitalist enemy. By the final scene, Student has lost his zeal and predicts a future without hope, as generations of wealthy and poor succeed each other in a constant class struggle:

> Student: Oh God, life is boring.
> Ida: When will the revolution be over?
> Student: When the others no longer have their villas.
> Ida: And when we have one?
> Student: That's when the next revolution begins.[1]

Methusalem must have appealed to Grosz's disdain for the complacent bourgeoisie as well as his reservations about the possibility of a utopian state. He produced at least three sets of costume designs for Goll's play, in two distinctly different styles.[2] The group of designs to which the Smart Museum's *Amalie* belongs proposes not so much costumes as huge masks, life-size cut-outs or shields which would completely obscure the actors behind them. One possible source for such conceptions might have been Alexandra Exter's contemporaneous theater designs in the Soviet Union;[3] indeed, Grosz visited the U.S.S.R. in the summer of 1922, the year he produced the designs for Goll's play.

During this trip, Grosz began to entertain grave doubts about the newly empowered communist regime, which he found repressive, jealous of its authority, and incapable of ameliorating the impoverised condition of its people.[4] The artist also met Vladimir Tatlin and saw the model for *The Tower of the Third International*, but he had a sense that Russian Constructivism, like Communism, had failed to achieve its humane ideals. Constructivists believed that art, informed by

Fig. 6. George Grosz, *Student*, 1922, watercolor on paper, 20½ x 14½ in. (52.1 x 36.8 cm.), Cleveland, Contemporary Collection of the Cleveland Museum of Art, 66.50.

modern technology, had the power to transform society, but Grosz later recalled that "people had no place in the creations of this school, or, if some members did depict them, they transformed them into wheels, cylinders, or puppets subservient to machines."[5]

Grosz might have been describing his own automatons for *Methusalem*. Assuming the posture of a Constructivist, who "saw the artist as both engineer and technician . . . order[ing] man's vision of the world,"[6] Grosz produced a series of costume studies which he signed and dated with a rubber stamp—"Grosz Constr. 22." This gesture, however, was not without irony; for the mechanistic emblems he devised for *Methusalem* announce a double-edged cynicism. Iconographically, the designs lampoon the types to whom they refer, literally transforming the characters into machines and equipping them with appropriate attributes: Amalie, for example, with a teapot coif, noisy klaxon horns, and a body like a locomotive; tattered Student with a book under his arm, lighted candle jutting from his head, and—perhaps to suggest the unlucky fate of the revolution—the number thirteen emblazoned across his chest. Stylistically, Grosz presses the clean lines and geometric shapes of Constructivism into the service of a sardonic play that is no less about the inevitable failure of utopian philosophies than the grotesqueries of the bourgeoisie. Card-carrying Communist though he may have been, the creator of these costume designs was nevertheless first and foremost bearer of the ironic and complex spirit of Dada.

Sue Taylor

1. Yvan Goll, *Methusalem or the Eternal Bourgeois*, trans. Arthur S. Wensinger and Clinton J. Atkinson, in *Plays for a New Theater: Playbook 2* (New York: New Directions, 1966), 100.

2. Grosz's designs, however, were never actually used in production. Andrew DeShong, *The Theatrical Designs of George Grosz* (Ann Arbor, Mich.: UMI Research Press, 1982), 36.

3. Ibid., 40.

4. George Grosz, *A Small Yes and a Big No: The Autobiography of George Grosz*, trans. Arnold J. Pomerans (London and New York: Allison and Busby, 1982), ch. 11.

5. Ibid., 136.

6. Martin Kane, "George Grosz: Constructivism Parodied" in *New Studies in Dada: Essays and Documents*, ed. Richard Sheppard (Driffield, Engl.: Hutton Press, Ltd., 1981), 37.

Suzanne Valadon
French, 1867–1938

47 *Portrait of Lily Walton*, 1923
Oil on canvas, 24 x 18 in. (61 x 45.7 cm.)
Bequest of Joseph Halle Schaffner in memory
of his beloved mother, Sara H. Schaffner
1973.119

47

Suzanne Valadon, baptized Marie Clémentine, was born in provincial Bessins-sur-Gartempe. While still a child, she moved with her mother to Paris, where she would spend the rest of her life, becoming familiar with the social and artistic life of Montmartre at an early age. Forced to leave school to help support the family, Valadon began to develop the skills she would later use as an artist by decorating hats for a milliner and making funeral wreaths; she then embarked on a brief stint as an acrobat and a longer and more successful career as an artist's model. She posed for innovative painters such as Pierre Puvis de Chavannes, Pierre-Auguste Renoir, and Henri de Toulouse-Lautrec, as well as academic artists such as Jean-Jacques Henner and the American Alfred Howland. At eighteen, Valadon gave birth to a child, who would later become the artist Maurice Utrillo. In 1914, she married one of his friends, André Utter, twenty-one years her junior. The threesome lived, worked, and exhibited together for many years; ultimately Utter, a painter of lesser stature, dedicated himself to marketing the work of the other two, providing them with a comfortable income.

Valadon is often seen in the context of the School of Paris, a group of non-radical figurative artists working in Paris between the wars. She was, nevertheless, highly individual and essentially self-taught. During her formative years, she was exposed to the work of a great many artists whose formal vocabulary she adapted to her own aesthetic. Edgar Degas, with whom she had a close and mutually respectful relationship, introduced her to drawing and etching and the linear emphasis so important in his pastels and prints. The influence of Paul Gauguin and the Pont-Aven School can be seen in the simplified form, flat color, and decorative quality of certain of her paintings, while others owe something to Vincent van Gogh, and her honest representations of ordinary women are indebted to Toulouse-Lautrec. Paralleling the experiments of Henri Matisse, as early as 1910 to 1912, Valadon began to incorporate elaborate patterns into some of her pictures. In her mature work of the twenties and early thirties, a combination of lively patterning and forceful plasticity yield a unique intensity and expressive power. Making use of the innovations of the avant garde, she infused their techniques with a personal quality that was vital and aggressive.

It is to this period of maturity that the Smart Museum's *Portrait of Lily Walton*, signed and dated 1923, belongs.[1] Valadon was at a high point of productivity and popularity in her career, exhibiting frequently and enjoying critical success. For several years, Lily Walton served as housekeeper at the studio at 12 rue de Cortot where Valadon worked from about 1896 until 1926.[2] In an earlier portrait of Walton, dated 1922, the housekeeper is fully visible, seated in a chair with Valadon's cat, Raminou, on her lap.[3] Space is defined by a diagonally placed chest topped with a number of still-life objects rendered with a linear energy equal to the forceful alertness of Walton herself. Behind the figure is a drapery arranged so that the abstract pattern of folds conveys a spirited vitality.

Many of the same qualities are evident in the Smart Museum portrait, in which we see only the upper portion of the figure; the rest of the body is hidden behind a table draped with an patterned cloth. On the table stands a vase of flowers, around which Walton literally wraps her hand. Valadon subjects the entire image to a process of distortion which results in a vigorous decorative design. Walton's right arm forms a curve counter to that of the pattern on the tablecloth in the lower portion of the painting. The right hand repeats the form of the vase, while the left hand and arm seem boneless, almost becoming part of the inanimate object. The blue of Walton's dress is extended into the lower left of the painting, treated abstractly rather than related to her body. All these flattening distortions, however, contrast to areas of strong plasticity. Walton's face, for example, is rendered with a convincing three-dimensionality which contributes to its seriousness and intensity. The contrast between the elegant patterning of the whole and the bold plastic quality of the vase, flowers, and figure—an uncompromising, no-nonsense woman—creates a dynamic tension.

Although Valadon did not paint many commissioned portraits, she depicted herself and those close to her on numerous occasions. She was at her best when her subjects were ordinary women. The many nude models she painted in various poses, with unidealized and often inelegant physical forms, are charged with feeling.[4] Her own background may have given her a sympathy and sensitivity to individuals like Walton, an ability to see the strength and dignity in her sitter, so clearly expressed in the Smart Museum painting.

Susan Weininger

1. A label on the back of the Smart Museum painting refers to a Valadon exhibition in Paris in 1948 and identifies the painting as "*Portrait de l'artiste par elle même* (no. 99)." The catalogue of this exhibition by Jean Cassou was not available to me to substantiate this information, but the misidentification of the painting as a self-portrait must have occurred sometime after Valadon's death. Because of the clear resemblance to Walton in the 1922 portrait discussed below, and an earlier inscription in red crayon on the stretcher identifying the painting as a "portrait of Lily Walton" (Exposition Suzanne Valadon, Genève, 1932), not to mention the lack of resemblance to the artist, it is safe to assume the sitter in the Smart Museum painting is Walton.

2. Musée National d'Art Moderne, *Suzanne Valadon* (Paris: Musée National d'Art Moderne, 1967), 56. In the entry for the *Portrait of Lily Walton* (no. 58), Walton is identified as the housekeeper at the rue de Cortot atelier.

3. Paul Pétridès, *L'Oeuvre complet de Suzanne Valadon* (Paris, 1971), P244. This painting measures 39⅜ x 31⅞ in. (100 x 81 cm.), slightly larger than the Smart Museum portrait. Valadon produced a number of similarly designed portraits in 1922, such as *Portrait of Mme. Nora Kars* (P243), *Portrait of Mme. Levy* (P246), and *Portrait of Mme. Noel* (P248). The Smart Museum portrait is not included in the Pétridès catalogue. The sitter in *Woman* (circa 1925, P305) bears a strong resemblance to Walton, particularly in the eyes, eyebrows, and shape of the mouth. It is possible that this last painting is a third portrait of Walton, and that Valadon thus painted her housekeeper more often than of anyone else outside her family.

4. For example, see *Woman at Her Toilet* (1913, P58), *Nude Combing Her Hair* (1916, P109), and *Catherine Seated on a Panther Skin* (1923, P274).

Henri Matisse
French, 1869–1954

48 *Nude on a Sofa* (*Nu sur un canapé*), 1924
 Cast bronze, ed. 1/10, h. 9½ in. (24.1 cm.)
 The Joel Starrels, Jr. Memorial Collection
 1974.137

The only artist of the twentieth century whose contribution rivals that of Pablo Picasso, Henri Matisse requires no introduction. Like Picasso's, his production includes sculpture in addition to paintings and works on paper, and thus aligns him with such nineteenth-century painter/sculptors as Honoré Daumier, Edgar Degas, and Pierre-Auguste Renoir. This bronze, titled *Nude on a Sofa* but also identified as *Nude in an Armchair*, can be placed early in the artist's Nice period, within his second major phase of sculptural activity, from 1924 to 1930. The piece was cast using the lost-wax process, as one (in this case, the first) in an edition of ten.[1] Initially modeled in clay, the sculpture has a variable, "painterly," light-reflective surface which establishes a tension between the tactile and the visual, or, between the activities of touching and seeing, for the viewer as well as the artist.[2]

The model for this sculpture most probably was Henriette Darricarerre, who posed consistently for Matisse during the mid-twenties. With respect to subject matter, the piece seems most directly connected with the larger bronze *Seated Nude*, dated 1924 to 1925 but not cast until 1927.[3] The critical literature divides on the question of whether or not this smaller, more casually composed and loosely handled version of the motif is in fact a study for the apparently subsequent, more "finished" piece. The *bozzetto*-like appearance of the *Nude on a Sofa* supports an affirmative answer to this debate,[4] although the existence of several previous states of the *Seated Nude* complicates matters.

This same subject figures in a number of approximately contemporary works by Matisse, including four paintings, two charcoal drawings, and at least two lithographs which are essentially variations on the same motif and directly resemble the larger sculptural *Seated Nude* in conception. These reiterations attest to Matisse's preoccupation, over a considerable period of time, with the subject of a seated female nude posed in this fashion. In addition, two lithographic sketches from 1922, *La Nuit* and *Le Jour* (*The Night* and *The Day*), reportedly done after plaster casts of Michelangelo's reclining Medici Tomb figures, are thought to be a formal source for the seated nude sculptures.[5] If so, however, Matisse has freely adapted his Renaissance models, markedly altering their supine character.

A more general influence than that of Michelangelo is to be found in the work of Auguste Rodin, with whom Matisse sought personal contact at one point and whose preoccupation with the female figure and with animated bronze surfaces seems akin to his. The nature of Matisse's sculptural pieces calls to mind the "pictorial" or optically oriented work of the impressionist sculptor Medardo Rosso, while this *Nude on a Sofa* in particular resembles similarly "unfinished" cast figures by Degas.

The larger issue raised by any consideration of Matisse's sculpture is that of its relationship to his painting. There are those who find the interaction between the two media negligible as well as those who acknowledge not only that Matisse's sculpture served an important artistic function vis-à-vis the painted images, but also that a direct influence of the former on the latter can be observed at certain points. Matisse himself viewed sculpture as both a facilitating adjunct to painting and as an important outgrowth of pictorial concerns.[6] The literal incorporation of the three- into the two-dimensional that occurs in several ways in Matisse's work is relevant to this discussion, too: for example, the sculptures often act as inanimate symbolic figures in the paintings.[7] There is also the neither-nor status of the quadripartite *Backs*, seen by some as having had an impact on Matisse's compositional style, and which as reliefs hover between three dimensions and two in a physical sense.[8]

Even the late *gouaches decoupées* have been perceived as analogues of sculpture, expressing the artist's sculptural impulses at a point when he ceased to make literal three-dimensional objects.[9] But it is the essentially visual or pictorial nature of the bronzes—in the sense that they are meant to be viewed rather than handled, emphasize surface rather than structure, and exhibit formal "distortions" intended to convey optical phenomena—which seems best to resolve this question of the relation between the artist's painting and sculpture.

Julia Bernard

1. The sculpture bears an inscription on its base: "1/10," and a stamp on its back: "Cire C. Valsuan perdue." According to Pierre Schneider, *Henri Matisse: Exposition Centenaire* (Paris: Grand Palais, 1970), most of Matisse's bronzes were cast in editions of ten.

2. See especially William Tucker, "Matisse's Sculpture: The Grasped and the Seen," *Art in America* 63 (July-August 1975): 62–66.

3. Alfred Barr, *Matisse: His Art and His Public* (New York: Museum of Modern Art, 1951), 213.

4. Albert Elsen has discussed the tradition of the *bozzetto* in conjunction with Matisse's sculpture in "The Sculpture of Matisse—Part II: Old Problems and New Possibilities," *Artforum* 7 (October 1968): 33.

5. See Claude Duthuit and Marguerite Matisse, *Henri Matisse: L'Oeuvre Gravé, Catalogue raisonné*, vol. 1 (Paris: Claude Duthuit, 1983), 28, 29, nos. 418, 419, pls. 32, 33.

6. For example, Matisse explained: "I took up sculpture because what interested me in painting was a clarification of my ideas. I changed my method, and worked in clay, in order to have a rest from painting where I had done all I could for the time being. That is to say that it was done for the purposes of organization, to put order into my feelings, and find a style to suit me." Quoted in Alicia Legg, *The Sculpture of Matisse* (New York: Museum of Modern Art, 1972), 1.

7. See Theodore Reff, "Meditations on a Statuette and a Goldfish," *Arts* 51 (November 1972): 109–115.

8. See Jack Flam, "Matisse's *Backs* and the Development of His Painting," *College Art Journal* 3 (Spring 1971): 352–361.

9. See John H. Neff, "Matisse, His Cut-Outs, and the Ultimate Method," in Jack Cowart et al., *Henri Matisse: Paper Cut-Outs* (St. Louis: St. Louis Art Museum, 1977), 26–28, where the cut-outs are presented as "technically . . . 'sculpture' or thin relief."

Otto Dix
German, 1891–1969

49 *The War* (*Der Krieg*), 1924
 Series of fifty intaglio prints in five portfolios
 Etching, aquatint, drypoint; various dimensions
 Karsch 70–119
 Marcia and Granvil Specks Collection
 1984.46–71, 1986.253–276

When World War I broke out in 1914, Otto Dix was a student at the School of Applied Arts in Dresden. Unmoved by the wave of enthusiasm that inspired many artists and intellectuals to enlist, Dix was drafted early in 1915. At the eastern and western fronts, he fought as a machine-gun guard and was wounded several times. He recorded his experiences in hundreds of drawings, from which came the etching cycle *The War*, a searingly realistic portrayal of the conflict in all its horror. In plate after plate, Dix presents suffering, torture, mutilation, death, and decay. He depicts the total nature of war, from the battlegrounds to the brothels, with techniques including etching, aquatint, and drypoint. In one image, a wounded soldier, grimacing in pain, grabs his shoulder and collapses in terror; here the splotchy effects of aquatint suggest the muddy explosion that shattered the man.

There are no heroic action scenes, only pictures of everyday survival. Troops lug heavy artillery, forced to trample their fallen comrades. An enemy bares his teeth and plunges a knife into a lookout's heart. A soldier resembling Dix eats caveman-style, shoveling rations into his mouth with his fist, indifferent to a skeleton sprawled next to him. Elsewhere, soldiers crawl on all fours, desperately clutching their mess kits in their teeth. In many scenes, the sleeping are indistinguishable from the dead; and the dead are everywhere. A helmeted guard dutifully clutches his rifle long after his tattered uniform has exposed his rotted remains. Other corpses, blackened and swollen from mustard gas, await disposal. A toppled horse, rigid legs pointing to the sky, has a cavity blown in its massive chest. Civilians are also victims, terrorized by an aerial bomber, or blasted from their beds through the brick wall of their home. A crazed mother fails to comprehend why her silent child will not nurse. Bosomy prostitutes accommodate soldiers spending their leave in bouts of mad debauchery. One plate, depicting a soldier raping a horrified nun, proved so disgusting Dix removed it from the cycle.

Dix began work on this fifty-plate cycle in 1923, five years after the war's end. An edition of seventy-five copies, each consisting of five portfolios of ten prints, was published in 1924 by Dix's strongest supporter, the Berlin art dealer Karl Nierendorf. The publicized premiere of *The War* at Galerie Nierendorf in Berlin on 1 August 1924 linked Dix in the critics' minds with the antiwar campaign mounted by political activists in the Weimar Republic. The series toured fifteen German cities and inspired discussion in German newspapers as well as in Belgian and Spanish art journals, where it was compared with Francisco Goya's *Disasters of War*. It was also described as the "most celebrated" artwork of the exhibition *Never Again War*, commemorating the tenth anniversary of the outbreak of World War I.[1] Additionally, a selection of twenty-four pictures was widely circulated in an inexpensive book edition, with a foreword by the French pacifist Henri Barbusse whose famous novel, *Under Fire*, appeared before the war's end.

A realist above all else, Dix himself considered the series an objective depiction of his wartime experiences. His brutal and barbaric scenes unite personal intensity and obsessive detail, but he also looked for inspiration to sixteenth-century northern masters such as Urs Graf, Matthias Grünewald, Albrecht Altdorfer, and Pieter Bruegel the Elder for their sober realism and morbid portrayals. Distinguished by the artist's first-hand involvement in the war and by his graphic proficiency, this cycle of images belongs to the tradition of great war prints by Goya, Jacques Callot, Georges Rouault, George Grosz, and Käthe Kollwitz.

In 1966, Dix said, "I believe that no one saw the reality of war as I did."[2] In these unrelenting images, unmasking the profanity of war in all its aspects, the artist insisted that it was important "to see things as they are."[3] Although Dix was disowned by the Expressionists for his bitter cynicism and veristic style, *The War* exhibits the highly personal content characteristic of expressionist art. It is a compelling statement of one man's abhorrence of war, equally applicable to Auschwitz or to Vietnam. Producing the cycle seems to have been a something of a catharsis for Dix. After 1924, he created fewer images of death and destruction. This change, perhaps attributable to his marriage and the birth of his first child, marks the dawn of *Neue Sachlichkeit* or New Objectivity, an unsparingly realist style of which Dix became the unparalleled exemplar.

 Marla H. Hand

1. O. K. Werckmeister, "Radical Art History," *Art Journal* 42 (Winter 1982): 288.
2. Interview with Reinhard Schubert, "Thüringer Landeszeitung," cited in Diether Schmidt, *Otto Dix im Selbstbildnis* (Berlin: Henschel Verlag, 1981), 273.
3. Fritz Löffler, *Otto Dix, Life and Work*, trans. R. J. Hollingdale (New York: Holmes & Meier Publishers, 1981), 69.

49 (Karsch 82)

49 (Karsch 116)

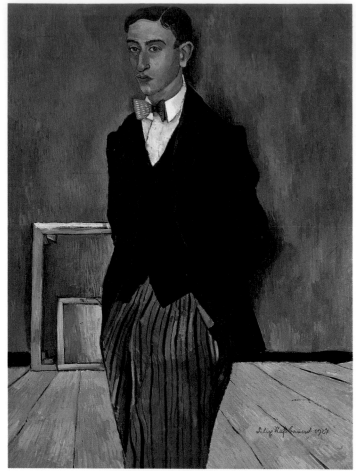

50 (obverse)

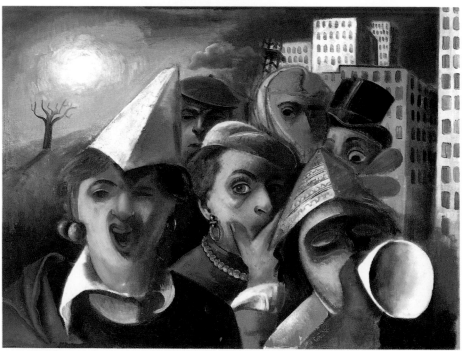

50 (reverse)

Felix Nussbaum
German, 1904–1944

50 *Portrait of a Young Man* (obverse), 1927
Carnival Group (*Narrengruppe* or *Mummenschanz*)
(reverse), circa 1939
Oil on canvas; obverse 38½ x 28½ in. (97.8 x 72.4 cm.),
reverse 28½ x 38½ in. (72.4 x 97.8 cm.)
Purchase, Gift of Mr. and Mrs. Eugene Davidson,
Dr. and Mrs. Edwin DeCosta, Mr. and Mrs. Gaylord
Donnelley, and The Eloise W. Martin Purchase Fund
1982.10

In 1924, Felix Nussbaum enrolled at the Berlin Academy of Fine Arts, where he was a student of Cesar Klein, Paul Plontke, and Hans Meid. He received a six-month grant to study in Rome in 1932, but this fellowship was withdrawn the following May, pursuant to Nazi laws forbidding employment to Jews. To avoid further persecution, Nussbaum moved to Belgium in 1935, where he lived alternately in Brussels and Ostende. In 1940, he was incarcerated for several months in St. Cyprien, France. Nussbaum returned to Brussels where he and his wife, Felka Platek, hid until July 1944, when they were deported to Auschwitz.

Portrait of a Young Man was painted in 1927, during Nussbaum's student years in Berlin; *Carnival Group*, on the verso of this canvas, dates to 1939 when the artist was in exile in Belgium. The portrait depicts a clean-shaven, formally dressed, dandified man, thought to have been a young Jew living in Berlin.[1] Physical space within the image appears constricted by the sharp incline of the flooring and the high viewpoint. That the setting is an artist's studio is evident from the two paintings leaning against the rear wall. The placement of these canvases, almost as if under the figure's arms, might indicate that the sitter was also a painter. The number 36 on the stretcher of the smaller canvas may have been assigned at Nussbaum's first exhibition, at Galerie Caspar in Berlin in 1927. If this is the case, the picture commemorates, albeit obliquely, an important moment in the artist's career.

Stylistically, the portrait combines the stark realism of *Neue Sachlichkeit* or New Objectivity with the heavy impasto and parallel brushstrokes of Vincent van Gogh. The unfinished or perhaps purposefully rubbed *Carnival Group*, on the other hand, reflects a later influence on Nussbaum, that of James Ensor, whose images of masked characters often comment on their alienation from society. Painted the year before the Nazi invasion of Belgium, the picture also marks the advent of Nussbaum's final period, in which he repeatedly represented the dire situation of Jews under fascist rule. Comprised of six figures,[2] each a self-portrait, this painting suggests the statelessness Nussbaum and his fellow Jews must have felt while living as political and religious refugees in the late thirties. Set in a barren landscape where nature is dead, buildings uninhabited, and communication impossible—note the broken radio tower—Nussbaum's image refers to the general despair of Jews in the aftermath of such reprisals as the *Kristallnacht* of November 1938 when Jews became the victims of special taxes and other forms of ostracism.

At the center of the painting, Nussbaum's "self" appears as a woman wearing a bangle earring and necklace. The only reference to Nussbaum as a male (or an artist) is the blue-green beret. The figure clasps her mouth in a symbol for silence or being silenced. Flanking this figure, two others shriek or shout. The figure at the right, wearing a paper tricornered hat, speaks through a megaphone, but has no eyes. The mouths of the figures in the background are all but obliterated; their expressions range from anger and fear to despair. The central figure in the back row wears what appear to be a *yarmulke* (skull cap), *tallis* (prayer shawl), and *tefillin* (phylacteries)—the typical accoutrements of orthodox Jewry—suggesting that it was the Jewish population as a whole that was most imperiled. The wide-eyed, top-hatted man at the right, a standard reference to the German burgher, is at risk by virtue of his inclusion in the group.

The two sides of the painting might be said to exist in ironic tension. During his years in exile, Nussbaum often painted both sides of his canvases and many of these double-sided works can be read as commenting on one another. The proud, affluent, successful, and assimilated young Jew in the portrait from prewar Germany contrasts markedly with the utter desolation of Jews in exile a scant twelve years later.

Sura Levine

1. Dr. Karl Georg Kaster of the Kulturgeschichtliches Museum, Osnabrück, and Emily D. Bilski of the Jewish Museum, New York, report that in 1985, the sitter was tentatively identified as Nussbaum's roommate in Berlin. Since he wished to maintain his anonymity, his actual identity still is not known.
2. A number of sketches and watercolors mark the transformations several of the figures underwent in preparation for this painting. See Peter Junk and Wendelin Zimmer, *Felix Nussbaum, Leben und Werk* (Cologne: DuMont Buchverlag, 1982), nos. 175, 176, 179–184, 207, 221, 224, and 226.

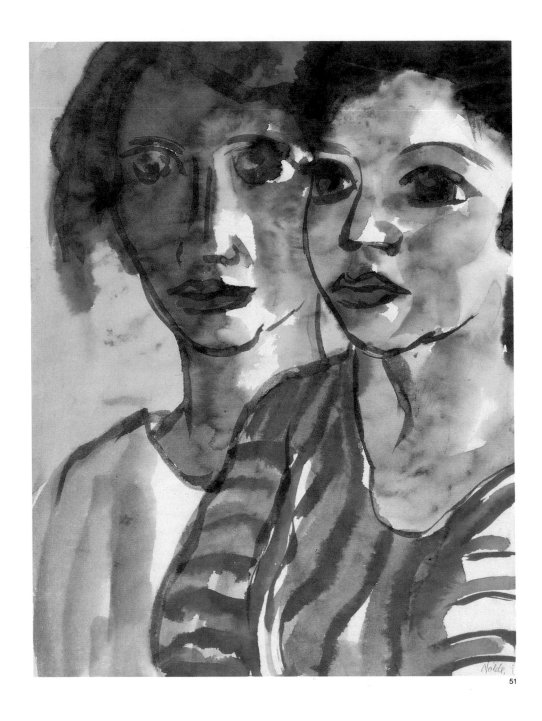

51

Emil Nolde
German, 1887–1956

51 *Two Girls*, circa 1929
 Watercolor on wove paper, sheet 16⅜ x 13¾ in.
 (41.6 x 34.9 cm.)
 The Mary and Earle Ludgin Collection
 1982.71

The Smart Museum is fortunate to possess this enigmatic watercolor by Emil Nolde, titled simply *Two Girls*, which exemplifies beautifully the way Nolde communicates emotional urgency through brilliant and dramatic contrasts of color. The deceptively simple and flowing effect achieved in this work on paper belies the years the artist spent perfecting his technique: although Nolde created his first watercolor in 1894, it was not until 1908 that his experiments with the medium matured into a personal style. He became one of the truly exceptional watercolorists of the modern age, responsible for elevating the watercolor into an expressive medium in its own right.

Nolde found watercolor ideally suited to his temperament because it demanded an intuitive, unpremeditated response. Like other Expressionists, he reacted against the prevailing materialism and rationalistic values of Europe in the early twentieth century. But of all the members of *Brücke*, the rebellious artists' group to which he belonged from 1906 to 1908, Nolde was perhaps the most anti-rational. He embraced a primitive, quasi-religious mysticism. Even in *Two Girls*, a subject with no overtly spiritual associations, Nolde draws one into a realm in which a mystical force seems present.

By contrasting, for example, the warm orange colors against cool magentas, Nolde transforms his women into glowing receptors. Pushing the figures towards the picture plane and positioning them so that the viewer must look up at them, Nolde gives his women a larger-than-life aspect. Their wide, dark, animallike eyes stare out into space, focusing on a reality inaccessible to the viewer. The three-quarter frontality of the figures, along with their stark facial features, and the dark outline surrounding their luminous shapes remind one of both early Christian icons and medieval stained-glass church windows. These are anonymous beings; transcending the everyday, material world, they represent modern-day icons or votive figures, mediators between mankind and a higher order. In this way, Nolde equates an encounter with his work to a religious experience.

Two Girls resides in the Smart Museum's collection today largely because of turbulent political events earlier in the century. The Nazis confiscated the piece, along with several other of Nolde's works, in 1937, designating them "degenerate" and not fit to be viewed. The watercolor formerly belonged to the Bielefeld Städtisches Kunsthaus in northern Germany. Dr. Heinrich Becker, director of the museum and a personal friend of Nolde's, had purchased the watercolor for the collection in 1929 from a Nolde exhibition. After it was seized by the Nazis, the work was probably brought to Berlin and sold or auctioned. *Two Girls* reappeared in New York at the Buchholz Gallery in 1939, and eventually found its way into the Smart Museum collection in 1982.

Nolde dated few of his watercolors, regarding it unnecessary and in conflict with his notions of art. Moreover, because there is little formal or thematic change in the watercolors after 1920, it is difficult to assign a precise date to *Two Girls* on the basis of style. Presumably, however, the piece belongs to the period when it was first exhibited (1929). It compares with another undated watercolor, also titled *Two Girls* (*Zwei Mädchen*), in the Ada and Emil Nolde Foundation Collection, Seebüll, which displays a similar dispersion of highlights and three-quarter frontality and monumentality of figures.

Robin Reisenfeld

Guy Pène du Bois
American, 1884–1958

52 *Four Arts Ball* (*Bal des quatres arts*), 1929
Oil on canvas, 28¾ x 36½ in. (73 x 92.7 cm.)
Gift of William Benton
1980.1

From 1924 to 1929, Guy Pène du Bois and his family lived in France, at Garnes par Dampierre, near the Chevreuse River. The large barn on the rented property had been converted into a sumptuous atelier, affording du Bois far more room than his previous studios in New York and Westport. The size of the new work space directly influenced the dimensions and spatial characteristics of *Four Arts Ball*: unlike the majority of du Bois's scenes, this one does not adhere to a friezelike frontal plane, but recedes dramatically into a deep, barrel-vaulted space. A first version, never brought to completion, was an ambitious twenty feet in length. The more resolved effort in the Smart Museum collection remains one of du Bois's larger canvases, and seems a direct reflection of his "magnificent studio" in the grange at Garnes.[1]

The Four Arts Ball provided du Bois with the perfect subject for experimenting with a larger scale. The hedonistic event was held annually to celebrate the summer vacation from the art academies. Huge Parisian halls were overrun with as many as three thousand male art students and women from all walks of life. Wearing inventive and extravagant costumes, the revelers indulged their erotic fantasies; drunken behavior was the norm. *Four Arts Ball* seems to refer to the final hours of debauchery. Typically, du Bois concentrates on the foreground figures, who appear exhausted, if not depressed. Their location in the immense interior suggests a stage on which a strange theatrical situation is unfolding. The viewer observes a dramatic pause, assuming the role of voyeur as the figures appear frozen in arbitrary gestures.

Du Bois commented enthusiastically about the painting and the potential of its subject matter:

I've begun a picture of a masquerade ball. I believe I shall do many of them. Their opportunity for social satire is limitless They permit almost any sort of comment and no end of symbolism. Costumes, poses, gestures, interlockings. Life can easily be made plain. Contrasts can be imposing and compositions monumental.[2]

While du Bois's remarks are of interest, they do not illuminate as much as they secure the veil of mystery. The artist refers to symbolic content, but his diaries do not reveal any precise interpretation for the iconography of *Four Arts Ball*. The painting succeeds through the atmospheric rendering of space and mannered postures rather than through narrative or

colloquial meaning. Without a specific explanation, the figures become social types, everymen in a modernist drama.

In keeping with the literal expanse of the dance hall, du Bois constructs an arched, three-dimensional space, reminiscent of Raphael's *School of Athens*, in which foreground figures also serve as sentries at the entrance of a subdued scene. The reclining figure at the lower right of du Bois's painting faces the viewer, but her pose is illegible. Has she fallen? Is she ill or intoxicated? The meaning of the entwined couple at the edge of the platform is equally uncertain; it is not clear whether the male figure is accosting or protecting the woman. His averted gaze is neither defiant nor accidental, but distracted into the vaulted heights of the room. The less active middle ground is occupied by the most prominent couple in the painting, the artist himself and a partner, possibly his wife, Floy. As they dance, they seem unconcerned with the aberrant gestures of the group on the platform. In another Renaissance conceit, du Bois establishes eye contact with the viewer, peering beyond the canvas surface into the viewer's space. Similarly, the odd figure of an amphibious cast on the left pauses to engage us. Masqueraders in the distance appear as detached as their foreground counterparts. The entire group seems composed of alienated individuals, whose only commonality is their disparateness.

This quality of alienation is supported by the painting's muted palette, which the artist uses to extend his predominantly circular motif. Under the rounded vaults, orbs float and cast a pale light. The serpentine line of the balcony curves along the outer edges of the enormous room and defines the void in which so much non-action takes place. Methodically orchestrated lights and darks, deep shadows and indirect light are cast over this surreal microcosm populated by du Bois's columnar figures.

The resultant mood is disquieting: the suspended moment and empty space are inhabited by menacing dancers who seem to mistrust each other, and the viewer becomes suspicious of them as well. The morose revelers hesitate, not to prolong their enjoyment, but wary of the future, victims of the nihilism that pervaded Paris during the late 1920s. The lost innocence and implied degeneracy conveyed in this picture constitute du Bois's most explicit reference to the lurking forces of the social unconscious and the underlying angstridden reality of everyday life. With *Four Arts Ball*, the artist offers a mysterious painting that challenges received ideas about his less provocative work, and suggests that du Bois perceived a more ambiguous reality than many of his well-known urbane social scenes imply.

Daphne Anderson Deeds

1. Corcoran Gallery of Art, *Guy Pène du Bois, Artist about Town* (Washington, D.C.: Corcoran Gallery of Art, 1980), 84.
2. Ibid.

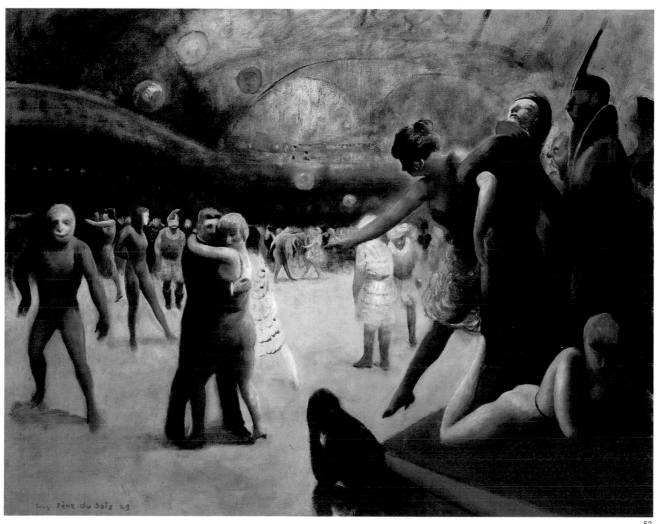

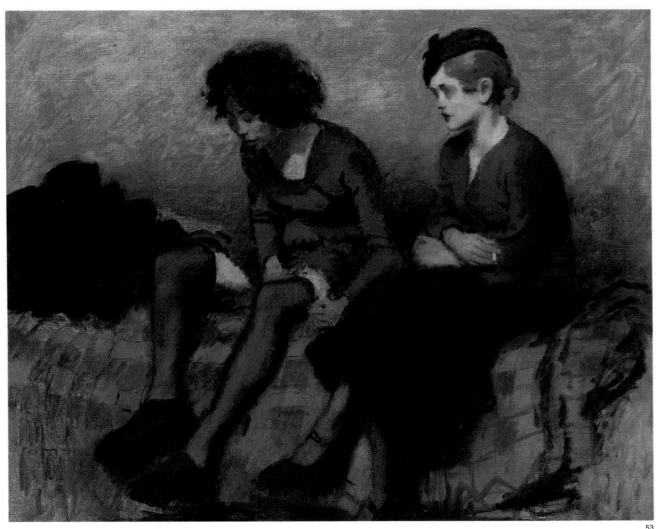

53

Raphael Soyer
American, 1899–1987

53 *Two Girls*, 1933
Oil on canvas, 24 x 30¼ in. (61 x 76.8 cm.)
The Mary and Earle Ludgin Collection
1982.72

Often associated with American Scene painters of the 1930s, Raphael Soyer was a committed urban realist throughout his sixty-year career. Indeed, after his death in 1987, he was poetically eulogized as "the last of the Ashcan School,"[1] carrying on the earlier tradition of Robert Henri and John Sloan long after the advent of European Modernism in New York. Soyer was highly critical of modern movements, of Cubism, for example, and abstraction; unimpressed by what he termed the "fleeting 'innovations'" of twentieth-century art,[2] he devoted himself most of all to figure painting. When he arrived in the United States as a teenager from his native Russia in 1912, he was already aware of his metier: along with his brothers, Moses and Isaac, he would forsake college for art school, enrolling in evening drawing classes at Cooper Union and later studying at the National Academy of Design and, briefly, at the Art Students League, where Sloan was director.

Soyer's earliest works depict family, friends, and neighborhood scenes; by the late 1920s, admiring the art of Edgar Degas and Jules Pascin, he turned with quiet passion to the theme of the female model in the studio. The two young women portrayed in the Smart Museum painting, which dates to 1933, are typical of Soyer's models of the period—distinctly working-class, with a vaguely bohemian air. Although many of his works of the 1930s represent the unemployed and homeless displaced by the Great Depression, Soyer was not a social critic who used art as a means of political protest. Instead, he focused on the simple humanity of his subjects, capturing a mood, isolating a private moment, always preferring the uneventful and the introspective to anything histrionic or heroic. There is often a certain psychological complexity even to Soyer's anonymous models; he liked to invoke the example of Russian literature, especially the plays of Anton Chekhov, to explain his preoccupation with the intricacies of the individual personality.[3]

Discussing a 1934 lithograph after *Two Girls*, the artist recalled that Eleanor, the pensive blonde depicted here, was an actress and an aspiring playwright.[4] Her companion, whom we can identify specifically as Gittel Poznansky, was a dancer in the West Village, about seventeen at the time and one of Soyer's favorite models. Even fifty years later, the ageing artist remembered Poznansky as an extraordinary, free-spirited, and "brilliant girl," who went on to become a professor of anthropology at Hofstra University.[5] Soyer highlights the special individuality of each of the two friends by juxtaposing them as a pair; the painting becomes a study in contrasts between the dark, olive-skinned dancer and the fair-haired actress: one, bare-headed with loose black curls, legs akimbo, and thighs exposed as she adjusts her stockings; the other neatly coiffed, with a stylish hat, arms and legs crossed in a contained or closed attitude, lost in a tired revery.

The intimacy enjoyed by the women is subtly suggested by their relaxed postures and physical proximity on the bed; in other instances, Soyer depicted them asleep together, resting, perhaps, after a long modeling session.[6] At times the artist allowed his models to sleep in the studio for lack of accommodations of their own. In *Two Girls*, there is a vague sense of those troubled years and the depressed mood of a nation after the Crash, if only in the muted tones of a palette enlivened solely by Eleanor's rust-colored blouse and touches of red on the models' lips. With characteristic understatement, without props or symbols, Soyer has achieved in this picture what he intended in all his figure paintings, "not isolated portraiture," but "an attempt at a knowledge of . . . people and an understanding of their environment."[7]

Sue Taylor

1. Milton W. Brown, "He Wore His Heart on His Sleeve," *Artnews* 87 (February 1988): 34.
2. The artist quoted in American Artists Group, *Raphael Soyer* (New York: American Artists Group, 1946), n.p.
3. Frank Gettings, *Raphael Soyer: Sixty-five Years of Printmaking* (Washington, D.C.: Smithsonian Institution Press, 1982), 11.
4. Ibid., 24, 30.
5. Soyer in an interview with Patricia Hills in *Raphael Soyer's New York: People & Places* (New York: Cooper Union, 1984). Another portrait of Poznansky, *Girl in a White Blouse* (1932), purchased in 1933 by the Metropolitan Museum of Art, New York, was the first of Soyer's paintings to be acquired by a museum.
6. See, for example, the lithograph *Sleep* (1931–32), reproduced in Sylvan Cole, ed., *Raphael Soyer: Fifty Years of Printmaking* (New York: Da Capo Press, 1967), no. 20.
7. The artist quoted in American Artists Group, *Raphael Soyer*, n.p.

54

Pablo Ruiz y Picasso
Spanish, 1881–1973

54 *The Diver* (*La Plongeuse*), 1933 or 1934 (plate 1932)
Soft-ground etching, collage; plate 5½ x 4⅜ in.
(14 x 10.9 cm.)
Geiser 277
The Joel Starrels, Jr. Memorial Collection
1974.280

Born in Malaga, Spain, Pablo Picasso studied first in Barcelona in 1895 and then in Paris beginning in 1900. He was initially influenced by international painting styles of the period, such as Art Nouveau and the works of Henri de Toulouse-Lautrec. Prior to 1930, he worked through a number of distinct styles, evolving from Naturalism to Symbolism to Cubism before returning to a more classical style in the late teens and 1920s. During the last half of his career, Picasso employed a wide spectrum of styles, at times returning to his own earlier works for inspiration.

Throughout his long career, Picasso's graphic works remained a reflection of his interests in other media. His peak period of graphic production is generally regarded as the early 1930s. The stage for this inventive and prolific period was set in 1931 by the appearance of two important sets of illustrations executed in his classical style—thirty prints illustrating Ovid's *Metamorphoses* published by Albert Skira and a set of etchings illustrating Honoré de Balzac's *Le Chef-d'oeuvre inconnu* published by Ambroise Vollard. The resounding success of these illustrations led to numerous graphic commissions for Picasso and resulted in extensive experimentation with a number of graphic media and styles.

The Diver, not directly related to any illustration project, is one of the many independent prints produced during this time of great inspiration. Its subject of nude bathers is one that Picasso frequently explored during the 1920s and after. The setting is an abstracted beach or poolside where two nudes watch a diver beginning to splash into the water while, in the distance, a mysterious sticklike figure approaches. The diver's scissorlike form cutting across the composition lends a phallic implication to the imagery, in keeping with the erotic undercurrents of Picasso's work of the early period. Humor also

figures prominently in the rendering—the breasts of the nude reclining bathers can be read as comic faces.

In *The Diver*, Picasso combined his classicizing style with elements of the analytic Cubism of his earlier work, much as he did in paintings and sculptures executed around this time. The cubist aspect is heightened in the Smart Museum proof by the superimposition of jagged planes of colored, translucent collage over different parts of the proof. In other impressions pulled from the same plate, Picasso explored different types of collage and relief processes. He also experimented with reversing the ground from positive (black on white) to negative (white on black). In each case, he lent a different stylistic emphasis and effect to the design and created a unique work of art.

Bernhard Geiser, the principal cataloguer of Picasso's graphic work of the early 1930s, lists two editions of the plate.[1] The first edition was pulled by the artist himself, probably shortly after the zinc plate was first etched in December 1932. This edition includes nine proofs, four in positive and five in negative, but none with the kind of collage overlays seen in the Smart Museum impression. The second edition was pulled in 1933 or 1934 by Roger Lacourière, Picasso's preferred printer. The artist provided different collages to be added when each impression was pulled. Six positive proofs of this type are recorded, of which five contain between one and four translucent collage overlays in colors that include red, yellow, black, rose, gray, and brown. Geiser lists the Smart Museum impression among these proofs. Three negative proofs are also recorded in this same edition.

Because the plate was pulled in two editions, this proof cannot be precisely dated. As mentioned above, the zinc plate (which still exists) was etched in December 1932. Picasso presumably pulled the first edition shortly thereafter; the second edition may have been pulled in 1933. There is, however, one dated impression from this edition inscribed "Picasso/pour Lacourière/Paris, le 19 février xxxiv." This suggests that the entire edition may not have been pulled until early 1934 or later.

James Yarnall

1. See Bernhard Geiser, *Picasso Peintre-Graveur Tome II: Catalogue raisonné de l'oeuvre gravé et des monotypes 1932–1934* (Berne: Editions Kornfeld and Klipstein, 1968), 22–23, cat no. 277.

Kurt Seligmann
Swiss, 1900–1962

55 *The Harpist* (*Joueuse de harpe*), 1933
Oil on board, 32¼ x 41¼ in. (81.9 x 104.8 cm.)
The Mary and Earle Ludgin Collection
1981.78

In the scant literature on Kurt Seligmann, one finds repeated mention of the artist's Swiss background, especially his childhood impressions of the annual carnival in Basel, celebrated by masked revelers to sounds of pulsing music.[1] As a young man, Seligmann studied Swiss Gothic and Renaissance art in the Basel museum, where painted panels depicting demonic tortures and sadistic martyrdoms preserved the violent fantasies of a medieval past. He attended the School of Fine Arts in Geneva in 1919, and later moved to Paris to pursue his career as an artist. Seligmann remained in Paris from 1927 until 1939, joining the *Abstraction-Création* group, occupying a studio-house next door to that of Salvador Dali, and forming friendships with other Surrealists including Jean Arp and Max Ernst. In 1933, he visited Basel on the occasion of an exhibition of graphic works by Urs Graf, the sixteenth-century Balois artist whose scenes of death, debauchery, and diabolical temptations had always intrigued him. Seligmann was fascinated, too, by primitive art, and most of all by magic and the occult; he published an historical account of *Magic, Supernaturalism and Religion* from ancient Mesopotamia to the eighteenth century,[2] and was a contributor to the surrealist journals *Minotaure*, *View*, and *VVV*.

Like many European artists and intellectuals, Seligmann emigrated to New York during World War II, transporting surrealist ideas to American shores. *The Harpist*, however, dates to his Paris period, when he had undoubtedly absorbed the influences of Pablo Picasso and Joan Miró. In this enigmatic picture, in a somber palette reminiscent of the earlier tans and grays of analytic Cubism, Seligmann conjures up an impossible image in which harp and harpist have become one. Punning references to a head in profile, a listening ear perhaps, or arms reaching out to embrace the instrument resist precise interpretation, while infusing an apparently inanimate object with signs of life. Significantly, the strange brownish ball in the foreground echoes similar disembodied round forms in biomorphic abstractions like Arp's *Bell and Navels* (1931) and Henry Moore's *Four-Piece Composition: Reclining Figure* (1934), in which the little sphere represents the umbilicus, a symbol for the connection of one life to another.[3] The two banners unfurling at the right of *The Harpist* add a note of pageantry, and one is reminded of Seligmann's study of heraldry and his abiding preoccupation with the Middle Ages. Other elements—the red-trimmed curtain, harp strings, tuning pegs, and the dangling switch of hair or feathers—coexist in an uneasy unity.

In a typically surrealist endeavor, Seligmann has brought these dislocated fragments together to form a hybrid reality only distantly related to our waking experience of the concrete world. Similarly, his later contribution to the International Exhibition of Surrealism held in Paris in 1938 consisted of a low stool supported by four female mannikin legs, each sporting a high-heel shoe.[4] This notorious assemblage, titled *Ultrafurniture*, relates to other surrealist fusions of human anatomy and still-life objects in the work of Dali, for example, or Ernst, or René Magritte. On another level, however, Seligmann's jarring juxtapositions in both sculpture and painting pertain to his own philosophical conviction, stated in an essay on "Magic and the Arts," that the multiplicity of the universe is "brought into One by a mysterious law" and that the artist's task is "to express the marvelous manifoldness of nature through the variety of forms he depicts."[5]

The Harpist illustrates this desire to subsume diverse forms in an organic whole. Iconographically, it also evokes Seligmann's mystical notion, derived from the medieval concept of *musica humana*, that musical relationships order all existence. Citing a treatise by the Christian Cabalist Robert Fludd (1574–1637), Seligmann compared the whole universe and the heavens to a musical instrument and, along with Scipio the Elder (237–183 B.C.), claimed that "men who know how to imitate this celestial music with their lyre, have traced their way back to this sublime realm, in the same way as others who have by their genius raised themselves to the knowledge of the divine."[6] Thus in Seligmann's arcane system, the artist and the priestly magician participate in the same project, and the harp player in the Smart Museum painting becomes a metaphor for the creative individual, sensitive to the secrets of the world's underlying harmonies.

Sue Taylor

1. "I can still hear," Seligmann wrote in his mid-thirties, "the rhythmic thunder of the fifes and drums in my inner ear." Quoted in Martica Sawin, "Magus, Magic, Magnet: The Archaizing Surrealism of Kurt Seligmann," *Arts* 60 (February 1986): 77.

2. Kurt Seligmann, *Magic, Supernaturalism and Religion* (New York: Pantheon Books, 1948).

3. Moore himself made this association overt in a discussion of *Four-Piece Composition*, "in which there is the head part, the leg part, the body, and the small round form, which is the umbilicus and which makes a connection." See John Hedgecoe, ed., *Henry Moore* (New York: Simon and Schuster, 1968), 77, and Alan Wilkinson, *Gauguin to Moore: Primitivism in Modern Sculpture* (Toronto: Art Gallery of Ontario, 1981), 282–283. I would like to thank Richard A. Born for pointing me to these references.

4. The object is pictured, along with *The Harpist* and other paintings and sculptures by Seligmann, in a photograph of the artist's studio in the Villa Seurat in Paris in 1937, in both the exhibition catalogue *Kurt Seligmann* (Geneva: Galerie Jacques Benador, 1974), n.p., and Sawin, "Magus, Magic, Magnet," 77.

5. Seligmann, "Magic and the Arts," *View*, Fall 1946, 15–17, reprinted in Lucy Lippard, ed., *Surrealists on Art* (Englewood Cliffs, N. J.: Prentice-Hall, Inc., 1970), 199–203.

6. Ibid. Seligmann is quoting from Cicero's *De Republica*, written in 54 B.C., in which the younger Scipio (185–129 B.C.) dreams that his grandfather, Scipio Africanus the Elder, "leads him to the stars which vibrate with a wonderful symphony," and thereupon instructs him about the divine harmony, "reproduced by the movement of the spheres."

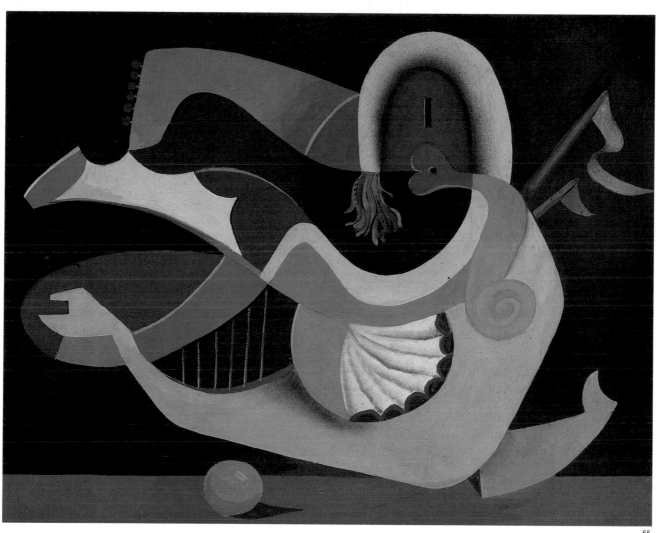

56

Marcel Duchamp
French, 1887–1968

56 *Box in a Valise* (*Boîte-en-valise*), 1935–1941 (1963 edition)
Mixed media, ed. 30, box (closed) 14¹³⁄₁₆ x 15¹⁵⁄₁₆ x 3⁹⁄₁₆ in.
(37.7 x 40.5 x 8.9 cm.)
Bonk series E, Lebel 173, Schwartz 311
Gift of Mrs. Robert B. Mayer
1983.30

The pre-eminent conceptual artist of the twentieth century, Marcel Duchamp began as a painter of conventional portraits and nudes in various post-impressionist styles. As early as 1912, however, he set out to prove the end of "retinal" art—pictures created merely to delight the eye with color, exotic subjects, or decorative brushwork—and attempted "to put painting once again at the service of the mind."[1] He initiated his iconoclastic attack on traditional definitions of art in 1913 with his first "readymade," in which two pre-existing functional objects, a bicycle wheel and a stool, were combined to produce a new, anti-utilitarian object with a new meaning. Four years later, when his notorious readymade *Fountain*, an inverted urinal signed with the pseudonym "R. Mutt," was rejected by the jury of the Society of Independent Artists, Duchamp defended the provocative sculpture, declaring the irrelevance of the handmade in art and emphasizing instead the importance of the artist's choice and the object's aesthetic context.[2] Duchamp rarely sold his art to galleries or museums. Much like a modern-day literatus, he presented his works to family and friends, or exchanged them with patrons like Walter and Louise Arensberg for such necessities as monthly rent.[3]

The Smart Museum's *Boîte-en-valise* fits easily into Duchamp's relatively small oeuvre.[4] Preceded by *The Box of 1914* and *The Green Box* (1934), collected facsimiles of the artist's notes, the *Boîte-en-valise* contains notes as well as reproductions of paintings and objects. Among these are miniature replicas of seminal works such as *L.H.O.O.Q.* (1919) and *The Bride Stripped Bare by Her Bachelors, Even* (*The Large Glass*, 1915–1923); the ensemble thus has the effect of autobiography or a retrospective exhibition. Transcending the personal and diaristic, however, and underlying the theory and creation of the *Boîte* is the idea of collection and preservation of cultural artefacts: Duchamp envisioned "a box in which all my works would be collected and mounted like a small museum, a portable museum, so to speak."[5]

While in Paris from 1935 to 1940, the artist commissioned technicians to produce tiny replicas of his readymades, and supervised the printing of small-scale color reproductions of his most famous paintings, drawings, and objects. With France under occupation in 1940, Duchamp posed as a cheese buyer to smuggle his miniatures from Paris into the free zone of Marseilles. The first *Boîte-en-valise* was completed at the end of that year; subsequently, Duchamp and various assistants, now in the United States, continued assembling others until 1968. Seven editions exist, varying in signature, contents, and outer coverings; only the first edition, a deluxe edition of twenty, was actually encased in a leather valise.[6] The Smart Museum's example, covered with dark-green linen imitation leather and light-green Ingres paper, belongs to the fifth edition, assembled in 1963.

Implicit in Duchamp's reference to the *Boîte* as museum is an ironic comment on the traditional concept of the museum as a repository of original "masterpieces." Mimicking the museum exhibition, Duchamp presents mounted works and framed images with labels on which, in a parody of the unique object, not only titles and dates but also exact times of creation are indicated.[7] Notions of uniqueness and singularity are further undercut by his "cloning" of the *Boîte*: there are at least three hundred in existence, and the contents of one look like those of the others. These objects are reproductions, moreover, not from the hand of the artist but made and assembled by technicians and assistants.[8] Unlike traditional multiples such as prints or cast sculptures, the *Boîte*'s reproductions were created in different media and dimensions years after many of their respective originals: paintings were reproduced as prints and readymades were remade in new materials.

Duchamp once said, "I'll tell you what's going to happen. The public will keep on buying more and more art, and husbands will start bringing home little paintings to their wives on their way from work, and we're all going to drown in a sea of mediocrity."[9] Perhaps Duchamp's miniature, portable museum is his ultimate joke on bourgeois systems of ownership, uniqueness, and monetary worth of the art object. Regardless of his original intent, however, the institutions that the *Boîte-en-valise* criticizes are the very same which have subsumed it in our time.

Stephanie D'Alessandro

1. Calvin Tomkins, *The Bride and the Bachelors: Five Masters of the Avant Garde* (New York: Penguin Books, Inc., 1987), 13.
2. Ibid., 41. *Fountain* is reproduced in miniature, and *Bicycle Wheel* appears in a photographic print included in the *Boîte-en-valise*.
3. In keeping with this attitude towards the monetary value of art, Duchamp originally priced the *Boîte-en-valise* only slightly higher than cost; he insisted on this project as a "business." Ibid., 60.
4. Duchamp's limited output is a result of his supposed unofficial retirement from artmaking in 1923, in favor of playing chess.
5. Marcel Duchamp, *The Writings of Marcel Duchamp*, ed. Michel Sanouillet and Elmer Peterson (1973; reprint, New York: Da Capo Press, 1989), 136.
6. The term "boîte" is used to differentiate all other editions from the deluxe edition of the 1941 "boîte-en-valise."
7. Certain objects in the *Boîte* are permanently fixed in place and each folio is arranged by theme or year, implying a conscious decision by the artist as to the organization and display of objects. However, it is contingent upon the viewer to open the *Boîte* and examine its contents: without the viewer, the *Boîte* remains as its title describes—a box. Duchamp invites the viewer to rearrange and reinterpret the objects, creating new juxtapositions and, in the end, a new reality for the the work of art. This follows his insistence that the viewer has a role equal to the artist's in the creation and interpretation of works of art: "Ce sont les *regardeurs* qui font les tableaux." (It is the *spectators* who make the pictures.) Interview by Jean Schuster, "Marcel Duchamp, vite," *Le Surréalisme, Même* 2 (Spring 1957). 144.
8. The Smart Museum's *Boîte* was assembled by Jackie Monnier, Duchamps's step-daughter from his marriage to Alexina (Teeny) Sattler.
9. Tomkins, *The Bride and the Bachelors*, 15.

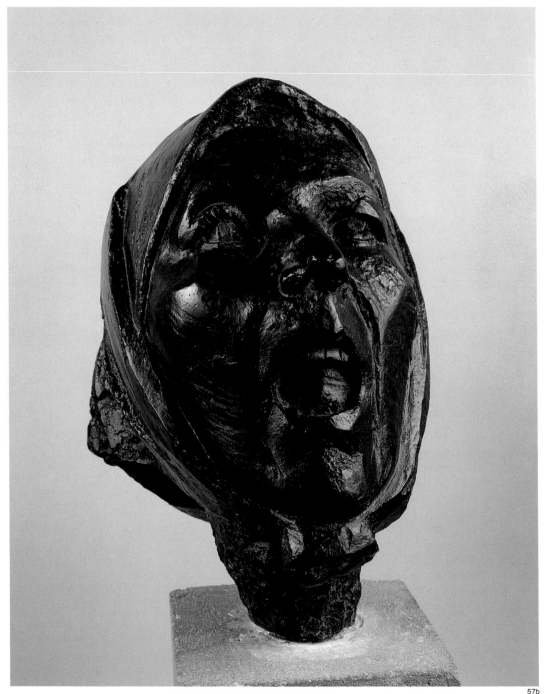

57b

Julio Gonzalez
Spanish, 1876–1942

57a *Head of the Montserrat* (*Tête de la Montserrat criante*), 1941
Pencil on wove paper, sheet 10¼ x 8¼ in. (26 x 21 cm.)
Merkert 249.D27
The Joel Starrels, Jr. Memorial Collection
1974.264

57b *Head of the Montserrat II* (*Tête de la Montserrat criante II*), 1942
Cast bronze, ed. 6/6, h. 12½ in. (31.8 cm.)
Merkert 249
The Joel Starrels, Jr. Memorial Collection
1974.223

The brief sculptural career of Julio Gonzalez is highlighted by his iron abstractions of the late 1920s and thirties, his collaboration with Pablo Picasso, and his influence on younger artists. Julio and older brother Juan were trained by their father, Concordio, as metalworkers, and Julio exhibited small-scale decorative metal pieces in the 1893 World's Columbian Exposition in Chicago. After Concordio's death, Juan moved the entire family from their home in Barcelona to Paris in 1900. Although Julio lived in France for the rest of his life, he always considered himself a Catalonian and was friends with many of the Spanish expatriate artists. Both brothers worked in a variety of media; in 1907, for example, Julio exhibited six paintings in the Salon des Indépendants in Paris.

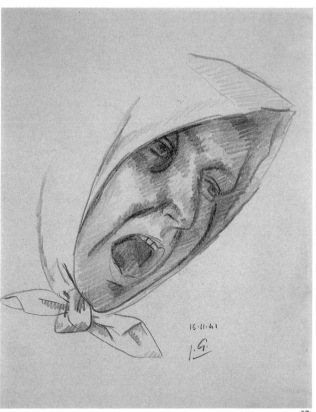

57a

Julio's friendship with Picasso had a great impact on the development of his sculpture. In 1928, he began working with Picasso, bringing his knowledge of welding to works like *Construction* and *Woman in the Garden*. Subsequently, in abstract welded-iron pieces, Gonzalez combined ostensibly incongruent forms into integrated wholes of positive and negative shapes. It is this style that brought Gonzalez recognition as one of the most dynamic modern sculptors, and that later influenced artists such as David Smith.

Gonzalez developed a second, more representational style; works in this mode were an expression of his social consciousness. As early as 1930, he titled a metal-ribbon mask *Montserrat*, after the site of the Benedictine monastery where one of Spain's most sacred statues of the Virgin Mary is located. In 1936, when the Spanish civil war began, Gonzalez created a full-figure iron sculpture, also titled *Montserrat*, of a woman carrying a child. Here he began using the female image as a symbol for the plight of Catalonia in the war. After the iron figure was exhibited with Picasso's *Guernica* at the Spanish Pavilion of the 1937 Paris World's Fair, Gonzalez's symbolic women became more anguished, echoing the open-mouthed screams of figures in Picasso's painting. Barcelona, Gonzalez's birthplace, had been an early rallying center for Republican freedoms and one of the last cities to fall to the nationalist forces. From his 1936 *Montserrat* to the small bronze *Petite Montserrat effrayée* of 1941 or 1942, Gonzalez's image of the peasant woman changed: as an emblem for Spain, she stood proud and noble; later, she evolved from a personification of pain and anger to one of resigned sorrow.

The bronze *Head of Montserrat II* is part of this later series and originated in a 1942 plaster head which was cast under the supervision of the artist's son-in-law, Hans Hartung, after Gonzalez's death. The plaster was part of an unfinished figure of which only the head, hands, and arms were completed; the sculpture was probably meant to be a larger version of *Petite Montserrat effrayée*. The scarcity of casting or welding materials in France in the early forties made it impossible for Gonzalez to work on a large scale; instead, he created drawings, plasters, and small iron pieces.

Gonzalez's screaming women sculptures of 1937 to 1942 are paralleled in a group of drawings with similar subjects. In the drawings, there is the same shift in mood, as seen, for instance, when comparing the 1938 *Head of the Crying Montserrat* to the forlorn image in the pencil drawing *Head of the Montserrat* from late 1941. The defiant brown color and the snarling scream in the earlier drawing, created when Barcelona still stood independent, are gone by 1941, replaced by a face sadly accepting of fate. Like the Catalonian people who had fallen to Franco in 1939, Gonzalez too was a captive. In occupied France, he was forced to wait and hope. But in the symbolic drawings and sculpture of the wailing *Montserrat*, he captured the spirit of his Spanish compatriots, as well as his own.

Mark A. Hall

Henry Moore
British, 1898–1986

58 *Sketch Model for Reclining Figure*, 1945
 Unglazed modeled earthenware, l. 6½ in. (16.5 cm.)
 Lund Humphries 245
 The Joel Starrels, Jr. Memorial Collection
 1974.138

Active for nearly seven decades, the British sculptor Henry Moore left an oeuvre of more than nine hundred sculptures in wood, stone, and bronze and over five thousand known drawings.[1] In the 1930s, Moore championed an abstract sculptural vocabulary and established the authority of direct carving in stone and wood. In formal and technical command of his medium, from the end of World War II, Moore focused on his preferred subject, the human figure, inventively uniting a modern formalist aesthetic with classical humanist thought.

Wartime restrictions and the Blitz over London prevented Moore from making sculpture from 1940 to 1943. In 1945, he began carving his first postwar large-scale reclining figure, in elm wood. At the same time, he fashioned a half dozen small clay models for wooden sculpture, including the Smart Museum maquette.[2] The present terracotta was conceived several years earlier, in the richly colored 1942 drawing *Reclining Figure and Red Rocks* (London, British Museum).[3] Despite the independent status of this sheet, like many other of Moore's drawings it served as a handy reference for future sculptural ideas. Nearly all Moore's sculptures from 1921 to the early 1950s are based on preparatory drawings. By the late thirties, he established an additional, intermediary stage in the working process, which he called a sketch-model, before the execution of the final piece. The Smart Museum's reclining figure is an early example of one of these small hand-held maquettes, usually modeled in clay or carved in hard plaster.[4] Unlike his two-dimensional studies, the sketch-models did not limit the sculptural conception to a few key points of view (front, back, ends). With the maquettes, Moore believed he was able to exploit the full potential of multiple views afforded by freestanding sculpture.

Formally, the Smart Museum figurine belongs with Moore's surrealist-derived biomorphic sculpture of the mid- and late thirties, distinguished by smooth, highly reduced, curvilinear shapes that suggest the organic flow of elusive microscopic or cosmic life forces. In the terracotta, the extensive excavation of the torso and thinning of limbs—so that the spaces between parts and penetrations of the core are nearly equal in volume to the remaining mass—are consistent with Moore's rejection at the time of his own previous exploration of sculpture as a solid, unitary block. The hollowed body and attenuated limbs can also be understood in terms of the terracotta's function as a study for a sculpture in *wood*: "I have always known," the artist later explained, "how much easier it is to open out wood forms than stone forms, so it was quite natural that the spa-

tial opening-out idea of the reclining figure . . . first appeared in wood [in 1936]."[5]

In 1961, assessing four decades of his career, the artist noted that "the reclining figure is an absolute obsession with me."[6] It is, with the mother and child theme, his major subject. Despite the overwhelming significance for Moore of ancient non-western and tribal sculpture in the 1920s, the reclining figure was probably first suggested to him by the classical Mediterranean tradition of the recumbent river god, personification of nature's flowing energy. In addition to examples of the type in antique and Renaissance statuary, there are also Michelangelo's carvings of *Dawn* and *Night*, complex allegories in the guise of awakening or slumbering supine nudes (Florence, Medici Chapel, San Lorenzo). The reclining figure gained impetus after Moore discovered the stone Toltec-Mayan rain-god, *Chacmool*, from Chichén Itzá.[7]

One of Moore's greatest contributions to twentieth-century sculpture has been the use of the human figure as a metaphor for landscape, in which the recumbent body assumes the contours and rhythms of a mountain range. The artist wrote in 1930 that what moved him most was "strong and vital, giving out something of the energy and power of great mountains."[8] In the British Museum drawing, Moore places the reclining figure in an imaginary setting in front of an eccentrically shaped rock. Unequivocally establishing the interplay between the jutting rock and the corresponding limbs and head of the "wooden" female, he identifies the human body with elemental nature. The seminal forms of the natural world—ridges, swellings, holes, depressions, and protrusions—find equivalents in the human form in the drawing and, by extension, in the Smart Museum terracotta.

Richard A. Born

1. In addition to this *Sketch Model for Reclining Figure*, there are eleven bronze sculptures by Moore in the Smart Museum collection, dating from 1934 to 1963, and twenty drawings, from 1928 to 1956.

2. The Smart Museum's terracotta is reproduced in *Henry Moore: Sculpture and Drawings*, 3d rev. ed. (London: Lund Humphries and Co., 1949), no. 700. The maquette is extremely close to no. 70m, reproduced on the same page. In the 1957 revised edition of the book, no. 700 is not illustrated, but it is in all likelihood LH245: the medium and dimensions are the same, and it immediately follows the piece identified as 70m in the 1949 edition. If LH245 is the Smart Museum maquette, the piece was incorrectly noted as destroyed in the 1957 edition. The inscription by Moore on the reverse of a photograph of the Smart Museum's sculpture (on file at the Smart Museum) gives the same title as LH245.

3. Alan G. Wilkinson, *The Drawings of Henry Moore* (London and Ontario: Tate Gallery and Art Gallery of Ontario, 1977), cat. no. 190.

4. Many of the sketch-models executed in 1945, including the Smart Museum figure, remained unrealized in wood or stone. However, a bronze edition of six in the original size of the maquette was published in 1962 by Marlborough Fine Art, Ltd., London, from this rare mid-forties terracotta.

5. Henry Moore quoted in Philip James, ed., *Henry Moore on Sculpture*, (London: MacDonald and Co., 1966), 264.

6. Ibid., 265.

7. Although Moore may have seen a reproduction of this pre-Columbian carving as early as 1922, as recorded in two sketches in his *No. 2 Notebook* (Henry Moore Foundation, Much Hadham, England), its impact, stylistically as well as thematically, was not felt in his sculpture until 1928.

8. James, *Henry Moore on Sculpture*, 58.

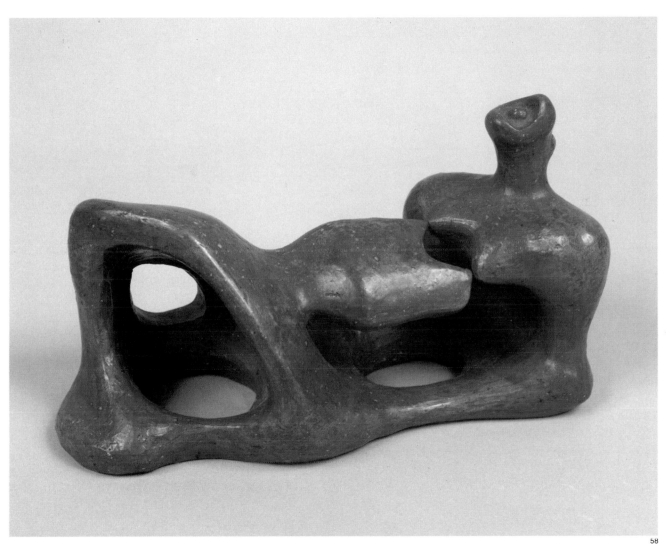

58

Alberto Giacometti
Swiss, 1901–1966

59 *Portrait of Annette Arm* (?), 1947
 Pencil on wove paper, sheet 16⅛ x 14⅜ in.
 (40.9 x 36.3 cm.)
 The Joel Starrels, Jr. Memorial Collection
 1974.303

Alberto Giacometti is best known for his sculptures of extremely thin, almost spindly figures standing or striding in distant solitude, and for portraits of friends isolated in the late-night stillness of the artist's studio. His friend Jean-Paul

Sartre saw in the artist's barren vistas trenchant visualizations of an emotionally null, meaningless modern existence described in Sartre's existentialist philosophy, which briefly dominated European arts and letters after World War II.[1] In its somewhat hurried and chaotic facture, Giacometti's mature work also recalls the creativity theory of Sartre's forebear Friedrich Nietzsche, who claimed that "if there is to be art, if there is to be any aesthetic doing and seeing, one physiological condition is indispensable: frenzy."[2] Giacometti's irregular techniques resulted, paradoxically, in an outward order that further mirrors Nietzsche's thought as summarized by one of his commentators: "In former times men believed that God created the universal cosmos out of chaos. In a world in which

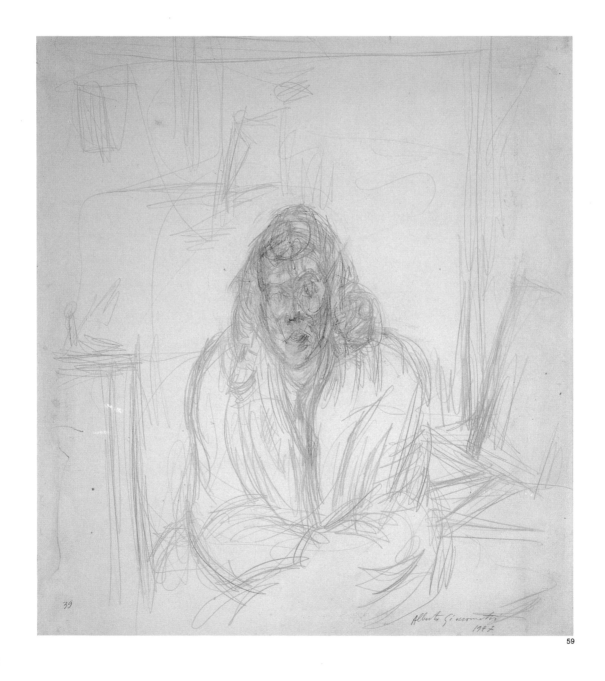

59

the myth of the creator god has been exploded, the artist is the most godlike of beings, for in the work of art he creates a miniature cosmos from the chaos within him."[3]

The eldest of four children, Giacometti was born in the Italian-speaking Bregaglia Valley of Switzerland. At the age of eighteen, he left school to work in his father's painting studio. He attended the Ecole des Beaux-Arts in Geneva, but subsequently withdrew for more than two years of traveling and studies in Switzerland and the artistic centers of Italy. In 1922, Giacometti went to Paris to work under the Rodin-influenced sculptor Antoine Bourdelle (1861–1919). Though Bourdelle had no lasting effect on his student, Paris did; aside from brief trips, visits to his mother's home, and a wartime exile, Giacometti remained in Paris for the rest of his life. He was drawn to the leading artists and writers of the interwar period, notably André Masson and the surrealist littérateur and spokesman, André Breton, who, along with Salvador Dali, invited Giacometti to join the Surrealists in 1930. The eerie, sometimes disturbing sculptures Giacometti created during this time, the most familiar of his early works, soon attracted wide acclaim and serious collectors, and the artist entered his most critical and inventive period. But by 1934, he began to work from nature, an activity anathema to the Surrealists, and was promptly expelled from their group. For the next decade and more Giacometti labored in particular isolation—intensified between 1942 and 1945 when he fled Nazi-occupied Paris for neutral Geneva—as he forged the unique style that would characterize his sculpture, painting, and drawing for the remainder of his career.

In October 1943, Giacometti met Annette Arm (b. 1923), a strong-willed young woman seeking excitement and escape from her parents' restrictive home. She came to the artist's studio-apartment the night they met, and stayed with him until his return to Paris in September 1945. After visiting Geneva the following spring, Giacometti yielded to Arm's pleas and allowed her to join him in Paris in July 1946. She soon began posing for him, a significant step in many of Giacometti's relationships, and persuaded him to marry her in July 1949. Arm remained his partner and frequent model until his death in 1966.[4]

Their reunion in 1946 came during a period of unparalleled creativity for Giacometti as he struggled toward his mature style. The Smart Museum drawing, dated 1947, contains many elements of his emerging technique in this medium: the rapid scribbles that both allude to and define form; the increasingly frequent and dense layering of lines toward the focal point of the subject; the reductive effects of repeated erasures; the almost violent gouging of the paper's surface as the artist intensified the darkest passages.[5] The portrait is reminiscent of late drawings by Paul Cézanne, one of Giacometti's favorite artists:[6] Cézanne's restructuring of pictorial space into the geometricized grids that augured Cubism is echoed in Giacometti's underdrawing—in the tilted circle at the top of the head, for example, in the saucer shapes that describe the subject's arching eyebrows and prominent cheekbones, and in

the lozenge-shaped lips. It is in the repetitious reworking of lines along the contours of objects, however, that Giacometti's debt to Cézanne is most evident.

Though the drawing is not titled, it is almost certainly a portrait of Arm. Were it not for Giacometti's tendency to highlight similar features in many of his sitters, the identification might be more easily confirmed; nonetheless, various evidence recommends Arm as the subject. First, the drawing was made shortly after her arrival in Paris, when she was by far Giacometti's most frequent model.[7] The face and hair style in the drawing strongly resemble those of Arm in photographs from the late 1940s. The subject's youth is appropriate; Arm would have been twenty-three or twenty-four at time. Last, and most compelling, the forward-leaning posture of the model clothed in her heavy jacket or overcoat suggests an intimacy with and power over the artist that perhaps only one or two other women achieved.[8] Significantly, of the studio portraits Giacometti made during this period, only those of Sartre possess this powerful presence. Most of Giacometti's other contemporaneous portraits show the subjects receding away from the picture plane as if viewed at a great distance through a cavernous interior. Regardless of the subject, this portrait—one of six Giacometti drawings in the Smart Museum's Starrels Collection—reveals the artist's efforts to achieve a vision, by pictorial means, that he had only just begun to articulate in his sculpture. The portrait thus provides a critical insight into Giacometti's development at a turning point in his life and work.

Jeffrey Abt

1. Jean-Paul Sartre, "La recherche de l'absolu," *Les temps modernes* 3, no. 28 (January 1948): 1153–1163.

2. Friedrich Nietzsche, *The Genealogy of Morals*, trans. F. Golffing (Garden City, N.J.: Doubleday, 1956), 178–179.

3. W. T. Jones, *Kant to Wittgenstein and Sartre* (New York: Harcourt, Brace & World, 1969), 260.

4. James Lord, *Giacometti: A Biography* (New York: Farrar, Straus, Giroux, 1985).

5. The number in the lower left-hand corner of the drawing suggests that it is from a sketchbook. Other evidence supports this conclusion: the left-hand edge of the sheet appears as though torn from a sewn or adhesive binding; the bottom and right edges are clearly machine trimmed (the top edge is rather crudely cropped, probably by the artist, eliminating what was almost certainly a machine-trimmed edge, and thereby changing the sheet's likely rectangular shape to its present nearly square proportion); and finally, the quality of the paper is consistent with what one might expect to find in a commercially manufactured sketchbook. On the verso of the sheet is a rough, unresolved drawing of a bird on a stand, with the beginnings of a human head to one side. For a summary of Giacometti's drawing materials, see Lord, *Alberto Giacometti Drawings* (Greenwich, Conn.: New York Graphic Society, 1974), 21.

6. William Rubin, "Cézannisme and the Beginnings of Cubism," in *Cézanne: The Late Work*, ed. William Rubin (New York: Museum of Modern Art, 1977), 151–202.

7. Although there is no reason to doubt the accuracy of the drawing's date, it should be noted that Giacometti seldom signed and dated his drawings upon their completion. Rather, he is known to have added his signature and date when releasing drawings for sale or presenting them as gifts to friends. Lord, *Giacometti Drawings*, 24–25.

8. The same forward-leaning pose, with arms crossed and resting on the knees, appears in a print, dated 1964, identifying Arm as the subject. See Herbert C. Lust, *Giacometti: The Complete Graphics* (New York: Tudor Publishing Co., 1970), 140, and 223, no. 178.

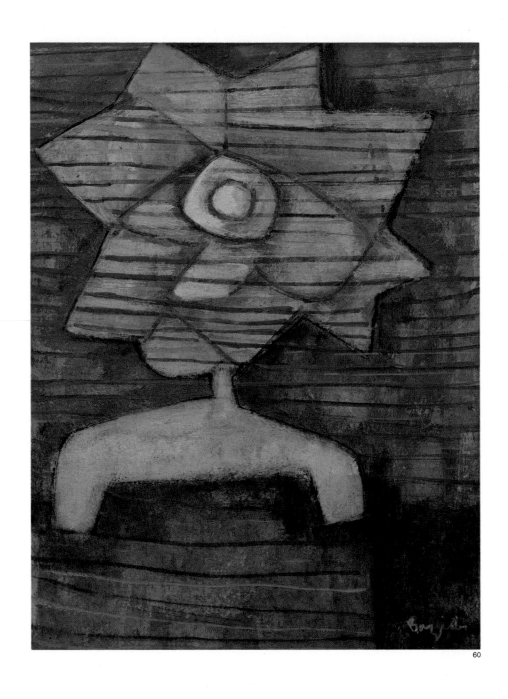

60

William Baziotes
American, 1912–1963

60 *Waterflowers*, 1947
 Oil on canvas, 16⅛ x 12⅛ in. (41 x 30.8 cm.)
 Gift of Mr. and Mrs. William G. Swartchild, Jr.
 1974.37

Born in Pittsburgh in 1912, William Baziotes became an active participant in that loose association of painters known as the Abstract Expressionists, who brought American art to international attention following World War II. After studying painting at the National Academy of Design and participating in the Works Progress Administration's Federal Art Project from 1938 to 1941, Baziotes developed close relationships with a number of renowned European painters who emigrated to New York during the war. His friendships with Joan Miró, Marcel Duchamp, Max Ernst, and Roberto Matta-Echaurren prompted him to experiment with the surrealist technique of psychic automatism, in which the artist attempted to express subconscious feelings directly and spontaneously on paper or canvas, without interference from the conscious mind. Although Baziotes later tempered his own use of this technique with a more deliberate method of painting, his enthusiasm for it as a means of self-discovery was passed on to his American colleagues, many of whom, including Jackson Pollock, came to regard it as an integral part of the painting process.

Automatism had a great appeal for Baziotes and those of his contemporaries who believed that traditional methods of representing nature, based on rational systems of perception and analysis, were outmoded and even immoral since they could be—and had been—diverted into propagandistic uses by the likes of Hitler, Mussolini, and Stalin. Rejecting these artistic conventions, the young Abstract Expressionists turned inward to find a personal imagery which would convey not objective reality but pure emotional truth, untainted by history or tradition.

In the search for forms that would communicate primal feelings with immediacy and power, Baziotes was led naturally by his Greek ancestry to the adaptation of ancient mythology. The critic Thomas Hess once remarked that Baziotes was "a card-carrying Hellene . . . for whom myth is not exotic but as domestic and necessary as bread and water."[1] Of particular interest were early Greek tales of forest and water nymphs, in which plant, animal, and human life merged in unnatural but compelling unions. *Waterflowers* evokes such a hybrid: the plant stem branches out to suggest shoulders and arms, and the petal forms surround an emblematic eye, giving the image a watchful, observant presence. The suggestion of consciousness in inanimate nature was one means by which Baziotes and several of his contemporaries, notably Mark Rothko and Adolph Gottlieb, attempted to describe the possibility of a spiritual union among all living things.

The whimsy of this conceptual blending of plant and animal forms is not unlike that employed by Paul Klee, whose work Baziotes knew and admired. The childlike outline that defines the image was probably also influenced by Klee, who appreciated the art of children for its unspoiled honesty— among the very qualities Baziotes sought to express. It is interesting to note that while most of the Abstract Expressionists were increasing the size of their paintings, Baziotes continued to work on an intimate scale. Rather than creating environmental experiences, he invented private dreams. The small scale of his paintings makes them easily apprehensible and allows the viewer to concentrate on the artist's vision of a world that is at once familiar and alien.

Baziotes' use of color is also extremely personal. From the time of his first one-man show in 1944, critics praised the lyricism and poetry of his color, even before they had a vocabulary adequate to describe and assess his abstract imagery. In *Waterflowers*, the color is almost phosphorescent, and is used as an independent pictorial element rather than as a means for modeling the forms. Transparent as water, the colored lines that shroud the figure in a mysterious vapor do not in any way obscure it.

Waterflowers was painted early in Baziotes' career, yet it contains the elements essential to his lifelong aesthetic exploration. The hypnotic image of a quiet, mutant personage, immersed in a haze of luminous color, became his hallmark. In 1959, by which time Baziotes had been publicly acknowledged as one of the forerunners and masters of the new American abstraction, he succinctly summed up the objective he had been working toward since the late 1940s: "It is the mysterious that I love in painting. It is the stillness and the silence. I want my pictures to take effect slowly, to obsess and to haunt."[2]

Naomi Vine

1. Quoted in Irving Sandler, "Baziotes: Modern Mythology," *Art News* 63 (February 1965): 30.
2. William Baziotes, "Notes on Painting," *It Is*, no. 4 (Autumn 1959): 11.

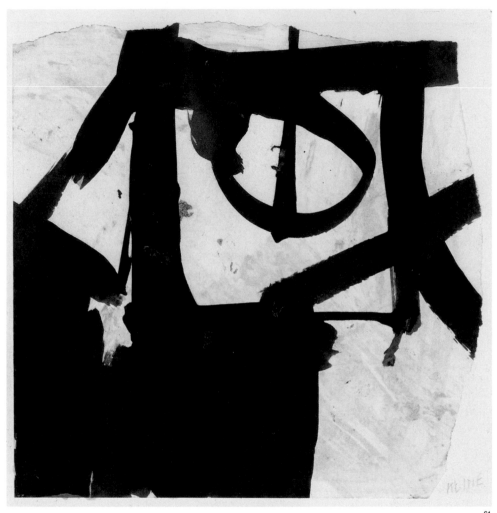

61

Franz Kline
American, 1910–1962

61 *Untitled*, circa 1950
 Ink, paint on wove paper mounted on rag board;
 sheet 7½ x 7½ in. (19 x 19 cm.)
 Gift of Katharine Kuh
 1969.2

The Abstract Expressionist Franz Kline is remembered for his innovative, large black-and-white paintings. This small drawing is significant because it embodies the same scale, space, and vigor of his larger works, and has much to tell us about the energy of his concentrated expression, the complexity of his construction, and the process of his style in the 1950s. Kline's drawing is unequivocally abstract; his marks are empty signs in relation to the language of the objective world. Yet in a few bold, dramatic strokes the artist transforms a neutral space into a rich expression that depends on the language of its own line, color, value, and texture. The immediate visual force suggests the drawing is only a truncated fragment of a larger vision. But like our own physical relationship to the world in which we live, the drawing's import is independent, alive, and self-focused. Kline sought this impact, but believed it could not be stated outside the language of painting's own medium.

Kline did not theorize extensively about his art, but he did say enough to validate the more systematic evaluations of the critic Clement Greenberg and others. Kline admired the contrasts of light and dark in Rembrandt and thus, Greenberg suggested, stripped his paintings down to the essential contrast of black and white. Greenberg positioned Kline's work in the modernist tradition since Cézanne: of Kline's paintings of the early fifties, the critic remarked, "Though presenting signs and marks floating free on a clear and expanding field, his pictures actually repeat—and in fact, succeed most when they do so most—the solid, one-piece cubic rectangle with its emphatic enclosing shape."[1]

Perhaps the most striking feature of the Smart Museum drawing is the emphatic geometrical design. The large square that dominates the central area of the drawing is an important motif for Kline which appears pristinely in *Wotan* (1950, Houston, Museum of Fine Arts) and over and over through-out his black-and-white period until *Four Square* of 1956 (Washington, D.C., National Gallery of Art).[2] The square is often intersected by diagonal or curvilinear lines as in this drawing, giving his works their characteristic calligraphic appearance. Kline denied any oriental influence, insisting that his canvases were arenas for black *and* white painting: "People sometimes think I take white canvas and paint a black sign on it, but this is not true. I paint the white as well as the black, and the white is just as important."[3] The geometrical design controls the drawing, and the fractures and intersecting lines give it force and energy.

"If anyone had told me that at forty I would be painting only in black and white, I wouldn't have believed it. These things happen slowly."[4] So Kline reflected after returning to color later in the fifties. Perhaps one of the most fascinating elements of the drawing is the touch of green at its base. Kline had not yet let color escape from his drawing, and because of this small but telling mark, we may date the drawing to 1950 and no later. Kline's style in the early 1950s is characterized not only by the gradual transition from color to black and white, but by the use of drawings themselves as a reservoir of inspiration. The artist sketched hundreds of drawings on telephone book pages, newspapers, and rag paper. He often drew from this store like water from a well, combining elements to create motifs for his larger works. Many admirers and scholars alike have observed the correspondence between Kline's small sketches such as this one and the large canvases.

Thus while the Smart Museum drawing is an independent work, vigorous and taut, nonetheless it represents many stylistic features characteristic of Kline's most mature work. Kline was an innovator and a simplifier, who as one critic said, "between 1950 and 1956 set black and white on fire."[5] The fragile condition of the drawing belies its power and its significance as a testament of Kline's powerful Abstract Expressionism.

Thomas F. Rugh

1. Clement Greenberg, *Art and Culture* (Boston: Beacon Press, 1961), 151. Greenberg's original evaluation appeared in *Partisan Review* in 1952.
2. Both paintings are illustrated in Harry F. Gaugh, *The Vital Gesture: Franz Kline* (New York: Abbeville Press, 1985), 94–95 and 103, respectively.
3. Franz Kline, quoted in Katharine Kuh, *The Artist's Voice* (New York: Harper and Row, 1962), 144.
4. Ibid., 144.
5. Gaugh, *The Vital Gesture*, 22.

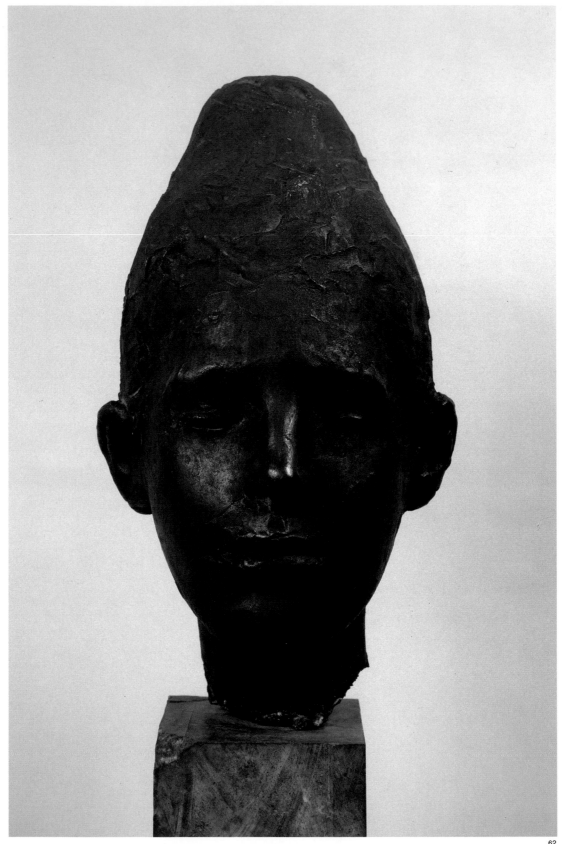

Giacomo Manzu
Italian, b. 1908

62 *Sonja's Head*, 1955
 Cast bronze, h. 13 in. (33 cm.)
 Gift of Allan Frumkin
 1981.94

The Italian sculptor Giacomo Manzu, born the eleventh child of a poor family in Bergamo in 1908, enjoyed little formal training in art. Various early apprenticeships, to a wood carver and gilder and to a decorator in plaster, preceded his brief enrollment at the Verona Academy in the late 1920s. Essentially, however, Manzu is self-taught in the techniques of cast sculpture. His autodidacticism is somewhat astonishing, given achievements like *Sonja's Head* and important commissions such as relief portals for St. Peter's in Rome (1940) and for Strasbourg Cathedral (1955).

Manzu's work both reflects and has assimilated a wide variety of sculptural traditions. It is distinguished by its wonderful revivification of ancient and Renaissance figurative bronze sculpture in which a very sensitive play of emotion, often of a seemingly transient nature, is caught freshly and immutably in the spontaneous modeling touches of the living artist and the "eternal" permanence of the bronze material. These are qualities we admire in the busts and portraits of Donatello, whether in terracotta or bronze, and which give to us, centuries later, the immediate awareness not only of the artist's animated eye and hand but also of the fleeting state of mind of the subject. The subtlety of Manzu's modeling and his uncanny ability to deal with the most evanescent expressions recall his great predecessor and compatriot Medardo Rosso, who at the turn of the century created such a memorable gallery of figures and heads in wax, plaster, and bronze. Also, the tell-ing delicacy and sureness of Auguste Rodin's touch, assimilating as it does the French eighteenth-century tradition of terracotta portrait busts which was transmitted to him by his early master, Albert-Ernest Carrier-Belleuse, is discernible in Manzu's art. In fact, the dreamy absorption in the features of Rodin's first major successful bronze figure, *The Age of Bronze* (1877), is akin to the strange internal awareness seen in *Sonja's Head*.

Sonja's Head comes from a period in which Manzu worked regularly with two striking models, sisters whose sullen beauty and odd combination of tranquility with fresh, mobile features fascinated him. The girls figure in a variety of Manzu's works from the mid-1950s, either as entire figures of skaters, dancers, and the like or as single heads. In the heads, Manzu has lavished the most sensitive imaginable surface treatment upon the original wax to capture the trembling softness of the flesh and skin over the underlying structure of bone, and has also given the model an expression of timeless, inward mental focus, apart from the countless changes and incidents of daily existence. The closed eyes of *Sonja's Head* seal out the shifting aspects of the external world and emphasize instead the primacy of a secret inner life, experienced in sleep or dreams, or in trancelike concentration. Moreover, the smooth hair piled atop the head gives the whole piece the powerful suggestion of the beautiful and sleek cranial shapes of Amarna-period Egyptian royal portrait heads, and also brings to mind the swelling *usnisa* topknots and cranial bulges of Ghandaran, Tang Chinese, or Khmer classic images of Buddha—the outer, physical signs of spiritual wisdom.

The casting of this unique bronze sculpture is of the greatest refinement. Very careful attention has been given to the color, chasing, and patination of the metal to give the head, simply as a metal object, a remarkable degree of sumptuous material beauty, so much so that an important proportion of the emotion created by the piece resides in this ravishing technical expertise.

Dennis Adrian

Larry Rivers
American, b. 1923

63 *Portrait*, 1956
 Oil on canvas, 21 x 26 in. (53.3 x 66 cm.)
 Gift of Lindy Bergman in memory of Edwin A. Bergman
 1986.14

Born and reared in the Bronx, New York, Yitzroch Loiza Grossberg changed his name to Larry Rivers in the early 1940s while earning a living as a saxophonist in various jazz bands. Rivers first studied painting informally with Nell Blaine in 1946, and subsequently with Hans Hofmann and William Baziotes, among others. By the early fifties, he had earned a bachelor's degree in art education from New York University. During this time, Rivers frequented the Cedar Bar in lower Manhattan, where he met Willem de Kooning, Jackson Pollock, Franz Kline, and other abstract expressionist painters. Also decisive for the formation of his style, and confirming his particular interest in representation, were exhibitions of paintings by Pierre Bonnard and Chaim Soutine at the Museum of Modern Art in 1948 and 1950 respectively, and a 1952 exhibition of de Kooning's *Woman* paintings. In a series of works produced during the early 1950s, Rivers converted the Abstract Expressionists' emphasis on gesture and heavily worked surfaces into an elegant, nervous script of drawn, smudged, or partially erased lines which construct recognizable images.

Rivers moved to Southhampton, Long Island, which was then emerging as a veritable artists' colony, in 1953, and found employment as a part-time art instructor. During that year, his neighbor Fairfield Porter, a representational painter and critic for *Art News* magazine, invited Rivers to use his studio. There Rivers executed his enormous *Washington Crossing the Delaware*, which immediately became a *succès de scandale* and was acquired for the Museum of Modern Art. John Bernard Myers, at that time director of Tibor de Nagy Gallery, where Rivers exhibited from 1951 until 1963, secured various commissions for the artist in those early years. The many portrait commissions of 1955 and 1956 provide evidence of both Myers's influential support and the effect of museum purchases such as the Modern's on Rivers's career.[1]

The Smart Museum portrait is similar in style and execution to the 1956 portrait of Dr. Kenneth Wright (Southhampton, New York, Collection of Dorothy Wright), though the latter is painted on a terracotta-tinted ground.[2] Both portraits feature a frontal, bust-length presentation whose effect is one of attention and formality. The facial features are more evenly finished in these commissioned portraits than in those Rivers painted of his family and friends. In the Smart Museum canvas, the formally dressed woman is placed against a sketchy background. On the left, vertical forms and a washed plane suggest a window, while delicately drawn foliates and arabesques can be read as embroidered lace curtains and floral wallpaper. To the right, another figure is vaguely implied by the line of a shoulder and neck. (Rivers frequently included several positions of the same figure in his paintings of this period, evocative more of informal sketching procedures than of the multiple viewpoints of Cubism.) A string of pearls whose position has been shifted slightly downward on the sitter's throat reminds one of de Kooning's *Woman and Bicycle* (1952–1953, New York, Whitney Museum of American Art), in which smiling teeth reappear below the figure's mouth as a necklace.

The painterly incidents that enliven this portrait recall Rivers's contention that he thinks of a painting as " . . . a surface the eye travels over in order to find delicacies to munch on a smorgasbord of the recognizable."[3] This notion owes much to the aesthetic proposed by Rivers's close friend Frank O'Hara, whose poems juxtapose fragments in an often provocative mixture of the poignant and the mundane. Defining himself in distinction to his friend de Kooning, Rivers remarked: "I am the kind of person who lets himself be moved by outside influences. I paint and draw on commission a lot of my art comes from other peoples' desires."[4] Thus, while the occasional portrait is exceptional in de Kooning's oeuvre, Rivers consistently pursued an anecdotal, representational imagery in conscious opposition to prevailing avant-garde taste.[5] Paradoxically, it is his willingness to work in traditional genres and his ability to move easily in the social milieu of art collectors—both exemplified in this painting—that constitute an important part of Rivers's originality.

Levi Smith

1. Early critical and financial support also came from the art historian Meyer Schapiro, and Alfred Barr, Director of the Museum of Modern Art. They were backed by the Gloria Vanderbilt Stokowski Foundation, which provided funds for the purchase of *Washington Crossing the Delaware* and Rivers's earlier painting, *The Burial*, acquired for the Fort Wayne Museum by Schapiro. The following year, Rivers's *Self-Figure* was acquired by the Corcoran Gallery of Art, Washington, D.C. In 1956, the Whitney Museum bought his *Double Portrait of Berdie* and the Metropolitan Museum of Art, New York, acquired a portrait of his mother-in-law Berdie, titled *The Sitter*.

2. Illustrated in Helen A. Harrison, *Larry Rivers* (New York: Harper and Row, 1984), 58.

3. Quoted in Irving Sandler, *The New York School* (New York: Harper and Row, 1978), 108.

4. Larry Rivers, in Rivers and Carol Brightman, *Drawings and Digressions* (New York: Crown Publishers, 1979), 259.

5. Rivers's later portraiture is represented in the Smart Museum collection by *Spirit of Chicago (Carol Selle)* of 1967 (oil on canvas with collage, acc. no. 1986.167).

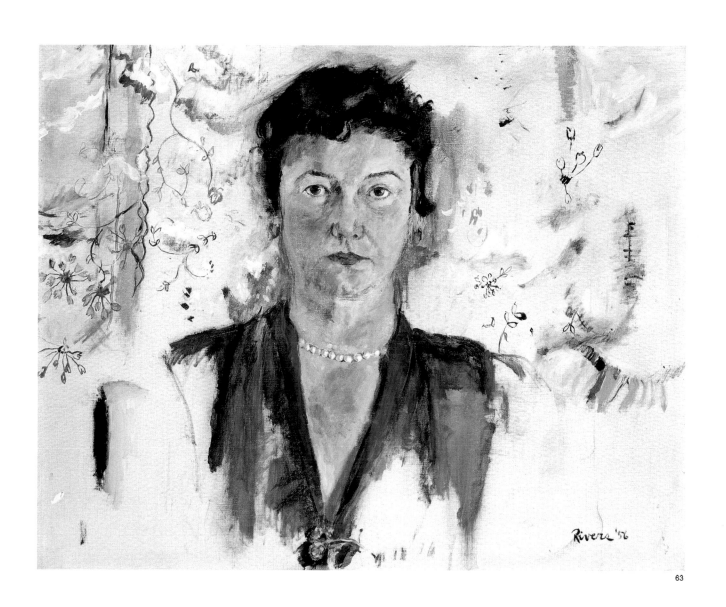

Isamu Noguchi
American, 1904–1988

64 *Iron Wash* (*Okame*), 1956
 Cast iron, h. 9½ in. (24.1 cm.)
 Botnick and Grove 421
 The Joel Starrels, Jr. Memorial Collection
 1974.183

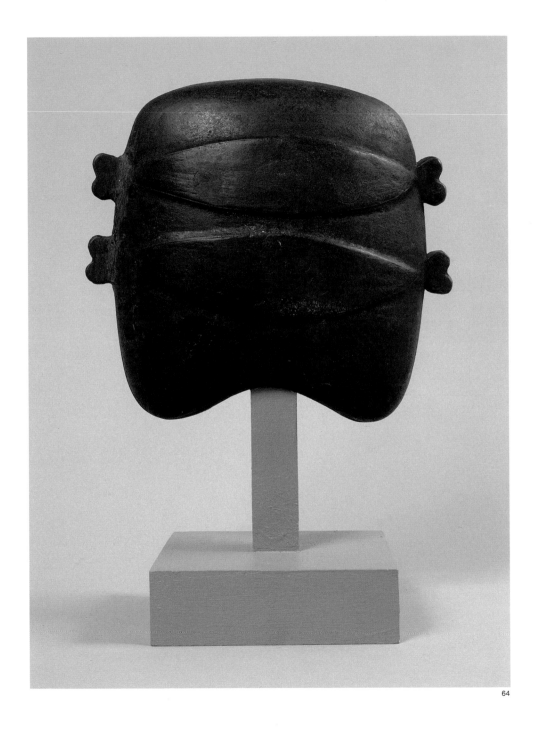

64

Born in Los Angeles of an American mother and a Japanese father, Isamu Noguchi was brought to Tokyo two years later, where, at age ten, he was apprenticed to a Japanese cabinet-maker. The sensitive appreciation for materials and tools he developed at this time was later reinforced by a studio assistantship to Constantin Brancusi in Paris in 1927, after a period of study in LaPorte, Indiana, and New York. Throughout his career, Noguchi worked in a variety of materials, including terracotta, bronze, iron, aluminum, slate, marble, stone, paper, glass, and plastic, carefully responding to their inherent physical properties.

Among Noguchi's earliest projects were abstract sculptures indebted to Brancusi and portrait heads in the tradition of Auguste Rodin. By the mid-1940s, he was working with biomorphic shapes reminiscent of the surrealist paintings of Joan Miró or sculptures of Jean Arp. Despite such overt responses to European art, Noguchi was concurrently stimulated by Japanese gardens and their unique spatial properties; he designed his first environmental projects in 1933, eventually laying out gardens in Tokyo, Paris, and Tel Aviv. Although identified with sculptors of the New York School in the forties and fifties, Noguchi is not easily classified, and is best understood as an individualist. Not surprisingly, in Japan his work often has been considered foreign, whereas in the West his sculpture is regarded as oriental in nature.

Noguchi's activity in cast-iron sculpture is preceded by and related to previous work in fired clay. His earliest pottery dates from the beginning of the 1930s, when he studied ceramics with the famous Kyoto potter Uno Jinmatsu and was impressed by the unglazed terracotta *haniwa* figurines of warriors, shamans, and animals that guarded the tumulus burials of Japan's bronze- and iron-age Yayoi culture. After a hiatus of two decades, Noguchi returned to terracotta during trips to Japan in 1950 and 1952, when he met the great folk potter Kitaōji Rosanjin, who introduced the sculptor to the Bizen pottery tradition. The coarse clays, unglazed surfaces, and simple construction methods employed in high-fired Bizen ware immediately informed the conception of Noguchi's own ceramic pieces. In 1952, the artist wrote of his new work in clay: "There has I trust been a minimum of imposition of will and thought. The medium which is the earth itself has its own way."[1] Noguchi's quasi-figurative ceramics from this period revivified the relationship between pottery and statuary that is the essence of *haniwa* figurines.

A series of iron sculptures, including *Okame*, followed between 1954 and 1957. Noguchi was an admirer of medieval Japanese iron pots, especially the unpretentious water kettles prized by Japanese tea-masters as the embodiment of lofty aesthetic ideals. Noguchi's fondness for native iron casting and his renewed interest in folk pottery dovetailed perfectly, since ceramic models and molds are central to iron casting.[2] Finding in the city of Gifu masters skilled in traditional methods of iron casting, the artist "set about making objects . . . more

simple and crude than one would normally associate with bronze."[3] Each of the four casts of *Okame* is marked by an individual finish of light incisions, rough patches, depressions, and the occasional hole; in the final chasing Noguchi imparted a unique aspect to each piece, rejecting the uniformity conventionally sought in sculptural editions in the West.

The alternate title of the Smart Museum sculpture, *Iron Wash*, may allude to the Japanese iron kettle; *Okame* translates as "honorable bell" and implies a sense of good fortune.[4] Like another work from the series, *Bell Image*, *Okame* manifests features of ancient bronze bells of the Yayoi culture: the piece is symmetrical, with a continuous profile broken by knobby projections, surface decoration of stringcourses or bands, and clearly defined front and back views. In particular, the double sets of scrolled protrusions and their placement in *Okame* recall the ornamental flanges of such bells. Ceremonially buried in the countryside, these bells, called *dōtaku*, seem to have been cast expressly for ritual purposes and were never intended to be sounded in daily use, since they are without clappers and their walls are too thin for resonant striking in the fashion of the Chinese gong. The flanges, surface bands, and double incised circles of *Okame* suggest a human head as in many *dōtaku*. The shape of *Okame* also recalls the late Zhou clapperless Chinese gong, in its squarish profile, curved open bottom, and flattened form.[5]

The contradictions of the *dōtaku*—utilitarian shape/nonfunctional construction, common utensil/cultic use—parallel the ambiguity of form and meaning in Noguchi's iron sculptures. The artist may have conceived *Okame* as both a mysterious implement fraught with private significance and an autonomous object within the Western sculptural tradition. Moreover, his professed admiration for the "archaic and primitive" reveals a concern for the possibility of universal meaning in forms inspired by the artist's response to his environment, because, in Noguchi's words, "the repeated distillation of art brings you back to the primordial."[6]

Richard A. Born

1. Isamu Noguchi in Shuzo Takiguchi, *Noguchi* (Tokyo: Bijutsu Shuppan-Sha, 1953), n.p.

2. Almost symbolically, a photograph of Noguchi's Japanese studio in 1952 shows both a traditional iron kettle on the hearth and a terracotta *haniwa* head displayed in a niche above. See Noguchi, *Isamu Noguchi: A Sculptor's World* (New York and Evanston, Ill.: Harper and Row, 1968), pl. 74.

3. Ibid., 35.

4. My thanks to Professor Harrie A. Vanderstappen for help in translating and interpreting the Japanese title.

5. Noguchi's reference to Japan's early material culture in *Okame* or in the 1963 granite carving *Jōmon*—the title refers to the neolithic culture of Japan distinguished by its ritual terracotta female figurines—is never illustrative. The allusion is to the essential quality of the model, not its mere outward appearances, in the manner of traditional Chinese painting, and indeed, Noguchi studied brush painting for eight months with the master Qi Baishi in Beijing in 1930.

6. Katharine Kuh, "An Interview with Isamu Noguchi," *Horizon* 2 (March 1960): 112.

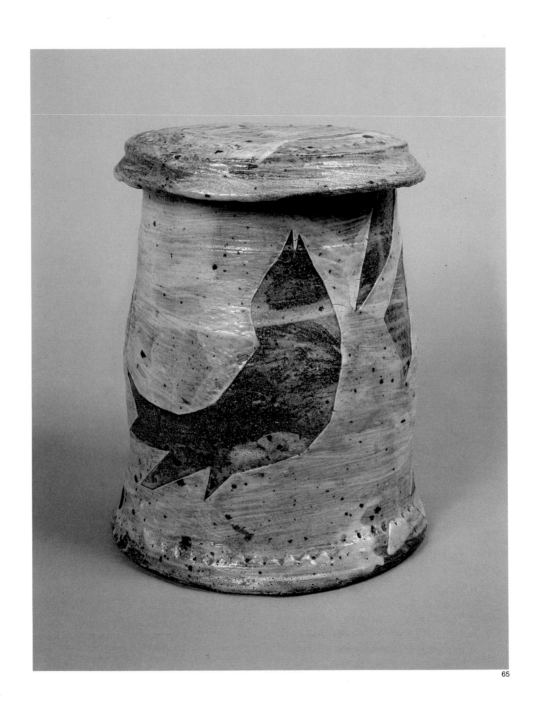

65

Peter Voulkos
American, b. 1924

65 *Covered Jar*, 1956–1957
Stoneware with negative stencil relief, iron-oxide slip,
cobalt slip, thin transparent glaze; h. with lid 8½ in.
(21.6 cm.)
The Duffie Stein Collection
1976.162

Peter Voulkos is widely considered the major force of the far-
reaching ceramics revolution generated at the Otis Art In-
stitute (later the Los Angeles County Art Institute) in Califor-
nia during the mid-1950s. His ideas, technical expertise, and
enormous vitality provided a model for several generations of
artists working in clay and seeking a new aesthetic identity
based on both ceramic tradition and contemporary fine-art
theory.

Born in Montana of Greek immigrant parents, Voulkos
studied painting on the G.I. Bill but subsequently turned to
ceramics in his senior year, completing a master's degree at the
California School of Arts and Crafts in 1952. As chairman of
the newly formed ceramics department at Otis in 1954, he at-
tracted students by virtue of his national reputation as a prize-
winning potter of astonishing facility and innovation. Soon
after, artists in other media gravitated towards Otis to partic-
ipate in an experiment that was radically to change the per-
ception of clay as a minor art medium.

This experiment was motivated by a crisis of challenge in
Voulkos's goals after he encountered the work of the Abstract
Expressionists. It was during a residency in the summer of 1953
at Black Mountain College in North Carolina, followed by
a visit to New York, that he came in touch with avant-garde
artists in a variety of disciplines, being particularly influenced
by the painters Franz Kline and Willem de Kooning. In a
spirited interchange with students and colleagues at Otis,
Voulkos embarked on a search for new sculptural models
based on pottery's inherent formal properties. Projected in
those structures were the ideals of an expressionist investiga-
tion of spontaneity, process, and material conceived in terms
of the attributes and technology of ceramics.

Throughout this fervent period, which lasted until his de-
parture to Berkeley in 1959, Voulkos continued to throw func-
tional pots much as a composer develops a repertoire of
themes. The Smart Museum's jar, produced at Otis and re-
cently redated by the artist to 1956 or 1957, should be consid-
ered in this context. Its shape, ornamentation, and brushwork
exhibit a compilation of earlier traditional influences while
providing some indication of future development. The loose
handling of the slightly bellied cylindrical pot and the brushy
treatment of the white slip surface suggest both the Zen idea
of beauty in imperfection and expressionist demonstrations
of intuition and gesture in material form.

The flared foot and beveled capped lid—Voulkos wrote his
master's thesis on lids—of the elemental pottery shape recall
the fundamentalism of folk pottery: Japanese peasant jars,
early American stoneware butter crocks, and Korean burial
urns of the ninth century. The naïveté of the indented zigzag
banding that runs along the foot of the jar and top of the lid
are in some contradiction to the modernist surface decoration.
Consciously influenced by the paper cutouts of Henri Matisse,
Voulkos devised a negative relief technique in 1953 which was
later used on this jar. He cut stencils out of heavy blotter pa-
per, soaked them in water, and edged them with cobalt slip.
He applied the patterns to the jar, already brushed with a light
coat of white slip, and then brushed a second, heavier coat of
slip over the entire jar. When the stencils were removed, a thin
relief of about one thirty-second of an inch had been created
around the indented patterns. These are further enhanced by
the bleeding of the cobalt color into the white ground. Finally,
the artist applied a thin coat of transparent glaze before firing
the vessel in a reduction gas kiln at cone 10.

The upward thrust of the flat, sharp-edged birds and tree
asymmetrically placed around the vessel play against the
horizontal brushing of the slip surface. This visual tension
projects a sense of the process of wheel-thrown pottery in the
kinetic opposition of the rotating wheel in relation to the ver-
tical tug of the pulled pot. Such verticality recurs more em-
phatically in the artist's stacked sculptures of the seventies,
where the elemental aspects of this jar form echo in the lower
section of the pieces. In this respect, the Smart Museum's cov-
ered jar can be seen as a transitional piece.

Esther Saks

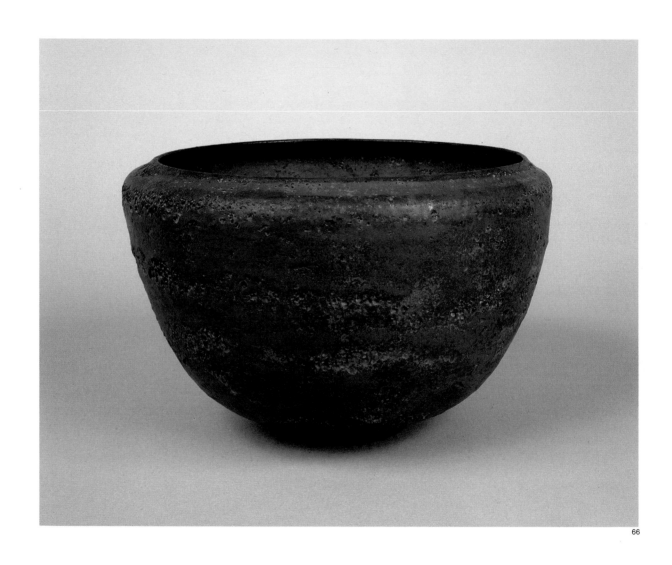

Gertrud Natzler
Austrian, 1908–1971
Otto Natzler
Austrian, b. 1908

66 *Bowl*, circa 1960
 Earthenware, uranium glaze; h. 5⁷⁄₁₆ in. (13.9 cm.),
 diam. of foot 2⅛ in. (5.3 cm.),
 diam. of mouth 7¹⁄₁₆ in. (18 cm.)
 Gift of Mr. and Mrs. Leon Despres
 1975.47

Gertrud and Otto Natzler met in their native Vienna in 1933 and set up a studio that same year with only a few months training in ceramics between them. Their early efforts determined the division of talent that lasted until Gertrud's death; she threw the pots and Otto created the glazes. The Natzlers left Vienna for the United States in 1938 and settled permanently in Los Angeles one year later.

The Natzlers' aesthetic aim was to explore the potter's traditional materials and classic shapes of bowls and vases. Gertrud was a natural potter, and her thin-walled and graceful vessels shaped the Natzlers' approach to their art. They were not alone in their goals; a revival of interest in the standard methods and forms of ceramics had begun in the United States in the late 1930s. The example and teaching of such potters as Glen Lukens in Los Angeles and Arthur Baggs in Columbus, Ohio, helped halt the attempts of American ceramicists to compete with sculptors in designing large clay figures, and led back to work with the potter's wheel and kiln. America had an audience receptive to the Natzlers' work from their first days in this country.

The Smart Museum bowl is a fine example of the Natzlers' most renowned decorative glaze—the crater or volcanic glaze. Otto first developed the glaze in 1948 by accident when he tried to make an ordinary glaze of many colors and layers. He analyzed and experimented with his mistake until he could repeat the result. His crater glaze is admired for its evocation of fire: the pitted surface and bubbly texture of the glaze, caused by gases rising up from the underlayers, suggest the intense temperature in the kiln during the firing process. The rough cracks in the outer layer of orange and the exposed inner glazes of brown, gray, and black add to the idea of the destructive power of heat. The association with volcanic heat is intentional; Otto has compared the flow of the glaze on another bowl to lava flowing from the mouth of a volcano.[1] Neither Natzler would admit to any influence on their art except that of nature, especially nature as seen in the deserts and volcanic sites of California and the western United States, the forms and colors of which can be seen in their crater glaze. The bowl itself is typical of Gertrud's work—small and shaped to fit in one hand with a tiny base spreading out to a larger and beautifully articulated rim. The Natzlers believed that certain glazes were suitable for certain pots, so that one most often sees the crater glaze on bowls of this shape.

Cheryl Washer

1. M. H. de Young Memorial Museum, *The Ceramic Work of Gertrud and Otto Natzler* (San Francisco: Fine Arts Museums of San Francisco, 1971), 20.

Mark Rothko
American, 1903–1970

67 *Untitled*, 1962
 Oil on canvas, 81 x 76 in. (205.7 x 193 cm.)
 Gift of Mrs. Albert D. Lasker
 1976.161

Born to Russian-Jewish parents in Dvinsk, Russia, Mark Rothko emigrated with his family to the United States at age ten. He attended high school in Portland, Oregon, and later studied mathematics at Yale University. Leaving Yale before completing his degree, he moved to New York, where he enrolled at the Art Students League with Max Weber in the twenties and worked for the Works Progress Administration's Federal Art Project in the late thirties. In 1945, Rothko was given an exhibition at Peggy Guggenheim's Art of This Century gallery, which presented works by European Surrealists in exile as well as by American artists such as William Baziotes, Robert Motherwell, Jackson Pollock, and Clyfford Still, who were later associated with Abstract Expressionism. From the late forties through the sixties, Rothko, Still, Adolph Gottlieb, and Barnett Newman pursued a somewhat independent style focusing on symbolic content expressed in broad, sweeping areas of color. Identified as the color-field or emblem painters within the abstract expressionist group, they developed an approach that contrasted with the less overtly symbolic and more spontaneously gestural style of Pollock, Willem de Kooning, and Franz Kline. Later in his career, Rothko extended the ideas introduced in his painting to several large-scale mural commissions including, in the mid-sixties, the entire interior of a small interfaith chapel at St. Thomas University, Houston, now widely known as the Rothko Chapel. In 1968, he suffered a severe illness which led to deep depression, to his final black and gray painting series, and ultimately to his suicide in 1970.

In 1943, Rothko, Gottlieb, and Newman stated in a famous letter to the editor of the *New York Times*, "We assert that the subject is crucial and only that subject is valid which is tragic and timeless."[1] This became a guiding principle for Rothko, reiterated at various points throughout his career. During the forties, his work evolved through phases of pictographic subjects based on mythological themes, to biomorphic "undersea landscapes," to his ultimate abstract statement about 1949 or 1950. The format developed at that time of several brushy rectangles floating within a broad field became the primary focus of the next two decades of his work, although variations

did occur in the murals and in the final, even more minimal black and gray series. While Rothko explored a broad variety of color combinations in his work of the fifties, his palette became generally more somber and brooding by the late fifties and early sixties. The works of this period are more palpably "tragic" in feeling, though it was certainly not through darker tones alone that Rothko sought to communicate his essential content.

Untitled (1962) is a representative example of Rothko's style of the early sixties. It continues his signature format and incorporates the more sober, closely related hues typical of the work of that period. The painting's larger upper rectangle is tinted a sharp violet over maroon, which gives the color area a deep, pulsating life. The lower rectangle, a flatter matte red, unites more firmly with the unusually loosely brushed, maroon ground. *Untitled*, like all Rothko's works in this format, is a study in ambiguity: the rectangles seem alternately to grow and shrink, to sink within or emanate from the surrounding field. Rothko's subtle layerings of sponge- and rag-applied colors seem to glow from some inexplicable source within the painting. This sense of the form and light seeming to advance and recede in Rothko's compositions, to glow and fade, is the carrier of his content. His paintings have life, are about life, but always life on the verge of extinction.

From his early surrealist-inspired interest in myth, his study of Friedrich Nietzsche's *Birth of Tragedy*, and his undoubted awareness of existential philosophy, Rothko formulated the notion of the necessity for art to transcend the hopelessness of life lived in the face of death. From his consciousness of World War II and the Holocaust, and perhaps his own psychological predisposition, he internalized this sense of the tragedy of life. In his words, he wanted to overcome the "unfriendliness of society" and "concern with the fact of mortality" through "transcendental experiences."[2] For him, painting was this transcendental experience, though it finally remained tragic because fate could not be overcome. Such was the content Rothko wished his fluttering rectangles of color to convey. Though the extent of their tragic content must be measured in the response of each viewer, it is important to note that the color, luminosity, and fluid space that activate *Untitled* and most of Rothko's canvases always evoke an equivocal and ultimately fragile existence.

Russell Bowman

1. Adolph Gottlieb, Barnett Newman, and Mark Rothko, letter to the editor, quoted in Edward Alden Jewell, "'Globalism' Pops into View," *New York Times*, 13 June 1943; reprinted in Herschel B. Chipp, ed., *Theories of Modern Art* (Berkeley: University of California Press, 1968), 544.
2. Rothko, "The Romantics Were Prompted," *Possibilities* 1 (Winter 1947/48): 84; reprinted in Chipp, *Theories of Modern Art*, 548.

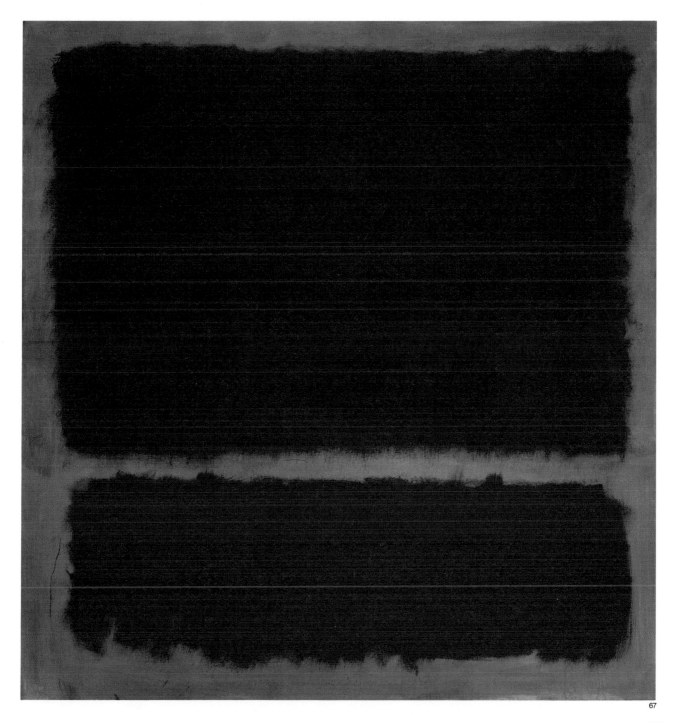

John Chamberlain
American, b. 1927

68 *Untitled*, 1963
Welded painted and chromium-plated steel automobile
body parts, 36 x 50 x 53 in. (91.4 x 127 x 134.6 cm.)
Sylvester 172
Gift of Mr. and Mrs. Richard L. Selle
1972.3

Born in Rochester, Indiana, Chamberlain moved to Chicago in 1931, following his parents' divorce, to live with his maternal grandmother. After a stint in the United States Navy from 1943 to 1946, he returned to Chicago, where he worked as a hairdresser and, briefly, studied sculpture at the School of the Art Institute. In 1955, he attended Black Mountain College in Asheville, North Carolina, encountering the poets Charles Olson, Robert Duncan, and Robert Creeley, whose ideas would have a lasting effect on his work. Chamberlain spent the years from 1956 to 1963 in New York, at which time he became known for his sculptures made of crushed automobile parts. After 1963, he developed a pattern of living several years in the western United States alternating with several years on the East Coast. Presently he resides in Sarasota, Florida.

Chamberlain's arrival in New York coincided with both a renewed interest in abstract sculpture and its formal problems, and the introduction of images of everyday objects into painting and sculpture by artists such as Jasper Johns. In 1958, while Johns displayed his target and flag paintings at the newly opened Castelli Gallery, Chamberlain exhibited *Shortstop*, the first of his many auto-part sculptures, at the Tenth Street Cooperative, Hansa Gallery, with members of the New Sculpture Group. This group sought an abstract art based on non-relational composition (that is, rejecting balanced relations of part to part and part to whole as a compositional ideal)[1] to supplant older sculptural methods derived from cubist principles. *Shortstop*, made from parts of a junked Ford belonging to the painter Larry Rivers, was spot-welded but also driven over, "literally and figuratively retaining the tracks of its making."[2]

The Smart Museum sculpture, *Untitled*, is one of the large auto-body works made just prior to Chamberlain's departure from New York for the West Coast in 1963. Like other sculptures from this New York period, *Untitled* was constructed by nesting one piece of contoured or crumpled painted sheet-metal into another so that the sculpture is built up into a dense mass, held together by gravity, which stresses the physical properties of the metal. (After construction, the parts were welded together to allow the work to be moved in one piece.) Above all, Chamberlain emphasizes the importance of "fit," a concept relating to his early fascination with Hindu sculptures depicting "columns of people all huddled together."[3] A snug assemblage of disparate parts, with its restless movement and multiplicity of complex profiles *Untitled* nonetheless resists easy visual analysis of the mechanics of its structure.

This piece combines the abstract aims of the New Sculpture Group with the references to American culture seen in Johns's work. Chrome bumpers, a gas tank, running-board (from a pick-up truck?), the winglike, dented, olive-green hood, even a motorcycle fender conjure up the piles of rusted, crushed autos that are familiar sights along American highways. Such cultural allusions, however, differ from those of Johns in that they are inherent in the materials and the way the materials are used rather than in what the work of art depicts. Although Chamberlain's preoccupation with the physicality of his medium, the process of making, and the object quality of sculpture forecasts the work of Donald Judd and Richard Serra in the late sixties and early seventies, his sculpture still reflects the existential concerns of artists and poets of the early 1950s where chance and free association were integral to the work of art. Certainly the paintings by Willem de Kooning and Franz Kline in the collection of the Art Institute of Chicago had made a deep impression on Chamberlain during his student years, and Abstract Expressionism has always informed his thinking about color, form, and intuitive procedures.

Following the construction principles of his sculpture, Chamberlain often titled works with short words or syllables that fit together through sound to make a new connection. Earlier titles such as *Jo-So* or *Longclove* of 1960, for example, recall the collage effects of Black Mountain poetry. However, the lack of a title for the Smart Museum sculpture reflects the artist's shift in focus in 1963 from the poetic free association of the previous decade towards the more abstract, formal issues that dominated American sculpture in the 1960s.

Holliday T. Day

1. For a later discussion of non-relational composition, see Donald Judd's remarks in Bruce Glaeser, "Questions to Stella and Judd," in Ellen Johnson, ed., *American Artists on Art: 1940–1980* (New York: Harper and Row, 1982), 114–115.
2. Klaus Kertess, "Color in the Round and Then Some: John Chamberlain's Work, 1954–1985," in Julie Sylvester, *John Chamberlain: A Catalogue Raisonné of the Sculpture 1954–1985* (New York: Hudson Hills Press in association with the Museum of Contemporary Art, Los Angeles, 1986), 29.
3. John Chamberlain in "Auto/Bio: Conversations with John Chamberlain," in Sylvester, *Catalogue Raisonné*, 10.

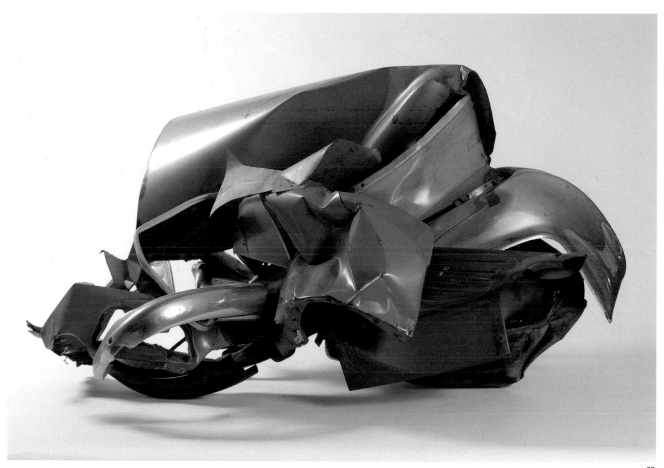

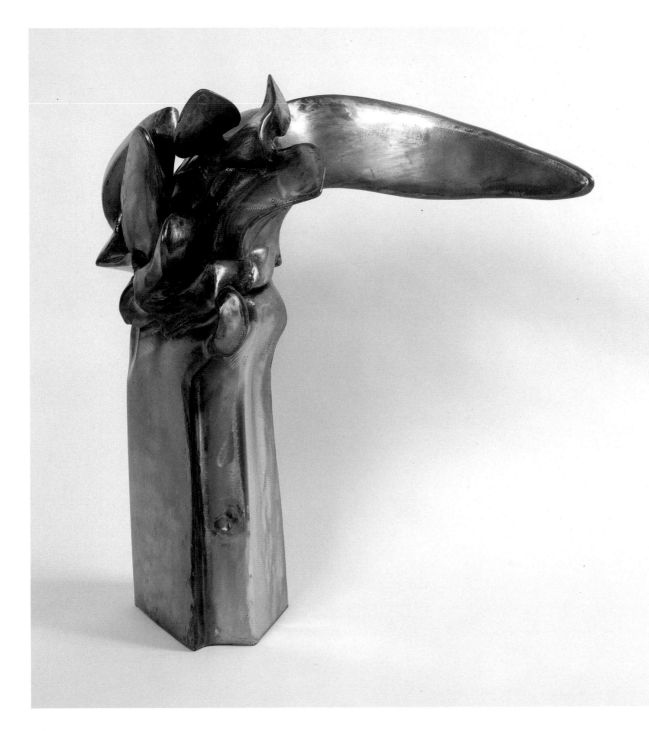

Richard Hunt
American, b. 1935

69 *Winged Hybrid Figure No. 3*, 1965
 Welded steel, h. 27³/₁₆ in. (69.2 cm.)
 Gift of Mr. and Mrs. Edwin A. Bergman in honor
 of Charles and Hanna Gray
 1982.3

Along with Cosmo Campoli, Joseph Goto, and H. C. Wester-mann, Richard Hunt represents the finest expression of modern sculpture in Chicago from the generation of artists whose first artistic maturity was achieved at the end of the 1950s. Although these four sculptors have strongly differing styles, Hunt may be said to share, particularly in his works of the 1960s such as *Winged Hybrid Figure No. 3*, some of the concerns of two of the other three. The bold and massive volumes of directly welded metal have some affinities with Goto's dense and ponderous steel pieces, and the organic forms make one think of some of the swelling budlike shapes in Campoli's bronzes.

Hunt's piece is one of a large number of compositions in which the formal themes of a massive, usually vertical socle, and a flamboyant upper section growing out of it combine shapes that seem related to the beams and bars of industrial metalwork with others that appear to have been formed by the principles of natural growth. The organic shapes can suggest such things as the articulated shoulder, clavicle, and scapular bones of some creature, tumescent buds or rhizomes, the air- or water-worn core of some figurative sculptural fragment, or all of these things. The association of these particular forms connected with ideas of things living or once so and their material—steel—is sharp and memorable. The alate nature of the large horizontally cantilevered bladelike shape has a metaphorical function here and brings forth ideas about imaginative poetic flight, the unfettered nature of artistic invention, and becomes poignant when one realizes that the whole composition can be read as a fragment of some winged entity, no longer of the air and realms of flight but now transformed into a heavy material fixed and earthbound. A parallel but contrasting idea is that out of the world of regular forms of industrial production may grow freer, less predictably regular forms of art.

The group of pieces in which Hunt explores these and related ideas forms the central focus of his fully mature work. Compositions of this kind exist in small maquettes and sketches (usually bronze) to very large monumental pieces in aluminum, bronze, or Cor-ten steel. The present piece, a gift from the distinguished collection of Mr. and Mrs. Edwin A. Bergman, is among the most complex and vigorously designed and carefully finished works from the group.

Dennis Adrian

Philip Pearlstein
American, b. 1924

70 *Portrait of Allan Frumkin*, 1965
 Oil on canvas, 60 x 48 in. (152.4 x 121.9 cm.)
 Bowman 259
 Gift of Allan Frumkin
 1976.73

Philip Pearlstein was born in Pittsburgh, Pennsylvania, and was the winner of several national high school art competitions. Following army service, which took him to Italy in the final years of World War II, Pearlstein studied art and commercial design at Pittsburgh's Carnegie Institute of Technology (now Carnegie-Mellon University) on the G.I. Bill. In 1949, he moved to New York with his friend and classmate Andy Warhol and, like Warhol, began work in commercial design. While continuing to paint, Pearlstein also completed a master's degree in art history at the Institute of Fine Arts, New York University, with a thesis on Francis Picabia's dada machine aesthetics. His paintings of the fifties are primarily landscapes with heavy overlays of the slashing brushwork so prevalent among the many artists influenced by first-generation Abstract Expressionism. It is important to note, though, that despite the essentially abstract form of these works, Pearlstein always retained some beginning point in nature. Following a 1958 Fulbright Scholarship trip to Italy, Pearlstein began to tighten his brushwork and to adhere to more realistic detail. He began drawing from the figure with an informal artists' group in 1959 and by the early sixties was experimenting with the concept of figure "as landscape" in painting.[1]

In 1962, Pearlstein published an article in *Art News* titled "Figure Paintings Today Are Not Made in Heaven." Outlining the modernist proscriptions against spatial illusionism, he wrote that "it seems madness on the part of any painter educated in twentieth-century modes of picture-making to take as his subject the naked human figure, conceived as a self-contained entity possessed of its own dignity, existing in an inhabitable space, viewed from a single vantage point."[2] It was, of course, precisely this "madness" that he set as a program for himself, and by 1963 he had developed the essential elements of his unique figurative style: the model seen objectively in the studio setting, close and static viewpoint, axial compositions which played between dramatic illusionistic depth and the picture surface, lack of academic "corrections" in drawing, sharp cropping of forms, multiple shadows cast by three incandescent studio lights, and restrained color. Many of these effects derive from the objective recording of his studio experience, but Pearlstein's compositions are also obviously indebted to modernist conventions, particularly the axial thrusts that intersect the edges of Franz Kline's abstract canvases. Like the paintings of so many of his generation, Pearlstein's work represents both a response to and a reaction against Abstract Expressionism.

Along with pop and minimal artists whose work was also developing in the early sixties, Pearlstein maintains a cool and detached attitude at odds with Abstract Expressionism's emotional and painterly abandon. However, in choosing as his subject the traditional figure in an interior recorded from direct observation, he takes on not only modernist canons but also the entire history of art since the Renaissance. It is a measure of his achievement that he has managed to recast realistic depiction through an adherence to modernist objectivity and spatial "push-pull" aesthetics. Thus, he has become, along with his contemporaries Alex Katz and Jack Beal who also apply modernist values to realistic representation, one of the leaders of the so-called New Realism in American art.

In addition to the nude in an interior, Pearlstein has pursued other traditional genres such as portraiture and landscape. The first major-scale portrait in his fully developed realist style, the Smart Museum's *Portrait of Allan Frumkin* of 1965 makes full use of some of the devices employed in his paintings of models: the close viewpoint; "uncorrected" disjunctions in drawing which leave the nearer right hand, for example, much larger than the more distant left hand or the projecting knee larger than the head; the fierce light which delineates each surface variation of hand or face; and the lack of facial expression. While spatial depth is readily apparent in the various axes of arms and legs, this illusionism is countered by the cropping of the figure by the canvas edges, by the limited color and evident brushwork. In this way Pearlstein combines a highly descriptive and fully illusionistic rendering with formal devices that leave his portraits, and his other paintings as well, with a specifically modernist spatial tension. Such tension, along with heroic scale and precise detail, provides the key to the intense physicality of Pearlstein's paintings, both as depictions and as material objects. In *Portrait of Allan Frumkin*, the artist eschews the expression of personality, traditionally thought to be an essential part of portraiture, but creates "a self-contained entity possessed of its own dignity"

Russell Bowman

1. Philip Pearlstein, in conversation with the author, February 1982.
2. Pearlstein, "Figure Paintings Today Are Not Made in Heaven," *Art News* 61 (Summer 1962): 29.

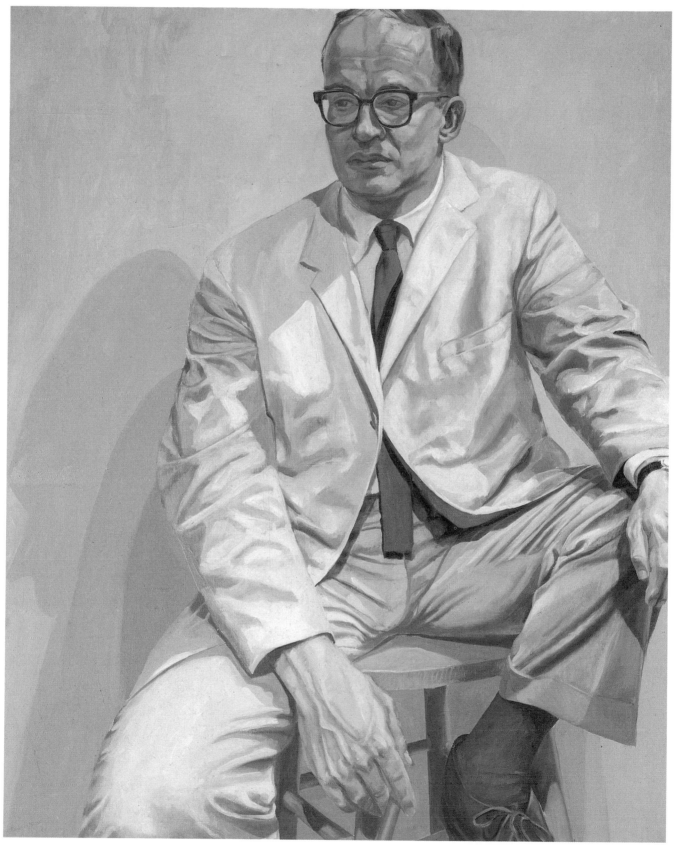

a nice little thing !

71

"Steping off the Room"

ESTIMATE BY J. NUTT

71 (detail of verso)

Jim Nutt
American, b. 1938

71 *Steping [sic] off the Room*, 1971
Acrylic on paper, 13 x 11 in. (33 x 27.9 cm.)
Gift of Gerald Elliott in memory of Leona Etta Spar
1985.4

Throughout the 1960s, a number of artistic developments of great quality, interest, and consequence occurred in the complex realm of Chicago art. These developments were set forth in important exhibitions, frequently organized with the extensive participation of the artists themselves. Perhaps the most memorable of such exhibitions were the three, involving the same six artists, under the title *Hairy Who*, held at the Hyde Park Art Center from 1966 through 1968.[1] These exhibitions, severally and together, stimulated in critical literature the formulation of a stylistic current known as Chicago Imagism. The work of Jim Nutt figured prominently in the *Hairy Who* exhibitions and is regarded by many as paradigmatic of the style and attitude they presented.

Nutt's work is concerned with a figurative imagery that seems to turn away from conventional currents in the West and takes little regard of widely accepted modernist styles. Instead, he creates a private world of *personnages* and invented beings which, although recognizably human, take their forms from intricate manipulations of bold shapes, strong colors, and aggressive patterning, to articulate complex and often disquieting states of feeling. In this pursuit, Nutt's works reflect his fascination with a number of visual sources such as early medieval art, Carolingian miniature painting, tribal arts, popular and folk art traditions, and the art of the insane and naïve (and indeed all varieties of what has come to be called "outsider" art), commercial illustration, Rajput and other Indian painting, and many other things. The elements that Nutt selectively shares with these sources are an interest in high-key, often uninflected color, an emphasis on linear structure and clear contours, seemingly disjunctive appositions of images, abstract designs and visual textures, organic forms, and compositions that are active and replete with intricate details.[2] There is also in Nutt's work an extremely high level of carefully developed and painstakingly realized technical finish.

Another important imagist tendency is to treat painting as an object, underlining the physical nature of the picture in various ways. Along with a number of other Chicago Imagists such as Karl Wirsum and Barbara Rossi, Nutt often uses supports other than canvas or conventional panels for his paintings and has employed such materials as metal, Plexiglas, and paper. *Steping off the Room* belongs to a series of small and intense paintings on paper done in the early 1970s. The support is a stiff sheet of watercolor paper with strongly deckled edges; the acrylic paint covering both sides of the sheet has given it the appearance and feeling of a thin hard leather. As is the case with many of the paintings in this group, the principal image on the recto is the bust of a figure—here, a man—set against a patterned background. A wide painted border of red dots on a yellow ground entirely surrounds the rectangular field of the figural image. Within this border and beneath the inner image field appears the inscription "a nice little thing!" These words can be understood to apply to the figural bust, the mysterious wrapped or bandaged phallic form angling up steeply from the lower limit of the central panel, or to the entire painting itself. The intense gaze the figure directs at the puzzling phallic object suggests that the latter is very likely the principal referent.

The verso of Nutt's painting presents a brilliant field of strong yellow, dotted overall with touches of bright red. Besides the two folded strips of paper (also painted yellow) attached to the back to facilitate hanging, two inscriptions appear, each in a lobular cartouche defined by a narrow white line. The larger of these is placed centrally above the horizontal median of the sheet and reads "Steping off the Room," with the quotation marks in the form of pairs of footprints of shod feet. The other cartouche at lower right reads "estimate by J. Nutt."

Because the artist has executed the verso as meticulously as the recto, the viewer is invited to consider the two sides of equivalent interest and to try to relate the phrases and images of both. Nutt's idosyncratic writing styles, aberrant spelling, and whimsical punctuation prod the viewer to investigate the possibility of expanded meanings in these inscriptions in the forms of visual and aural puns, anagrammatic suggestions, and reversed readings—the artist's surname itself has a variety of such potentials. An exfoliation of the intricate interplay of words and images in this painting would perhaps be tedious, but it is nonetheless important to draw attention to this aspect of most of Nutt's oeuvre.

While Nutt has certainly made paintings of monumental scale (over eight feet), one of his most significant purposes in *Steping off the Room* seems to be to underscore his conviction that works of small, even tiny dimensions can have an importance and power equal to those of much larger ones and that the absorbing complexities of an intimate object can match painting in a mural scale.

Dennis Adrian

1. For a more detailed account of these early exhibitions, see Dennis Adrian, "The Chicago Imagist Print," in Adrian and Richard A. Born, *The Chicago Imagist Print: Ten Artists' Works, 1958–1987. A Catalogue Raisonné* (Chicago: David and Alfred Smart Gallery, 1987), 15.
2. Ibid., 16–17.

Chinese, Shang dynasty, Anyang period

72 *Gu (Ritual Wine Beaker)*, late 13th–early 12th century B.C.
Cast bronze, h. 12 in. (30.5 cm.), diam. of mouth 6¼ in.
(15.9 cm.)
Gift of Prof. and Mrs. Herrlee G. Creel
1986.330

This object belongs to a class of ritual vessels used by the Shang, the first fully attested archaeologically verifiable dynasty in China. Although the ancient name of this type of vessel is not known, it has been called a *gu* since the eleventh century A.D., when scholars of the Northern Song dynasty published the first systematic studies of Chinese bronzes. Known as a wine beaker, the *gu* may well have been used to pour wine libations during ancestor worship. The form of this particular vessel in the Smart Museum collection is characteristic of the mature *gu*: the long bell of the neck fits into the socket of the short tubular waist section, and the floor of the vessel is at the lowest point of the waist, just above the cross-shaped opening on the hollow foot.

This architectonic structure reflects the way the piece was cast. Using piece-molds, the bronze master did nothing to hide the traces of the process. Instead, low flanges actually mark the junctures between mold sections on the foot and waist assemblies. Often seen on later vessels, seldom on earlier ones, these flanges never exist out of technical necessity but because bronze masters of the Anyang period delighted in celebrating structure despite their complicated and risky procedures. They had first to produce clay molds which could be carved or impressed with the delicate designs that would appear in reverse on the finished object. A vessel like this one required twelve mold pieces, four each for the foot, waist, and neck. Next, all these molds had to be bound around two cores shaped like the interior of the vessel. Finally, the whole assembly had to remain stable when the molten metal was poured into the narrow cavity between the mold sections and the cores. It is interesting to note that this *gu* was designed according to a very precise mathematical canon which dictated every aspect of its shape and proportions.[1]

In 1936, Professor Herrlee Creel, who collected this piece among others during early field work in China, marveled at the precision of the cast decoration on a *gu* similar to this one, noting that the Shang standard had yet to be equaled in modern times.[2] His remarks still hold true. An important feature of the decoration on this vessel is that all motifs are confined to distinct fields. Each zone, whether large or small, enjoys a quasi-independent status while simultaneously contributing to the overall composition. Thus, the animal mask on the foot can be read alone, or with its complementary cicada band, or as part of the total design. But no figure ever spreads beyond its borders. The snakes at the base of the neck zone, like the cicada at the top of the foot, are anchored in their assigned bands within a single mold section, and they do not intrude on the adjacent designs. Of course, the snakes and cicada could trade places; their relative positions are not absolute. The appeal of the decoration depends on the cumulative effect of these arrangements, one element added to another like motifs in a musical composition. The immediate charm of the piece is in its tall and slender shape.

Several excavated *gu*, all from Anyang, have the exact sequence of motifs found on this vessel.[3] The decoration on them is rendered in prominent relief and the different parts of the animal mask—horns, eyebrows, etc.—float unattached on the fine lines of the background. Prominent relief and the so-called dissolved form of the *taotie* (dragon or ogre mask) are symptoms of a late date. Neither trait is apparent in our vessel. Moreover, the snakes and cicada, which are arranged in strict bisymmetrical formality on the other pieces, occur in serial order on this *gu*. Our vessel seems somewhat earlier than the excavated ones. It can be placed in the Yinxu II-III phase of Shang art, that is, the late thirteenth or earlier twelfth century B.C.

Robert J. Poor

1. I made reference to the modular system underlying the form and proportions of such vessels in "The Master of the 'Metropolis'-Emblem Ku," *Archives of Asian Art* 41 (1988): 70–89. A comprehensive study of the subject will appear in a forthcoming volume of the *Bulletin of the David and Alfred Smart Museum of Art*.

2. When Creel's *Birth of China* was first published in 1936, "common knowledge" had it that bronzes were made by the lost-wax process. Creel, however, had a very fine insight regarding the use of molds for casting and technical procedures in general: "Yet there is other evidence which makes it seem that vessels were certainly sometimes cast directly from sectional molds." See Creel, *The Birth of China: A Survey of the Formative Period of Chinese Civilization* (London: Jonathan Cape, 1936; New York: John Day, 1937, Frederick Ungar Publishing Co., 1954, 1964), 113.

3. The *gu* found in the western-zone tomb GM198 exhibits a mask effect in both the waist and foot zones and emphasizes frontality throughout. Chinese archaeologists assign this tomb to the Yinxu III phase (*Yinxu qingtongqi*, Yi series no. 24 [Beijing: Wenwu chubanshe, 1985], 472, pl. 201 [incorrectly captioned GM907], figs. 68.3, 69, and 73.8). A *gu* from another western-zone tomb, GM907, also dated to the Yinxu III phase, has more reserved plasticity, like our vessel, and a similar decor in the waist zone. But GM907 was very much a mixed find. Another *gu* from that tomb looks like a pre-Anyang vessel. (*Yinxu qingtongqi*, 474, pl. 193 [incorrectly identified as GM198:3], figs. 71.3, 73.6; the earlier-looking piece, pl. 202). A pair of vessels found in M2006, R1043 and R1044, are so close to the first example GM198:3 that I attribute them to the same workshop (Li Chi and Wan Chia-pao, *Studies of the Bronze Ku-Beaker*, edited by Li Chi, Shih Chang-ju, and Kao Ch'ü-hsün, Archaeologia Sinica, n.s. no. 1 [Nankang, Taiwan: Institute of History and Philology Academia Sinica, 1964], 50, pl. XXIX-XXX, figs. 35–37). By a strange coincidence, Creel illustrated a vessel in the collection of P. C. Huang which could also belong to this group (Creel, *Birth of China*, pl. IX).

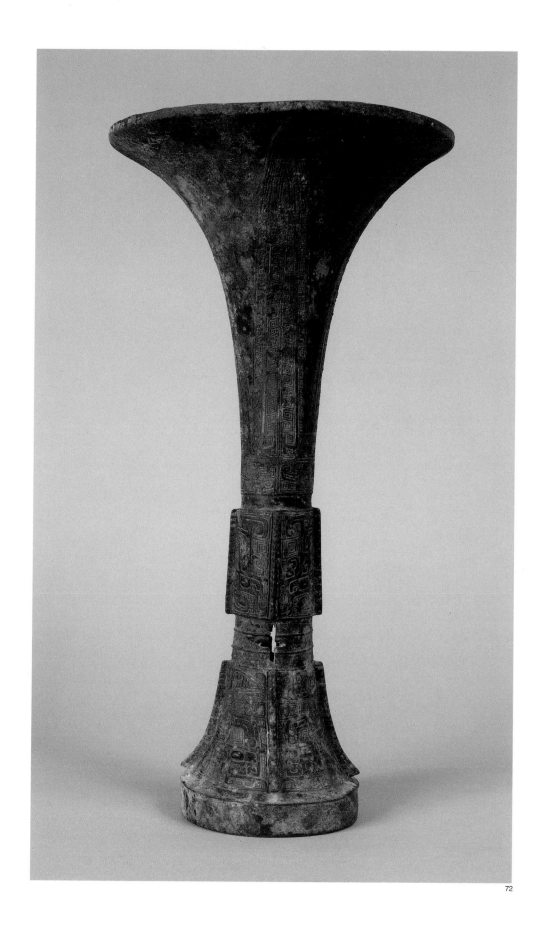

72

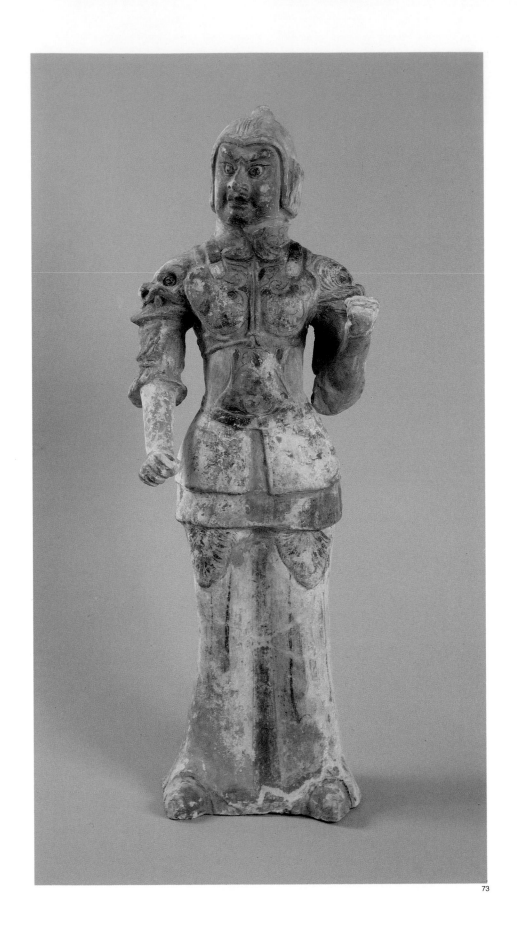

73

Chinese, Tang dynasty

73 *Tomb Guardian Figure*, circa 650–700
Molded and modeled earthenware, cold-painted
decoration, partial gilding, h. 27¼ in. (69.2 cm.)
Purchase, Gift of Gaylord Donnelly
1981.55

Funerary sculpture has an ancient history in China, where lavish burials have traditionally signaled both an enduring reverence for departed ancestors and the prestige of their surviving families.[1] Indeed, thousands of ceramic sculptures, dating from the Neolithic period (circa 8000–2000 B.C.) through the Ming dynasty (1368–1644 A.D.), have been discovered in excavated tombs in all parts of China. As early as the fourth century B.C., clay figures began to supplant the live servants, musicians, warriors, and horses that had been sacrificed to attend their royal patrons in the afterlife. Invaluable for the material information they provide, these sculptures also document changing artistic values and techniques.

The earthenware tomb figures of the Tang dynasty (618–907 A.D.), for instance, are characterized by fine polychrome painting and relatively robust proportions. The fully dressed and helmeted guardian figure in the Smart Museum collection has substantial remnants of its original surface paint, most attractive on parts of the armor and remarkable in color and brushstroke in the mustache, beard, and eyebrows. The brushstrokes range from very fine ones in the whimpers to broad curves used for the beard, parts of the garments, and the masks on the shoulders. Though the pose is lively, there is still a hesitancy in the full display of turning and bending limbs, with an emphasis on parts of particular vivacity such as the eyes. This and other aspects show that the figure should be dated to the early Tang dynasty in the middle of the seventh century. Examples for comparison may be found in figures from the tomb of Li Shou, a member of the Tang imperial family, who died in 631 A.D., and in an almost identical figure known formerly from the Jamieson Ritchie collection in England.[2]

Such Tang figures were produced during a time of great cultural and economic prosperity, when Chang'an, the imperial capital at one end of the Silk Road, received a steady multitude of foreign visitors and absorbed their international influences with open enthusiasm. The generally non-Chinese features that distinguish tomb guardian figures suggest models in Central Asian or nomadic soldiers, who had in turn borrowed their costumes from the West. In keeping with its apotropaic function, the Smart Museum figure, modeled in the round with broad shoulders and bulging hips, asserts itself with aggressive gestures and a twist of the head. The right arm is slightly bent with a balled fist put forward, and a similar fist is proffered to the height of the shoulder by the left arm bent sharply at the elbow. Except for the face, the head is completely covered by a leather helmet, featuring a double arch over the forehead and a fold-over at the back of the neck. The torso of the figure is protected by breastplates connected by shoulder straps to a back cover; all of this fits tightly over a tunic which covers the body from the shoulders down to the feet. The torso is furthermore demarcated by a high waist-rope strapped to hold the armor in place. The upper legs are covered by a flaring skirt of armor which, judging by the traces of paint, was made of layers of leather strips.

The long tunic is rare, but a feature common to many of these guardians is the appearance of ferocious animal heads at various junctions in the body, such as the waist, elbows, or, as in this case, the shoulders. While in this instance the animal heads may well be part of the leather armor, their use is known from earlier Chinese traditions in which ceremonial figures were covered with animal pelts, ritually appropriating the particular power represented by the beast whose skin was worn. Such ritual is well suited to guardian figures, enhancing the aura of spiritual prowess they embody.

Harrie A. Vanderstappen

1. For the most recent survey of Chinese tomb sculpture, see *The Quest for Eternity: Chinese Ceramic Sculptures from the People's Republic of China* (Los Angeles: Los Angeles County Museum of Art, 1987).
2. For the Li Shou figures, see *Wen Wu* 9 (1974): 71–80; for the Jamieson Ritchie figure, *Victoria and Albert Museum Picture Book of Chinese Pottery Figures* (London, 1928), pl. 10.

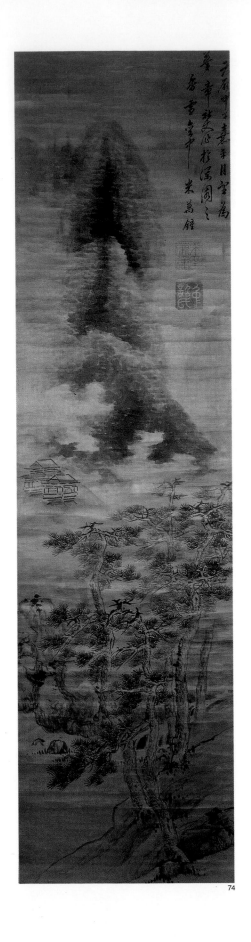

74

Mi Wanzhong
Chinese, circa 1570–1628

74 *Among the Fragrant Snowy Mountains of Lan Garden*, 1621
Hanging scroll, ink on satin; painting 73¹¹/₁₆ x 19⅛ in. (187.2 x 48.6 cm.)
Purchase, Gift of Mr. and Mrs. Gaylord Donnelley 1974.92

Mi Wanzhong was originally from Shaanxi province, Chang An prefecture, but spent much of his life in Beijing, serving in a number of official posts. He was famous as a calligrapher, working in the style of his ancestor Mi Fu, the eleventh-century painter, calligrapher, and literatus. Mi Wanzhong was also known for his landscapes and flower paintings. It is said that he was particularly fond of collecting strange rocks, hence his sobriquet, "You Shi," "Befriender of Stones."

Among the Fragrant Snowy Mountains of Lan Garden, a landscape painting in the hanging-scroll format in the Smart Museum collection, bears an inscription by Mi, and two of his seals. The inscription, which dedicates the painting to a Ming dynasty official, Fan Jingwen, indicates that the work was perhaps a gift or an exchange, to commemorate an occasion such as a wedding or birth, or possibly a gesture of inspired friendship:

Inscribed on the fifteenth day of the twelfth lunar month of 1621, for Ming Zhang (Fan Jingwen) among the fragrant snowy mountains of Lan Garden. Mi Wanzhong.

Not a depiction of a particular landscape, *Among the Fragrant Snowy Mountains* is instead a kind of aesthetic demonstration piece in the literati painting tradition. Through style more than subject matter, Mi's picture addresses the knowing collector or connoisseur about the non-professional scholar-artist's personal way of viewing nature.

In the upper half of the image, Mi paints a sequence of three cone-shaped mountain peaks in wet, rounded brushstrokes. The blotches of ink, lighter at the mountains' edges, build up into darker areas along the core of each shape. To the lower right of these mountains, Mi renders the upper stories of two buildings emerging from the surrounding mists. In the lower half of the painting, five gnarled pines near a stream stretch upward, their branches twisting and turning under the force of Mi's sharp, inky brushwork. The lively facture, startling in its contrasts, contributes to the energy established by Mi's use of exaggerated proportions. Throughout, one feels the vertical elongation of shapes: the mountains reach heavenward, their ascendant longing accented by the vertical alignment of dark and light tones and the rhyming of the simple rounded shapes; the trees below grow into the clouds, setting off a curious juxtaposition of near and far, of upper and lower zones of the painting. Mi also plays on the slight eccentricity of shapes, the peculiarity of their orientation and placement. There is an oddness, too, in the exaggeration of the pines' branches and needles and in the strange configurations of the mists.

Such idiosyncrasies constitute Mi's personal adaptation of a highly traditional aesthetic. For neither the motifs nor the essential visual language of this work are new nor unusual. The manner in which Mi paints mountains and mists is rooted in the Northern Song traditions of his ancestor Mi Fu, and the pines have precedents in tenth- and eleventh-century monumental landscape paintings by Li Cheng and Guo Xi respectively. What is new, and characteristic of Mi's work and Ming dynasty painting in general, is the recollection and reworking of these earlier landscape traditions, in a shift away from the realism still lingering in the refined literati paintings of the scholar-amateur Wu School. This shift reflects a new understanding of nature and its representation in art. For Mi and a number of his contemporaries—Li Shida, Wang Jianzhang, Song Xu, and Zhang Hong, for example—it was the vivacity not the appearance of nature that was significant. They discovered the being of a mountain, with its retinue of trees and streams, in the idiosyncratic presentation of its shapes and their relationships. From this point of view, nature has presence and life only by virtue of its underlying exuberance, expressed outwardly by the exotic rather than the routine features of landscape.

Stanley Murashige

Lan Ying
Chinese, 1585–after 1664

75 *Landscape (after Huang Gongwang)*, circa 1637–1638
Handscroll; frontispiece, ink on paper, 23 1/16 x 40 5/16 in.
(58.7 x 102.4 cm.); painting and colophons, ink and color
on silk, 23 1/16 x 379 1/8 in. (58.7 x 1014.7 cm.)
Gift of Jeannette Shambaugh Elliott in honor of
Professor Harrie A. Vanderstappen
1987.56

Lan Ying was a late-Ming professional painter who sold his
work for a living, not a "scholar-artist" for whom painting was
a cultured avocation. Nonetheless, Lan was well versed in the
painting styles of great artists of the past and couched his own
works in the manners of earlier literati painters. He could ex-
ecute strikingly good landscapes in the monumental North-
ern Song tradition.[1] Because Lan displayed talent at an early
age, he gained the esteem of well-known contemporary literati
such as Dong Qichang, Chen Jiru, and Sun Kehong. Lan was
introduced to their scholarly ideals—their concern with
brushwork and formal issues and their prejudice against court
academic and professional painters. He turned to the emula-
tion of artists approved by Dong Qichang in his formulation
of the Southern school lineage of Chinese painting, including
the Four Masters of the Yuan dynasty—Huang Gongwang, Ni
Zan, Wang Meng, and Wu Chen. In so doing, Lan combined
the technical competence of the professional painter with the
artistic aspiration of the scholar-amateur. But by the eight-
eenth century, critics disparagingly associated Lan with the
academicism and "bad taste" of the Zhe School, citing his
professionalism and his birthplace—Qiantang (Hangzhou),
Zhejiang province, the original center of the Zhe School in
the fifteenth and sixteenth centuries.

Lan's inscription towards the end of the Smart Museum
handscroll indicates that he considered this work one of his
finest:

Of all the extant scrolls by Huang Gongwang, I have had a chance
to see more than half the treasures in the empire. My thirty years
of research and study of the masters have come to this. If the Four
Yuan Masters could see this scroll of mine, they certainly would
allow me to enter their groves. Connoisseurs, what is your
opinion?[2]

The painting is monumental in conception, both unusually
large in size and grandiose in the endlessly changing moun-
tains and vistas revealed when the scroll is unrolled section by
section. Lan is recorded to have traveled widely and observed
the scenery of many regions of China, and although retrospec-
tive in style, the handscroll achieves some of its impact from
the attention given the specifics of each imaginary site.

An early album of 1622, *Following Ancient Masters*, includes
a leaf by Lan in the manner of Huang Gongwang that demon-
strates a close adherence to the soft texture strokes and moun-
tain forms in Huang's painting titled *Nine Pearllike Verdant
Peaks*.[3] Lan clearly developed a special affinity for the style of
this Yuan master. His works in the Huang manner are numer-
ous and include several dated hanging scrolls, handscrolls, and
album leaves.[4] The stylistic similarities between the Smart
Museum handscroll and dated works from the late 1630s and
early forties are supported by the inscriptions on the paint-
ing itself, which are dated from 1638 to 1646.[5] The work is
therefore likely to have been executed during or shortly be-
fore 1638.

Among the seven colophons written on the painting, the
first, in order of appearance on the scroll, is signed by Chen
Jiru, a well-known scholar, collector, and calligrapher and
close friend of Dong Qichang, in his eighty-first year (1638).

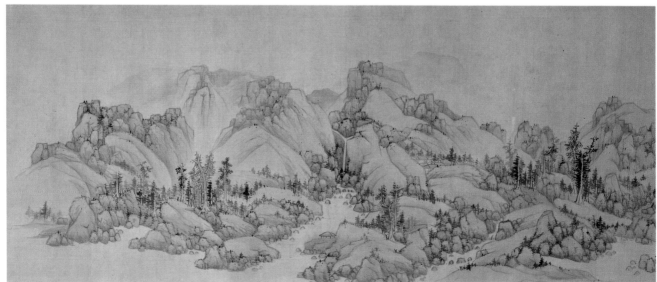

75 (detail)

Chen expresses the highest praise for Lan's painting, saying that viewing it gave him a strange feeling that Huang Gongwang had reappeared. The second inscription, by Fan Yunlin, a scholar and official who excelled at calligraphy and landscape painting, is also dated 1638. Fan confesses that when Lan showed him the scroll, he thought that he was looking at a real work by Huang, until he noticed the inscription by Chen. The third colophon is signed Wang Siren, an official, poet, and calligrapher from Shaoxing. Lan's own inscription, close to the end of the painting, is undated.

Appended to the painting are six additional colophons, the first by the painter and writer Yang Wencong. Although written in 1638—the same year as Chen's and Fan's inscriptions at the beginning of the scroll—Yang's comments are modestly placed after the painting instead of on it, probably because of their author's comparative youth. The third appended inscription, by Ma Shiying, is dated 1642. Ma was to become chief Grand Secretary of the scandalous Southern Ming court of the Hongguang Emperor, Zhu Yousong (d. 1646), and is considered one of the most treacherous villains of Ming history. Yang was criticized for his connections with his brother-in-law Ma. It is possible that Lan's reputation also suffered from his association with Ma, for scholarly opinion after his death reflects almost none of the admiration evident in the inscriptions on the Smart Museum handscroll. Zhang Geng (1685–1760), for example, records in the *Guochao huanzhenglu* that in his youth he heard his elders speak of Lan with disdain.[6] Yang Enshou, in whose late nineteenth-century catalogue the scroll is described and its inscriptions recorded (after an earlier nineteenth-century publication), wrote that Lan lived for a time on Ma's estate.[7] While there is no historical corroboration for this, both Ma and Lan appear as characters in the famous 1699 drama by Kong Shangren, *The Peach Blos-*

som Fan (Taohua shan).[8] The Smart Museum painting provides further evidence of an association between them and perhaps of the underlying reason for the decline of Lan's prestige in his later years and following his death, when he was derogatorily labeled as the last of the Zhe School painters.

Katherine R. Tsiang

1. See, for example, Lan's painting *Listening to a Waterfall in a Pavilion in Spring in the Manner of Li Cheng* (1622), Liaoning Provincial Museum, Shenyong, reproduced in James Cahill, *The Distant Mountains: Chinese Painting of the Late Ming Dynasty, 1570–1644* (New York and Tokyo: John Weatherhill, 1982), pl. 98.

2. Translated in part by Shen Fu and Marilyn Fu, in *Studies in Connoisseurship: Chinese Paintings from the Arthur M. Sackler Collection in New York and Princeton* (Princeton, N.J.: Princeton University Press, 1973), 112, from Yang Enshou's *Yanfubian*.

3. Both these works are preserved in the National Palace Museum, Taipei.

4. The handscroll in the Art Museum at Princeton University, for example, dated 1624, is based on Huang's greatest surviving painting, *Dwelling in the Fuchun Mountains*. (See Wen Fong et al., *Images of the Mind: Selections from the Edward L. Elliott Family and John B. Elliott Collections of Chinese Calligraphy and Painting at the Art Museum* [Princeton, N.J.: Art Museum, Princeton University, 1984], cat. no. 30.) Another, in the National Palace Museum, Taipei, dated 1639, has veined and steeply sloping mountains with squarish rocks clustered around the range's base. (Illustrated in National Palace Museum, *Wanming bianxing zhuyi huajia zuopin zhan* [*Style Transformed: A Special Exhibition of Works by Five Late Ming Artists*] [Taipei: National Palace Museum, 1977], cat. no. 049).

5. While the inscriptions have been discredited by some scholars, this has not been demonstrated by historical evidence. The date 1638, correctly indicated in the inscription appended to the painting by Yang Wencong, is erroneously recorded in Yang Enshou (*Yanfubian*, preface 1885, vol. 3, part 2, *juan* 15: 36a–41b) as 1608 or 1668, both impossible in the historical context of the painting (see Cahill, *Distant Mountains*, 183 and 278, n. 19).

6. Zhang Geng, *Guochao huazhenglu*, preface 1735, part 1:13. See also Fu and Fu, *Studies in Connoisseurship*, 113.

7. Yang Enshou, *Yanfubian*, vol. 3, part 1, *juan* 12.

8. Yang Wencong's name features prominently in the play as the artist who painted the fan by converting bloodstains into peach blossoms.

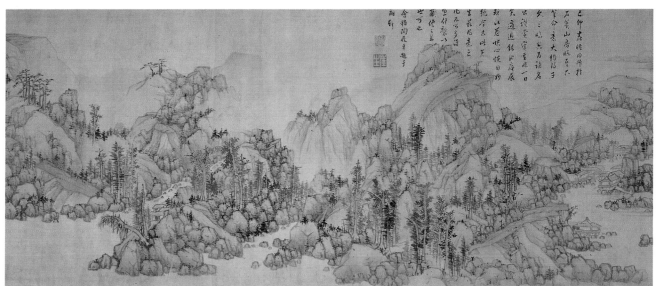

75 (detail)

Nittō, Head Priest of Ikegami Temple
Japanese, 1652–1733

76 *Nichiren's Nirvana*, late 17th–early 18th century
Hanging scroll, ink and color on silk; painting 42⅝ x
31⅞ in. (108.1 x 80.7 cm.)
Purchase, Gift of Mr. and Mrs. Gaylord Donnelley
1974.101

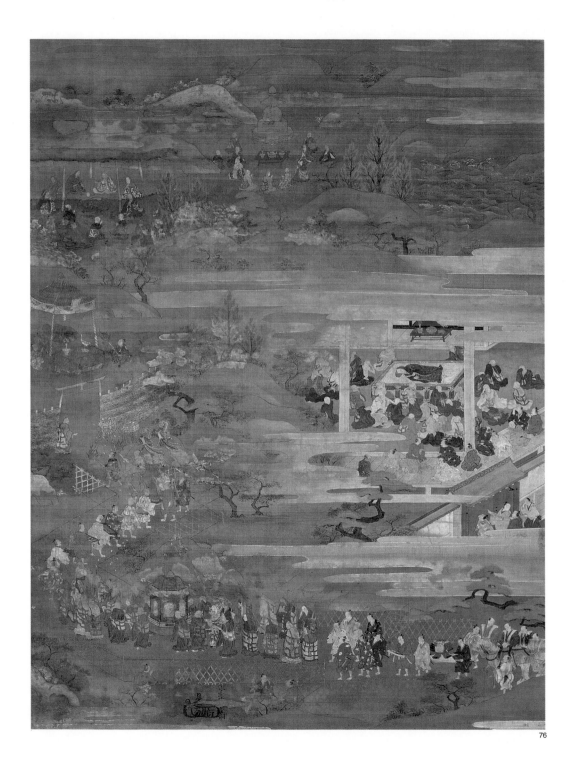

76

Narrative scrolls in a hanging format were often commissioned by Buddhist temples to commemorate the lives of patriarchs, extol their deeds and virtues, or describe legends associated with sects and temples they founded. Primarily didactic, these scrolls were used by *etoki*, "picture-explaining monks," in the temple halls during special ceremonies or on missionary journeys to instruct the lay populace.

The Smart Museum scroll describes the events surrounding the death and funeral of the monk Nichiren and the establishment of his tomb at Mt. Minobu in Kai province (modern Yamanashi prefecture) near Mt. Fuji.[1] Nichiren (1222–1282) was the founder of the *Hokke* or "Lotus" sect of Buddhism, which was popular in its appeal, nationalistic in its goals, and militant in its denunciation of established sects. In the ninth month of 1282, at the age of sixty-one and in failing health, Nichiren was persuaded by his disciples to leave Mt. Minobu, the residence of his later years, for a hot spring in Hitachi. On reaching the residence of Ikegami Munenaka in what is present-day Tokyo, Nichiren became too ill to continue his journey. He died on the morning of the thirteenth day of the tenth month, surrounded by faithful disciples chanting "*Namu-myōhō-renge-kyō*," "Homage to the Scripture of the Lotus of the Good Law"—the formulaic invocation of the Lotus Sutra in which Nichiren's teachings are embodied. This event is pictured in the central, right-hand portion of the scroll where the monk, in a vignette reminiscent of standard *nehan* pictures illustrating the death of Buddha, is seen reclining on a raised platform and clasping a rosary and fan, while his disciples are shown in various attitudes of mourning. The setting is the residence of Ikegami Munenaka, which was to become one of the most important Nichiren temples, the Ikegami Honmonji. Scarlet foliage, delicately rendered with a deft hand, clearly marks the autumn season.

The funeral procession, which in the painting winds along the lower portion of the composition through a pathway enclosed by a latticework fence, began at midnight on the day of Nichiren's demise. The procession is headed by disciples bearing torches and, immediately behind them, mourners with long staffs topped by paper lotus blossoms. Next, two followers carry banners made of red and white streamers; others hold an incense burner, cymbals, a bowl of what are probably flowers, a writing desk, and scrolls of the Lotus Sutra. One disciple bears a small bronze statue of the historical Buddha Shaka, a gift of Tomotaka Ito, feudal lord of Izu, which Nichiren reportedly kept with him wherever he went. The monk's shoes are carried by his disciple Saburo Gennai, and his coffin, over which a canopy is held, is borne by another group of followers. Bringing up the rear are two devotees carrying a sword and a suit of armor—both received as gifts—and finally, Nichiren's chestnut horse, presented to him by his disciple Sanenaga Hakiri. So attached had Nichiren become to this horse that he requested it remain in the care of its own groom after his death.

Nichiren's cremation is pictured in the central left-hand portion of the painting. The crematorium, called the *Haitō* or "Ash Tower," is now part of the Ikegami Honmonji. From standard biographies it is known that two days later the patriarch's ashes were collected and placed in an urn by his disciples. This event is illustrated above the cremation scene. Finally, centrally crowning the composition, is Nichiren's tomb, erected as he had requested at Mt. Minobu. There, after a journey of four days, a funeral service lasting two days was recited by his disciples and followers. The monks in dark robes are probably the *Roku Rōsō*, "Six Elder Priests" of the sect, personally chosen by Nichiren as his successors. These men—Nisshō, Nichirō, Nikkō, Nikō, Nicchō, and Nichiji—took turns guarding his tomb after the mourning period of one hundred days. To the right is Suruga Bay, which can be seen from Mt. Minobu. The maplike arrangement of the composition, with Mt. Minobu and its surroundings at the top, resembles the type of mandala that schematically depicts the abodes of deities in sanctuaries on earth. Nichiren's own words from his book *Minobusan Gosho*—"In this spot on Mt. Minobu . . . God himself seems to come down and bless the place"[2]—encourage us to view the painting in this way.

According to the inscription at the bottom of the scroll, the painting was done by Nittō, the 2[4th] head priest of the Ikegami Honmonji. (The second character of the number can no longer be read.) From the temple lineage, we know that Nittō (1652–1733) was indeed the twenty-fourth head priest of the Ikegami temple in Tokyo; we can thus date the painting to the late seventeenth or early eighteenth century, during the Edo period (1615–1868). The style of the painting supports this date as well. The scroll preserves certain elements of classical *yamato-e* painting: the distribution of scenes with intervening bands of mist, for example, and the softly rolling hills are characteristic of that lyrical native style which originated during the Heian period (794–1185). However, the figures in the procession, reminiscent of the work of the late seventeenth-century *ukiyo-e* pioneer Hishikawa Moronobu, as well as details of the landscape such as the treatment of the pine in the lower right corner, and the hardened, somewhat formulaic style, are in keeping with this phase of the Edo period.

The painting was executed when the popularity of Nichiren Buddhism had spread among the *machishu*, the new merchant class, and was undergoing something of a revival. At a time when Buddhism, on the whole, was in a period of comparative decline, Nichiren Buddhism gained new impetus with the support of the influential *machishu*.

Robin Scribnick Stern

1. I am indebted to Professor Yoshiro Tamura of Rissho University for his assistance in understanding this painting.
2. Mampei Chiba, *Life of St. Nichiren* (Tokyo: Seigakukan, 1975), part II, 29.

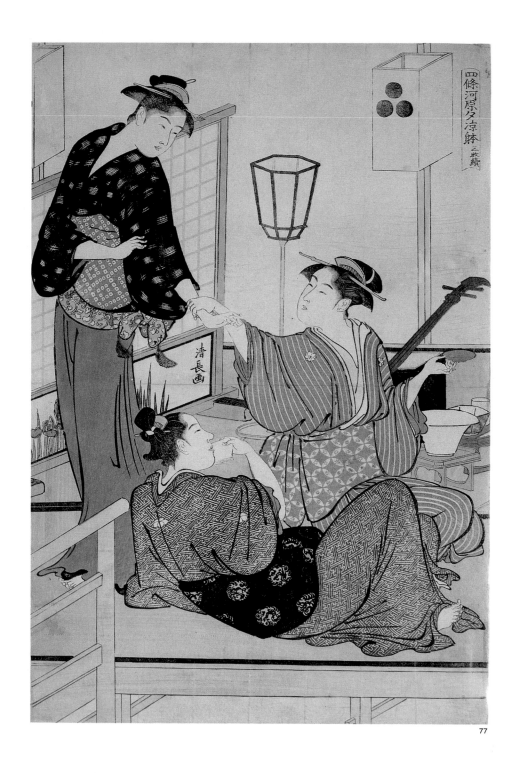

77

Torii Kiyonaga
Japanese, 1752–1815

77 *Women Resting above the Kamo River* (panel from an *ōban* triptych, *Cooling Off in the Evening at Shijō Rivershore*), circa 1784
Color woodblock, sheet 15⅛ x 10¼ in. (38.3 x 26 cm.)
Gift of Warren G. Moon, Madison, Wisconsin, in honor of Professor Harrie A. Vanderstappen
1984.8

Considered the greatest *ukiyo-e* master of the Tenmei period (1781–1789), Kiyonaga succeeded his teacher Kiyomitsu as the fourth titular head of the Torii school, a line of artists specializing in theatrical posters, prints, and playbills. He is, however, best known for large-scale compositions of graceful, classically posed beauties in evocative interior or landscape settings. Kiyonaga was a brilliant colorist and draughtsman; he was also the first artist fully to explore the *ōban*-size (about fifteen by ten inches), multiple-sheet format. Artists of the late eighteenth century were profoundly influenced by his original works, but after about 1790 Utamaro superceded him in popularity.

The woodcut by Kiyonaga in the Smart Museum collection is the center sheet of a triptych titled *Shijō-gawara Yu Suzumi no Tei* (*Cooling Off in the Evening at Shijō Rivershore*). In its complete form (fig. 7), the print shows six geisha and three female attendants (one, a young girl) on a platform, covered with *tatami* mats, constructed over the Kamo River in Kyoto. The triptych was published in the Tenmei era when middle-class culture, and consequently popular arts such as *ukiyo-e* (literally, pictures of the floating world), flourished with renewed vitality. Prints of this period often depict elegant outings or gatherings of ladies and guests enjoying the fleeting pleasures of fashion and romantic entertainment in the various seasons.

Although Kiyonaga's triptych represents a unified panoramic view, each panel is also conceived as an independent composition. The central sheet, like the two side panels, depicts a group of three women in varied poses. The viewer's attention is first directed to the upturned face of the seated geisha holding a saki cup. She grabs the wrist of the passing attendant, identified by her red apron with padded yellow sash. Both women are fashionably dressed in the latest styles of the capital, Edo (present-day Tokyo): they have *tōrōbin* (lantern) style hairdos and kimonos patterned with stripes and *kasuri* (splash design). The older, reclining geisha wears a more conservative hair style and a kimono with a subdued *manji tsunagi* (linked swastika) design. She is shown drying her mouth with a paper napkin.

The women are surrounded by beautifully crafted objects such as a *samisen* (three-stringed guitar), food bowls, and a *tsuitate* (low standing screen) with a panel showing irises as well as Kiyonaga's signature. One of the two lanterns is decorated with three black balls, emblematic of the pleasure quarter that had constructed the platform, probably in conjunction with a teahouse on the Shijō Rivershore (not shown in the triptych). The connecting railed walkway is seen extending from the lower left corner of this central sheet. Numerous such structures were temporarily built each year to provide relief from the heat of the early summer season, a period that officially lasted from the seventh to the eighteenth day of the sixth month, or about mid-July.

The triptych is considered one of Kiyonaga's masterpieces, as well as one of his earliest mature works: warm colors and fluidly rounded lines imbue the print with a natural ease missing in many of the artist's later, more static and polished compositions. Impressions of the triptych design are very rare; there are, however, complete examples at the Art Institute of Chicago, Minneapolis Institute of Arts (fig. 7), and Tokyo National Museum of Art.

Louise Virgin

Fig. 7. Torii Kiyonaga, *Cooling off in the Evening at Shijō Rivershore*, circa 1784, color woodblock *ōban* triptych, each sheet 15⅜ x 10½ in. (39.1 x 26.7 cm.), Minneapolis Institute of Arts, Bequest of Richard P. Gale, 74.1.126.

175

Indian, Orissa

78 *Kṛṣṇa and Brahmā*, late 19th–early 20th century
Folio from a manuscript of the *Bhāgavata Purāṇa*
Tempera, ink on wove paper, sheet 9⁷⁄₁₆ x 15³⁄₁₆ in.
(24.6 x 38.8 cm.)
Purchase, Gift of Mr. Harris J. Fishman
through the Alumni Fund
1974.62

In this rare manuscript page from Orissa,[1] Brahmā, the god of creation, sits astride his vehicle, the *haṃsa* (goose), which holds red foliage in its beak. Brahmā, whose four heads look in the four directions and symbolize the four sacred texts, the Vedas, confronts another god of the Hindu trinity, Viṣṇu, in his Kṛṣṇa *avatāra* (manifestation). The diminutive Kṛṣṇa stands in a simple, stylized landscape, holding his flute, with his *uttarīya* (long scarf) and *patka* (sash) flying about him stiffly. He wears his traditional peacock-feather headdress and sports a long, wavy braid of black hair. Like Brahmā, he is clothed in the traditional manner of gods: bare-chested, he wears only the *uttarīya* around his shoulders and a *dhoti* (loincloth). Both gods are heavily ornamented, also in the traditional manner, with earrings, necklaces, garlands, armbands, bracelets, and anklets. The artist has added the charming detail of polka dots on the orange and yellow raiment. In the Orissan manner, Brahmā's fair skin is shown as bright yellow; Kṛṣṇa's skin is most often depicted as blue—his name literally means "dark blue" or "black."

The *Bhāgavata Purāṇa* (*Ancient Story of God*), illustrated in this folio, is "the last scriptural compendium of the mythology of Viṣṇu."[2] Its twelve books were compiled from earlier tradition by the tenth century. The tenth book, by far the most important and commonly illustrated, recounts the life of Kṛṣṇa. This illustration of one episode from the tenth book depicts Brahmā stunned and confused by his vision of the god. The incident leading up to his vision—not inscribed on the folio[3]—is as follows: Brahmā decided to test Kṛṣṇa by spiriting away the cows and cowherd boys behind his back. Upon discovering this, Kṛṣṇa assumed the forms of all the boys and cows so that they would not be missed at home. Brahmā returned to the cowherd village one year later, only to find the same boys and cows in duplicate. Realizing they were all forms of Kṛṣṇa, he was overwhelmed. One of the verses inscribed on the miniature particularly describes Brahmā's state of mind:

Astounded by these experiences Brahmā turned his gaze away. All his eleven senses became completely stilled in the presence of the divine majesty he witnessed, and he stood silent like a statuette beside the main deity of Vraja (i.e., Kṛṣṇa).[4]

The style of this painting on paper is clearly Orissan, deriving from an earlier tradition of illustration on palm leaf which dates back to the late seventeenth century.[5] The manner is characterized by a bold linear style with no modeling or depth of field, no overlapping of figures, and a single ground line. Head and feet are drawn in profile, while the short, heavy-limbed body is frontal. Faces are stylized, with large, elongated eyes, pointed nose and chin, and arching S-shaped eyebrows.[6] The stiff, jutting scarves, and the idealized physical traits of broad shoulders and narrow waist are conventions also seen in earlier western Indian Jain manuscripts.

The present illustration can be dated no earlier than the late eighteenth or early nineteenth century, as paper was not used in Orissan manuscripts until the eighteenth century.[7] A comparable folio, illustrating Kṛṣṇa's meeting with the hunchback Kubja, from an eighteenth-century manuscript (Paris, Galerie Marco Polo)[8] is similar in format to this one: both folios are horizontal; in both cases the image covers the upper two-thirds of the page with the text below on an unpainted background; and the same color border that frames each painting also divides it from the text. The eighteenth-century manuscript, however, is more careful and skilled in style, while the Smart Museum page exhibits a certain rigidity of line and casualness in the application of color that point to a somewhat later date in the late nineteenth or even early twentieth century. For instance, the colors that define Kṛṣṇa's chin and scarves or Brahmā's proper left hand do not conform to their respective outlines. Another reason for the later dating is a portrayal of Brahmā from an artist's sketchbook, closely resembling this one, which is dated to between 1859 and 1921.[9]

Marion W. Covey

1. Only three or four Orissan manuscripts on paper are known to date, the earliest being from an early nineteenth-century *Gita Govinda* set in the New Delhi National Museum. The Musée Guimet, Paris, has one folio from the set to which the Smart Museum painting belongs.

2. Daniel J. Ehnbom, "An Analysis and Reconstruction of the Dispersed *Bhāgavata Purāṇa* from the *Caurapañcāśikā* Group" (Ph.D. diss., University of Chicago, 1984), 2.

3. The verses inscribed on the recto of the manuscript page are numbered 53–56, corresponding to verses 58–61 in volume 3, book 10, chapter 13 of Swami Tapasyananda's *Srimad Bhāgavata* (Madras: Sri Ramakrishna Math, 1981). The verses on the verso are the preceding ones, verses 43–52, corresponding to verses 48–57 in Tapasyananda.

4. Tapasyananda, *Srimad Bhāgavata*, 94, verse 56.

5. Stuart Cary Welch, *India, Art and Culture, 1300–1900* (New York: Metropolitan Museum of Art, 1986), 62, has dated the earliest known illustrated Orissan manuscript on palm leaf to circa 1690.

6. Jeremiah P. Losty, *Krishna, a Hindu Vision of God* (London: British Library, 1980), 30–31, fig. 40.

7. Charles L. Fabri, *History of the Art of Orissa* (Bombay: Orient Longman, 1974), 194.

8. Anna L. Dallapiccola, *Krishna, the Divine Lover: Myth and Legend through Indian Art* (Bombay: B. I. Publications, 1982), 65, fig. 64.

9. J. P. Das, *Puri Paintings, the Chitrakara and His Work* (Atlantic Highlands, N.J.: Humanities Press International, 1982), 181, fig. 43.

SOURCES FOR FURTHER STUDY

Euphronios

1 *Red-figure Neck-pelike Fragment: Ephebe (Youth) with a Walking Stick*, circa 510 B.C.
Slip-painted earthenware, l. 7¼ (18.4)
The F. B. Tarbell Collection, 1967.115.287
PROVENANCE: F. B. Tarbell Collection.
EXHIBITIONS: Art Institute of Chicago, *Greek Vase-Painting in Midwestern Collections*, 22 December 1979–24 February 1980, cat. no. 77.
LITERATURE: W. Klein, *Die griechischen Vasen mit Lieblingsinschriften*, 2d ed. (Leipzig, 1898), 81, no. 44; J. D. Beazley, *Attic Red-Figured Vases in American Museums* (Cambridge, Mass., 1918), 30; idem, *Attische Vasenmaler des rotfigurigen Stils* (Tübingen, 1925), 60, 9bis; Daniel C. Rich, *American Journal of Archaeology* 34 (1930): 153; Beazley, "Disjecta Membra," *Journal of Hellenic Studies* 51 (1931): 40, no. 6; M. Pallottino, *Studi Etruschi* 5 (1931): 273, no. 3 and pl. 15, 2 (graffito); Beazley, *Campana Fragments in Florence* (Oxford, 1933) 33, no. 4; Franklin P. Johnson, "Oltos and Euphronios," *Art Bulletin* 19 (1937): 537; 539, figs. 2, 3; 557ff.; Beazley, *Attic Red-Figure Vase-Painters*, 2d ed. (Oxford: Oxford University Press, 1942), 17, no. 10; A. Bruhn, *Oltos and Early Red-Figure Vase Painting* (Copenhagen, 1943), 66, no. 85, and 104; Dietrich von Bothmer, "Attic Black-Figured Pelikai," *Journal of Hellenic Studies* 71 (1951): 47; Beazley, *Attic Red-Figure Vase Painters* (Oxford, 1963), 16, no. 12; David and Alfred Smart Gallery, *David and Alfred Smart Gallery, The University of Chicago, 1974* (Chicago: David and Alfred Smart Gallery, University of Chicago, 1974), n.p. (illus.); Warren G. Moon and Louise Berge, *Greek Vase-Painting in Midwestern Collections* (Chicago: Art Institute of Chicago, 1979), 137, cat. no. 77 (illus.).

Greek, Attic, Group of Polygnotos

2 *Red-figure Calyx-krater Fragment: Battle of Kaineus and Centaur, Departure of a Youth*, circa 440–430 B.C.
Slip-painted earthenware, h. 5¹¹/₁₆ (14.4)
The F. B. Tarbell Collection, 1967.115.294
PROVENANCE: Hartwig Collection; E. P. Warren Collection, Lewes, England, until 1902; F. B. Tarbell Collection.
EXHIBITIONS: Art Institute of Chicago, *Greek Vase-Painting in Midwestern Collections*, 22 December 1979–24 February 1980, cat. no. 118.
LITERATURE: P. Hartwig, "Die Wiederkehr der Kora," *Mitteilungen des deutschen archäologischen Instituts, Römische Abteilung* (1897): 103, no. 18; P. Jacobsthal, "The Nekyia Krater in New York," *Metropolitan Museum Studies* 5 (1934–1936): 140, no. 40; Franklin P. Johnson, "Red-Figured Pottery at Chicago," *American Journal of Archaeology* 42 (1938): 352, 355, 356, fig. 20; J. D. Beazley, *Attic Red-Figure Vase-Painters*, 2d ed. (Oxford: Oxford University Press, 1942), 1057, no. 107; Yvonne Korshak, "Attic Red-Figure Calyx Krater Fragment," in Warren G. Moon and Louise Berge, *Greek Vase-Painting in Midwestern Collections* (Chicago: Art Institute of Chicago, 1979), 211, cat. no. 118 (illus.).

Greek, Boeotian, Workshop of the Kabiros Painter

3 *Kabiric Bowl: Odysseus's Men before Circe, Two Combatants*, circa 430–420 B.C.
Slip-painted earthenware, h. (restored) 5⁹/₁₆ (14.1)
The F. B. Tarbell Collection, Gift of E. P. Warren, 1902; 1967.115.276
PROVENANCE: E. P. Warren Collection, Lewes, England, until 1902; F. B. Tarbell Collection.
EXHIBITIONS: David and Alfred Smart Gallery, University of Chicago, *Earth, Water, Fire: Classical Mediterranean Ceramics*, 31 March–3 May 1976, cat. no. 99; Art Institute of Chicago, *Greek Vase-Painting in Midwestern Collections*, 22 December 1979–24 February 1980, cat. no. 122.
BIBLIOGRAPHY: Odette Touchefeu-Meynier, "Ulysse et Circé: Notes sur le chant X de l'*Odyssée*," *Revue des études anciennes* 63 (1961): 268–269, pls. 15–17; David and Alfred Smart Gallery, *Earth, Water, Fire: Classical Mediterranean Ceramics* (Chicago: David and Alfred Smart Gallery, 1976), 63, cat. no. 99; Warren G. Moon and Louise Berge, *Greek Vase-Painting in Midwestern Collections* (Chicago: Art Institute of Chicago, 1979), 216–217, cat. no. 122 (illus.).

French, Burgundy, School of Cluny III

4 *Architectural Fragment: Head (of an Angel?)*, circa 1120
Limestone, h. 7¼ (18.4)
Purchase, The Cochrane-Woods Collection, 1977.2
PROVENANCE: Antiquities Altounian-Lourbet, Mâcon.
LITERATURE: "Romanesque Sculpture," *Gallery* [Newsletter of the David and Alfred Smart Gallery] 1 (Fall 1977): n.p. (illus.).

5a *Architectural Fragment: Section of an Arcade*, circa 1120
Limestone, 15¾ x 9⁷/₁₆ x 4½ (40 x 24 x 11.4)
Purchase, The Cochrane-Woods Collection, 1977.3
PROVENANCE: Antiquities Altounian-Lourbet, Mâcon.
LITERATURE: "Romanesque Sculpture," *Gallery* [Newsletter of the David and Alfred Smart Gallery] 1 (Fall 1977): n.p.; C. Edson Armi and Elizabeth Bradford Smith, "The Choir Screen of Cluny III," *Art Bulletin* 66 (December 1984): 563; 565; 566, fig. 10; 568.

5b *Architectural Fragment: Capital*, circa 1120
Limestone, 6¾ x 11 x 6 (17.1 x 27.9 x 15.2)
Purchase, The Cochrane-Woods Collection, 1977.4
PROVENANCE: Antiquities Altounian-Lourbet, Mâcon.

LITERATURE: "Romanesque Sculpture," *Gallery* [Newsletter of the David and Alfred Smart Gallery] 1 (Fall 1977): n.p.

French, School of Burgundy
6 *Architectural Fragment: Bishop*, circa 1350–1400
Sandstone, traces of polychromy, h. 55⅛ (140)
Purchase, The Cochrane-Woods Collection, 1974.122
PROVENANCE: Private collection, Vienna; Hofgalerie, Vienna.

Ugolino Lorenzetti
7 *The Crucifixion*, circa 1350
Tempera and gilding on wood panel, 19¾ x 8⅝ (50.2 x 21.9)
Gift of the Samuel H. Kress Foundation, 1973.40
PROVENANCE: William Young Ottley, London; Henry Wagner, London; Christie's, 17 April 1936, no. 12 (as Jacopo del Casentino) purchased by Fenouil; Giuseppe Bellesi, London; Samuel H. Kress Collection, New York, 1936–1973.
EXHIBITIONS: Washington, D.C., National Gallery of Art, 1941–1951, cat. no. 441; Honolulu Academy of Arts, 1952–1960, cat. no. 10.
LITERATURE: National Gallery of Art, *Preliminary Catalogue* (Washington, D.C.: National Gallery of Art, 1941), 113, cat. no. 441; W. E. Suida, *The Samuel H. Kress Collection in the Honolulu Academy of Arts* (Honolulu: Honolulu Academy of Arts, 1952), 10, 11 (illus., as Master of S. Pietro Ovile and Ugolino Lorenzetti); Fern R. Shapley, *Paintings from the Samuel H. Kress Collection, Italian Schools XIII-XV Century* (New York: Phaidon Press, 1966), 55, no. K1045, fig. 142; Giuletta Chelazzi Dini, *Il gotico a Siena—Miniature pitture oreficerie oggetti d'arte* (Siena: Centro Di, 1982), 254.

Italian, Padua, Workshop of Severo Calzetta da Ravenna
8 *Candlestick and Inkwell (or Sandbox): Kneeling Satyr*, circa 1500–1509
Cast bronze, h. with base 9¾ (24.8)
Gift of the Samuel H. Kress Foundation, 1973.58
PROVENANCE: Stefano Bardini, Florence, April 1918; Clarence H. Mackay, Roslyn, N.Y.; Samuel H. Kress Collection, New York, 1936–1973.
EXHIBITIONS: New York, American Art Association, *De Luxe Illustrated Catalogue of the Beautiful Treasures and Antiquities Illustrating the Golden Age of Italian Art Belonging to the Famous Expert and Antiquarian Signor Stefano Bardini of Florence, Italy*, 23–27 April 1918, cat. no. 100.
LITERATURE: American Art Association, *De Luxe Illustrated Catalogue of the Beautiful Treasures and Antiquities Illustrating the Golden Age of Italian Art Belonging to the Famous Expert and Antiquarian Signor Stefano Bardini of Florence, Italy* (New York: American Art Association, 1918), n.p., cat. no. 100 (illus., as Riccio); Wilhelm Reinhold Valentiner, *Catalogue of the Clarence H. Mackay Collection* (New York: Privately Printed, 1926), n.p., cat. no. 23 (illus., as Riccio); Leo Planiscig, *Andrea Riccio* (Vienna: Verlag von Anton Schroll and Co., 1927), 330–331, 483, no. 110, pl. 382 (as Riccio); John Pope-Hennessy, *Renaissance Bronzes from the Samuel H. Kress Collection* (London: Phaidon Press, 1965), 128, no. 473, fig. 486 (as Riccio); Jolán Balogh, *Katalog der Ausländische Bildwerke des Museums der Bildenden Künste in Budapest, IV-XVIII. Jahrhundert* (Budapest: Akadémiai Kiadó, 1975), 153 (as workshop of Riccio); Sotheby Parke Bernet, *Good Medieval and Later Works of Art, Tapestries, Pewter and Furniture* (New York: Sotheby Parke Bernet, 1980), sale 28–29 November 1980, cat. no. 103 (references to Bardini, Mackay, and Kress bronze as Riccio); K. Corey Keeble, *European Bronzes in the Royal Ontario Museum* (Toronto: Royal Ontario Museum, 1982), 42 (as Riccio); Liebieghaus,

Museum alter Plastik, *Natur und Antike in der Renaissance* (Frankfurt: Liebieghaus, Museum alter Plastik, 1985), 451 (as workshop of Severo da Ravenna); Patrick M. de Winter, "Recent Accessions of Italian Renaissance Decorative Arts, Part I: Incorporating Notes on the Sculptor Severo da Ravenna," *Bulletin of the Cleveland Museum of Art* 73:3 (March 1986): 136, n. 68 (as workshop of Severo da Ravenna).

Italian, Rome
9 *Reliquary*, circa 1534–1549
Cast silver gilt, lapis lazuli, crystal, enamel, *églomisé*, h. 23½ (59.7)
Gift of the Samuel H. Kress Foundation, 1973.54
PROVENANCE: B. Licata, Prince di Baucina, Palermo; C. and E. Canessa Collection, New York, Paris, Naples; French and Company, New York; William Randolph Hearst Collection; Samuel H. Kress Collection, New York, 1948–1973.
EXHIBITIONS: New York, American Art Association, *C. and E. Canessa Collection*, 25–26 January 1924, cat. no. 213; Worcester, Mass., Worcester Art Museum, *Fiftieth Anniversary Exhibition of the Art of Europe during the XVIth and XVIIth Centuries*, 11 April–16 May 1948, cat. no. 25 (as Manno di Bastiano Sbarri); Art Institute of Chicago, *Renaissance Decorative Arts from Chicago Collections*, 2 March–14 June 1987, no. 32.
LITERATURE: A. Bertolotti, *Atti e memorie della R. Deputazione di Storia Patria per le provincie modenesi e parmensi*, vol. 3 (Modena, 1878), 169ff.; "Inventaire de la chapelle papale sous Paul III, en 1547, transcrit par M. Bertolotti et annoté par Mgr. X. Barbier de Montault," *Bulletin Monumental* 44 (1878): 421ff. and vol. 45 (1879): 177ff., 261ff.; L. v. Pastor, *Geschichte der Päpste*, vol. 5 (Freiburg, 1909), 772, n. 4; American Art Association, *C. and E. Canessa Collection* (New York: American Art Association, 1924), no. 213; Léon Dorez, *La Cour de Pape Paul III* (Paris, 1932), vol. I, 159ff. and vol. II, 171; J. Braun, *Die Reliquiare* (Freiburg im Breisgau, 1940), figs. 278, 279, 282, and 324–330; F. S. Orlando, *Il tesoro di S. Pietro* (Milan, 1958), 84s, pls. 124–131; David and Alfred Smart Gallery, *David and Alfred Smart Gallery, The University of Chicago, 1974* (Chicago: David and Alfred Smart Gallery, University of Chicago, 1974), n.p. (illus.); Ulrich Middeldorf, *Sculptures from the Samuel H. Kress Collection: European Schools XVI-XIX Century* (London: Phaidon Press, 1976), 79–80, figs. 140–146, no. K1613; Ian Wardropper, "Italian Renaissance Decorative Arts in Chicago Collections," *Apollo* 75 (March 1987): 202 (illus. 204, fig. 4); idem, "Renaissance Decorative Arts from Chicago Collections" (Chicago: Art Institute of Chicago, 1987), n.p., checklist no. 32 (illus., erroneously, as no. 31); "Object Lessons," *University of Chicago Magazine* 82 (Fall 1989): 23 (illus.).

Hans Reinhart the Elder
10 *The Fall of Man* (obverse)
 The Crucifixion (reverse), 1536
 Cast silver medallion, diam. 2¹¹⁄₁₆ (6.8)
 Purchase, The Cochrane-Woods Collection, 1977.100
PROVENANCE: Mayer, Germany; Claus Mayer, Larchmont, N.Y.; Blumka Gallery, New York.
EXHIBITIONS: Art Institute of Chicago, *Renaissance Decorative Arts from Chicago Collections*, 2 March–14 June 1987, no. 46.
LITERATURE: Georg Habich, *Die deutschen Schaumünzen des XVI. Jahrhunderts*, vol. 2, part 1 (Munich: F. Bruckmann, Ag., 1929); H. Kuhn, *Hans Reinhart, ein Meister der Mitteldeutschen Renaissance-Medaille* (Halle, 1942); "A Message from the Director," *Gallery* [Newsletter of the David and Alfred Smart Gallery] 1 (Fall 1977): n.p.; Ian Wardropper, "Renaissance Decorative Arts from Chicago

Collections" (Chicago: Art Institute of Chicago, 1987), n.p., checklist no. 46.

Il Pordenone (Giovanni Antonio de Sacchi)

11a *Milo of Croton Attacked by Wild Beasts*, 1534–1536
 Oil on canvas, 80½ x 93¾ (204.5 x 238.1)
 Purchase, The Cochrane-Woods Collection, 1975.31

PROVENANCE: Vincenzo Imperiali, Genoa, 1661; Queen Christina of Sweden, Rome, 1667; Livio Odescalchi, Rome, 1692; Philippe, Duke of Orleans, Palais Royal, Paris, 1721; Philippe Egalité, France; Walkvers, Brussels, 1792; Laborde de Méréville, France; Duke of Bridgewater, England; Earl of Darnley, Cobham Hall, 1798–1800; R. P. Roupel, Esq.; Honorable Society of Lincoln's Inn; David Edge, Esq.; Sotheby's, London; Christopher Gibbs, Ltd., London, March 1973–1978.

EXHIBITIONS: David and Alfred Smart Gallery, University of Chicago, *A New Acquisition: Milo of Croton by Il Pordenone*, 21 January–17 March 1976; Friuli, Italy, Comune di Pordenone, Villa Manin di Passariano, *Il Pordenone*, 1984, cat. no. 2.39.

LITERATURE: Dubois de Saint Gelais, *Description des tableaux du Palais Royal* (Paris, 1727); J. Couché, *Galerie du Palais Royal gravée d'après les tableaux des différentes écoles qui le composent avec une abrège de la vie des peintres et une description historique de chaque tableau par m.r. l'abbé de Fontenai* (Paris, 1786–1808); G. F. Waagen, *Treasures of Art in Great Britain. III* (London, 1854), 19; G. Campori, *Raccolta di cataloghi ed inventari inediti* (Modena, 1870), 376; *Roupel Sale*, 1887, 82–83; C. Stryienski, *Galerie du Régent Philippe, Duc d'Orléans* (Paris, 1913); F. Mauroner, "Incisioni pordenonesi," *Ce Fastu?*, April 1944, 4; I. Furlan, "La Natività dei Pescincanna," *Il Noncello* 7 (1956): 47; E. K. Waterhouse, "Queen Christina's Italian Pictures in England," in *Queen Christina of Sweden, Documents and Studies* (Stockholm, 1966), 374; Giuseppe Fiocco, *Giovanni Antonio Pordenone* (Pordenone: Cosarini Editori, 1969), vol. 1, 85, 177; Charles E. Cohen, "The Art of Giovanni Antonio de Pordenone" (Ph.D. diss., Harvard University, 1971), vol. 1, 503–505, vol. 2, 400–401; *Sotheby's*, 21 March 1973, cat. no. 51; *Sotheby's*, 18 December 1973, cat. no. 5; A. Luzio, *La Galleria Gonzaga venduta all'Inghilterra nel 1627–1628* (Rome, 1974), 306; M. Lucco, "Pordenone à Venezia," *Paragone* 309 (November 1975): 26; Dennis Adrian, "Bright New Artists, Crisp New Gallery," *Chicago Daily News*, 7–8 February 1976, Panorama section, 11; Harold Haydon, "There Is a Lot to See in Town," *Chicago Sun-Times*, 1 February 1976, Show section, 6; D. Rosand and Michelangelo Muraro, *Titian and the Venetian Woodcut* (Washington, D.C., 1976), 250–252; David and Alfred Smart Gallery, "A New Acquisition: *Milo of Croton* by Il Pordenone" (Chicago: David and Alfred Smart Gallery, University of Chicago, 1976); "New Additions to the Collection," *Gallery* [Newsletter of the David and Alfred Smart Gallery] 1 (Spring 1976): n.p. (illus.); Caterina Furlan, "Tra Giorgione e il Pordenone: a proposito di alcuni dipinti già nella collezione del duca d'Orleans," in *Giornata di studio per il Pordenone*, ed. P. Ceschi Lavagetto (Piacenza, 1982), 18–20; D. Landau, "Printmaking in Venice and the Veneto," in *The Genius of Venice 1500–1600* (London, 1983), 345; Caterina Furlan, "Rivisitando Il Pordenone: congetture, ipotesi, proposte," in *Il Pordenone*, ed. Caterina Furlan (Milan: Electra Editrice, 1984), 136–137, cat. no. 2.39, (illus.); Giulio Bora, "Nota su Pordenone e i cremonesi (e su alcuni nuovi disegni)," in *Il Pordenone, Atti del convegno internazionale di studio*, ed. Caterina Furlan (Pordenone: Biblioteca dell' Immagine, 1985), 155; 156, no. 23; 157, fig. 20.8; Cohen, "The Fame and Influence of Pordenone's *Milo di Croton*," *Bulletin of the David and Alfred Smart Gallery* 1 (1987–1988): 14–19, (illus. p. 15, fig. 1); Bruce Davis, *Mannerist Prints: International Style in the Sixteenth Century* (Los Angeles: Los Angeles County Museum of Art, 1988), 55, fig. 9a.

Niccolò Boldrini

11b *Milo of Croton Attacked by Wild Beasts*, after Il Pordenone, mid 16th century
 Chiaroscuro woodcut (key block only), image 11⅝ x 16¼ (29.5 x 41.3)
 Gift of Mr. and Mrs. H. W. Janson, 1977.109

EXHIBITIONS: David and Alfred Smart Gallery, University of Chicago, *Chiaroscuro Woodcuts: Color and Reproduction*, 30 May–2 September 1985, cat. no. 3; Ann Arbor, University of Michigan Museum of Art, *All Creatures Great and Small*, 31 March–21 May 1989.

LITERATURE: John C. Baum, "Chiaroscuro Woodcuts: Color and Reproduction" (Chicago: David and Alfred Smart Gallery, University of Chicago, 1985), n.p., cat. no. 3; Charles E. Cohen, "The Fame and Influence of Pordenone's *Milo of Croton*," *Bulletin of the David and Alfred Smart Gallery* 1 (1987–1988): 15 (illus. p. 16, fig. 2); Graduate Students in Museum Practice, *All Creatures Great and Small* (Ann Arbor: University of Michigan Museum of Art, 1989), 7; "U-M Museum of Art Exhibits *All Creatures Great and Small*," *Michigan Alumnus* 95 (May-June 1989): 13 (illus.).

Luca Cambiaso

12 *Madonna and Child with St. John the Baptist and St. Benedict*, circa 1562
 Oil on wood panel, 55 x 40⅝ (139.7 x 103.2)
 Gift of the Samuel H. Kress Foundation, 1973.50

PROVENANCE: Brignole family, Palazzo Rosso, Genoa, 1694–1813; Contini Bonacossi; Samuel H. Kress Collection, New York, 1950–1973.

EXHIBITIONS: Houston, Museum of Fine Arts, 1953–1961; Genoa, Palazzo dell' Accademia, *Luca Cambiaso*, June–October 1956, cat. no. 12.

LITERATURE: Carlo Giuseppe Ratti, *Instruzione di quanto può vedersi di più bello in Genova in pittura, scultura, ed architettura ecc.*, 2d ed. (Genoa: Presso Ivone Gravier, 1780), 255; Museum of Fine Arts of Houston, *The Samuel H. Kress Collection at the Museum of Fine Arts of Houston. An Introduction to 36 Paintings* (Houston: Museum of Fine Arts of Houston, 1953), n.p., pl. 16; Bertina Suida Manning, "A Rediscovered Work by Luca Cambiaso," *Art Quarterly* 17 (Spring 1954): 30–41, fig. 1; G. Frabetti and A. M. Gabbrielli, *Luca Cambiaso* (Genoa: Palazzo dell' Accademia, 1956), cat. no. 12; A. Griseri, "Una Traccia per il Cambiaso," *Paragone* 75 (March 1956): 20; Manning and W. E. Suida, *Luca Cambiaso: Le Vite e le Opere* (Milan: Casa editrice Ceschina, 1958), 160; Fern R. Shapley, *Paintings from the Samuel H. Kress Collection, Italian Schools XVI-XVIII Century* (New York: Phaidon Press, 1973), 5, no. K1772, fig. 7; David and Alfred Smart Gallery, *David and Alfred Smart Gallery, The University of Chicago, 1974* (Chicago: David and Alfred Smart Gallery, University of Chicago, 1974), n.p. (illus.).

Hendrik Goudt

13a *The Mocking of Ceres*, after Adam Elsheimer, 1610
 Engraving, second state; plate 12⅜ x 9⅝ (31.4 x 24.4)
 Dutuit 6, Hollstein 5, Reitlinger 6
 Signed and dated beneath an eight-line verse: "A Elsheimer pinxit . . . H Goudt sculpsit et dicauit Romae. 1610."
 University transfer from Max Epstein Archive, Gift of Max Epstein, 1937; 1976.145.197

LITERATURE: Eugène Dutuit, *Manuel de l'amateur d'estampes*, vol. 4–6, *Ecoles flamande et hollandaise* (Paris, 1881–1885; reprint, Amsterdam, 1971), vol. II, 522, no. 6; Henry Reitlinger, "Hendrick, Count Goudt," *Print Collector's Quarterly* 8 (1921): 231–246, no. 6, esp. 242 and 243 (illus.); F. W. Hollstein, *Dutch and Flemish Etchings, Engravings,*

and Woodcuts, ca. 1450–1700 (Amsterdam, 1949), vol. 3, p. 155, no. 5 (illus.).

Wenceslaus Hollar

13b *The Mocking of Ceres*, after Hendrik Goudt, 1646
Etching, plate 11¾ x 9 (29.8 x 22.9)
Parthey 273, Pennington 273
Signed and dated beneath an eight-line verse: "A Elsheimer pinxit, W Hollar fecit, aqua forti/1646"
University transfer from Max Epstein Archive,
Gift of Max Epstein, 1937; 1976.145.200
LITERATURE: Gustav Parthey, *Wenzel Hollar* (Berlin, 1853; reprint, Amsterdam, 1963), 52, cat. no. 273; Richard Pennington, *A Descriptive Catalogue of the Etched Work of Wenceslaus Hollar 1607–1677* (Cambridge: Cambridge University Press, 1982), 37, cat. no. 273.

Alessandro Algardi

14a *The Infant Hercules Subduing the Serpent*, after circa 1635
Cast bronze, l. 17 (43.2)
Montagu 127.c.5
Purchase, The Cochrane-Woods Collection, 1977.103
PROVENANCE: Heim Gallery, London.
EXHIBITIONS: London, Heim Gallery, *Paintings and Sculptures of the Italian Baroque*, 30 May–21 September 1973, cat. no. 25.
LITERATURE: Heim Gallery, *Paintings and Sculptures of the Italian Baroque* (London: Heim Gallery, 1973), n.p., cat. no. 25; "A Message from the Director," *Gallery* [Newsletter of the David and Alfred Smart Gallery] 1 (Fall 1977): n.p.; Jennifer Montagu, *Alessandro Algardi* (New Haven and London: Yale University Press, 1985), vol. 2, 406, no. 127.c.5.

Attributed to **Michel Anguier**

14b *The Infant Hercules Subduing the Serpent*, after Alessandro Algardi, circa 1641
Cast bronze, l. 18½ (47)
Montagu 127.c.6
Purchase, The Cochrane-Woods Collection, 1977.101
PROVENANCE: Michael Hall Fine Arts, New York.
LITERATURE: "A Message from the Director," *Gallery* [Newsletter of the David and Alfred Smart Gallery] 1 (Fall 1977): n.p.; Jennifer Montagu, *Alessandro Algardi* (New Haven and London: Yale University Press, 1985), vol. 2, 406–407, no. 127.c.6.

Cecco Bravo (Francesco Montelatici)

15 *Angelica and Ruggiero*, circa 1640–1645
Oil on canvas, 12¾ x 17½ (32.4 x 44.5)
Gift of the Samuel H. Kress Foundation, 1973.42
PROVENANCE: Dan Fellows Platt, Englewood, N.J.; Samuel H. Kress Collection, New York, 1943–1973.
EXHIBITIONS: Washington, D.C., National Gallery of Art, 1945–1960, no. 801 (as Furini, then as Mazzoni); Detroit Institute of Arts, *Art in Italy, 1600–1700*, 6 April–9 May 1965, cat. no. 128; New York, Metropolitan Museum of Art, *Florentine Baroque Art from American Collections*, 16 April–15 June 1969, cat. no. 45; Florence, Palazzo Strozzi, *Il Seicento Fiorentino*, 21 December 1986–4 May 1987, cat. no. I.193.
LITERATURE: F. Mason Perkins, "Dipinti italiani nella raccolta Platt. Parte II," *Rassegna d'Arte* 11 (September 1911): 145; N. Ivanoff, "Sebastiano Mazzoni," *Saggi e memorie di storia dell' arte* 2 (1959): 222; Gerhard Ewald, "Hitherto Unknown Works by Cecco Bravo," *Burlington Magazine* 102 (August 1960): 351–352, n. 28 and 35, fig. 3; M.

Muraro, "Cosimo De' Noferi ignoto fiorentino," *Rivista d'Arte* 35 (1960): 74, n. 5 (as *Angelica e Medoro*); Ewald, "Addenda to Cecco Bravo," *Burlington Magazine* 103 (1961): 348, n. 6; A. R. Massetti, *Cecco Bravo pittore toscano del Seicento* (Venice: Neri Pozza, 1962), 59, 91, and n. 19; Detroit Institute of Arts, *Art in Italy, 1600–1700* (Detroit: Detroit Institute of Arts, 1965), 118–119, cat. no. 128 (illus.); Metropolitan Museum of Art, *Florentine Baroque Art from American Collections* (New York: Metropolitan Museum of Art, 1969), 49–50, fig. 26, cat. no. 45; Fern R. Shapley, *Paintings from the Samuel H. Kress Collection, Italian Schools XVI-XVIII Century* (New York: Phaidon Press, 1973), 86, fig. 153; P. Bigongiari, "Biliverti e l'energia affabulante del segno, e altre reflessioni sulla pittura fiorentina del prima seicento," *Paradigma* 4 (1982): 85–110; G. Cantelli, "Mitologia sacra e profana e le sue eroine nella pittura fiorentina della prima metà del Seicento (II)," *Paradigma* 4 (1982): 142; Pierre Granville, "Contribution à la connaissance de l'oeuvre de Giovanni Biliverti," *La Revue du Louvre et des Musées de France* 32:5/6 (December 1982): 348, no. 5 (illus.); Palazzo Strozzi, *Il Seicento Fiorentino* (Florence: Palazzo Strozzi, 1986), 362, 363 (illus.), cat. no. I.193.

Luca Giordano

16 *The Anointment of King Solomon*, 1692–1694
Oil on paper mounted on canvas, 14¾ x 14¼ (37.5 x 36.2)
Purchase, Gift of Mr. and Mrs. Eugene Davidson, 1976.69
PROVENANCE: Ira Spanierman, Inc., New York.
LITERATURE: Dawson W. Carr, "Luca Giordano at the Escorial: The Frescoes for Charles II" (Ph.D. diss., New York University, 1987), vol. I, 284–287, pls. 192, 194, 201.

Noël Hallé

17 *Joseph Accused by Potiphar's Wife*, circa 1740–1744
Oil on canvas, 55¾ x 65⅝ (141.7 x 166.5)
Purchase, Gift of The Mark Morton Memorial Fund and Mr. and Mrs. Eugene Davidson, 1974.116
PROVENANCE: Sale after the death of the artist, 2 July 1781, no. 21; bequeathed to Jean-Noël Hallé, M.D., 1785, by his mother; M. Pétin, Paris; anonymous sale, 6 November 1972, Hôtel Drouot, Paris; Heim Gallery, London.
EXHIBITIONS: Paris, Académie Royale de Peinture et de Sculpture, *Salon of 1748*, cat. no. 49; London, Heim Gallery, *Religious and Biblical Themes in French Baroque Painting*, 29 May–30 August 1974, cat. no. 19; Toledo Museum of Art, *The Age of Louis XV: French Painting 1710–1774*, 1975 (traveled to Art Institute of Chicago; Ottawa, National Gallery of Canada), cat. no. 45; Rochester, N.Y., Memorial Art Gallery of Rochester, *La Grande Manière: Historical and Religious Painting in France 1700–1800*, 30 April–16 August 1987 (traveled to New Brunswick, N.J., Zimmerli Art Museum, Rutgers University, 12 September–22 November 1987; Atlanta, High Museum of Art at Georgia-Pacific Center, 7 December 1987–29 January 1988), cat. no. 26.
LITERATURE: Louis-Guillaume Baillet de Saint-Julien, *Réflexions sur quelques circonstances présentes. Contenant deux lettres sur l'Exposition des Tableaux au Louvre cette année 1748. A. M. le Conte de R.*** et une autre Lettre à Monsieur de Voltaire au sujet de sa Tragédie de Semiramis*, n.d., Collection Deloynes, pl. III, pièce 38; *Lettre sur la peinture, la sculpture, et l'architecture. A. M. *** par une Société d'Amateurs* (Paris, 1748), Collection Deloynes, vol. III, pièce 32; *Mercure de France*, September 1748, 162; Académie Royale de Peinture et de Sculpture, *Collection des Livrets des anciennes expositions depuis 1673 jusqu'en 1800* (Paris: Liepmanns-Sohn et Dufour, 1869–1872), 14:21, cat. no. 49; O. Estournet, "La famille des Hallé," *Réunion des Sociétés des Beaux-Arts des Départments* 29 (1905): 71–236, cat. no. 3; Chantelou [pseud. Granville], "Loggia del Bigallo," *Le Monde*, 23 February 1973, 19; Heim

Gallery, *Religious and Biblical Themes in French Baroque Painting* (London: Heim Gallery, 1974), cat. no. 19; Pierre Rosenberg, *The Age of Louis XV: French Painting 1710–1774* (Toledo: Toledo Museum of Art, 1975), 44, cat. no. 45, pl. 67; Heim Gallery, *Portraits and Figures in Paintings and Sculpture, 1570–1870* (London: Heim Gallery, 1983), no. 16; David Lomax, "The Early Career of Noël Hallé," *Apollo* 117 (February 1983): 106–109, fig. 5; Sotheby Parke Bernet, *Tableaux anciens et de début du XIXe siècle* (Monaco: Sotheby Parke Bernet, 1983), 82–83, cat. no. 474; Donald Rosenthal, *La Grande Manière: Historical and Religious Painting in France, 1700–1800* (Rochester, N.Y.: Memorial Art Gallery of the University of Rochester, 1987), 106, cat. no. 26; "Object Lessons," *University of Chicago Magazine* 82 (Fall 1989): 22 (illus.).

Il Sansone (Giuseppe Marchesi)

18 *The Magdelene Attended by Two Angels*, circa 1740–1750
Oil on canvas, 57¼ x 66⅜ (146 x 168.4)
Purchase, Gift of Mrs. Eugene Davidson, 1977.104
PROVENANCE: P & D Colnaghi and Co., London; Sotheby Parke Bernet, New York, 1977.
EXHIBITIONS: New York, Sotheby Parke Bernet, *Important Old Master Paintings*, 10–15 June 1977, cat. no. 31 (as Giovan Gioseffo dal Sole.)
LITERATURE: Sotheby Parke Bernet, *Important Old Master Paintings* (New York: Sotheby Parke Bernet, 1977), cat. no. 31 (illus., as Giovan Gioseffo dal Sole); Dwight Miller, "Reflections on Bolognese Painting," *Burlington Magazine* 121 (August 1979): 525, 529, fig. 75.

French, Chantilly Factory

19 *Shell-form Bowl with Platter*, circa 1750
Soft-paste porcelain, bowl 4½ x 10½ (11.4 x 26.7), platter l. 13½ (34.3)
Gift of Mrs. Helen Regenstein, 1976.10
PROVENANCE: Thelma Chrystler Foy; Parke-Bernet Galleries, New York, 1959; Sotheby and Co., New York, 1971; Mrs. Helen Regenstein, Chicago, 1971–1976.
EXHIBITIONS: New York, Parke-Bernet Galleries, *French Modern Paintings and Drawings, Eighteenth Century French Furniture, Marble and Terra Cotta Sculptures [and] Bronze Doré Objects of Art Collected by the late Thelma Chrystler Foy*, 13–16 May 1959, no. 256; New York, Sotheby and Co., *French Porcelain, German Porcelain, Russian Porcelain*, 11–13 July 1971, no. 161; David and Alfred Smart Gallery, University of Chicago, *Concentrations in the Collection: European and American Decorative Arts*, 10 January–17 March 1985.
LITERATURE: Parke-Bernet Galleries, *French Modern Paintings and Drawings, Eighteenth Century French Furniture, Marble and Terra Cotta Sculptures [and] Bronze Doré Objects of Art Collected by the late Thelma Chrystler Foy* (New York: Parke-Bernet Galleries, 1959), 104, fig. 256; Sotheby and Co. *French Porcelain, German Porcelain, Russian Porcelain* (New York: Sotheby and Co., 1971), n.p., no. 161, pl. V.

John Baptist Jackson

20 *The Crucifixion*, after Tintoretto, 1740 (dated 1741)
Four-color chiaroscuro woodcut, left sheet 23⅞ x 18½ (60.6 x 47), center 24¾ x 18¼ (62.9 x 46.3), right 23⅞ x 18½ (60.6 x 47)
Post-publication printing with altered blocks, not recorded in Le Blanc 9, Kainen 22, Nagler 13
University transfer from Max Epstein Archive, 1967.116.144–146
PROVENANCE: Max Epstein Archive, University of Chicago, 1949.

Silesian, Warmbrunn

21 *Goblet with Lid (Pokal)*, 1760
Clear glass, gilt decoration, with 19th-century brass finial, h. with lid 8½ (21.6)
Gift of Mrs. Else Felber, 1981.75
EXHIBITIONS: David and Alfred Smart Gallery, University of Chicago, *Concentrations in the Collection: European and American Decorative Arts*, 10 January–17 March 1985.

Italian, Doccia Factory

22 *Portrait Medallion with Bust of Marchese Carlo Ginori*, circa 1757
Hard-paste porcelain, h. 6¾ (17.1)
Purchase, The Harold T. Martin Fund, 1979.54
PROVENANCE: Christie's, New York, 29 November 1979.
EXHIBITIONS: New York, Christie's, *European Porcelain and Pottery*, 29 November 1979, no. 222; David and Alfred Smart Gallery, University of Chicago, *Concentrations in the Collection: European and American Decorative Arts*, 10 January–17 March 1985.
LITERATURE: Christie's, *European Porcelain and Pottery* (New York: Christie's, 1979), 61, no. 222 (illus.).

Jean-Baptiste Le Prince

23 *The Russian Dance (La Dance Russe)*, 1769
Etching, aquatint; plate 15⅛ x 12⅛ (38.4 x 30.7)
Hédou 137
University transfer from Max Epstein Archive, 1976.145.391
LITERATURE: Jules Paul Ernest Hédou, *Jean Le Prince et son oeuvre* (Paris: P. Baur, 1879), no. 137.

Franz Anton Maulbertsch

24a *The Sausage Woman (Die Würstelbräterin)*, circa 1785–1790
Oil on wood panel, 12¹¹⁄₁₆ x 14¹⁄₁₆ (30.7 x 35.8)
Purchase, Gift of Viola Manderfeld, 1978.184
PROVENANCE: Tom Lenz, Milwaukee; Ran Gallery, Cincinnati; Sotheby Parke Bernet, New York, 28 November 1978.
EXHIBITIONS: New York, Sotheby Parke Bernet, *Old Master Paintings and Drawings*, 28 November 1978, no. 110 (as Dutch School).
LITERATURE: Sotheby Parke Bernet, *Old Master Paintings and Drawings* (New York: Sotheby Parke Bernet, 1978), n.p., no. 110 (illus., as Dutch School).

24b *The Pancake Woman (Das Krapfenweib)*, circa 1785–1790
Oil on wood panel, 12¹¹⁄₁₆ x 14¹⁄₁₆ (30.7 x 35.8)
Purchase, Gift of Viola Manderfeld, 1978.185
PROVENANCE: Tom Lenz, Milwaukee; Ran Gallery, Cincinnati; Sotheby Parke Bernet, New York, 28 November 1978.
EXHIBITIONS: New York, Sotheby Parke Bernet, *Old Master Paintings and Drawings*, 28 November 1978, no. 110 (as Dutch School).
LITERATURE: Sotheby Parke Bernet, *Old Master Paintings and Drawings* (New York: Sotheby Parke Bernet, 1978), n.p., no. 110 (illus., as Dutch School).

German, Berlin, Royal Porcelain Manufactory

25 *Plate*, circa 1810–1815
Hard-paste porcelain, overglaze enamel, gilt decoration; diam. 9⁷⁄₁₆ (24)
Purchase, Gift of Mrs. Lois Bader Adelman, 1979.51
PROVENANCE: Mrs. Paul Felber, Chicago.
EXHIBITIONS: David and Alfred Smart Gallery, University of Chicago, *Concentrations in the Collection: European and American Decorative Arts*, 10 January–17 March 1985.

Pierre-Henri de Valenciennes

26 *Cloud Study*, circa 1817
 Oil on paper mounted on paperboard, 9¼ x 14⅛ (23.5 x 35.9)
 Purchase, The Cochrane-Woods Collection, 1982.19
PROVENANCE: Dr. Herman Pollack, Belgium.
LITERATURE: "On the Permanent Collection," *Gallery* [Newsletter of the David and Alfred Smart Gallery] 7 (Fall 1982): n.p. (illus.).

Louis Dupré

27 *Portrait of M. Fauvel, the French Consul, with View of the Acropolis*, 1819
 Oil on canvas, 20½ x 25¼ (52.1 x 64.1)
 Gift of Mr. and Mrs. Frank H. Woods, 1980.33
PROVENANCE: Julius H. Weitzner, Inc., New York; Mr. and Mrs. Frank H. Woods, Lake Forest, Ill., 1972–1980.
EXHIBITIONS: New York, Michael Ward, Inc., *A Romantic Vision of Greece and Turkey: Louis Dupré's Voyage of 1819 to Athens and Constantinople*, 20 April–30 June 1988, cat. no. 30.
LITERATURE: C. W. J. Eliot, "Gennadeion Notes II, Athens at the Time of Lord Byron," *Hesperia* 37 (April-June 1968): 134–158, pl. 53b; "Important Gift from Woods Family," *Gallery* [Newsletter of the David and Alfred Smart Gallery] 4 (Summer 1980): n.p. (illus.); Michael Ward, Inc., *A Romantic Vision of Greece and Turkey: Louis Dupré's Voyage of 1819 to Athens and Constantinople* (New York: Michael Ward, Inc., 1988), n.p., cat. no. 30.

Julius Veit Hans Schnorr von Carolsfeld

28 *The Sleep of Emperor Frederick Barbarossa*, circa 1835–1837
 Oil on wood panel, 18¾ x 14 (47.6 x 35.6)
 Purchase, The Cochrane-Woods Collection, 1980.3
PROVENANCE: Arnoldi-Livie, Munich; Shepherd Gallery, New York.
EXHIBITIONS: New York, Shepherd Gallery, *Nineteenth Century European Paintings, Drawings and Sculpture*, Winter 1979–1980, cat. no. 92.
LITERATURE: Shepherd Gallery, *Nineteenth Century European Paintings, Drawings and Sculpture* (New York: Shepherd Gallery, 1979), n.p., cat. no. 92 (illus.); "New Gallery Gifts," *Gallery* [Newsletter of the David and Alfred Smart Gallery] 5 (Spring 1981): n.p. (illus.).

Jean-Auguste Barre

29 *Louis-Philippe I and Marie-Amelie, King and Queen of the French* (obverse)
 The Royal Family [Portraits of Eugénie Adelaide Louise; Ferdinand and Louise; Louis, Clémentine, and Antoine; Henri, Marie, and François d'Orléans] (reverse), circa 1832
 Cast bronze medallion, diam. 2¹⁵⁄₁₆ (7.5)
 Purchase, Gift of Mr. and Mrs. Richard Elden, Mr. and Mrs. Robert Feitler, and Mr. and Mrs. John Smart in honor of Mrs. Florence Richards, 1983.5
PROVENANCE: Victor D. Spark, New York, 1974–1983.
EXHIBITIONS: David and Alfred Smart Gallery, University of Chicago, *The Charged Image: Political Satire in the Age of Daumier*, 4 October–4 December 1988.
LITERATURE: Richard A. Born, "Curator's Corner," *Gallery* [Newsletter of the David and Alfred Smart Gallery] 8 (Fall 1983): n.p. (illus.).

Princess Marie-Christine d'Orléans

30 *Joan of Arc*, after 1835
 Cast silvered bronze, h. 11⅝ (29.5)
 Purchase, Gift of the Friends of the Smart Gallery, 1983; 1983.4
PROVENANCE: Shepherd Gallery, New York.

EXHIBITIONS: New York, Shepherd Gallery, *French and Other Drawings, Paintings and Sculpture of the Nineteenth Century*, Winter 1981–1982, cat. no. 150.
LITERATURE: J. Chaudes-Aigues, "Notice sur Jeanne d'Arc," *Revue de Paris* 42 (1837); idem, "Statue de Jeanne d'Arc," *L'Artiste* 1 (1838); Shepherd Gallery, *French and Other Drawings, Paintings and Sculpture of the Nineteenth Century* (New York: Shepherd Gallery, 1981), n.p., cat. no. 150 (illus.); "Friends News," *Gallery* [Newsletter of the David and Alfred Smart Gallery] 8 (Fall 1983): n.p. (illus.).

Jean-Baptiste Clésinger

31a *Seated Faun*, after 1862
 Cast bronze, h. 16 (40.6)
 Gift of Mr. and Mrs. Edward A. Maser, 1982.11
PROVENANCE: Shepherd Gallery, New York, 1981.
EXHIBITIONS: New York, Shepherd Gallery, *French and Other European Drawings, Paintings and Sculpture of the Nineteenth Century*, Winter 1981–1982, cat. no. 47.
LITERATURE: Shepherd Gallery, *French and Other European Drawings, Paintings and Sculpture of the Nineteenth Century* (New York: Shepherd Gallery, 1981), n.p., cat. no. 47 (illus.).

31b *Seated Faun*, after 1862
 Cast bronze, h. 12¾ (32.4)
 Gift of Ann Englander, 1985.80

Margaret F. Foley

32 *Portrait of Jenny Lind*, 1865
 Marble, diam. 16½ (41.9)
 Gift of Dr. and Mrs. Isadore Isoe, 1973.35
EXHIBITIONS: Washington, D.C., National Museum of Women in the Arts, *American Women Artists 1830–1930*, 10 April–14 June 1987 (traveled to Minneapolis Institute of Arts, 5 July–30 August 1987; Hartford, Conn., Wadsworth Atheneum, 19 September–15 November 1987; San Diego Museum of Art, 5 December 1987–31 January 1988; Dallas, Meadows Museum, Southern Methodist University, 20 February–17 April 1988), cat. no. 104.
LITERATURE: National Museum of Women in the Arts, *American Women Artists 1830–1930* (Washington, D.C.: National Museum of Women in the Arts, 1987), n.p., cat. no. 104 (illus).

William Merritt Chase

33 *Portrait of a Man*, circa 1875
 Oil on wood panel, 45½ x 30½ (115.6 x 77.5)
 Gift of Mrs. Robert B. Mayer, 1974.49
PROVENANCE: Chicago Art Galleries, 28 January 1973; Mr. and Mrs. Robert B. Mayer, Winnetka, Ill., 1973–1974.

Auguste Rodin

34 *The Thinker* (*Le Penseur*), circa 1880 (model)
 Cast bronze, h. 28 (71.1)
 The Harold H. Swift Bequest, 1962; 1967.30
PROVENANCE: Musée Rodin, Paris(?); Harold H. Swift, Chicago (bequest 1962).
EXHIBITIONS: Milwaukee, Brooks Memorial Union, Marquette University, *Great Art from Private Colleges and Universities*, 20–27 February 1964; Peoria, Ill., Lakeview Museum of Arts and Sciences, *The Passion of Rodin: Sculpture from the B. Gerald Cantor Collection*, 1 May–3 July 1988.
LITERATURE: Marquette University, *Great Art from Private Colleges and Universities* (Milwaukee: Brooks Memorial Union, Marquette University, 1964), n.p. (illus.).

Emile René Ménard

35 *Homer*, circa 1885
 Oil on canvas, 51 x 62 (129.5 x 157.5)
 Purchase, Gift of Mr. and Mrs. Eugene Davidson, 1980.4
PROVENANCE: Sir Andrew Noble, Newcastle-upon-Tyne, 1896; Jesmond Towers, Newcastle, 1926; J. L. Collins, Gateshead, England; Sotheby Parke Bernet & Co., London, 19 April 1978; Barry Friedman, Ltd., New York.
EXHIBITIONS: Paris, Société des Artistes Français, *Exposition des Beaux-Arts de 1885*, May 1885, cat. no. 1731; Paris, *Exposition Nationale des Beaux-Arts*, April 1896, cat. no. 882; London, Sotheby Parke Bernet & Co., *Fine Eighteenth, Nineteenth and Twentieth Century European Paintings and Works of Islamic Interest*, 19 April 1978, cat. no. 161.
LITERATURE: F-G. Dumas, ed., *Catalogue illustré du Salon* (Paris: Librairie d'Art L. Baschet, 1885), xxxix, cat. no. 1731; *Explication des ouvrages de peinture, sculpture, architecture, gravure et lithographie des artistes vivants exposés au Palais des Champs-Elysées le 1er mai 1885* (Paris: E. Bernard et Cie., 1885), 151, cat. no. 1731; *Exposition Nationale des Beaux-Arts: Catalogue Illustré des ouvrages de peinture, sculpture et gravure exposés au Champ-de-Mars le 25 Avril 1896* (Paris: E. Bernard et Cie., 1896), xxii, cat. no. 882; Sotheby Parke Bernet & Co., *Fine Eighteenth, Nineteenth and Twentieth Century European Paintings and Works of Islamic Interest* (London: Sotheby Parke Bernet & Co., 19 April 1978), n.p., no. 161 (illus.); "New Acquisitions," *Gallery* [Newsletter of the David and Alfred Smart Gallery] 5 (Fall/Winter 1980): n.p. (illus.); Neil McWilliam, "Limited Revisions: Academic Art History Confronts Academic Art," *Oxford Art Journal* 12 (1989): 73 (illus.).

Jean-Léon Gérôme

36 *Pygmalion and Galatea*, circa 1890
 Oil on canvas, 17⅜ x 13¼ (44.1 x 33.6)
 Purchase, Gift of Mr. and Mrs. Eugene Davidson, 1980.73
PROVENANCE: Estate of Suzanne Morot (the artist's sister); Gift of Gérôme to Aimé Morot; Barry Friedman, Ltd., New York.
LITERATURE: "New Gallery Gifts," *Gallery* [Newsletter of the David and Alfred Smart Gallery] 5 (Spring 1981): n.p. (illus.); Naomi Maurer, "Breathing Life into Sculpture: *Pygmalion and Galatea* by Jean-Léon Gérôme," *Bulletin of the David and Alfred Smart Gallery* 1 (1987–1988): 11–13 (illus. 12, fig. 1).

Childe Hassam

37 *On the Lake Front Promenade, Columbian World Exposition*, 1893
 Oil on canvas, 17⅝ x 23⅝ (44.8 x 60)
 The Harold H. Swift Bequest, 1962; 1976.146

Hilaire Edgar Germain Degas

38 *Woman Stretching (Femme s'étirant)*, 1896–1917 (cast 1919–1921)
 Cast bronze, ed. 53/D, h. 14⅜ (36.5)
 Rewald LXIV
 The Joel Starrels, Jr. Memorial Collection, 1974.147
PROVENANCE: Justin K. Tannhauser, New York; Private collection, New York; Harold Diamond, New York, 1963–1964, Mr. and Mrs. Joel Starrels, Sr., Chicago, to 1974.
EXHIBITIONS: New York, Buchholz Gallery, *Edgar Degas Bronzes, Drawings, Pastels*, 3–27 January 1945, cat no. 45; David and Alfred Smart Gallery, University of Chicago, *The Joel Starrels, Jr. Memorial Collection*, October–December 1974.
LITERATURE: Buchholz Gallery, *Edgar Degas Bronzes, Drawings, Pastels* (New York: Buchholz Gallery, 1945), n.p., cat. no. 45; John Rewald and Leonard von Matt, *Degas Sculpture*, trans. John Coleman

and Noel Moulton (New York: Abrams, 1956), 156, no. LXIV, pls. 66, 67.

Louis-Ernest Barrias

39a *Nature Unveiling Herself to Science*, after 1899
 Cast bronze, partial *doré* patination, h. 28½ (72.4)
 Gift of John N. Stern, 1984.6
EXHIBITIONS: Oberlin, Oh., Allen Memorial Art Museum, Oberlin College, *Ecole to Deco: Small Sculptures from a Private Collection*, 8 May–2 September 1979, cat. no. 20; David and Alfred Smart Gallery, University of Chicago, *Alumni Who Collect II: Sculpture from 1600 to the Present*, 18 April–16 June 1985.
LITERATURE: Allen Memorial Art Museum, *Ecole to Deco: Small Sculptures from a Private Collection* (Oberlin, Oh.: Allen Memorial Art Museum, 1979), 22–23, cat. no. 20 (illus.).

39b *Nature Unveiling Herself to Science*, after 1899
 Cast bronze, partial *doré* patination, h. 16¾ (42.5)
 Gift of Mr. and Mrs. John N. Stern, 1987.15
LITERATURE: *Bulletin of the David and Alfred Smart Gallery* 1 (1987–1988): 24 (illus.).

Gustave Serrurier-Bovy

40 *Fireplace Surround*, circa 1902–1905
 Brass, copper, wrought iron, mahogany, mirror, glazed porcelain tile, 98 x 56 (249 x 142.2)
 Gift of Seymour Stein, 1984.20

Frank Lloyd Wright

41 *Dining Table and Six Chairs*, 1907–1910
 Table: oak, leaded glass, ceramic, 55⅝ x 96¼ x 53½ (140 x 244.5 x 135.9)
 Chairs: oak, leather, h. 52⅜ (132.8)
 University transfer, 1967.73–79
PROVENANCE: Frederick C. Robie, Chicago, 1910; David Lee Taylor, Chicago, 1911; Wilber family, Chicago, 1912; Chicago Theological Seminary, 1936; University of Chicago, 1967.
EXHIBITIONS: Princeton, N.J., Princeton University Art Museum, *The Arts and Crafts Movement in America 1876–1916*, 21 October–17 December 1972 (traveled to Art Institute of Chicago, 24 February–22 April 1973; Washington, D.C., Renwick Gallery of the National Collection of Fine Arts, 1 June–10 September 1973), cat. no. 93; Washington, D.C., Renwick Gallery of the National Collection of Fine Arts, *The Decorative Designs of Frank Lloyd Wright*, 16 December 1977–30 July 1978 (traveled to Grey Art Gallery and Study Center, New York University, 26 September–4 November 1978; David and Alfred Smart Gallery, University of Chicago, 10 January–25 February 1979), checklist no. 24; Art Institute of Chicago, *Chicago Architecture, 1872–1922: Birth of a Metropolis*, 16 July–15 September 1988 (traveled to Paris, Musée d'Orsay, 2 October 1987–4 January 1988; Frankfurt, Deutsches Architekturmuseum, 5 February–25 April 1988), cat. no. 176.
LITERATURE: Grant Carpenter Manson, *Frank Lloyd Wright to 1910: The First Golden Age* (New York: Reinhold Publishing, 1958), 200, fig. 131; W. R. Hasbrouck, ed., "A Portfolio of the Prairie School Furniture," *Prairie School Review* 1 (Fourth Quarter 1964): 17 (illus.); Donald Kalec, "The Prairie School Furniture," *Prairie School Review* 1 (Fourth Quarter 1964): 11; H. Allen Brooks, *The Prairie School: Frank Lloyd Wright and His Midwestern Contemporaries* (Toronto: University of Toronto Press, 1972); Robert Judson Clark, ed., *The Arts and Crafts Movement in America 1876–1916* (Princeton, N.J.: Princeton University Press, 1972), 73, fig. 93; *Annual Report of the Art*

Institute of Chicago (1972–1973): 5 (illus.); Henry Russell Hitchcock, *In the Nature of Materials: The Buildings of Frank Lloyd Wright, 1881–1941* (New York: Da Capo Press, 1973), n.p., fig. 166; David A. Hanks, *The Decorative Designs of Frank Lloyd Wright* (Washington, D.C.: United States Government Printing Office, 1978), n.p., checklist no. 24 (illus.); idem, *The Decorative Designs of Frank Lloyd Wright* (New York: E. P. Dutton, 1979), 46, 106–108, fig. 107; Joseph Connors, *The Robie House of Frank Lloyd Wright* (Chicago: University of Chicago Press, 1984), 37, figs. 25–27; Donald Hoffmann, *Frank Lloyd Wright's Robie House: The Illustrated Story of an Architectural Masterpiece* (New York: Dover Publications, 1984), 73–75, fig. 120; John W. Keefe, "Furniture," *World Book Encyclopedia*, vol. F (Chicago: World Book, 1985), 508 (illus.); Laura Satersmoen, "A Study of the Dining Room Furniture in Frank Lloyd Wright's Robie House and Its Role in the Architectural Plan" (Master's thesis, University of Chicago, 1986); John Zukowsky, ed., *Chicago Architecture, 1872–1922: Birth of a Metropolis* (Chicago: Art Institute of Chicago, and Munich: Prestel-Verlag, 1987), 391, cat. no. 176, figs. 52, 53; Keefe, "Furniture," *World Book Encyclopedia*, vol. F (1988), 582 (illus.).

Erich Heckel

42 *East Baltic Seacoast* (*Ostseeküste*), 1911
Pencil, watercolor on wove paper; sheet 10⁹/₁₆ x 13¼ (26.8 x 33.6)
Bequest of Joseph Halle Schaffner in memory of his beloved mother, Sara H. Schaffner, 1973.93
PROVENANCE: Galerie Nierendorf, Berlin; Leonard Hutton Galleries, New York, 1968; Parke-Bernet Galleries, New York, 9 April 1969; Hauswedell and Nolte, Hamburg and New York.
EXHIBITIONS: New York, Leonard Hutton Galleries, *Fauves and Expressionists*, 18 April–12 June 1968, cat. no. 31; New York, Parke-Bernet Galleries, *German Expressionist and Other Twentieth Century Paintings and Sculpture*, 9 April 1969, cat. no. 18; David and Alfred Smart Gallery, University of Chicago, *Modern German and Austrian Art from the Permanent Collection*, 20 May–1 July 1984.
LITERATURE: Leonard Hutton Galleries, *Fauves and Expressionists* (New York: Leonard Hutton Galleries, 1968), 58, cat. no. 31 (illus.); Parke-Bernet Galleries, *German Expressionist and Other Twentieth Century Paintings and Sculpture* (New York: Parke-Bernet Galleries, 1969), 33, cat. no. 18 (illus.).

Helen Saunders

43 *Island of Laputa*, 1915
Pen and ink, collage on wove paper, 10⅝ x 9⅛ (26.9 x 23.1)
The Joel Starrels, Jr. Memorial Collection, 1974.275
PROVENANCE: John Quinn Collection, New York, 1917–1927; Benjamin Galleries, Chicago, 1954; Mr. and Mrs. Joel Starrels, Sr., Chicago, 1954–1974.
EXHIBITIONS: London, Doré Galleries, *Vorticist Exhibition*, June 1915, no. 3a; New York, Penguin Club, *Exhibition of Vorticists at the Penguin*, January 1917, no. 64; David and Alfred Smart Gallery, University of Chicago, *The Joel Starrels, Jr. Memorial Collection*, October–December 1974; David and Alfred Smart Gallery, University of Chicago, *British Landscape Drawings and Watercolors: 18th–20th Centuries*, May–July 1986.
LITERATURE: Wyndham Lewis, ed., *Blast: Review of the Great English Vortex*, no. 2, July 1915 (London and New York: John Lane, 1915), 8 (black monochrome xylograph of collage-drawing); *John Quinn 1870–1925* [sic]: *Collection of Paintings, Water Colors, Drawings and Sculpture* (Huntington, N.Y.: Pidgeon Hill Press, 1927), 21; Hayward Gallery, *Vorticism and Its Allies* (London: Hayward Gallery, 1974), 100 (illus.), cat. no. 415 (as "whereabouts unknown"); Richard Cork,

Vorticism and Abstract Art in the First Machine Age (Los Angeles and Berkeley: University of California Press, 1976), 2:424; Richard A. Born, "Curator's Corner," *Gallery* [Newsletter of the David and Alfred Smart Gallery] 8 (1984): n.p. (illus.).

Jean Metzinger

44 *Soldier at a Game of Chess* (*Le Soldat à la partie d'échecs*), circa 1915–1916
Oil on canvas, 32 x 24 (81.3 x 61)
Gift of John L. Strauss, Jr. in memory of his father, John L. Strauss, 1985.21
EXHIBITIONS: Iowa City, University of Iowa Museum of Art, *Jean Metzinger in Retrospect*, 31 August–13 October 1985 (traveled to Austin, Archer M. Huntington Art Gallery, University of Texas, 10 November–22 December 1985; David and Alfred Smart Gallery, University of Chicago, 23 January–9 March 1986; Pittsburgh, Museum of Art, Carnegie Institute, 29 March–25 May 1986), cat. no. 49; David and Alfred Smart Gallery, University of Chicago, *Cross Sections: Recent Additions to the Collection*, 9 October–7 December 1986, cat. no. 3.
LITERATURE: University of Iowa Museum of Art, *Jean Metzinger in Retrospect* (Iowa City: University of Iowa Museum of Art, 1985), 56, cat. no. 49 (illus.); David and Alfred Smart Gallery, *Cross Sections: Recent Additions to the Collection* (Chicago: David and Alfred Smart Gallery, University of Chicago, 1986), n.p., cat. no. 3; "Object Lessons," *University of Chicago Magazine* 82 (Fall 1989): cover (illus.); Fritz Metzinger and Daniel Robbins, *Die Entstehung des Kubismus: Eine Neubewertung* (Frankfurt: R. G. Fischer Verlag, 1990), pl. 20.

Jacques Lipchitz

45 *Seated Bather*, 1916–1917
Limestone, h. 33 (83.8)
The Joel Starrels, Jr. Memorial Collection, 1974.177
PROVENANCE: Purchased from the artist by Mr. and Mrs. Joel Starrels, Sr., Chicago, to 1974.
EXHIBITIONS: Chicago, Museum of Contemporary Art, *Modern Masters in Chicago Collections*, 8 September–22 October 1972; David and Alfred Smart Gallery, University of Chicago, *The Joel Starrels, Jr. Memorial Collection*, October–December 1974.
LITERATURE: Museum of Contemporary Art, *Modern Masters in Chicago Collections* (Chicago: Museum of Contemporary Art, 1972), n.p.

George Grosz

46 *Amalie*, 1922
Gouache, ink, graphite on wove paper; sheet 20¾ x 16¼ (52.7 x 41.2)
The Joel Starrels, Jr. Memorial Collection, 1974.140
PROVENANCE: George Grosz Estate; E. V. Thaw and Co., Inc., New York; B. C. Holland Gallery, Chicago, 1965; Mr. and Mrs. Joel Starrels, Sr., Chicago, 1965–1974.
EXHIBITIONS: Chicago, Museum of Contemporary Art, *20th Century Drawings from Chicago Collections*, 15 September–11 November 1973; David and Alfred Smart Gallery, University of Chicago, *The Joel Starrels, Jr. Memorial Collection*, October–December 1974; David and Alfred Smart Gallery, University of Chicago, *Theater and the Arts*, 1984; David and Alfred Smart Gallery, University of Chicago, *Modern German and Austrian Art from the Permanent Collection*, 20 May–1 July 1984; Chicago, Museum of Contemporary Art, *Dada and Surrealism in Chicago Collections*, 1 December 1984–27 January 1985.
LITERATURE: Richard West, "George Grosz, Figure for Yvan Goll's *Methusalem*," *Bulletin of the Cleveland Museum of Art* 55:4 (April

1968), 90–94, fig. 3; David and Alfred Smart Gallery, *David and Alfred Smart Gallery, The University of Chicago, 1974* (Chicago: David and Alfred Smart Gallery, University of Chicago, 1974), n.p. (illus.); Andrew de Shong, *Theatrical Designs of George Grosz* (Ann Arbor, Mich.: UMI Research Press, 1982), 35–44, pl. 13; "Theatre and the Visual Arts: A Mini-Exhibition," *Gallery* [Newsletter of the David and Alfred Smart Gallery] 8 (Spring 1984): n.p. (illus.); Museum of Contemporary Art, *In the Mind's Eye: Dada and Surrealism* (Chicago: Museum of Contemporary Art; New York: Abbeville Press, Inc., 1986), 153 (illus.); "Object Lessons," *University of Chicago Magazine* 82 (Fall 1989): 24 (illus.).

Suzanne Valadon

47 *Portrait of Lily Walton*, 1923
Oil on canvas, 24 x 18 (61 x 45.7)
Bequest of Joseph Halle Schaffner in memory of his beloved mother, Sara H. Schaffner, 1973.119
PROVENANCE: Dr. Roudenesco, Paris, 1948; Joseph Halle Schaffner, Santa Barbara, Calif.
EXHIBITIONS: Paris, 1923; Geneva, Galerie Moos, *Utrillo-Valadon-Utter*, May 1932; Paris, Musée National d'Art Moderne, *Hommage à Suzanne Valadon*, 1948, cat. no. 99.
LITERATURE: Musée National d'Art Moderne, *Hommage à Suzanne Valadon* (Paris: Musée National d'Art Moderne, 1967).

Henry Matisse

48 *Nude on a Sofa* (*Nu sur un canapé*), 1924
Cast bronze, ed. 1/10, h. 9½ (24.1)
The Joel Starrels, Jr. Memorial Collection, 1974.137
PROVENANCE: E. V. Thaw and Co., Inc., New York, 1964; B. C. Holland Gallery, Chicago, 1964; Mr. and Mrs. Joel Starrels, Sr., Chicago, 1964–1974.
EXHIBITIONS: David and Alfred Smart Gallery, University of Chicago, *The Joel Starrels, Jr. Memorial Collection*, October–December 1974.
LITERATURE: David and Alfred Smart Gallery, *David and Alfred Smart Gallery, The University of Chicago, 1974* (Chicago: David and Alfred Smart Gallery, University of Chicago, 1974), n.p. (illus.).

Otto Dix

49 *The War* (*Der Krieg,*) 1924
Series of fifty intaglio prints in five portfolios
Etching, aquatint, drypoint; various dimensions
Karsch 70–119
Marcia and Granvil Specks Collection, 1984.46–71, 1986.253–276
PROVENANCE: Marcia and Granvil Specks, Evanston, Ill.
LITERATURE: Florian Karsch, ed., *Otto Dix: Das graphische Werk* (Hanover: Fackelträger-Verlag Schmidt-Küster, 1970), 90–110, figs. 70–119.

Felix Nussbaum

50 *Portrait of a Young Man* (obverse), 1927
Carnival Group (*Narrengruppe* or *Mummenschanz*) (reverse), circa 1939
Oil on canvas; obverse 38½ x 28½ (97.8 x 72.4), reverse 28½ x 38½ (72.4 x 97.8)
Purchase, Gift of Mr. and Mrs. Eugene Davidson, Dr. and Mrs. Edwin DeCosta, Mr. and Mrs. Gaylord Donnelly, and The Eloise W. Martin Purchase Fund, 1982.10
PROVENANCE: Dr. Grosfils, Brussels, June/July 1942; on deposit at Kulturgeschichtliches Museum, Osnabrück, West Germany; Estate

of the artist (Mr. and Mrs. Heinz Moses), May 1970; Michael Hasenclever, Munich, September 1975; Barry Friedman Ltd., New York, October 1980.
EXHIBITIONS: Osnabrück, West Germany, Kulturgeschichtliches Museum, *Felix Nussbaum 1904-1944 Gemälde aus dem Nachlass*, 19 February–4 April 1971, cat. no. 9; Munich, Michael Hasenclever Gallery, *Realismus der Zwanziger Jahre. Bilder, Zeichnungen, Druckgraphik*, 14 October–15 November 1980, cat. no. 77; David and Alfred Smart Gallery, University of Chicago, *Modern German and Austrian Art from the Permanent Collection*, 20 May–1 July 1984; New York, Jewish Museum, *Art and Exile: Felix Nussbaum, 1904-1944*, 15 April–15 August 1985, cat. no. 52.
LITERATURE: Kulturgeschichtliches Museum, *Felix Nussbaum 1904-1944 Gemälde aus dem Nachlass* (Osnabrück, West Germany: Kulturgeschichtliches Museum, 1971), n.p., cat. no. 9 [obverse only]; Michael Hasenclever Gallery, *Realismus der Zwanziger Jahre. Bilder, Zeichnungen, Druckgraphik* (Munich: Michael Hasenclever Gallery, 1980), n.p., cat. no. 77 (illus.); Peter Junk, "Lässt meine Bilder nicht sterben," *Art* 9 (September 1982): 71 (illus.); idem, and Wendelin Zimmer, *Felix Nussbaum Leben und Werk* (Cologne: Du Mont Buchverlag, 1982), 59, 61, 62, 129–132, 213, 245 (illus.); Emily D. Bilski, *Art and Exile: Felix Nussbaum, 1904-1944* (New York: Jewish Museum, 1985), cover (illus.), 43, cat. no. 52.

Emil Nolde

51 *Two Girls*, circa 1929
Watercolor on wove paper, sheet 16⅜ x 13¾ (41.6 x 34.9)
The Mary and Earle Ludgin Collection, 1982.71
PROVENANCE: Bielefeld Städtisches Kunsthaus, Germany, March 1929–August 1937; Buchholz Gallery, New York, 1939; Mary and Earle Ludgin, Chicago.
EXHIBITIONS: Germany, March 1929; New York, Buchholz Gallery, *Emil Nolde Watercolors*, 1939; San Fransisco Museum of Art, 7 June 1939; Art Institute of Chicago, *Chicago Collectors*, 20 September–27 October 1963; David and Alfred Smart Gallery, University of Chicago, *A Selection from the Mary and Earle Ludgin Collection*, 14 July–31 August 1982; David and Alfred Smart Gallery, University of Chicago, *Modern German and Austrian Art from the Permanent Collection*, 20 May–1 July 1984.
LITERATURE: Art Institute of Chicago, *Chicago Collectors* (Chicago: Art Institute of Chicago, 1963), n.p.

Guy Pène du Bois

52 *Four Arts Ball* (*Bal des quatres arts*), 1929
Oil on canvas, 28¾ x 36½ (73 x 92.7)
Gift of William Benton, 1980.1
PROVENANCE: Encyclopaedia Britannica Collection, Chicago.
EXHIBITIONS: Minneapolis Institute of Arts, *The Encyclopaedia Britannica Collection of American Paintings*, 11 September–13 October 1946, cat. no. 38; New York, Gallery of Modern Art, *20s Revisited*, 29 June–5 September 1965; Washington, D.C., Corcoran Gallery of Art, *Guy Pène du Bois: Artist about Town*, 10 October–30 November 1980 (traveled to Omaha, Joslyn Art Museum, 10 January–1 March 1981; Evanston, Ill., Mary and Leigh Block Gallery, Northwestern University, 20 March–10 May 1981), cat. no. 52.
LITERATURE: Royal Cortissoz, *Guy Pène du Bois* (New York: Whitney Museum of American Art, n.d.), 9, 24 (illus.); Grace Pagano and Donald Bear, *Contemporary American Painting: The Encyclopaedia Britannica Collection* (New York: Duell, Sloan, and Pearce, 1945), XVIII and no. 38 (illus.); Minneapolis Institute of Arts, *The Encyclopaedia Britannica Collection of American Paintings* (Minneapolis: Minneapolis Institute of Arts, 1946), n.p., cat. no. 38;

Corcoran Gallery of Art, *Guy Pène du Bois: Artist about Town* (Washington, D.C.: Corcoran Gallery of Art, 1980), 59, 84, cat. no. 52 (illus.); David Elliott, "Cunning Painter of 'Smart Set,'" *Chicago Sun-Times*, 29 March 1981; Joseph Dreiss, "Guy Pène du Bois," *Arts Magazine* 55 (January 1981): 15 (illus.); Jack Flam, "Guy Pène du Bois," *American Heritage* 40 (February 1989): 77 (illus.).

Raphael Soyer

53 *Two Girls*, 1933
Oil on canvas, 24 x 30¼ (61 x 76.8)
The Mary and Earle Ludgin Collection, 1982.72
PROVENANCE: Associated American Artists, New York; Mary and Earle Ludgin, Chicago.
EXHIBITIONS: New York, Valentine Gallery, *Recent Paintings by Raphael Soyer*, 18 February–7 March 1935, cat. no. 9; New York, Whitney Museum of American Art, *Raphael Soyer*, 25 October–3 December 1967 (traveled to Chapel Hill, William Hayes Ackland Memorial Art Center, University of North Carolina, 7 January–7 February 1968; Atlanta, High Museum of Art, 25 February–7 April 1968; San Francisco, California Palace of the Legion of Honor, 1–30 June 1968; Columbus, Oh., Columbus Gallery of Fine Arts, 25 July–25 August 1968; Minneapolis Institute of Arts, 11 September–6 October 1968; Des Moines Art Center, 1 November–1 December 1968), cat. no. 19; David and Alfred Smart Gallery, University of Chicago, *A Selection from the Mary and Earle Ludgin Collection*, 14 July–31 August 1982.
LITERATURE: Lloyd Goodrich, *Raphael Soyer* (New York: Harry N. Abrams, n.d.), 75 (illus); American Artists Group, *Raphael Soyer* (New York: American Artists Group, 1946), n.p. (illus., as *2 Girls in the Studio*); Nathan Krueger, ed., *Raphael Soyer: Paintings and Drawings* (New York: Shorewood Publishing Co., n.d. [1960]), 69; Sylvan Cole, ed., *Raphael Soyer: Fifty Years of Printmaking, 1917–1967* (New York: Da Capo Press, 1967), n.p.; Frank Gettings, *Raphael Soyer: Sixty-five Years of Printmaking* (Washington, D. C.: Smithsonian Institution, 1982), 30–31.

Pablo Ruiz y Picasso

54 *The Diver* (*La Plongeuse*), 1933 or 1934 (plate 1932)
Soft-ground etching, collage; plate 5½ x 4⅜ (14 x 10.9)
Geiser 277
The Joel Starrels, Jr. Memorial Collection, 1974.280
PROVENANCE: Zwemmer Gallery, London; Mr. and Mrs. Joel Starrels, Sr., Chicago, to 1974.
EXHIBITIONS: David and Alfred Smart Gallery, University of Chicago, *The Joel Starrels, Jr. Memorial Collection*, October–December 1974; David and Alfred Smart Gallery, University of Chicago, *Twentieth-Century Prints from the Permanent Collection*, 8 July–27 August 1978.
LITERATURE: Bernhard Geiser, *Picasso Peintre-Graveur Tome II: Catalogue raisonné de l'oeuvre gravé et des monotypes 1932–1934* (Berne: Editions Kornfeld and Klipstein, 1968), 22–23, cat. no. 277, edition B, first proof.

Kurt Seligmann

55 *The Harpist* (*Joueuse de harpe*), 1933
Oil on board, 32¼ x 41¼ (81.9 x 104.8)
The Mary and Earle Ludgin Collection, 1981.78
EXHIBITIONS: New York, Alexandre Iolas Gallery, *Seligmann*, 3–22 February 1953; David and Alfred Smart Gallery, University of Chicago, *A Selection from the Mary and Earle Ludgin Collection*, 14 July–31 August 1982; Chicago, Museum of Contemporary Art, *Dada*

and Surrealism in Chicago Collections, 1 December 1984–27 January 1985.
LITERATURE: Alexandre Iolas Gallery, *Seligmann* (New York: Alexandre Iolas Gallery, 1953), n.p.; Galerie Jacques Benador, *Kurt Seligmann* (Geneva: Galerie Jacques Benador, 1974), n.p. (illus.); "Recent Gifts to the Gallery," *Gallery* [Newsletter of the David and Alfred Smart Gallery] 6 (Spring 1982): n.p. (illus.); Museum of Contemporary Art, *In the Mind's Eye: Dada and Surrealism* (Chicago: Museum of Contemporary Art; New York: Abbeville Press, 1986), 217 (illus.); Martica Sawin, "Magus, Magic, Magnet: The Archaizing Surrealism of Kurt Seligmann," *Arts* 60 (February 1986): 77 (illus.).

Marcel Duchamp

56 *Box in a Valise* (*Boîte-en-valise*), 1935–1941 (1963 edition)
Mixed media, ed. 30, box (closed) 14¹³⁄₁₆ x 15¹⁵⁄₁₆ x 3⁹⁄₁₆ (37.7 x 40.5 x 8.9)
Bonk series E, Lebel 173, Schwartz 311
Gift of Mrs. Robert B. Mayer, 1983.30
EXHIBITIONS: St. Louis, Washington University Gallery of Art, *School of Paris and Modern Art*, 24 August–9 November 1986.
BIBLIOGRAPHY: Robert Lebel, *Sur Marcel Duchamp* (Paris: Trianon Press, 1959), no. 173, pl. 109; Arturo Schwartz, *The Complete Works of Marcel Duchamp* (New York: Harry N. Abrams, Inc., 1969), 511–513, no. 311; Reinhold Heller, "An Important Recent Gift," *Gallery* [Newsletter of the David and Alfred Smart Gallery] 8 (Fall 1983): n.p. (illus.); Ecke Bonk, *Marcel Duchamp, the Box in a Valise: de ou par Marcel Duchamp ou Rrose Selavy: inventory of an edition* (New York: Rizzoli, 1989), 400, series E.

Julio Gonzalez

57a *Head of the Montserrat* (*Tête de la Montserrat criante*), 1941
Pencil on wove paper, sheet 10¼ x 8¼ (26 x 21)
Merkert 249.D27
The Joel Starrels, Jr. Memorial Collection, 1974.264
PROVENANCE: B. C. Holland Gallery, Chicago; Mr. and Mrs. Joel Starrels, Sr., Chicago, to 1974.
EXHIBITIONS: Los Angeles, Felix Landau Gallery, *Julio Gonzalez: Sculpture, Paintings and Drawings*, 4–30 October 1965, cat. no. 64; David and Alfred Smart Gallery, University of Chicago, *The Joel Starrels, Jr. Memorial Collection*, October–December 1974; St. Louis, Laumeier Sculpture Park, *Great Sculptors at Laumeier*, 18 February–17 April 1983; David and Alfred Smart Gallery, University of Chicago, *Victors and Victims: Artists' Responses to War from Antiquity through the Vietnam War Era*, 11 July–1 September 1985, cat. no. 61.
LITERATURE: Felix Landau Gallery, *Julio Gonzalez: Sculpture, Paintings and Drawings* (Los Angeles: Felix Landau Gallery, 1965), n.p., cat. no. 64; Laumeier Sculpture Park, *Great Sculptors at Laumeier* (St. Louis: Laumeier Sculpture Park, 1983), n.p.; David and Alfred Smart Gallery, *Victors and Victims: Artists' Responses to War from Antiquity through the Vietnam War Era* (Chicago: David and Alfred Smart Gallery, University of Chicago, 1985), 18, cat. no. 61; Jörn Merkert, *Julio González: Catalogue raisonné des sculptures* (Milan: Electa Spa, 1987), 299 (illus.), cat. no. 249.D27.

57b *Head of the Montserrat II* (*Tête de la Montserrat criante II*), 1942
Cast bronze, ed. 6/6, h. 12½ (31.8)
Merkert 249
The Joel Starrels, Jr. Memorial Collection, 1974.223
PROVENANCE: Galerie Chalette, New York; Mr. and Mrs. Joel Starrels, Sr., Chicago, to 1974.
EXHIBITIONS: New York, Galerie Chalette, *Julio Gonzalez*, October–November 1961, cat. no. 57; Arts Club of Chicago, *Julio*

Gonzalez, 22 September–18 October 1969, cat. no. 69; David and Alfred Smart Gallery, University of Chicago, *The Joel Starrels, Jr. Memorial Collection*, October–December 1974; St. Louis, Laumeier Sculpture Park, *Great Sculptors at Laumeier*, 18 February–17 April 1983; David and Alfred Smart Gallery, University of Chicago, *Victors and Victims: Artists' Responses to War from Antiquity through the Vietnam War Era*, 11 July–1 September 1985, cat. no. 62.

LITERATURE: Galerie Chalette, *Julio Gonzalez* (New York: Galerie Chalette, 1961), 71 (illus.), cat. no. 57; Arts Club of Chicago, *Julio Gonzalez* (Chicago: Arts Club of Chicago, 1969), 61, cat. no. 69; Laumeier Sculpture Park, *Great Sculptors at Laumeier* (St. Louis: Laumeier Sculpture Park, 1983), n.p.; David and Alfred Smart Gallery, *Victors and Victims: Artists' Responses to War from Antiquity through the Vietnam War Era* (Chicago: David and Alfred Smart Gallery, University of Chicago, 1985), n.p.; Jörn Merkert, *Julio González: Catalogue raisonné des sculptures* (Milan: Electa Spa, 1987), 297, cat. no. 249.

Henry Moore

58 *Sketch Model for Reclining Figure*, 1945
Unglazed modeled earthenware, l. 6½ (16.5)
Lund Humphries 245
The Joel Starrels, Jr. Memorial Collection, 1974.138

PROVENANCE: Robert Schoelkopf Gallery, New York; B. C. Holland Gallery, Chicago; Mr. and Mrs. Joel Starrels, Sr., Chicago, 1963–1974.

EXHIBITIONS: Renaissance Society, University of Chicago, *Chicago's Homage to Henry Moore*, 1–22 December 1967, cat. no. 59; David and Alfred Smart Gallery, University of Chicago, *The Joel Starrels, Jr. Memorial Collection*, October–December 1974; Columbus, Oh., Columbus Museum of Art, *Henry Moore: The Reclining Figure*, 14 October–2 December 1984 (traveled to Archer M. Huntington Art Gallery, University of Texas at Austin, 13 January–17 February 1985; Salt Lake City, Utah Museum of Fine Arts, University of Utah, 10 March–12 May 1985; Portland Museum of Art, 11 June–21 July 1985; San Francisco Museum of Modern Art, 22 August–13 October 1985), cat. no. 18; David and Alfred Smart Gallery, University of Chicago, *Henry Moore: Drawings, Prints, Sculpture*, 21 May–29 June 1986.

LITERATURE: *Henry Moore: Sculpture and Drawings*, 3d rev. ed. (London: Lund Humphries and Co., 1949), no. 700 (illus.); David Sylvester, ed., *Henry Moore*, vol. 1, *Sculpture and Drawings 1921–1948*, 4th rev. ed. (London: Lund Humphries and Co., 1957), no. LH245; Renaissance Society, University of Chicago, *Chicago's Homage to Henry Moore* (Chicago: Renaissance Society, University of Chicago, 1967), n.p., cat. no. 59 (illus.); David and Alfred Smart Gallery, *The David and Alfred Smart Gallery, The University of Chicago, 1974* (Chicago: David and Alfred Smart Gallery, University of Chicago, 1974), n.p. (illus.); Sotheby Park Bernet, *Modern Paintings and Sculpture* (New York: Sotheby Park Bernet, 1977), lot no. 367A (bronze edition, identified as LH244).

Alberto Giacometti

59 *Portrait of Annette Arm* (?), 1947
Pencil on wove paper, sheet 16⅛ x 14⅜ (40.9 x 36.3)
The Joel Starrels, Jr. Memorial Collection, 1974.303

PROVENANCE: Allan Frumkin Gallery, Chicago, 1958; Mr. and Mrs. Joel Starrels, Sr., Chicago, to 1974.

William Baziotes

60 *Waterflowers*, 1947
Oil on canvas, 16⅛ x 12⅛ (41 x 30.8)
Gift of Mr. and Mrs. William G. Swartchild, Jr., 1974.37

PROVENANCE: Samuel M. Kootz Gallery, New York; Mr. and Mrs. William G. Swartchild, Jr., Chicago, to 1974.

EXHIBITIONS: David and Alfred Smart Gallery, University of Chicago, *Abstract Expressionism: A Tribute to Harold Rosenberg, Paintings and Drawings from Chicago Collections*, 10 October–24 November 1979, cat. no. 1; Chicago, Richard L. Feigen & Company, *William Baziotes: A Commemorative Exhibition*, 3 April–2 May 1987, checklist no. 17 (as *Water Flower*).

LITERATURE: Solomon R. Guggenheim Museum, *William Baziotes: A Memorial Exhibition* (New York: Solomon R. Guggenheim Museum, 1965), 11 (as *Waterflower*); David and Alfred Smart Gallery, *Abstract Expressionism: A Tribute to Harold Rosenberg, Paintings and Drawings from Chicago Collections* (Chicago: David and Alfred Smart Gallery, University of Chicago, 1979), cat. no. 1; Richard L. Feigen & Company, *William Baziotes: A Commemorative Exhibition* (Chicago: Richard L. Feigen & Company, 1987), n.p., checklist no. 17 (as *Water Flower*).

Franz Kline

61 *Untitled*, circa 1950
Ink, paint on wove paper mounted on rag board; sheet 7½ x 7½ (19 x 19)
Gift of Katharine Kuh, 1969.2

PROVENANCE: Gift of the artist to Muriel Newman, Chicago; Katharine Kuh, New York.

EXHIBITIONS: David and Alfred Smart Gallery, University of Chicago, *New York School Drawings of the 1950s*, 26 March–10 May 1986.

LITERATURE: University of Chicago, *The Cochrane-Woods Art Center/David and Alfred Smart Gallery/Groundbreaking October 29, 1971* (Chicago: University of Chicago, 1971), cover (illus.); David and Alfred Smart Gallery, *The David and Alfred Smart Gallery, The University of Chicago, 1974* (Chicago: David and Alfred Smart Gallery, University of Chicago, 1974), n.p. (illus.).

Giacomo Manzu

62 *Sonja's Head*, 1955
Cast bronze, h. 13 (33)
Gift of Allan Frumkin, 1981.94

EXHIBITIONS: Chicago, Allan Frumkin Gallery, *Giacomo Manzu: Recent Sculpture*, 1958, cat. no. 8; St. Louis, Laumeier Sculpture Park, *Great Sculptors at Laumeier*, 18 February–17 April 1983.

LITERATURE: Allan Frumkin Gallery, *Giacomo Manzu: Recent Sculpture* (Chicago: Allan Frumkin Gallery, n.d. [1958]), n.p., cat. no. 8 (illus.); Laumeier Sculpture Park, *Great Sculptors at Laumeier* (St. Louis: Laumeier Sculpture Park, 1983), n.p.

Larry Rivers

63 *Portrait*, 1956
Oil on canvas, 21 x 26 (53.3 x 66)
Gift of Lindy Bergman in memory of Edwin A. Bergman, 1986.14

PROVENANCE: Marlborough Gallery, Inc., New York; Museum of Contemporary Art Auction, Chicago, 25 April 1981; Mr. and Mrs. Edwin A. Bergman, Chicago, 1981–1986.

EXHIBITIONS: Chicago, Museum of Contemporary Art, *5th Benefit Art Auction*, 25 April 1981, checklist no. 51; David and Alfred Smart Gallery, University of Chicago, *Cross Sections: Recent Additions to the Collection*, 9 October–7 December 1986, cat. no. 6.

LITERATURE: Museum of Contemporary Art, *5th Benefit Art Auction* (Chicago: Museum of Contemporary Art, 1981), n.p., checklist no. 51; David and Alfred Smart Gallery, *Cross Sections: Recent Additions to the Collection* (Chicago: David and Alfred Smart Gallery, University of Chicago, 1986), n.p., cat. no. 6; *Bulletin of the David and Alfred Smart Gallery* 1 (1987–1988): 22 (illus.).

Isamu Noguchi
64 *Iron Wash (Okame)*, 1956
Cast iron, h. 9½ (24.1)
Botnick and Grove 421
The Joel Starrels, Jr. Memorial Collection, 1974.183
PROVENANCE: Holland-Goldowsky Gallery, Chicago, 1961; Mr. and Mrs. Joel Starrels, Sr., Chicago, 1961–1974.
EXHIBITIONS: David and Alfred Smart Gallery, University of Chicago, *The Joel Starrels, Jr. Memorial Collection*, October–December 1974; St. Louis, Laumeier Sculpture Park, *Great Sculptors at Laumeier*, 18 February–17 April 1983.
LITERATURE: Diane Botnick and Nancy Grove, *The Sculpture of Isamu Noguchi, 1924–1979: A Catalogue* (New York and London: Garland Publishing Co., 1980), cat. no. 421; Laumeier Sculpture Park, *Great Sculptors at Laumeier* (St. Louis: Laumeier Sculpture Park, 1983), n.p.

Peter Voulkos
65 *Covered Jar*, 1956–1957
Stoneware with negative stencil relief, iron-oxide slip, cobalt slip, thin transparent glaze; h. with lid 8½ (21.6)
The Duffie Stein Collection, 1976.162
EXHIBITIONS: Evanston, Ill., Exhibit A, *Peter Voulkos–Platter Forms from 1973–1975*, 25 February–25 March 1976.
LITERATURE: Andy Nassisse, "Peter Voulkos [at Exhibit A]," *New Art Examiner* 3 (April 1976): 12.

Gertrud and Otto Natzler
66 *Bowl*, circa 1960
Earthenware, uranium glaze; h. 5⁷⁄₁₆ (13.9), diam. of foot 2⅛ (5.3), diam. of mouth 7¹⁄₁₆ (18)
Gift of Mr. and Mrs. Leon Despres, 1975.47

Mark Rothko
67 *Untitled*, 1962
Oil on canvas, 81 x 76 (205.7 x 193)
Gift of Mrs. Albert D. Lasker, 1976.161
PROVENANCE: Mrs. Albert D. Lasker, New York; on loan to Federal Reserve Board, Washington, D.C., circa 1974–1976.
EXHIBITIONS: David and Alfred Smart Gallery, University of Chicago, *A New Acquisition by Mark Rothko*, March 1977; David and Alfred Smart Gallery, University of Chicago, *Abstract Expressionism: A Tribute to Harold Rosenberg, Paintings and Drawings from Chicago Collections*, 10 October–24 November 1979, cat. no. 35.
LITERATURE: "A New Rothko for the Gallery," *Gallery* [Newsletter of the David and Alfred Smart Gallery] 1 (Spring 1977): n.p.; David and Alfred Smart Gallery, *A New Acquisition by Mark Rothko* (Chicago: David and Alfred Smart Gallery, University of Chicago, 1977); David and Alfred Smart Gallery, *Abstract Expressionism: A Tribute to Harold Rosenberg, Paintings and Drawings from Chicago Collections* (Chicago: David and Alfred Smart Gallery, University of Chicago, 1979), cat. no. 35.

John Chamberlain
68 *Untitled*, 1963
Welded painted and chromium-plated steel automobile body parts, 36 x 50 x 53 (91.4 x 127 x 134.6)
Sylvester 172
Gift of Mr. and Mrs. Richard L. Selle, 1972.3
PROVENANCE: Leo Castelli Gallery, New York; Mr. and Mrs. Richard Selle, Chicago, to 1972.

LITERATURE: David and Alfred Smart Gallery, *David and Alfred Smart Gallery, The University of Chicago, 1974* (Chicago: David and Alfred Smart Gallery, University of Chicago, 1974), n.p. (illus.); Julie Sylvester, *John Chamberlain: A Catalogue Raisonné of the Sculpture 1954–1985* (New York: Hudson Hills Press and Los Angeles: Museum of Contemporary Art, 1986), no. 172 (illus.).

Richard Hunt
69 *Winged Hybrid Figure No. 3*, 1965
Welded steel, h. 27³⁄₁₆ (69.2)
Gift of Mr. and Mrs. Edwin A. Bergman in honor of Charles and Hanna Gray, 1982.3
EXHIBITIONS: St. Louis, Laumeier Sculpture Park, *Great Sculptors at Laumeier*, 18 February–17 April 1983.
LITERATURE: "Recent Gifts to the Gallery," *Gallery* [Newsletter of the David and Alfred Smart Gallery] 6 (Spring 1982): n.p. (illus.); Laumeier Sculpture Park, *Great Sculptors at Laumeier* (St. Louis: Laumeier Sculpture Park, 1983), n.p.

Philip Pearlstein
70 *Portrait of Allan Frumkin*, 1965
Oil on canvas, 60 x 48 (152.4 x 121.9)
Bowman 259
Gift of Allan Frumkin, 1976.73
EXHIBITIONS: Milwaukee Art Museum, *Philip Pearlstein: A Retrospective*, 15 April–19 June 1983 (traveled to Brooklyn Museum, 14 July–15 September 1983; Philadelphia, Pennsylvania Academy of Fine Arts, 15 December 1983–26 February 1984; Toledo Museum of Art, 18 March–29 April 1984; Pittsburgh, Museum of Art, Carnegie Institute, 19 May–15 July 1984), cat. no. 40; Chicago, Museum of Contemporary Art, *Portraits*, 10 December 1988–22 April 1989.
LITERATURE: *Kunstwerk* (April 1966): 79 (illus.); Russell Bowman, *Philip Pearlstein: The Complete Paintings* (New York and London: Alpine Fine Arts Collection, Ltd., 1983), 103, 320, fig. 259; Milwaukee Art Museum, *Philip Pearlstein: A Retrospective* (New York: Alpine Fine Arts Collection, Ltd., 1983), 103, cat. no. 40 (illus.).

Jim Nutt
71 *Steping [sic] off the Room*, 1971
Acrylic on paper, 13 x 11 (33 x 27.9)
Gift of Gerald Elliott in memory of Leona Etta Spar, 1985.4
PROVENANCE: Phyllis Kind Gallery, Chicago; Gerald Elliott, Chicago, to 1985.
EXHIBITIONS: David and Alfred Smart Gallery, University of Chicago, *From Chicago*, October–December 1985; David and Alfred Smart Gallery, University of Chicago, *Cross Sections: Recent Additions to the Collection*, 9 October–7 December 1986, cat. no. 4.
LITERATURE: David and Alfred Smart Gallery, *Cross Sections: Recent Additions to the Collection* (Chicago: David and Alfred Smart Gallery, University of Chicago, 1986), n.p., cat. no. 4.

Chinese, Shang dynasty, Anyang period
72 *Gu (Ritual Wine Beaker)*, late 13th–early 12th century B.C.
Cast bronze, h. 12 (30.5), diam. of mouth 6¼ (15.9)
Gift of Prof. and Mrs. Herrlee G. Creel, 1986.330
EXHIBITIONS: David and Alfred Smart Gallery, University of Chicago, *Ritual and Reverence: Chinese Art at The University of Chicago*, 10 October–3 December 1989, cat. no. 15.
LITERATURE: *Bulletin of the David and Alfred Smart Gallery* 1 (1987–1988): 32 (illus.); David and Alfred Smart Gallery, *Ritual and*

Reverence: Chinese Art at The University of Chicago (Chicago: David and Alfred Smart Gallery, University of Chicago, 1989), 46–47, cat. no. 15 (illus.).

Chinese, Tang dynasty
73 *Tomb Guardian Figure*, circa 650–700
 Molded and modeled earthenware, cold-painted decoration, partial gilding, h. 27¼ (69.2)
 Purchase, Gift of Gaylord Donnelly, 1981.55
 PROVENANCE: David E. J. Pepin, Grant Park, Ill.
 LITERATURE: Committee on Southern Asian Studies, University of Chicago, *Asian Studies* (Chicago: University of Chicago, 1985), 16 (illus.); "Object Lessons," *University of Chicago Magazine* 82 (Fall 1989): 26 (illus.); David and Alfred Smart Gallery, *Ritual and Reverence: Chinese Art at The University of Chicago* (Chicago: David and Alfred Smart Gallery, University of Chicago, 1989), 8, 10, n. 12.

Mi Wanzhong
74 *Among the Fragrant Snowy Mountains of Lan Garden*, 1621
 Hanging scroll, ink on satin; painting 73¹¹⁄₁₆ x 19⅛ (187.2 x 48.6)
 Purchase, Gift of Mr. and Mrs. Gaylord Donnelly, 1974.92
 PROVENANCE: Mayuyama, Tokyo, 1970.
 EXHIBITIONS: David and Alfred Smart Gallery, University of Chicago, *Ritual and Reverence: Chinese Art at The University of Chicago*, 10 October–3 December 1989, cat. no. 106.
 LITERATURE: Suzuki Kei, *Comprehensive Illustrated Catalog of Chinese Paintings* (Tokyo: University of Tokyo Press, 1982–1983), no. A2–001 (illus.), 1:28, 5:177; David and Alfred Smart Gallery, *Ritual and Reverence: Chinese Art at The University of Chicago* (Chicago: David and Alfred Smart Gallery, University of Chicago, 1989), 108–109, cat. no. 106 (illus.).

Lan Ying
75 *Landscape (after Huang Gongwang)*, circa 1637–1638
 Handscroll; frontispiece, ink on paper, 23¹⁄₁₆ x 40⁵⁄₁₆ (58.7 x 102.4); painting and colophons, ink and color on silk, 23¹⁄₁₆ x 379⅛ (58.7 x 1014.7)
 Gift of Jeannette Shambaugh Elliott in honor of Professor Harrie A. Vanderstappen, 1987.56
 PROVENANCE: Mi Fu Gallery, New York, 1973; on loan from the Jeannette Shambaugh Elliott Collection to David and Alfred Smart Gallery, University of Chicago, 1974–1987.
 EXHIBITIONS: David and Alfred Smart Gallery, University of Chicago, *Ritual and Reverence: Chinese Art at The University of Chicago*, 10 October–3 December 1989, cat. no. 108.
 LITERATURE: Yang Enshou, *Yanfubian* (author's preface dated 1885), part II, *juan* 15, in *Danyuan chuanji*, reprint Taipei: Wenshizhe Chubanshe, 1971; Suzuki Kei, *Comprehensive Illustrated Catalog of Chinese Paintings* (Tokyo: University of Tokyo Press, 1982–1983), no.

A2–011, 1:30–31, 5:177; *Bulletin of the David and Alfred Smart Gallery* 1 (1987–1988): 35 (illus.); "Object Lessons," *University of Chicago Magazine* 82 (Fall 1989): 26–27 (illus.); David and Alfred Smart Gallery, *Ritual and Reverence: Chinese Art at The University of Chicago* (Chicago: David and Alfred Smart Gallery, University of Chicago, 1989), 112–113, cat. no. 108 (illus.); "Art of Asia Acquired by North American Museums, 1988," *Archives of Asian Art* 42 (1989): 94–95, fig. 12.

Nittō, Head Priest of Ikegami Temple
76 *Nichiren's Nirvana*, late 17th–early 18th century
 Hanging scroll, ink and color on silk; painting 42⅝ x 31⅞ (108.1 x 80.7)
 Purchase, Gift of Mr. and Mrs. Gaylord Donnelly, 1974.101
 PROVENANCE: Yamanaka & Co., Ltd., Kyoto, 1972.

Torii Kiyonaga
77 *Women Resting above the Kamo River* (panel from an *ōban* triptych, *Cooling Off in the Evening at Shijō Rivershore*), circa 1784
 Color woodblock, sheet 15⅛ x 10¼ (38.3 x 26)
 Gift of Warren G. Moon, Madison, Wisconsin, in honor of Professor Harrie A. Vanderstappen, 1984.8
 PROVENANCE: Henri Vever Collection, Paris; Sotheby Parke Bernet & Co., London, March 1978; R. E. Lewis, Inc., San Raphael, Calif., March 1979; Warren G. Moon, Madison, Wisc.
 EXHIBITIONS: London, Sotheby Parke Bernet & Co., *Fine Japanese Prints, Drawings and Paintings*, March 1978, cat. no. 125; San Raphael, Calif., R. E. Lewis, Inc., *17th and 18th Century Japanese Books and Prints [and] Indian Miniatures*, March 1979, cat. no. 7; David and Alfred Smart Gallery, University of Chicago, *Cross Sections: Recent Additions to the Collection*, 9 October–7 December 1986, cat. no. 36.
 LITERATURE: Sotheby Parke Bernet & Co., *Catalogue of Fine Japanese Prints, Drawings and Paintings—The Property of a Gentleman* (London: Sotheby Parke Bernet, 1978), cat. no. 125; R. E. Lewis, Ltd., *17th and 18th Century Japanese Books and Prints—Indian Miniatures* (San Raphael, Calif.: R. E. Lewis, Ltd., 1979), cat. no. 7, cover (illus.); Committee on Southern Asian Studies, University of Chicago, *Asian Studies* (Chicago: University of Chicago, 1985), 18 (illus.); David and Alfred Smart Gallery, *Cross Sections: Recent Additions to the Collection* (Chicago: David and Alfred Smart Gallery, University of Chicago, 1986), n.p., cat. no. 36.

Indian, Orissa
78 *Kṛṣṇa and Brahmā*, late 19th–early 20th century
 Folio from a manuscript of the *Bhāgavata Purāṇa*
 Tempera, ink on paper, sheet 9⁷⁄₁₆ x 15³⁄₁₆ (24.6 x 38.8)
 Purchase, Gift of Mr. Harris J. Fishman through the Alumni Fund, 1974.62
 PROVENANCE: Phyllis Kind Gallery, Chicago, June 1974.

SELECTED CHECKLIST OF THE COLLECTION

This list presents a cross section of the Smart Museum's holdings in Western and Oriental art, in terms of period and medium. Necessarily selective, it characterizes the overall range and depth of the collection while focusing on its strengths, both concentrations forming broad study collections and individual works of outstanding significance. Beginning with the art of the West followed by the art of East and Southeast Asia, the checklist is organized chronologically by the following headings: Classical; Late Antique and Medieval; Renaissance, Baroque, and Eighteenth Century; Nineteenth Century and Modern (Europe and the Americas); Chinese; Japanese; Korean; Southeast Asian. Within sub-categories designated by medium or type, works are arranged by date of manufacture;

those without known dates are placed within approximate chronological sequence. In instances of multiple examples by the same artist, works are listed sequentially by date before proceeding to the next artist's entry. An alphabetical index of artists follows the checklist.

Dimensions are given in inches, followed by centimeters in parentheses. Unless otherwise noted, height precedes width precedes depth. The following abbreviations are used: h. = height, w. = width, l. = length, diam. = diameter. Dimensions for works on paper are for the sheet, unless otherwise indicated. For prints and serial sculpture, the edition follows medium. Catalogue raisonné references precede donor acknowledgments. Works in the catalogue are marked with an asterisk.

WESTERN ART

Classical

CERAMICS AND VASE PAINTING

Cypriote, Early Cypriote III-Middle Cypriote I
Two Tripodic Amphorae Joined, 1900–1750 B.C.
Slip-painted earthenware with incised decoration, h. 8¼ (21)
The Stanley McCormick Collection, 1967.115.11CYP

Cypriote, Early Cypriote IIIB-Middle Cypriote I
Gourd Jug, 1875/1850–1750 B.C.
Slip-painted earthenware with applied and incised decoration, h. 6⅞ (17.5)
The Stanley McCormick Collection, 1967.115.2CYP

Cypriote, Middle Cypriote I
Jug, 1800–1750 B.C.
Slip-painted earthenware with applied and incised decoration, h. 7¼ (18.4)
The Stanley McCormick Collection, 1967.115.7CYP

Cypriote, Middle Cypriote I-Middle Cypriote II
Jug, 1800–1700 B.C. (?)
Slip-painted earthenware with applied,

incised, and punch-hole decoration, h. 9¹³⁄₁₆ (24.9)
The Stanley McCormick Collection, 1967.115.8CYP

Cypriote, Late Cypriote IA-Late Cypriote IB
Wish-bone Handled Bowl, 1550–1400 B.C.
Earthenware with slip-painted decoration, diam. of mouth 7¹⁄₁₆ (18)
The Stanley McCormick Collection, 1967.115.35CYP

Cypriote, Late Cypriote IB-Late Cypriote IIA
Base-ring Jug, 1425/15–1340 B.C.
Slip-painted earthenware, h. 9¼ (23.5)
The Stanley McCormick Collection, 1967.115.38CYP

Mycenaean, Bronze age, Late Helladic IIIB
Fragment of a Kylix, 1300–1230/1200 B.C.
Earthenware with slip-painted decoration, h. 4¾ (12), diam. of reconstructed mouth 7¹⁄₁₆ (18)
The F. B. Tarbell Collection, 1967.115.245

Cypriote, Cypro-Geometric IIB-Cypro-Geometric IIIB
Short-stemmed Bowl, 1050–850 B.C.
Earthenware with slip-painted decoration, h. 4½ (11.5), diam. of mouth 5½ (14)
The Stanley McCormick Collection, 1967.115.50CYP

Greek, Boeotian or **Attic**,
Geometric period
Kantharos/Bowl, late 8th–early 7th century B.C.
Earthenware with slip-painted decoration, h. 5⅜ (13.7), diam. of mouth 6½ (16.5)
The F. B. Tarbell Collection,
Gift of E. P. Warren, 1902; 1967.115.279

Greek, Corinthian
Black-figure Column Krater Handle Fragment: Two Heads in Profile,
7th–early 6th century B.C.
Earthenware with slip-painted decoration, l. 5⁹⁄₁₆ (14.2)
The F. B. Tarbell Collection, 1967.115.246

Greek, Attic, Group E
Black-figure Dinos Fragment: Ivy Leaves, Chariot Race, Forepart of Warship,
circa 540–530 B.C.
Earthenware with slip-painted decoration, h. 1⅝ (3.3), w. 2¹³⁄₁₆ (7.1)
The F. B. Tarbell Collection, 1967.115.284

Greek, Attic, Nikosthenic Workshop
Black-figure Nikosthenic Amphora Handle Fragment: Satyr's Head and Upper Torso,
circa 535–520 B.C.
Earthenware with slip-painted decoration, h. 3⅛ (7.9), w. 1¾ (4.5)
The F. B. Tarbell Collection,
Gift of E. P. Warren, 1967.115.268

Lydos
Greek, Attic
Black-figure Panathenaic Amphora Fragment: Two Runners, circa 530 B.C.
Earthenware with slip-painted decoration, h. 4 (10.2), w. 9 1/16 (23)
The F. B. Tarbell Collection, 1967.115.263

Oltos
Greek, Attic
Red-figure Kylix Fragment: A Komos (Party Scene), circa 515–510 B.C.
Earthenware with slip-painted decoration, l. 6 1/2 (16.5)
Joins with fragments from the Campana Collection (Museo Archaeologico, Florence)
The F. B. Tarbell Collection, 1967.115.285

*** Euphronios**
Greek, Attic
Red-figure Neck-pelike Fragment: Ephebe (Youth) with a Walking Stick, circa 510 B.C.
Earthenware with slip-painted decoration, l. 7 1/4 (18.4)
Joins with neck-pelike in Museo di Villa Giulia, Rome
The F. B. Tarbell Collection, 1967.115.287

Greek, Attic
Black-figure Eye Kylix: Dionysos Seated between Two Satyrs, circa 510–500 B.C.
Earthenware with slip-painted decoration, h. 3 5/16 (8.4), diam. of mouth 8 11/16 (22.1)
The F. B. Tarbell Collection, Gift of E. P. Warren, 1902; 1967.115.337

The Painter of Berlin 2268
Greek, Attic
Red-figure Alabastron: Two Running Warriors Carrying Peltas, circa 510–500 B.C.
Earthenware with slip-painted decoration, h. 6 3/8 (16.2)
The F. B. Tarbell Collection, Gift of E. P. Warren, 1967.115.346

The Eucharides Painter
Greek, Attic
Black-figure Pelike: Two Visitors to the Sphinx (Oedipus Confronting the Theban Sphinx ?) (obverse), Hermes Playing the Flute to Two Satyrs (reverse), circa 490 B.C.
Earthenware with slip-painted decoration, h. 13 1/2 (34.3)
The F. B. Tarbell Collection, Gift of E. P. Warren, 1902; 1967.115.340

The Niobid Painter
Greek, Attic
Red-figure Fragment from a Lekanis (?): Warrior with a Thracian Helmet, circa 465–460 B.C.
Earthenware with slip-painted decoration, h. 2 1/8 (5.2)
The F. B. Tarbell Collection, 1967.115.296

The Niobid Painter
Red-figure Fragment: Head and Shoulder of a Woman, circa 450 B.C.
Earthenware with slip-painted decoration, h. 1 3/4 (4.5)
The F. B. Tarbell Collection, 1967.115.319

Greek, Attic, Follower of Douris (?)
Red-figure Skyphos Fragment: Head and Shoulder of a Woman, circa 450 B.C.
Earthenware with slip-painted decoration, h. 1 1/2 (3.8)
The F. B. Tarbell Collection, 1967.115.290

*** Greek, Attic, Group of Polygnotos**
Red-figure Calyx-krater Fragment: Battle of Kaineus and Centaur (upper register), Departure of a Youth (lower register), circa 440–430 B.C.
Earthenware with slip-painted decoration, h. 5 11/16 (14.4)
The F. B. Tarbell Collection, 1967.115.294

Greek, Attic, Manner of the Peleus Painter
Red-figure Bell-krater Fragment: Two Youths (Orestes and Pylades at the Altar in Taurus ?), circa 435–425 B.C.
Earthenware with slip-painted decoration, h. 8 7/16 (21.9)
The F. B. Tarbell Collection, 1967.115.289

Greek, Attic, Recalls the Kleophon Painter
Red-figure Fragment from a Large Vase: Part of a Woman, circa 430 B.C.
Earthenware with slip-painted decoration, h. 3 (7.6)
The F. B. Tarbell Collection, 1967.115.291

*** Greek, Boeotian, Workshop of the Kabiros Painter**
Kabiric Bowl: Odysseus's Men before Circe, Two Combatants, circa 430–420 B.C.
Earthenware with slip-painted decoration, h. (restored) 5 9/16 (14.1)
The F. B. Tarbell Collection, Gift of E. P. Warren, 1902; 1967.115.276

Greek, Attic, Vicinity of the Jena Painter
Red-figure Lekanis Lid Fragment: Woman Sitting on a Rock, circa 400–375 B.C.
Earthenware with slip-painted decoration, l. 5 11/16 (14.4)
The F. B. Tarbell Collection, 1967.115.293

Italic, Etruscan (?)
Kantharos, 4th century B.C.
Earthenware with uniform slip-painted decoration, h. 7 9/16 (19.2), diam. of mouth 6 1/16 (15.4)
The F. B. Tarbell Collection, Gift of E. P. Warren, 1902; 1967.115.354

Cypriote, Early Cypriote III–Middle Cypriote I
Torso of a Female Idol, 1900–1750 B.C.
Slip-painted earthenware with applied, incised, and punch-hole decoration, h. 4 1/2 (11.4)
The Stanley McCormick Collection, 1967.115.75CYP

Cypriote, Middle Cypriote I–II
Horned Head, 1800–1700 B.C. (?)
Slip-painted earthenware with incised decoration, h. 3 11/16 (9.3)
The Stanley McCormick Collection, 1967.115.74CYP

Mycenaean (?), Bronze age, Late Helladic
Head, 1400–1200 B.C.
Earthenware with slip-painted decoration, h. 2 3/4 (7)
Gift of Mrs. Carl E. Buck, 1966; 1967.115.421

Cypriote, Cypro-Archaic
Horse and Rider, 700–475 B.C.
Earthenware with slip-painted decoration, h. 6 13/16 (17.3), l. 5 1/2 (14)
The Stanley McCormick Collection, 1967.115.82CYP

Greek, Boeotian
Horse and Rider, circa 550 B.C.
Earthenware with slip-painted decoration, h. 3 3/4 (9.5), l. 3 9/16 (9.1)
Gift of Mrs. Carl E. Buck, 1966; 1967.115.402

Greek, Attic
Seated Female Deity (Athena?), late 6th–early 5th century B.C.
Slip-painted earthenware with cold-painted decoration, h. 4 13/16 (12.2)
Gift of Mrs. Carl E. Buck, 1966; 1967.115.392

Hellenistic, Greek
Standing Female Holding a Bird and Fan, 4th–3rd century B.C.
Earthenware with slip-painted decoration, h. 8 9/16 (21.7)
The F. B. Tarbell Collection, Gift of E. P. Warren, 1902; 1967.115.60

Hellenistic, Greek, Smyrna (?)
Standing Draped Female, late 3rd–early 2nd century B.C.
Molded earthenware, h. 7 1/4 (18.4)
The F. B. Tarbell Collection, Gift of E. P. Warren, 1902; 1967.115.59

Hellenistic, Greek, Myrina
Standing Female (Aphrodite?) Holding a Pomegranate, 2nd century B.C.
Slip-painted earthenware with cold-painted decoration, h. 8 15/16 (22.7)
The F. B. Tarbell Collection, Gift of E. P. Warren, 1902; 1967.115.62

Hellenistic or **Roman**
Harpocrates, n.d.
Cast bronze, h. 1¹³⁄₁₆ (4.6)
The F. B. Tarbell Collection,
Gift of E. P. Warren, 1967.115.26

Hellenistic or **Roman**
Standing Nude Male Holding a Patera, n.d.
Cast bronze, h. 3¼ (8.2)
The F. B. Tarbell Collection,
Gift of E. P. Warren, 1967.115.4

Italo/Etruscan
Hercules, 3rd–1st century B.C.
Cast bronze, h. 2⁹⁄₁₆ (6.5)
The F. B. Tarbell Collection, 1967.115.39

Roman
Baubo, 1st–2nd century A.D.
Cast bronze, h. 3½ (8.9)
Purchase, Unrestricted Funds, 1984.3

Roman, Rome or environs
Mural Relief: Nike Sacrificing a Bull,
1st–2nd century A.D.
Slip-painted molded and modeled
earthenware, h. 8¹⁵⁄₁₆ (22.7), l. 12⅜ (31.4)
The F. B. Tarbell Collection,
Gift of W. G. Hale, 1918; 1967.115.405

Roman, Rome or environs
*Mural Relief: Youth in Phrygian Hat Feeding
a Griffin*, early 2nd century A.D.
Slip-painted molded earthenware,
h. 11⅜ (28.9), l. 10⅛ (25.6)
The F. B. Tarbell Collection,
Gift of W. G. Hale, 1918; 1967.115.407

Roman
Seated Male (Dionysos or Achilles?), 100–175 A.D.
Ivory or bone plaquette (two fragments
joined and one unjoined section),
h. 7½ (19.1)
The F. B. Tarbell Collection,
Gift of E. P. Warren, 1902; 1967.115.455

Roman
Aphrodite from Aphrodisias, 2nd–3rd
century A.D. (?)
Marble, h. without base 7⅞ (20)
The F. B. Tarbell Collection,
Gift of E. P. Warren, 1902; 1967.115.413

Roman (?), **Smyrna** (?)
Standing Female (Artemis?), n.d.
Cast bronze, h. 5 (12.7)
The F. B. Tarbell Collection,
Gift of E. P. Warren, 1902; 1967.115.40

DECORATIVE ARTS

Roman, Syrian
Beaker, 1st–2nd century A.D.
Mold-blown purple glass with lotus
bud/almond knop design, h. 3⅞ (9.8)
The F. B. Tarbell Collection, Gift of Mrs.
Chauncey J. Blair, 1916; 1967.115.68

Roman, Syrian (?)
Aryballos, 2nd century A.D.
Blown dark-blue glass with applied
handles, h. 2¹⁄₁₆ (5.3)
The F. B. Tarbell Collection, Gift of Mrs.
Chauncey J. Blair, 1916; 1967.115.99

Late Antique and Medieval

PAINTING

**Late Antique/Early Christian,
Northern Syrian, Homs**
Floor Fragment: Deer and Duck,
late 5th–mid 6th century
Mosaic of marble and stone tesserae,
55 x 46⅞ (139.7 x 119.1)
Anonymous Gift in honor of Mr. and Mrs.
Raymond L. Smart at the opening of the
David and Alfred Smart Gallery in 1974;
1974.60

**Late Antique/Early Christian,
Northern Syrian, Homs**
Floor Fragment: Rampant Tiger,
late 5th–mid 6th century
Mosaic of marble and stone tesserae,
35¹⁄₁₆ x 58¹¹⁄₁₆ (89.1 x 149.1)
Anonymous Gift in honor of Mr. and Mrs.
Raymond L. Smart at the opening of the
David and Alfred Smart Gallery in 1974;
1974.61

* **Ugolino Lorenzetti**
Italian, Sienese School, active circa
1320–1360
The Crucifixion, circa 1350
Tempera and gilding on wood panel,
19¾ x 8⅝ (50.2 x 21.9)
Gift of the Samuel H. Kress Foundation,
1973.40

Artist Unknown, German
Royal Saint with a Ring, circa 1465
Oil and gilding on wood panel,
20½ x 6¾ (52.1 x 17.1)
Gift of the Samuel H. Kress Foundation,
1973.52

SCULPTURE

**Late Antique/Early Christian,
North African, Carthage** (?)
Female Head (An Empress?),
late 4th–early 5th century
Limestone, h. 9 (22.9)
Anonymous Gift in honor of John W.
McKay, Trail, British Columbia, Canada,
1979.37

Islamic Spanish (Omayyad dynasty),
near Córdoba (palace-city of Medina
az-Zahra?)
Architectural Fragment: Composite Capital,
10th century
Marble, h. 7½ (19)

Anonymous Gift in memory of Professor
Edward A. Maser, Founding Director of
the Smart Gallery, 1973–1983; 1988.78

* **French, Burgundy, School of Cluny III**
Architectural Fragment: Head (of an Angel?),
circa 1120
Limestone, h. 7¼ (18.4)
Purchase, The Cochrane-Woods
Collection, 1977.2

* **French, Burgundy, School of Cluny III**
*Architectural Fragment: Section of an
Arcade*, circa 1120
Limestone, 15¾ x 9⁷⁄₁₆ x 4½ (40 x 24 x 11.4)
Purchase, The Cochrane-Woods
Collection, 1977.3

* **French, Burgundy, School of Cluny III**
Architectural Fragment: Capital, circa 1120
Limestone, 6¾ x 11 x 6 (17.1 x 27.9 x 15.2)
Purchase, The Cochrane-Woods
Collection, 1977.4

French, Languedoc, School of Moissac
*Architectural Fragment: Crowned Head
(King David or An Elder of the Apocalypse?)*,
circa 1125
Stone, h. 11 (27.9)
Purchase, Gift of the Women's Board of
The University of Chicago, 1977.5

* **French, School of Burgundy**
Architectural Fragment: Bishop,
circa 1350–1400
Sandstone with traces of polychromy,
h. 55⅛ (140)
Purchase, The Cochrane-Woods
Collection, 1974.122

French, Burgundy
A Magus, circa 1480
Limestone with traces of polychromy,
h. 12½ (31.7)
Gift of Mrs. Ruth Blumka and her family
in memory of Thomas F. Flannery, Jr.,
1980.143

DECORATIVE ARTS

**Early Christian, Eastern Mediterranean,
Tiberias, Galilee**
Oil Lamp, 4th–5th century
Cast bronze, h. 1½ (3.8), l. 4⅞ (12.4)
University transfer, Early Christian
Archaeological Seminar Collection of the
Divinity School, 1988.42

**Early Christian,
Syro-Palestinian/Egyptian**
Votive or "Evil Eye" Plaque, 5th–6th century
Unglazed terracotta with traces of cold-
paint decoration, 5¾ x 3¹³⁄₁₆ (14.6 x 9.7)
University transfer, Early Christian
Archaeological Seminar Collection of the
Divinity School, 1988.39

Early Christian, Egyptian
St. Menas Ampulla, 5th-6th century
Unglazed terracotta with stamped
decoration (recto) and Greek inscription
(verso), h. 3½ (8.9)
University transfer, Early Christian
Archaeological Seminar Collection of the
Divinity School, 1988.41

French
Portion of a Gothic Monstrance, 15th century
Cast, cut, and twisted gilt bronze,
h. 7⁷⁄₁₆ (18.9)
Gift of Mrs. Ruth Blumka, 1974.73

French
Liturgical Comb, late 15th century
Boxwood, 3¹³⁄₁₆ x 3¹¹⁄₁₆ (9.6 x 9.3)
Gift of Mrs. Ruth Blumka, 1982.5

Renaissance, Baroque, and Eighteenth Century

PAINTING

Master of the Apollo and Daphne Legend
Italian, Florentine School, active end of
15th century
Daphne Found Asleep by Apollo, circa 1500
Oil, formerly on panel, transfered to
canvas, 25⅝ x 53¾ (65.1 x 136.5)
Gift of the Samuel H. Kress Foundation,
1973.44

Master of the Apollo and Daphne Legend
Daphne Fleeing from Apollo, circa 1500
Oil, formerly on panel, transfered to
canvas, 25⅝ x 53¾ (65.1 x 136.5)
Gift of the Samuel H. Kress Foundation,
1973.45

Bartolommeo Suardi, called **Bramantino**
Italian, Milanese School, circa 1465–1530
The Gathering of Manna, circa 1505–1506
Oil on panel, 10¾ x 17 (27.3 x 43.2)
Gift of the Samuel H. Kress Foundation,
1973.48

Bartolommeo Suardi, called **Bramantino**
The Raising of Lazarus, circa 1505–1506
Oil on panel, 10⅝ x 17¾ (27 x 45.6)
Gift of the Samuel H. Kress Foundation,
1973.49

* **Giovanni Antonio de Sacchi**, called **Il Pordenone**
Italian, Venetian School, 1483/4–1539
Milo of Croton Attacked by Wild Beasts,
1534–1536
Oil on canvas, 80½ x 93¾ (204.5 x 238.1)
Purchase, The Cochrane-Woods
Collection, 1975.31

Attributed to **Paolo Veronese**
Italian, Venetian School, 1528–1588
The Assumption of the Virgin, circa 1548
Oil on canvas, oval 31⅛ x 22 (79 x 55.9)
Gift of the Samuel H. Kress Foundation,
1973.38

* **Luca Cambiaso**
Italian, Genoese School, 1527–1585
*Madonna and Child with St. John the Baptist
and St. Benedict*, circa 1562
Oil on wood panel, 55 x 40⅝ (139.7 x 103.2)
Gift of the Samuel H. Kress Foundation,
1973.50

Paolo Farinati
Italian, Veronese School, 1524–1606
Neptune and Amphitrite, n.d.
Oil on canvas, 30 x 30¾ (76.2 x 78.1)
Gift of Ira Spanierman, 1980.69

Martin de Vos
Flemish, active in Antwerp, 1532–1603
Madonna and Child, n.d.
Oil on wood panel, 36 x 28¼ (91.4 x 71.8)
Gift of Mr. and Mrs. Eugene Davidson,
1978.61

Artist Unknown, Northern European, Flemish (?)
Apollo and Marsyas, circa 1600
Oil on canvas, 15 x 20 (38.1 x 50.8)
Purchase, The Cochrane-Woods
Collection, 1982.18

Artist Unknown, Italian, Bolognese School, Circle of Guido Reni
St. Dorothy and an Angel, circa 1630
Oil on canvas, 40¾ x 31 (103.5 x 78.7)
Gift of Mr. and Mrs. Eugene Davidson,
1978.17

* **Francesco Montelatici**, called **Cecco Bravo**
Italian, Florentine School, 1607–1661
Angelica and Ruggiero, circa 1640–1645
Oil on canvas, 12¾ x 17½ (32.4 x 44.5)
Gift of the Samuel H. Kress Foundation,
1973.42

Jan Steen
Dutch, 1626–1679
A Game of Skittles, circa 1650
Oil on canvas, 25½ x 32¾ (64.8 x 83.2)
Gift of the Samuel H. Kress Foundation,
1973.51

Gérard de Lairesse
Belgian, active in The Hague and
Amsterdam, 1641–1711
The Sacrifice of Polyxena
(formerly *The Sacrifice of Iphigenia*), n.d.
Oil on canvas, 56 x 38½ (142.2 x 97.8)
Gift of Max Schwarz, 1961; 1967.12

Attributed to **Luca Giordano**
Italian, Neapolitan School, 1634–1702
St. Peter Liberated from Prison, n.d.
Oil on stone (basalt?), 22⅛ x 25 (56.2 x 63.5)
Purchase, Gift of Helen Findlay, 1974.77

Artist Unknown, Spanish (?),
formerly attributed to Paolo de Matteis
(Italian, Neapolitan School, 1662–1728)
The Martyrdom of St. Stephen, after Luca
Giordano, 1700–1750 (?)
Oil on canvas, 10¹³⁄₁₆ x 13¹⁵⁄₁₆ (27.4 x 35.4)
Purchase, The Cochrane-Woods
Collection, 1979.41

Donato Creti
Italian, Bolognese School, 1671–1749
St. John the Baptist Preaching,
circa 1690–1710
Oil on canvas, 35⅝ x 24⅝ (90.5 x 62.5)
Gift of the Samuel H. Kress Foundation,
1973.46

Michele Rocca, called **Il Parmigianino**
Italian, Roman School, 1666–circa 1730
The Finding of the Infant Moses, circa 1710
Oil on canvas, 20¾ x 15½ (52.7 x 39.4)
Gift of the Samuel H. Kress Foundation,
1973.47

Francesco Fontebasso
Italian, Venetian School, 1709–1769
The Martyrdom of St. Catherine, n.d.
Oil on canvas, 16¹⁵⁄₁₆ x 24⅜ (42.9 x 61.9)
Purchase, The Cochrane-Woods
Collection, 1978.23

* **Noël Hallé**
French, 1711–1781
Joseph Accused by Potiphar's Wife,
circa 1740–1744
Oil on canvas, 55¾ x 65⅝ (141.7 x 166.5)
Purchase, Gift of The Mark Morton
Memorial Fund and Mr. and Mrs. Eugene
Davidson, 1974.116

* **Giuseppe Marchesi**, called **Il Sansone**
Italian, Bolognese School, 1699–1771
The Magdalene Attended by Two Angels,
circa 1740–1750
Oil on canvas, 57¼ x 66⅜ (146 x 168.4)
Purchase, Gift of Mrs. Eugene Davidson,
1977.104

Anton Raphael Mengs
German, 1728–1779
The Lamentation of Christ, circa 1777
Oil on panel, 8⅝ x 6½ (21.9 x 16.5)
Study for the *Rinucci Lamentation* cartoon
(Museum of Fine Arts, Boston)
Purchase, Gift of Mr. and Mrs. Eugene
Davidson, 1977.1

Artist Unknown, German or **Italian, School of Anton Raphael Mengs**
*Head and Bust of a Female Mythological
Figure*, n.d.

Oil on canvas, 23¾ x 19 (60.3 x 48.2)
Bequest of John N. and Dorothy C.
Estabrook, 1988.11

*Franz Anton Maulbertsch
Austrian, 1724–1796
The Sausage Woman (Die Würstelbräterin),
circa 1785–1790
Oil on wood panel, 12¹/₁₆ x 14¹/₁₆ (30.7 x 35.8)
Purchase, Gift of Viola Manderfeld,
1978.184

*Franz Anton Maulbertsch
The Pancake Woman (Das Krapfenweib),
circa 1785–1790
Oil on wood panel, 12¹/₁₆ x 14¹/₁₆ (30.7 x 35.8)
Purchase, Gift of Viola Manderfeld,
1978.185

Giuseppe Cades
Italian, Roman School, 1750–1799
Madonna and Child, n.d.
Oil on canvas, 33⅝ x 26⅛ (102.2 x 83.2)
Gift of Mr. and Mrs. George B. Young, 1983.115

DRAWINGS AND PAINTINGS ON PAPER

Abraham Bloemaert
Dutch, 1569–1647
Allegorical Figure Holding a Sphere, n.d.
Pen and ink with wash and preliminary
graphite underdrawing on laid paper,
11⅛ x 8⅛ (28.3 x 20.2)
Bequest of Joseph Halle Schaffner in
memory of his beloved mother,
Sara H. Schaffner, 1973.72

*Luca Giordano
Italian, Neapolitan School, 1634–1705
The Anointment of King Solomon,
1692–1694
Oil on paper mounted on canvas, 14¾ x
14¼ (37.5 x 36.2)
Purchase, Gift of Mr. and Mrs. Eugene
Davidson, 1976.69

Andrea dell'Asta
Italian, Neapolitan School, 1673–1721
Saint Nicolas, n.d.
Pen and ink with wash and preliminary
pencil drawing on laid paper, 12¼ x 9¾
(31.1 x 24.8)
Bequest of Joseph Halle Schaffner in
memory of his beloved mother,
Sara H. Schaffner, 1973.123

Attributed to Jean Jouvenet
French, 1644–1717
Reclining Male Nude, circa 1700–1710
Chalk on blue wove paper, 16 x 17¼
(41.1 x 44)
Purchase, Gift of the Friends of the Smart
Gallery, 1988, and Mrs. George B. Young,
1988.69

Daniel Gran
Austrian, 1694–1757
Design for a Ceiling, n.d.
Pen and ink with wash and preliminary
graphite underdrawing on laid paper,
14 x 16½ (35.6 x 41.9)
Gift of Mr. and Mrs. Frank H. Woods, Jr.,
1980.28

Andreas de la Calleja
Spanish, 1705–1785
*Ecstasy of a Male Saint before an Altar with
Infant Angels*, n.d.
Chalk, pen and brush with ink and wash
on laid paper, 15¼ x 8¼ (38.7 x 20.9)
Bequest of Joseph Halle Schaffner in
memory of his beloved mother,
Sara H. Schaffner, 1973.73

Attributed to Anton Kern
Bohemian, 1710–1747
St. Gilbert Visiting the Sick, n.d.
Oil on paper mounted on canvas, 10 x 8
(25.4 x 20.3)
Purchase, The Cochrane-Woods
Collection, 1977.111

Artist Unknown, South German
Christ Healing the Paralytic, circa 1750
Pen and ink with wash on laid paper,
9½ x 14⁷/₁₆ (24.2 x 36.7)
Purchase, Gift of Friends of Mrs. Bezas,
1976.54

Thomas Gainsborough
English, 1727–1788
Landscape with Trees, 1770–1780s
Watercolor washes over preliminary offset
(?) drawing on wove paper, in gilt mat with
pen and ink with wash, and stamped with
signature, oval 7⅝ x 9¹/₁₆ (19.4 x 23)
Bequest of Joseph Halle Schaffner in
memory of his beloved mother,
Sara H. Schaffner, 1973.86

PRINTS

Cristofano di Michele Martini,
called Cristofano Robetta
Italian, 1462–circa 1535
Adoration of the Magi, circa 1506
(plate), probably 18th-century impression
Engraving, plate 11¾ x 10⅞ (29.8 x 27.6)
Gift of Anne Abrons, 1984.135

Urs Graf the Elder
Swiss, circa 1485–1527/28
The Crucifixion, from *The Early Strassburg
Passion* series, 1506
Woodcut with hand-coloring in water-
color, block (trimmed) 8⁷/₁₆ x 6 (21.5 x 15.2)
Bartsch 2
University transfer from Max Epstein
Archive, Gift of the Carnegie
Corporation, 1927; 1967.116.133

Hans Leonhard Schäufelein
German, 1480/85–1538/40
Christ Before Pilate, from *The Passion*
(*Speculum passionis*) series, 1507
Woodcut, block 9⅜ x 6⅜ (23.8 x 16.2)
Bartsch 34, Oldenbourg 174
University transfer from Max Epstein
Archive, Gift of the Carnegie
Corporation, 1927; 1967.116.103

Albrecht Dürer
German, 1471–1528
The Descent from the Cross, from
The Small Passion series, 1509–1511
Woodcut, block (trimmed) 5¹/₁₆ x 3¹³/₁₆
(12.8 x 9.7)
Bartsch 42, Meder 151
University transfer from Max Epstein
Archive, Gift of the Carnegie
Corporation, 1927; 1967.116.101

Albrecht Dürer
The Veronica Napkin, 1513
Engraving, plate (trimmed) 4 x 5½ (10.2 x 14)
Bartsch 25, Meder 26
Gift of Mr. and Mrs. Richard L. Selle,
1979.1

Lambert Hopfer
German, active 1520–1530
The Entombment of Christ, n.d.
Etching, plate 5½ x 3⅞ (14 x 8.8)
Bartsch VIII, 528, 14
University transfer from Max Epstein
Archive, 1967.116.102

Ugo da Carpi
Italian, 1479/80–1532
*Sybil Reading, Lighted by a Child with a
Torch*, after Raphael, n.d.
Two-color chiaroscuro woodcut, line block
10½ x 8½ (26.6 x 21)
Bartsch XII, 5, 6
University Transfer from Max Epstein
Archive, acquired 1950; 1967.116.106

Girolamo Francesco Maria Mazzola,
called Il Parmigianino
Italian, 1503–1540
The Annunciation, n.d.
Etching, plate 4³/₁₆ x 2½ (10.7 x 6.4)
University transfer from Max Epstein
Archive, acquired 1959; 1976.145.15

Niccolò Vicentino
Italian, active first half of 16th century
Cloelia's Flight, Crossing the Tiber, after
Maturino da Firenze, 1608
(published by Andrea Andreani)
Three-color chiaroscuro woodcut,
II/II, line block 11³/₁₆ x 16¾ (28.4 x 42.5)
Bartsch XII, 96, 5 II/II
University transfer from Max Epstein
Archive, acquired 1949; 1967.116.142

Heinrich Aldegrever
German, 1502–1555/61
The Rich Man and the Devil, plate 3 from
The Story of the Rich Man and Lazarus
series, 1554
Engraving, plate 3 x 4¼ (7.6 x 10.8)
Bartsch 46
University transfer from Max Epstein
Archive, Gift of Mrs. C. Phillip Miller,
1963; 1967.116.95

*Niccolò Boldrini
Italian, 1510–after 1566
Milo of Croton Attacked by Wild Beasts,
after Il Pordenone, mid 16th century
Chiaroscuro woodcut (key/line block
only), image 11⅝ x 16¼ (29.5 x 41.3)
Gift of Mr. and Mrs. H. W. Janson,
1977.109

Luca Cambiaso
Italian, Genoese School, 1527–1585
Poseidon and the Nymphs, n.d.
Woodcut, trimmed at top and bottom,
with later additions in pen and ink,
restored sheet 8¾ x 11¾ (22.2 x 29.8)
Gift of Mrs. Leo M. Zimmerman in
memory of Dr. Leo Zimmerman, 1984.138

Hendrik Goltzius
Dutch, 1558–1617
Christ Crowned with Thorns, plate 7 from
The Passion series, 1597
Engraving, plate 7¾ x 5⅛ (19.6 x 13.1)
Bartsch 33
University transfer from Max Epstein
Archive, Gift of the Carnegie
Corporation,1927; 1967.116.15

Jerome Wierix
Flemish, circa 1553–1619
St. Jerome by the Pollard Willow,
after Albrecht Dürer (Bartsch 59), n.d.
Engraving, plate 8³⁄₁₆ x 7¹⁄₁₆ (20.9 x 18)
Alvin 991
University transfer from Max Epstein
Archive, 1976.145.248

*Hendrik Goudt
Dutch, 1573–1648
The Mocking of Ceres,
after Adam Elsheimer, 1610
Engraving, second state, plate 12⅜ x 9⅝
(31.4 x 24.4)
Dutuit 6, Hollstein 5, Reitlinger 6
University transfer from Max Epstein
Archive, Gift of Max Epstein, 1937;
1976.145.197

Paulus Moreelse
Dutch, 1571–1638
Love (Amor) Between Two Dancing Women,
1612
Two-color chiaroscuro woodcut, line block
9⁷⁄₁₆ x 11⅝ (24 x 29.5)
De Jonge 15, Hollstein 2, Strauss 153
University transfer from Max Epstein
Archive, acquired 1952; 1967.116.9

Ludolph Büsinck
German, 1599/1602–1669
The Flute Player, after George Lallemand,
circa 1623–1629
Three-color chiaroscuro woodcut,
line block 10⁵⁄₁₆ x 8⁵⁄₁₆ (26.2 x 21.1)
Hollstein 23, Le Blanc 24, Stechow 23,
Strauss 95
University transfer from Max Epstein
Archive, acquired 1952; 1967.116.99

Jacques Callot
French, 1592/3–1635
View of the Louvre (*Vue du Louvre*), n.d.
Etching, II/V, plate 6⁹⁄₁₆ x 13⅛ (16.7 x 33.4)
Lieure 667, Meaume 713
Gift in memory of Bernard Weinberg by
the Weinberg Family, 1974.46

*Wenceslaus Hollar
Dutch, 1607–1677
The Mocking of Ceres, after Hendrik Goudt,
1646
Etching, plate 11¾ x 9 (29.8 x 22.9)
Parthey 273, Pennington 273
University transfer from Max Epstein
Archive, Gift of Max Epstein, 1937;
1976.145.200

Rembrandt Harmensz van Rijn
Dutch, 1606–1669
*Rembrandt's Mother Seated at a Table,
Looking Right*, circa 1631
Etching, second state, plate 5⅞ x 5³⁄₁₆
(15 x 13.1)
Hollstein B343 II
University transfer from Max Epstein
Archive, The Harold H. Swift Bequest,
1963; 1967.116.12

Rembrandt Harmensz van Rijn
Virgin and Child in the Clouds, 1641 (plate)
Etching, drypoint, plate 6½ x 4¼
(16.5 x 10.7)
Bartsch 61
Gift of John F. Peloza in memory of Sylvia
Spacapan Peloza Miletich, 1988.4

Rembrandt Harmensz van Rijn
Jan Lutma, Goldsmith, 1656
Etching, drypoint, second state,
plate (trimmed) 7¹¹⁄₁₆ x 5¾ (19.6 x 14.6)
Hollstein B276 II
University transfer from Max Epstein
Archive, The Harold H. Swift Bequest,
1963; 1967.116.197

John Baptist Jackson
English, 1701 (?)–1777 (?)
Venus and Cupid with a Bow,
after Parmigianino, 1731
Three-color chiaroscuro woodcut,
proof before fourth block, block 8⅝ x 6¹⁄₁₆
(21.9 x 15.4)
Kainen 2
University transfer from Max Epstein
Archive, 1976.145.201

*John Baptist Jackson
The Crucifixion, after Tintorretto, 1740
(dated 1741)
Four-color chiaroscuro woodcut, left sheet
23⅞ x 18½ (60.6 x 47), center 24¾ x 18¼
(62.9 x 46.3), right 23⅞ x 18½ (60.6 x 47)
Eighteenth-century post-publication
printing with altered blocks, not recorded
in Le Blanc 9, Kainen 22, or Nagler 13
University transfer from Max Epstein
Archive, 1967.116.144–1967.116.146

Antonio Maria Zanetti
Italian, 1679–1757
Woman with Two Children,
after Parmigianino, n.d.
Four-color chiaroscuro woodcut,
block 6¾ x 4¹¹⁄₁₆ (17.1 x 11.9)
Bartsch 59
University transfer from Max Epstein
Archive, acquired 1952; 1967.116.111

Giovanni Battista Piranesi
Italian, 1720–1778
View of the Piazza Monte Cavallo (*Vedute
della Piazza di Monte Cavallo*), from the
Vedute di Roma (*Views of Rome*) series,
circa 1765–1778
Etching, IV/VI, plate 15¼ x 21⅜ (38.9 x 53.7)
Hind 15 IV/VI
University transfer from Max Epstein
Archive, Gift of Morton Zabel,
1967.116.148

Giovanni Battista Piranesi
*The Piazza Navonna with Sant' Agnese on
the Left* (*Vedute di Piazza Navonna sopra le
rovine del Circo Agonale*), from the
Vedute di Roma (*Views of Rome*) series,
circa 1773–1778
Etching, I/IV, plate 42⁷⁄₁₆ x 51¹⁵⁄₁₆
(107.8 x 131.9)
Hind 108 I/IV
University transfer from Max Epstein
Archive, 1979.62

*Jean-Baptiste Le Prince
French, 1734–1781
The Russian Dance (*La Danse Russe*), 1769
Etching, aquatint, plate 15⅛ x 12⅛
(38.4 x 30.7)
Hédou 137
University transfer from Max Epstein
Archive, 1976.145.391

SCULPTURE

Italian, Genoa
Tabernacle, mid 15th century
Marble with gilding and polychrome
decoration, 41½ x 27 (105.4 x 68.6)
Gift of the Samuel H. Kress Foundation,
1973.55

Matteo de' Pasti
(Matteo di Maestro de' Pasti)
Italian, active 1441–1467/8
Sigismondo Pandolfo Malatesta (1417–1468),
Lord of Rimini 1432–1468 (obverse),
Rimini Castle, called the "Rocca
Malatestiana" (reverse), 1446
Cast bronze medallion, diam. 3⁵/₃₂ (8)
Purchase, Gift of Members of the Baroque
and Rococo Tour, 1982; 1983.6

North Italian, Padua (?)
Phoenix Rising from the Flames,
early 16th century
Cast bronze, h. 5¼ (13.3)
Purchase, Gift of Mrs. Chester Tripp in
memory of her husband, 1979.18

North Italian, Padua (?)
The Dead Christ Attended by Angels,
circa 1525–1550
Cast silver-gilt bronze plaquette, 3⁹/₁₆ x 4½
(9 x 11.4)
Purchase, Gift of Mrs. Thomas F.
Flannery, Dr. Burton Grossman, Mr. Julius
Lewis, Mrs. Ruth K. McCollum, Mrs.
Mary M. McDonald, Mr. and Mrs.
Leonard J. O'Conner, and Mr. and Mrs.
Frederick H. Prince, 1982.22

Giovanni Bernardi da Castelbolognese
Italian, 1496–1553
Pope Clement VII de' Medici (1478–1534)
(obverse), *Joseph Reveals Himself to His*
Brothers (reverse), 1529–1530
Struck gilt bronze medal, diam. 1⅜ (3.5)
Purchase, The Cochrane-Woods
Collection, 1977.117

Domenico de' Vetri
(Domenico di Polo di Angelo de' Vetri)
Italian, circa 1480–1547
Alessandro de' Medici (1510–1537), First Duke
of Florence 1531–1537 (obverse), *Allegory of*
Peace and Abundance (reverse), 1534
Struck silvered bronze medal,
diam. 1⁷/₁₆ (3.6)
Purchase, Gift of Mrs. John V. Farwell III,
1977.7

* **Hans Reinhart the Elder**
German, circa 1517–1561
The Fall of Man (obverse), *The Crucifixion*
(reverse), 1536
Cast silver medallion, diam. 2¹¹/₁₆ (6.8)
Purchase, The Cochrane-Woods
Collection, 1977.100

Peter Flötner
German, 1485/90–1546
Mars as a Sign of the Zodiac, circa 1540
Cast gilt bronze plaquette, 2⅝ x 4 (6.7 x 10.2)
Purchase, The Cochrane-Woods
Collection, 1977.115

Peter Flötner
Allegory of the Sense of Smell, circa 1540
Cast bronze plaquette, 2½ x 3⅜ (6.4 x 8.6)
Purchase, The Cochrane-Woods
Collection, 1977.116

Jacopo Nizzola da Trezzo
Italian, 1515/19–1589
King Philip II of Spain (1527–1598) (obverse),
Apollo in a Quadriga (reverse), 1555
Cast bronze medallion, diam. 2¹¹/₁₆ (6.8)
Purchase, The Cochrane-Woods
Collection, 1977.114

South German, Augsburg, Workshop of
Matthias Wallbaum (?) or Johannes Flicker
III or IV (?)
Allegory of Summer, late 16th century
Cast brass or bronze plaquette, 1⅝ x 3⅝
(4.1 x 9.2)
Gift of Mrs. Ruth Blumka in memory of
Professor Edward A. Maser, Founding
Director of the Smart Gallery, 1973–1983;
1989.6

Italian, Rome
St. Cecilia, after Stefano Maderno,
17th century
Cast bronze, l. 8¼ (21)
Gift of Kelvyn G. Lilley, 1977.108

Alessandro Algardi
Italian, 1598–1654
Christ Falling Beneath the Cross, n.d.
Cast bronze, h. 5¾ (14.6), l. 9¾ (24.8)
Purchase, Gift of the Friends of the Smart
Gallery, 1980; 1980.48

* **Alessandro Algardi**
The Infant Hercules Subduing the Serpent,
after circa 1635
Cast bronze, l. 17 (43.2)
Montagu 127.c.5
Purchase, The Cochrane-Woods
Collection, 1977.103

* Attributed to **Michel Anguier**
French, 1612–1686
The Infant Hercules Subduing the Serpent,
after Alessandro Algardi, circa 1641
Cast bronze, l. 18½ (47)
Montagu 127.c.6
Purchase, The Cochrane-Woods
Collection, 1977.101

Italo-Flemish or Franco-Flemish
Venus Chastizing Cupid,
17th or early 18th century
Cast bronze, h. 15¼ (38.7)
Gift of Mr. and Mrs. Frank H. Woods,
1980.27

South German
Angel, 17th or early 18th century
Cast bronze, h. 21 (53.3)
Purchase, Gift of Mrs. Harold T. Martin in
memory of Professor Edward A. Maser,
Founding Director of the Smart Gallery,
1973–1983; 1988.22

Charles-Jean-François Cheron
French, 1635–1698
Pietro da Cortonna (obverse),
Allegory of Fame (reverse), n.d.
Cast bronze medallion, diam. 2⅞ (7.3)
Gift of Paul A. Kirkley, Ph.B. '24,
in memory of his wife, Martha L. Skinner
Kirkley, Ph.B. '24; 1978.134

Bartolommeo Giovanni Vaggelli
Swiss, active in Italy, died 1744
Antonio Magliabechi (1633–1714) (obverse),
Allegorical Scene with a Book on a Table
(reverse), 1714
Cast bronze medallion, diam. 3⅜ (8.6)
Purchase, The Cochrane-Woods
Collection, 1979.40

Italian, Rome (?)
Head of a Cherub, circa 1720
Cast gilt bronze, h. 3¾ (9.5)
Purchase, Gift of Members of the Baroque
and Rococo Tour, 1979; 1980.60

German (?)
Young Lion, 18th century
Unglazed modeled terracotta, h. 7⅞ (20),
l. 7¾ (19.7)
Purchase, Gift of Members of the Baroque
and Rococo Tour, 1980; 1980.70

German, Meissen Factory
Johann Friederich Eberlain, modeler,
active at Meissen 1735–1749
Adam and Eve in Paradise, 1745 (model, this
cast bearing the mark of the Marcolini period)
Hard-paste porcelain with overglaze
enamel, model no. 665, h. 13⅝ (34.6)
Gift of Mrs. Leopold Blumka in memory
of Leopold Blumka, 1979.55

* **Italian, Doccia Factory**
Gaspero Bruschi, modeler, active at Doccia
1742–1780
Portrait Medallion with Bust of Marchese
Carlo Ginori, circa 1757
Hard-paste porcelain, h. 6¾ (17.1)
With original gilt and tooled-leather case
Purchase, The Harold T. Martin Fund,
1979.54

Louis-Félix de la Rue
French, 1720/31–1765
Satyress with Putti and Young Satyrs, n.d.
Cast bronze relief, 5¾ x 11⅛ (14.6 x 28.2)
Purchase, The Cochrane-Woods
Collection, 1977.112

German, Munich, Nymphenburg Factory
Dominikus Auliczek, modeler, active
1763–1797
Dog Attacking a Bull, n.d.
Hard-paste porcelain, h. 5¼ (13.3),
l. of base 7¹³⁄₁₆ (19.8)
Gift of Kelvyn G. Lilley, 1979.24

Joseph-Charles Marin
French, 1759–1834
Bathing Girl, 1788
Unglazed modeled terracotta, h. 7¾ (19.7)
Gift of the Samuel H. Kress Foundation,
1973.53

DECORATIVE ARTS

Italian, Venice (Murano)
Footed Bowl, circa 1500
Gilded and enameled blown green glass,
h. 5¹⁵⁄₁₆ (15.1)
Gift of the Samuel H. Kress Foundation,
1973.56

* **Italian, Padua, Workshop of
Severo Calzetta da Ravenna**
*Candlestick and Inkwell (or Sandbox):
Kneeling Satyr*, circa 1500–1509
Cast bronze, h. 9¾ (24.8),
h. without base 8⅛ (20.6)
Gift of the Samuel H. Kress Foundation,
1973.58

* **Italian, Rome**
Reliquary, circa 1534–1549
Cast silver gilt, lapis lazuli, crystal, enamel,
and *églomisé*, h. 23½ (59.7)
Bearing the arms of Alessandro Farnese,
Pope Paul III (1534–1549)
Gift of the Samuel H. Kress Foundation,
1973.54

**Italian, Urbino, Workshop of
Orazio (?) Fontana**
Birth Bowl (Ciottola puerperile), circa 1575
Polychrome tin-glazed earthenware (majol-
ica), h. 2⅛ (5.4), diam. of mouth 8¾ (22.2)
Purchase, The Cochrane-Woods
Collection, 1979.42

North Italian, Venice (?)
Inkwell: Putto on a Dolphin, circa 1650–1675
Cast bronze, h. 4½ (11.4)
Purchase, Gift of Eloise W. Martin, 1982.12

English, Lambeth (?)
Posset Pot, circa 1680–1700
Polychrome tin-glazed earthenware
(delftware), h. 5 (12.7)
Anonymous Gift, 1982.44

Italian (?)
Holy Water Stoup, 18th century
Modeled earthenware with partial glazing
and traces of gilding, h. 15 (38.1)
Gift of Mrs. Leopold Blumka in memory
of Leopold Blumka, 1973.13

* **French, Chantilly Factory**
Shell-form Bowl and Platter, circa 1750
Soft-paste porcelain, bowl: h. 4½ (11.4),
l. 10½ (26.7), platter: l. 13½ (34.3)
Gift of Mrs. Helen Regenstein, 1976.10

English, Lambeth
Charger, 1750–1760
Polychrome tin-glazed earthenware
(delftware), diam. of rim 13⅝ (34.6)
Anonymous Gift, 1983.59

English, London
Large Plate, circa 1760
Cobalt-blue tin-glazed earthenware
(delftware), diam. of rim 13⅞ (35.2)
Gift of Chase Gilmore in honor of
John and Peggy Carswell, 1987.10

English, London
Large Plate, circa 1760
Polychrome tin-glazed earthenware
(delftware), diam. of rim 13⅞ (35.2)
Gift of Chase Gilmore in honor of
John and Peggy Carswell, 1987.11

* **Silesian, Warmbrunn**
In the manner of Christian Gottfried
Schneider, engraver
Goblet with Lid (Pokal), 1760
Mold-blown, cut, engraved, and partially
gilded clear glass with 19th-century brass
replacement of original glass finial,
h. with lid 8½ (21.6)
Gift of Mrs. Else Felber, 1981.75

German, Berlin, Gotowski Factory
Partial Tea Set: Tea Pot, Milk Jug, Tea Caddy,
1761–1763
Partially glazed porcelain, tea pot: h. 3¼
(8.3), milk jug: h. 4¼ (10.3), tea caddy: h. 4⅜
(11.1)
Gift of Charlotte Vern Olson, 1983.78–1983.80

Austrian, Vienna Factory
Covered Tureen and Platter, circa 1765
Porcelain with overglaze enamel,
tureen: h. 8⅞ (22.5), l. 13⅜ (33.5), platter: l.
15¼ (38.5)
Purchase, Gift of Burton J. Grossman,
M.D. '49, in honor of his father,
Paul Grossman, 1979.20

German, Frankenthal Factory
Bowl, circa 1775
Hard-paste porcelain with overglaze
enamel and gilt decoration, h. 3¼ (8.3),
diam. of mouth 7 (17.8)
Gift of John W. Keefe in honor of
Eloise W. Martin, 1980.50

English, Worcester Factory, Dr. Wall period
Bowl, circa 1770–1780
Porcelain with embossed and underglaze
blue decoration, h. 1⅞ (4.8),
diam. of mouth 3¹⁵⁄₁₆ (10)
Gift of Charlotte Vern Olson, 1983.75

English, Worcester Factory,
Thomas Flight period
Tea Bowl and Saucer, 1783–1792
Hard-paste porcelain with overglaze
enamel and gilt decoration, bowl: h. 2 (5.1),
diam. 3⅜ (8.6), saucer: diam. 5¼ (13.4)
Gift of Kelvyn G. Lilley, 1977.15

Bohemian
Beaker, late 18th century
Cold-painted and engraved gold and silver
foil sandwiched between two clear glasses,
the outer one cut (Zwischengoldglas and
Zwischensilberglas), h. 2½ (6.3),
diam. of rim 2⅜ (6)
Gift of Mrs. Else Felber in memory of
Dr. Karl Werner, 1983.50

Italian, Doccia Factory
Coffee Pot, circa 1790–1810
Porcelain with overglaze enamel and gilt
decoration, h. without lid 8⅝ (22)
Gift of Mr. and Mrs. Edward A. Maser,
1983.92

Nineteenth Century and Modern: Europe

PAINTING

Artist Unknown, English, formerly
attributed to John Constable
(English, 1776–1837)
Study of a Grove of Trees, circa 1800
Oil on paperboard, 12½ x 9½ (31.7 x 24.1)
Bequest of John N. and Dorothy C.
Estabrook, 1988.9

* **Louis Dupré**
French, 1789–1837
*Portrait of M. Fauvel, the French Consul,
with View of the Acropolis*, 1819
Oil on canvas, 20½ x 25¼ (52.1 x 64.1)
Gift of Mr. and Mrs. Frank H. Woods,
1980.33

* **Julius Veit Hans Schnorr von Carolsfeld**
German, 1794–1872
The Sleep of Emperor Frederick Barbarossa,
circa 1835–1837
Oil on wood panel, 18¾ x 14 (47.6 x 35.6)
Purchase, The Cochrane-Woods
Collection, 1980.3

George Cruikshank
English, 1792–1878
Farm House Interior with Mother and Child,
circa 1860
Oil on paperboard, 9⅜ x 11⅜ (23.8 x 28.9)
Bequest of John N. and Dorothy C.
Estabrook, 1988.10

Charles-François Daubigny
French, 1817–1878
River Landscape, n.d.
Oil on wood panel, 7¾ x 22½ (19.7 x 57.2)
The Harold H. Swift Bequest, 1962; 1967.47

Paul Guigou
French, 1834–1871
A Bend in the Dry Durance
(*Un Bras sur la Durance à sec*), 1869
Oil on wood panel, 9 x 18¼ (22.9 x 46.3)
Gift of Mr. and Mrs. Frank H. Woods,
1980.31

Eugène Médard
French, 1847–1887
A Patrol, St. Cloud, September 1870,
after 1870
Oil on canvas, 13³⁄₁₆ x 9¾ (34 x 24.8)
Purchase, The Cochrane-Woods
Collection, 1977.9

Henri-Léopold Lévy
French, 1840–1904
Head of John the Baptist Presented to Salome
(Study for *Herodias*), circa 1872
Oil on wood panel, 9¾ x 8¼ (24.8 x 21)
Purchase, The Cochrane-Woods
Collection, 1980.6

Félix-Adolphe Cals
French, 1810–1880
Self-Portrait, 1875
Oil on canvas, 14½ x 12½ (36.8 x 31.8)
Purchase, The Cochrane-Woods
Collection, 1978.14

Charles-Emile-Auguste Carolus-Duran
French, 1837–1917
The Triumph of Marie de Medici, 1876
Oil on paperboard, 20¼ x 21 (51.4 x 53.3)
Sketch for a ceiling fresco in the Louvre,
Paris, 1877–1878
Purchase, The Cochrane-Woods
Collection, 1980.5

Attributed to **Gustave Caillebotte**
French, 1848–1894
An Estuary of the Seine, 1883
Oil on canvas, 20¾ x 25 (52.7 x 63.5)
Gift of Mr. and Mrs. Frank H. Woods,
1980.26

* **Emile René Ménard**
French, 1862–1930
Homer, circa 1885
Oil on canvas, 51 x 62 (129.5 x 157.5)
Purchase, Gift of Mr. and Mrs. Eugene
Davidson, 1980.4

* **Jean-Léon Gérôme**
French, 1824–1904
Pygmalion and Galatea, circa 1890
Oil on canvas, 17⅜ x 13¼ (44.1 x 33.6)
Purchase, Gift of Mr. and Mrs. Eugene
Davidson, 1980.73

Jan Styka
Polish, active in France, 1858–1925
*Sappho (Portrait of Eugénie Meurlot-
Chollet)*, n.d.
Oil on paperboard, 37⅜ x 25⅝ (94.9 x 65.1)
Gift of Seymour Stein, 1982.39

Hans Fechner
German, 1860–1931
Portrait of Agnes Samson, 1896
Oil and pastel on canvas board, 49¼ x 40¾
(125.1 x 103.5)
Gift of Mr. W. R. Magnus, 1983.116

* **Jean Metzinger**
French, 1883–1956
Soldier at a Game of Chess
(*Le Soldat à la partie d'échecs*), circa 1915–1916
Oil on canvas, 32 x 24 (81.3 x 61)
Gift of John L. Strauss, Jr. in memory of
his father, John L. Strauss, 1985.21

* **Suzanne Valadon**
French, 1867–1938
Portrait of Lily Walton, 1923
Oil on canvas, 24 x 18 (61 x 45.7)
Bequest of Joseph Halle Schaffner in
memory of his beloved mother,
Sara H. Schaffner, 1973.119

* **Felix Nussbaum**
German, 1904–1944
Portrait of a Young Man (obverse), 1927,
Carnival Group (*Narrengruppe* or
Mummenschanz) (reverse), circa 1939
Oil on canvas, obverse 38½ x 28½
(97.8 x 72.4), reverse 28½ x 38½ (72.4 x 97.8)
Purchase, Gift of Mr. and Mrs. Eugene
Davidson, Mr. and Mrs. Edwin DeCosta,
Mr. and Mrs. Gaylord Donnelly,
and The Eloise W. Martin Purchase Fund,
1982.10

* **Kurt Seligmann**
Swiss, lived in France and U.S.A.,
1900–1962
The Harpist (*Joueuse de harpe*), 1933
Oil on board, 32¼ x 41¼ (81.9 x 104.8)
The Mary and Earle Ludgin Collection,
1981.78

Georges Rouault
French, 1871–1958
Biblical Landscape (*Paysage biblique*), n.d.
Oil on paperboard, 10 x 14 (25.4 x 35.6)
The Joel Starrels, Jr. Memorial Collection,
1974.238

Francis Picabia
French, 1879–1953
Money Is the Reason for Work (*Le Salaire est
la raison du travail*), 1949
Oil on paperboard, 21¼ x 14 (54 x 35.6)
Gift of Stanley G. Harris, Jr., 1972.1

John Bratby
British, born 1928
Kitchen Table, n.d.
Oil on masonite, 48 x 28 (121.9 x 71.1)
The Mary and Earle Ludgin Collection,
1982.69

Dame Barbara Hepworth
British, 1903–1975
Pierced Forms, 1959
Enamel and pencil on masonite, 13½ x 21½
(34.3 x 54.6)
The Joel Starrels, Jr. Memorial Collection,
1974.277

DRAWINGS, WATERCOLORS, AND
PAINTINGS ON PAPER

George Romney
English, 1734–1802
Banquet Scene from MacBeth, circa 1800
Pencil and wash on laid paper, 13¼ x 19¾
(33.7 x 50.2)
Purchase, Gift of Mr. and Mrs. Eugene
Davidson, 1976.71

Jacob Linkh
German, 1786–1841
Italian Landscape, circa 1808–1810
Pen and ink with wash and preliminary
graphite underdrawing on laid paper,
11¼ x 17 (28.6 x 43.2)
Gift of Mrs. Richard L. Selle, 1979.3

* **Pierre-Henri de Valenciennes**
French, 1750–1819
Cloud Study, circa 1817
Oil on paper mounted on paperboard,
9¼ x 14⅛ (23.5 x 35.9)
Purchase, The Cochrane-Woods
Collection, 1982.19

Charles-François Eustache
French, 1820–1870
Landscape, n.d.
Chalk on gray laid paper, 9⅝ x 16
(24.5 x 40.6)
Gift of Julius Lewis, 1986.170

Camille Pissarro
French, 1831–1903
Six Figures (recto), *Man with a Pole* (verso),
circa 1875
Pen and ink (recto), pencil, pen and ink
(verso) on wove paper, recto 4¹⁄₁₆ x 7¹¹⁄₁₆
(11.6 x 19.5), verso 7 ¹¹⁄₁₆ x 4¹⁄₁₆
(19.5 x 11.6)
The Joel Starrels, Jr. Memorial Collection,
1974.232

Camille Pissarro
The Vineyard (*La Vigne*), 1878–1879
Charcoal on wove paper, 9¼ x 7⅛
(23.5 x 18.1)
The Joel Starrels, Jr. Memorial Collection,
1974.284

Camille Pissarro
St. Martin (*La St. Martin*), circa 1880–1883
Pencil, pen and ink, wash on wove paper,
7¾ x 6⅛ (19.7 x 15.6)
The Joel Starrels, Jr. Memorial Collection,
1974.283

Camille Pissarro
Two Peasants (recto), *Untitled* (verso),
circa 1882–1884
Pencil, charcoal, wash (recto), charcoal
(verso) on wove paper, 7⁵/₁₆ x 5⁷/₈ (18.5 x 14.9)
The Joel Starrels, Jr. Memorial Collection,
1974.285

Pierre Auguste Renoir
French, 1841–1919
Study of Heads, probably after 1883
Charcoal on laid paper, 9⁷/₁₆ x 6¹/₈ (24 x 15.6)
The Joel Starrels, Jr. Memorial Collection,
1974.281

Karel Vítěslav Mašek
Czechoslovakian, 1865–1927
Male Nude (Academy), 1885
Charcoal on laid paper, 24 x 16⁷/₁₆ (61 x 41.7)
Gift of Mr. Richard Armstrong, 1980.57

Auguste Rodin
French, 1840–1917
Nude, circa 1896
Pencil on wove paper, 12¹/₄ x 7¹¹/₁₆
(31.1 x 19.5)
The Joel Starrels, Jr. Memorial Collection,
1974.274

Gustav-Adolph Mossa
French, 1883–1971
Pierrot, n.d.
Ink on waxed paper, 16¹/₂ x 11 (41.9 x 27.9)
Gift of Mr. Seymour Stein, 1982.38

*** Erich Heckel**
German, 1883–1970
East Baltic Seacoast (Ostseeküste), 1911
Pencil, watercolor on wove paper,
10⁹/₁₆ x 13¹/₄ (26.8 x 33.6)
Bequest of Joseph Halle Schaffner in
memory of his beloved mother,
Sara H. Schaffner, 1973.93

*** Helen Saunders**
British, 1885–1963
Island of Laputa, 1915
Pen and ink, collage on wove paper,
10⁵/₈ x 9¹/₈ (26.9 x 23.1)
The Joel Starrels, Jr. Memorial Collection,
1974.275

Christian Rohlfs
German, 1849–1938
The Spirit of God Above the Waters
(Der Geist Gottes über den Wassern),
1915–1916
Tempera on wove paper, 22⁵/₁₆ x 18⁹/₁₆
(56.7 x 47.2)
Marcia and Granvil Specks Collection,
1984.78

Joan Miró
Spanish, lived in France, 1893–1983
Study of a Nude, 1916
Pencil on wove paper, 8¹/₄ x 6 (21 x 15.2)

Bequest of Joseph Halle Schaffner in
memory of his beloved mother,
Sara H. Schaffner, 1973.103

Joan Miró
Study of a Standing Woman, circa 1917
Pencil on wove paper, 8³/₁₆ x 5¹⁵/₁₆ (20.9 x 15.1)
Bequest of Joseph Halle Schaffner in
memory of his beloved mother,
Sara H. Schaffner, 1973.102

*** George Grosz**
German, lived in U.S.A., 1893–1959
Amalie, 1922
Gouache, ink, graphite on wove paper,
20³/₄ x 16¹/₄ (52.7 x 41.2)
The Joel Starrels, Jr. Memorial Collection,
1974.140

George Grosz
Massage, 1930
Pencil on wove paper, 18³/₁₆ x 23¹¹/₁₆
(46.2 x 60.1)
Bequest of Joseph Halle Schaffner in
memory of his beloved mother,
Sara H. Schaffner, 1973.113

Paul Signac
French, 1863–1935
Bridge to the Isle Saint Louis, Paris, 1923
Watercolor, pencil on laid paper,
10³/₈ x 16¹/₄ (26.3 x 41.3)
The Martin A. Ryerson Bequest, 1967.22

*** Emil Nolde**
German, 1887–1956
Two Girls, circa 1929
Watercolor on wove paper, 16³/₈ x 13³/₄
(41.6 x 34.9)
The Mary and Earle Ludgin Collection,
1982.71

Henry Moore
British, 1898–1986
Two Reclining Figures, 1928
Crayon, wash on wove paper, 8³/₄ x 9³/₁₆
(22.3 x 23.3)
H.M.F. [Henry Moore Foundation] 686
The Joel Starrels, Jr. Memorial Collection,
1974.247

Henry Moore
Studies for Sculpture: Big Powerful Forms,
1929
Pen, brush and ink on wove paper,
16⁷/₈ x 13⁹/₁₆ (42.9 x 34.5)
H.M.F. 740
The Joel Starrels, Jr. Memorial Collection,
1974.254

Henry Moore
Two Standing and One Seated Figure, 1931
Pencil, crayon, pen and brush and ink on
thin wove paper, 9¹⁵/₁₆ x 7⁷/₈ (25.3 x 20.1)
H.M.F. 854
The Joel Starrels, Jr. Memorial Collection,
1974.246

Henry Moore
Ideas for Sculpture: Seven Seated Figures, 1931
Pencil, pen and brush and ink on wove
paper, 14⁷/₁₆ x 10¹¹/₁₆ (36.7 x 27.2)
H.M.F. 865
The Joel Starrels, Jr. Memorial Collection,
1974.276

Henry Moore
Ideas for Sculpture
(Transformation Drawing), 1932
Pencil on wove paper, 14⁷/₁₆ x 10¹¹/₁₆
(36.7 x 27.2)
H.M.F. 978
The Joel Starrels, Jr. Memorial Collection,
1974.243

Henry Moore
Mother and Child Studies, 1933
Pencil, charcoal, pen and ink, watercolor
on wove paper, 22 x 15 (56 x 38.1)
H.M.F. 1006
The Joel Starrels, Jr. Memorial Collection,
1974.292

Henry Moore
Ideas for Sculpture, 1936
Pencil, crayon, pen and brush and ink on
wove paper, 14⁷/₁₆ x 21⁷/₈ (36.7 x 55.6)
H.M.F. 1262
The Joel Starrels, Jr. Memorial Collection,
1974.267

Henry Moore
Heads, 1939
Crayon, pen and ink, pastel wash on wove
paper, 17 x 10¹/₁₆ (43.2 x 25.6)
H.M.F. 1436
The Joel Starrels, Jr. Memorial Collection,
1974.251

Henry Moore
Two Figures, 1939
Pencil, charcoal, pen and ink, pastel wash
on wove paper, 22 x 14¹⁵/₁₆ (55.9 x 38)
H.M.F. 1442
The Joel Starrels, Jr. Memorial Collection,
1974.255

Henry Moore
Reclining Figures: Ideas for Sculpture, 1939
(misdated later by the artist 1942)
Pencil, pen and ink on wove paper,
10¹¹/₁₆ x 7¹/₈ (27.1 x 18)
H.M.F. 1469
The Joel Starrels, Jr. Memorial Collection,
1974.261

Henry Moore
Shelter Drawing, 1941
Pencil, crayon, charcoal, wash on wove
paper, 14¹³/₁₆ x 10⁷/₈ (37.1 x 27.5)
H.M.F. 1776
The Joel Starrels, Jr. Memorial Collection,
1974.249

Henry Moore
Two Studies for Family Groups, 1944
Pencil, crayon, wash on laid paper,
7¹/₁₆ x 8¹⁵/₁₆ (18 x 22.7)
H.M.F. 2211
The Joel Starrels, Jr. Memorial Collection,
1974.241

Henry Moore
Four Studies: Family Groups, 1944
Pencil, crayon, wash, gouache on
laid paper, 7⅛ x 8¹⁵/₁₆ (17.9 x 22.7)
H.M.F. 2212
The Joel Starrels, Jr. Memorial Collection,
1974.242

Henry Moore
Mother and Child with Figure in a Room,
1948
Pencil, crayon, wash on wove paper,
19½ x 22⁹/₁₆ (49.5 x 57.3)
H.M.F. 2483
The Joel Starrels, Jr. Memorial Collection,
1974.256

Henry Moore
*Studies for Family Groups and Two Seated
Figures*, 1949
Pencil, pen and ink, crayon, wash on wove
paper, 11⅜ x 9⁵/₁₆ (29 x 23.7)
H.M.F. 2471A
The Joel Starrels, Jr. Memorial Collection,
1974.268

Henry Moore
*Ideas for Sculpture: Four Studies of Reclining
Figures, One Half Figure*, 1949
Pencil, pen and ink, crayon, wash on wove
paper, 15⁷/₁₆ x 10¾ (39.2 x 27.2)
H.M.F. 2542
The Joel Starrels, Jr. Memorial Collection,
1974.248

Henry Moore
*Ideas for Sculpture: Internal/External
Forms*, 1950
Pencil, crayon, wash, pastel wash on wove
paper, 11⁷/₁₆ x 9⁷/₁₆ (29 x 23.9)
H.M.F. 2604
The Joel Starrels, Jr. Memorial Collection,
1974.245

Henry Moore
Two Figures in a Landscape, 1950
Pencil, pen and ink, crayon, wash on wove
paper, 9⅝ x 9 (24.4 x 22.8)
H.M.F. 2647
The Joel Starrels, Jr. Memorial Collection,
1974.252

Henry Moore
Seated Figure, 1951
Pencil, crayon, gouache, wash on wove
paper, 11⅜ x 9¼ (28.9 x 23.5)
H.M.F. 2672
The Joel Starrels, Jr. Memorial Collection,
1974.244

Henry Moore
Studies for Two Reclining Figures, 1956
Pencil, pen and ink on wove paper,
10⅜ x 8¾ (26.4 x 22.3)
H.M.F. 2909
The Joel Starrels, Jr. Memorial Collection,
1974.253

Julio Gonzalez
Spanish, lived in France, 1876–1942
Cactus Man (Homme cactus), 1939
Pencil, india ink, crayon, watercolor, wash
on wove paper, 8⅜ x 3⅜ (21.3 x 8.6)
Merkert 236.D8
The Joel Starrels, Jr. Memorial Collection,
1974.231

Julio Gonzalez
Musician with Accordian, 1941
Pencil, ink, crayon on laid paper,
9⁷/₁₆ x 6³/₁₆ (23.9 x 15.8)
The Joel Starrels, Jr. Memorial Collection,
1974.286

Julio Gonzalez
Musician, 1941
Pencil, ink, crayon on wove paper,
7⁹/₁₆ x 6¹/₁₆ (9.2 x 5.5)
The Joel Starrels, Jr. Memorial Collection,
1974.282

Julio Gonzalez
Warrior I, 1941
Pen and ink, wash on wove paper,
14⅝ x 10⁷/₁₆ (37 x 26.5)
The Joel Starrels, Jr. Memorial Collection,
1974.269

*Julio Gonzalez**
*Head of the Montserrat
(Tête de la Montserrat criante)*, 1941
Pencil on wove paper, 10¼ x 8¼ (26 x 21)
Merkert 249.D27
The Joel Starrels, Jr. Memorial Collection,
1974.264

Alberto Giacometti
Swiss, 1901–1966
Head of a Woman (The Artist's Mother),
circa 1945
Pencil on laid paper, 10⁵/₁₆ x 8¹¹/₁₆
(27.1 x 22.1)
The Joel Starrels, Jr. Memorial Collection,
1974.262

*Alberto Giacometti**
Portrait of Annette Arm (?), 1947
Pencil on wove paper, 16⅛ x 14⅜ (40.9 x 36.3)
The Joel Starrels, Jr. Memorial Collection,
1974.303

Alberto Giacometti
Caroline, circa 1958–1965
Blue ballpoint pen on gridded spiral
notebook paper, 5¾ x 4⁵/₃₂ (13.7 x 10.5)
The Joel Starrels, Jr. Memorial Collection,
1974.234

Alberto Giacometti
Figure Studies (Troyes), circa 1958–1965
Blue ballpoint pen on wove paper,
6½ x 6⁹/₁₆ (16.5 x 16.7)
The Joel Starrels, Jr. Memorial Collection,
1974.236

Alberto Giacometti
Figures, 1961
Blue ballpoint pen on wove paper,
6¹⁵/₁₆ x 4²¹/₃₂ (16 x 11.8)
The Joel Starrels, Jr. Memorial Collection,
1974.233

Alberto Giacometti
Head of a Woman, n.d.
Blue ballpoint pen on glossy paper,
8¼ x 6³/₁₆ (21 x 15.7)
The Joel Starrels, Jr. Memorial Collection,
1974.235

Jacques Lipchitz
Lithuanian, lived in France and U.S.A.,
1891–1973
Study for Sacrifice, n.d.
Ink, wash with pencil on wove paper,
17 x 10⅞ (43.2 x 27.6)
The Joel Starrels, Jr. Memorial Collection,
1974.259

Jacques Lipchitz
Study of Sculpture: Inspiration, circa 1955
Watercolor (blue), ink, wash with pencil
on wove paper, sight 16⁷/₁₆ x 11³/₁₆
(41.8 x 28.4)
The Joel Starrels, Jr. Memorial Collection,
1974.258

Jacques Lipchitz
Study of Sculpture: Inspiration, circa 1955
Watercolor (brown), ink, wash with pencil
on wove paper, sight 16⁷/₁₆ x 11³/₁₆
(41.8 x 28.4)
The Joel Starrels, Jr. Memorial Collection,
1974.250

Ludwig Mies van der Rohe
German, lived in U.S.A., 1886–1969
Problems of a Chair Design, circa 1950
Pencil on wove paper, 14 x 8⅜ (35.5 x 21.3)
Gift of Dr. Hans Swarzenski, 1976.8

Sonia Delaunay-Terk
Russian, lived in France, 1885–1979
Composition, 1950–1953
Gouache on wove paper, 21⅛ x 14¾
(53.7 x 37.5)
The Joel Starrels, Jr. Memorial Collection,
1974.257

Pavel Tchelitchew
Russian, lived in France and U.S.A.,
1898–1957
Spiral Head, 1952
Pastel on blue wove paper, sight 19⅛ x 12⅜
(31.5 x 48.6)
Gift of Rue Winterbotham Shaw, 1979.16

Karel Appel
Dutch, born 1921
Splintered Landscape (Paysage éclaté), 1959
Crayon on wove paper, 13 x 16⅛ (33 x 41)
Anonymous Gift, 1979.44

PRINTS AND PHOTOGRAPHS

English, Various Artists, working for the
publishers John and Joshua Boydell, London
*A Collection of Prints, from Pictures Painted
for the Purpose of Illustrating the Dramatic
Works of Shakespeare by Artists of Great
Britain*, 1803 (publication date)
Engravings, two volumes comprised of 111
pages with ninety-nine plates, each sheet
22⅛ x 32 ⅞ (56 x 83.5)
Anonymous Gift, 1976.66–1976.68

David Octavius Hill
Scottish, 1802–1870
Robert Adamson
Scottish, 1821–1848
Scottish Monk, 1845
Salted pepper print from calotype negative,
vintage impression, image 7¾ x 5¾ (19.7 x 14.6)
Gift of David C. Ruttenberg, 1978.123

Louis-Desiré Blanquart-Evrard
French, 1802–1872
*St. Ursula and Her Companions by Memling
(Ste. Ursule et ses Compagnes peintes par
Memling sur la Châsse conservée à l'hôpital
St. Jean à Bruges)*, from his first publication
*Album photographique de l'Artiste et de
l'Amateur*, 1851
Positive print from a paper negative with
original mount, vintage impression,
image 8 x 5⅜ (20.3 x 13.6)
Gift of Mr. and Mrs. Kingman Douglass,
1988.72

Edouard-Denis Baldus
French, 1813–1882
*Roman Temple, Nîmes
(La Maison Carrée, Nîmes)*, circa 1860s
Albumen print on original mount, vintage
impression, image 8 x 11 (20.3 x 27.9)
Gift of Mr. and Mrs. Kingman Douglass,
1988.70

Bisson Frères
Auguste-Rosalie Bisson
French, 1826–1900
Louis-Auguste Bisson
French, 1814–1876
St. Germain, circa 1860s
Albumen print, vintage impression,
image 14¼ x 17 (36.2 x 43.2)
Gift of Mr. and Mrs. Kingman Douglass,
1987.25

Adolphe Braun
French, 1811–1877
Untitled (Wreath of Flowers), circa 1860s
Albumen print with original mount,
vintage impression, image 14¾ x 17⅝
(37.5 x 44.8)
Gift of Mr. and Mrs. Kingman Douglass,
1987.27

Max Klinger
German, 1857–1920
A Love (Opus Ten) (Eine Liebe [Opus X]),
1887 (1st edition), 4th edition 1903
Portfolio of ten etchings, engravings, and
etchings with aquatint, with original cover,
each sheet 23¾ x 17⅞ (60.3 x 45.4)
Singer 157–170
Purchase, Unrestricted Funds, 1983.49a-j

Oskar Kokoschka
Austrian, 1886–1980
*Columbus Chained (Der Gefesselte
Kolumbus)*, 1916
Suite of twelve lithographs, first edition,
composition dimensions vary
Wingler-Welz 44–54
Marcia and Granvil Specks Collection,
1986.277–1986.288

Lovis Corinth
German, 1858–1925
Ancient Legends (Antike Legenden), 1919
Portfolio of thirteen etchings, 36/50,
plate dimensions vary
Schwarz 351 I-XIII
Marcia and Grandville Specks Collection,
1985.55–1985.67

Lovis Corinth
With the Corinths (Bei den Corinthern), 1919
Portfolio of fourteen etchings, 57/90,
plate dimensions vary
Schwarz 380 I-XIV
Marcia and Granvil Specks Collection,
1985.41–1985.54

Lovis Corinth
Martin Luther, 1920
Set of forty-six lithographs of proofs and
trial proofs of various states in the original
mats, with progressive annotations by the
artist, for the 1920 suite of forty
lithographs, *Martin Luther*, composition
dimensions vary, each sheet 19 x 13 (48.3 x 33)
Schwarz 44 II-IV, VI A, VII-VIII, VIII A, IX-XI,
XII 1 and 2, XIII-XXI, XXI A, XXII-XXIII A,
XXIV-XL A and B
Marcia and Granvil Specks Collection,
1986.194–1986.239

Lovis Corinth
William Tell (Wilhelm Tell), 1923
Series of thirteen color lithographs (title
page and twelve compositions) forming the
1923 suite of illustrations for Friedrich
Schiller's *Wilhelm Tell*, from the edition of

seventy-five on handmade J. W. Zanders
paper, each composition 9 x 7½ (22.9 x 19.1)
Marcia and Granvil Specks Collection,
1986.240–1986.252

Max Beckmann
German, 1884–1950
Fair (Jahrmarkt), 1922
Portfolio of ten drypoints in original
sequentially numbered mats, plus title
page and bound introductory pages with
original portfolio cover, each plate
11½ x 10 (29.2 x 25.4)
Gallwitz 163–172
Marcia and Granvil Specks Collection,
1983.129–1983.138

* **Otto Dix**
German, 1891–1969
The War (Der Krieg), 1924
Fifty prints combining etching, aquatint,
and drypoint; all works from five
portfolios comprising the series numbered
10/70 on B.S.B. cream laid paper; media,
plate dimensions, and sheet sizes vary
Karsch 70–119
Marcia and Granvil Specks Collection,
1984.46–1984.71 and 1986.253–1986.276

André Lhote
French, 1885–1962
Broad Sweep (Grande Largue), 1925
Deluxe edition of the portfolio, consisting
of six woodcuts together with the six origi-
nal drawings in the original jacket, number
one from the 1925 edition of twenty-five
(1/21–21/21 plus A, B, C, D) on Dutch van
Gelder paper, dimensions of blocks and
sheets vary
Marcia and Granvil Specks Collection,
1986.289–1986.300

Ernst Barlach
German, 1870–1938
Schiller, Ode to Joy (Schiller, An die Freude),
1927
Series of nine woodcuts, each block
10 x 14³⁄₁₆ (25.4 x 36.1)
Schult 271–279
Gift of Perry Goldberg, 1983.123–1983.124
and 1983.161–1983.167

* **Pablo Ruiz y Picasso**
Spanish, lived in France, 1881–1973
The Diver (La Plongeuse), 1932 (plate),
this impression 1933 or 1934
Soft-ground etching with colored paper
collage, plate 5½ x 4⅜ (14 x 10.9)
Geiser 277
The Joel Starrels, Jr. Memorial Collection,
1974.280

* **Marcel Duchamp**
French, lived in U.S.A., 1887–1968
Box in a Valise (Boîte-en-valise), 1935–1941
(1963 edition)
Mixed media, edition of thirty,
box (closed) 14¹³⁄₁₆ x 15¹⁵⁄₁₆ x 3⁹⁄₁₆
(37.7 x 40.5 x 8.9)
Bonk series F, Lebel 173, Schwarz 311
Gift of Mrs. Robert B. Mayer, 1983.30

Joan Miró
Spanish, lived in France, 1893–1983
Series V, 1953 (plate), this impression before
1963
Etching, hand-colored in watercolor,
37/60, plate 5³⁄₈ x 4⁷⁄₈ (13.6 x 12.4)
Wember 135 (original edition of 26;
an undescibed edition of sixty published
after 1953 and before 1963)
Gift of Henry Cohen, 1986.13

Henri Cartier-Bresson
French, born 1908
*Untitled (Woman Seated on Bench in
Moscow Subway Station)*, circa 1954
Silver gelatin print, image 6⁵⁄₈ x 9⁷⁄₈
(16.8 x 25.1)
Gift of Mr. and Mrs. Kingman Douglass,
1987.33

SCULPTURE

Luigi Pichler
Italian, active in Vienna, 1773–1854
Farnese Bull, n.d.
Cut (intaglio) amber glass oval medallion,
h. 1⁵⁄₈ (4.1)
Gift of Mrs. Ruth Blumka in memory of
Professor Edward A. Maser, Founding
Director of the Smart Gallery, 1973–1983;
1989.5

Friederich-Anton König
German, 1794–1844
*Prince Gebhard Leberecht von Blucher
(1742–1819)* (obverse), *Allegory of Victory*
(reverse), 1816
Cast iron medallion, diam. 3¹⁄₈ (7.9)
Purchase, The Cochrane-Woods
Collection, 1977.113

Richard James Wyatt
English, 1795–1850
Narcissus, n.d.
Marble, h. 27 (68.6)
Purchase, The Eloise W. Martin Purchase
Fund, 1982.7

Bartolomeo Pinelli
Italian, 1781–1835
A Trastevere Family, 1832
Unglazed modeled terracotta, h. 12⁷⁄₁₆ (31.6)
Purchase, Gift of Dr. Burton J. Grossman,
M.D. '49, in memory of Rosinna
Sonnenschein, 1979.22

* **Jean-Auguste Barre**
French, 1811–1896
*Louis-Philippe I and Marie-Amelie, King and
Queen of the French* (obverse), *The Royal
Family* [Portraits of Eugénie Adelaide
Louise; Ferdinand and Louise; Louis,
Clémentine, and Antoine; Henri, Marie,
and François d'Orléans] (reverse), circa 1832
Cast bronze medallion, diam. 2¹⁵⁄₁₆ (7.5)
Purchase, Gift of Mr. and Mrs. Richard
Elden, Mr. and Mrs. Robert Feitler, and
Mr. and Mrs. John Smart in honor of
Mrs. Florence Richards, 1983.5

* **Princess Marie-Christine d'Orléans**
French, 1813–1839
Joan of Arc, after 1835
Cast silvered bronze, h. 11⁵⁄₈ (29.5)
Purchase, Gift of the Friends of the Smart
Gallery, 1983; 1983.4

* **Jean-Baptiste Clésinger**
French, 1814–1883
Seated Faun, after 1862
Cast bronze, h. 16 (40.6)
Gift of Mr. and Mrs. Edward A. Maser, 1982.11

* **Jean-Baptiste Clésinger**
Seated Faun, after 1862
Cast bronze, h. 12³⁄₄ (32.4)
Gift of Ann Englander, 1985.80

Vincenzo Vela
Italian, 1820–1891
The Last Days of Napoleon, after 1867
Cast bronze, h. 16¹⁄₂ (41.9)
The Erskine M. Phelps Collection on
Napoleana, 1976.74

Henri-Michel-Antoine Chapu
French, 1833–1891
Joan of Arc at Domrémy, after 1870–1872
Cast bronze, h. 17¹⁄₂ (44.5)
Purchase, Gift of the Friends of the Smart
Gallery, 1986; 1986.12

Henri-Michel-Antoine Chapu
Joan of Arc at Domrémy, after 1870–1872
Cast plaster, h. 17³⁄₄ (45.1)
University transfer, 1967.31

Auguste Rodin
French, 1840–1917
Titan I, from the *Titan Vase*
(*Vase des Titans*), 1879–1880 (model)
Cast bronze, h. 14 (35.6)
The Joel Starrels, Jr. Memorial Collection,
1974.175

* **Auguste Rodin**
The Thinker (*Le Penseur*, originally titled
The Thinker: The Poet, Fragment of a Door),
circa 1880 (model)
Cast bronze, h. 28 (71.1)
The Harold H. Swift Bequest, 1962; 1967.30

Auguste Rodin
Small Standing Torso, 1882 (model),
Musée Rodin cast 1958
Cast bronze, h. 8³⁄₄ (22.2)
The Joel Starrels, Jr. Memorial Collection,
1974.213

Auguste Rodin
Clenched Hand (Study for *The Mighty
Hand*?), circa 1884–1885 (model), Musée
Rodin cast 1959
Cast bronze, 7/12, h. 5³⁄₈ (13.6)
The Joel Starrels, Jr. Memorial Collection,
1974.218

Auguste Rodin
Reclining Figure (Study for *Danaid*?),
circa 1885 (model), Musée Rodin cast,
possibly 1956
Cast bronze, l. 5¹⁄₂ (14)
The Joel Starrels, Jr. Memorial Collection,
1974.217

Auguste Rodin
Head of Pierre de Wiessant (Type A),
circa 1885–1886 (model), this cast before
circa 1910–1911
Cast plaster, h. with self base 19 (48.3),
h. without base 13¹⁄₄ (33.7)
Bequest of Joseph Halle Schaffner in
memory of his beloved mother,
Sara H. Schaffner, 1973.108

Auguste Rodin
Despair, early 1880s or circa 1890 (model),
Musée Rodin cast 1956
Cast bronze, h. 6³⁄₄ (7.1)
The Joel Starrels, Jr. Memorial Collection,
1974.206

Attributed to **Auguste Rodin**
Nude Female Figure, mid 1880s or late 1890s
(model)
Cast bronze, l. 13 (33)
The Joel Starrels, Jr. Memorial Collection,
1974.194

Auguste Rodin
The Juggler, 1892–1895 or 1909
(model), Musée Rodin cast 1956
Cast bronze, 1/12, h. 11¹⁄₄ (28.6)
The Joel Starrels, Jr. Memorial Collection,
1974.156

Auguste Rodin
The Cathedral, 1908 (model)
Cast bronze, h. 25 (63.5)
The Joel Starrels, Jr. Memorial Collection,
1974.165

Aimé-Jules Dalou
French, 1838–1902
Antoine-Laurent Lavoisier (1743–1794), circa 1886–1888 (model), this cast after 1892
Cast bronze with partial gilding, h. 20¼ (51.4)
Purchase, Gift of the Friends of the Smart Gallery, 1977; 1977.102

Victor Oskar Tilgner
Austrian, 1844–1896
Bust of the Playwright Julius Bauer, 1890
Marble, h. 27⅜ (69.5)
Purchase, Gift of Gaylord Donnelley, 1982.37

Louis-Ernest Barrias
French, 1841–1905
Joan of Arc as a Prisoner, after 1892
Cast bronze, h. 13¾ (34.9)
Gift of Mrs. William Drews, 1977.99

*** Louis-Ernest Barrias**
Nature Unveiling Herself to Science, after 1899
Cast bronze with partial *doré* patination, h. 28½ (72.4)
Gift of John N. Stern, 1984.6

*** Louis-Ernest Barrias**
Nature Unveiling Herself to Science, after 1899
Cast bronze with partial *doré* patination, h. 16¾ (42.5)
Gift of Mr. and Mrs. John N. Stern, 1987.15

*** Hilaire Edgar Germain Degas**
French, 1834–1917
Woman Stretching (Femme s'étirant), 1896–1917 (wax model), edition cast 1919–1921
Cast bronze, 53/D, h. 14⅜ (36.5)
Rewald LXIV
The Joel Starrels, Jr. Memorial Collection, 1974.147

Maurice Bouval
French, circa 1870–1920
Ruth, circa 1900
Cast gilt bronze, h. 17¾ (45.1)
Gift of John N. Stern, 1982.50

Artist Unknown, French
Dear Alice, circa 1900
Unglazed cast (?) terracotta with cold-paint decoration, h. 20 (50.8)
Gift of John N. Stern, 1984.7

Aristide Maillol
French, 1861–1944
Seated Nude (Study for *Mediterranean*), circa 1902
Cast bronze, 5/6, h. 7 (17.8)
Bequest of Joseph Halle Schaffner in memory of his beloved mother, Sara H. Schaffner, 1973.99

Aristide Maillol
Woman with a Crab, 1905
Cast bronze, h. 6½ (16.5)
The Joel Starrels, Jr. Memorial Collection, 1974.211

Paul (Pavel) Troubetzkoy
Russian, lived in Italy, 1866–1938
Auguste Rodin, circa 1906–1914
Cast bronze, h. 20 (50.8)
The Joel Starrels, Jr. Memorial Collection, 1974.144

Jacques Lipchitz
Lithuanian, lived in France and U.S.A., 1891–1973
Head, 1914
Cast bronze, 2/7, h. 8¾ (22.2)
The Joel Starrels, Jr. Memorial Collection, 1974.219

*** Jacques Lipchitz**
Seated Bather, 1916–1917
Limestone, h. 33 (83.8)
The Joel Starrels, Jr. Memorial Collection, 1974.177

Jacques Lipchitz
Pierrot with Clarinet, 1919
Cast bronze, 6/7, h. 29½ (74.9)
The Joel Starrels, Jr. Memorial Collection, 1974.300

Jacques Lipchitz
Seated Man (Meditation), 1925
Cast bronze, h. 13¾ (34.9)
The Joel Starrels, Jr. Memorial Collection, 1974.185

Jacques Lipchitz
Reclining Figure, 1928
Cast bronze, 2/7, h. 5½ (14), l. 6¾ (17.1)
The Joel Starrels, Jr. Memorial Collection, 1974.170

Jacques Lipchitz
The Rape of Europa, 1938
Cast bronze, 5/7, h. 15¼ (38.7), l. 20⅝ (52.4)
The Joel Starrels, Jr. Memorial Collection, 1973.37

Jacques Lipchitz
Study for the Rachels, n.d.
Cast bronze, 1/7, h. 5 (12.7), l. 8½ (21.6)
The Joel Starrels, Jr. Memorial Collection, 1974.171

Jacques Lipchitz
Study for Hagar, n.d.
Cast stone, 4/10, h. 10 (25.4), l. 10 (25.4)
The Joel Starrels, Jr. Memorial Collection, 1974.160

Jacques Lipchitz
Hagar, 1948
Cast bronze, 2/7, h. 6¼ (15.9), l. 8¾ (22.2)
The Joel Starrels, Jr. Memorial Collection, 1974.169

Jacques Lipchitz
Study for the Virgin, 1948
Cast bronze, h. 35½ (90.2)
The Joel Starrels, Jr. Memorial Collection, 1974.227

Jacques Lipchitz
The Sacrifice, 1948–1958
Cast bronze, 2/7, h. 18½ (47)
The Joel Starrels, Jr. Memorial Collection, 1974.172

Henri Laurens
French, 1885–1954
Woman with a Mandolin, 1919 or 1922
Unglazed cast terracotta, h. 13½ (34.4)
The Joel Starrels, Jr. Memorial Collection, 1974.151

*** Henri Matisse**
French, 1869–1954
Nude on a Sofa (Nu sur un canapé), 1924
Cast bronze, 1/10, h. 9½ (24.1)
The Joel Starrels, Jr. Memorial Collection, 1974.137

Sir Jacob Epstein
British, born in U.S.A., 1880–1959
Kathleen, The Artist's Wife, 4th Portrait, 1933
Cast bronze, edition of 10, h. 14 (35.6)
Bequest of Joseph Halle Schaffner in memory of his beloved mother, Sara H. Schaffner, 1973.132

Sir Jacob Epstein
The Princess de Braganza, 1944
Cast bronze, h. 24 (61)
Bequest of Joseph Halle Schaffner in memory of his beloved mother, Sara H. Schaffner, 1973.131

Leon Underwood
British, 1890–1975
Torso: June of Youth, 1934 (model), this cast 1958?
Cast bronze, h. 24⅛ (61.3)
The Joel Starrels, Jr. Memorial Collection, 1974.145

Henry Moore
British, 1898–1986
Four-Piece Composition, 1934 (reinforced concrete original), bronze edition 1962
Cast bronze, 9/9, l. 16¾ (42.5)
Lund Humphries 140
The Joel Starrels, Jr. Memorial Collection, 1974.163

Henry Moore
Head and Shoulders, 1935 (model), bronze edition 1960s?
Cast bronze, 5/6, h. 5 (12.7)
Not in Lund Humphries
The Joel Starrels, Jr. Memorial Collection, 1974.202

*Henry Moore
Sketch Model for Reclining Figure, 1945
Unglazed modeled earthenware,
h. 3¾ (9.5), l. 6½ (16.5)
Lund Humphries 245
The Joel Starrels, Jr. Memorial Collection,
1974.138

Henry Moore
Helmet Head No. 1, 1950 (lead original),
bronze edition 1960
Cast bronze, 8/9, h. 12½ (31.8)
Lund Humphries 279
The Joel Starrels, Jr. Memorial Collection,
1974.190

Henry Moore
*Working Model for Reclining Figure
(Internal and External Forms)*, 1951
Cast bronze, edition of 9, l. 21 (53.4)
Lund Humphries 298
The Mary and Earle Ludgin Collection,
1985.101

Henry Moore
Upright Motive: Maquette No. 4, 1955
Cast bronze, edition of 9, h. 11⅜ (28.9)
Lund Humphries 381
The Joel Starrels, Jr. Memorial Collection,
1974.200

Henry Moore
Upright Motive: Maquette No. 5, 1955
Cast bronze, edition of 9, h. 11 (27.9)
Lund Humphries 382
The Joel Starrels, Jr. Memorial Collection,
1974.201

Henry Moore
Upright Motive: Maquette No. 8, 1955
Cast bronze, edition of 9, h. 11¾ (29.8)
Lund Humphries 387
The Joel Starrels, Jr. Memorial Collection,
1974.199

Henry Moore
Two-Piece Reclining Figure: Maquette No. 3,
1961
Cast bronze, 5/9, l. 7¾ (19.7)
Lund Humphries 475
The Joel Starrels, Jr. Memorial Collection,
1974.205

Henry Moore
Draped Seated Figure: Headless, 1961
Cast bronze, 5/9, h. 7¾ (19.7)
Lund Humphries 485
The Joel Starrels, Jr. Memorial Collection,
1974.204

Henry Moore
Slow Form: Tortoise, 1962
Cast bronze, 2/9, l. 7½ (19.1)
Lund Humphries 502
The Joel Starrels, Jr. Memorial Collection,
1974.203

Henry Moore
Mother and Child: Round Head, 1963
Cast bronze, 1/6, h. 11 (27.9)
Lund Humphries 512
The Joel Starrels, Jr. Memorial Collection,
1974.186

Jean Arp
French, 1887–1966
Concrete Sculpture "Mirr," 1936
Cast bronze, 7⅜ x 5 x 6¾ (18.7 x 12.7 x 17.2)
The Joel Starrels, Jr. Memorial Collection,
1974.226

Jean Arp
De Silence "Corneille," circa 1946
Cast bronze, 8¾ x 13½ x 10¾
(22.2 x 34.3 x 27.3)
The Joel Starrels, Jr. Memorial Collection,
1974.225

Julio Gonzalez
Spanish, lived in France, 1876–1942
Small Sickle (Petite faucile) or *Standing
Woman (Femme debout)*, circa 1937
Cast bronze, 2/6, h. 11 (27.9)
Merkert 222
The Joel Starrels, Jr. Memorial Collection,
1974.139

*Julio Gonzalez
*Head of the Montserrat II
(Tête de la Montserrat criante II)*, 1942
Cast bronze, 6/6, h. 12½ (31.8)
Merkert 249
The Joel Starrels, Jr. Memorial Collection,
1974.223

Kenneth Armitage
British, born 1916
Two Figures Walking, 1952
Cast bronze, h. 11½ (29.2)
The Joel Starrels, Jr. Memorial Collection,
1974.207

Kenneth Armitage
Children by the Sea, circa 1952
Cast bronze, h. 17 (43.2)
The Mary and Earle Ludgin Collection,
1985.100

Kenneth Armitage
Little Box Figure, 1961
Cast bronze, 1/9, h. 11⅞ (30.1)
The Joel Starrels, Jr. Memorial Collection,
1974.208

Reg (Reginald Cotterell) Butler
British, born 1913
Cassandra, 1953
Cast bronze, h. 28½ (72.4)
The Joel Starrels, Jr. Memorial Collection,
1974.158

Reg (Reginald Cotterell) Butler
The Machine, 1953
Cast bronze, h. 13 (33), l. 30 (76.2)
The Joel Starrels, Jr. Memorial Collection,
1974.154

Reg (Reginald Cotterell) Butler
Torso, 1954
Cast bronze, 2/8, h. 12⅞ (32.7)
The Joel Starrels, Jr. Memorial Collection,
1974.215

Reg (Reginald Cotterell) Butler
Bust of a Girl, Head Looking Up, 1955–1956
Cast bronze, 2/8, h. 8 (20.3)
The Joel Starrels, Jr. Memorial Collection,
1974.216

Fritz Wotruba
Austrian, 1907–1975
Head, 1953–1954
Cast bronze, h. 13¾ (34.9)
The Joel Starrels, Jr. Memorial Collection,
1974.180

Germaine Richier
French, 1904–1959
Grain (Le Grain), 1955
Bronze, 4/6, h. 59 (144.9)
The Joel Starrels, Jr. Memorial Collection,
1974.221

Germaine Richier
Horse with Six Heads (Small Version), 1956,
this edition 1959
Bronze, 0/8, 13¾ x 16¹¹⁄₁₆ x 11¹³⁄₁₆
(34.9 x 42.4 x 30)
The Joel Starrels, Jr. Memorial Collection,
1974.162

William Turnbull
British, born 1922
Untitled, circa 1955
Cast bronze, h. 10½ (26.7)
The Joel Starrels, Jr. Memorial Collection,
1974.153

*Giacomo Manzu
Italian, born 1908
Sonja's Head, 1955
Cast bronze, h. 13 (33)
Gift of Allan Frumkin, 1981.94

Robert Adams
British, born 1917
Maquette for an Architectural Screen, 1956
Cast bronze, 9 x 29 x 3¼ (22.9 x 73.7 x 8.3)
The Joel Starrels, Jr. Memorial Collection,
1974.164

Marino Marini
Italian, born 1901
Dancer, 1956
Partially painted cast bronze,
2/6, h. 19 (48.3)
The Joel Starrels, Jr. Memorial Collection,
1974.181

Eduardo Paolozzi
British, born 1924
Untitled (Man in a Car), circa 1957
Cast bronze, h. 7 (17.8), l. 7½ (19)
Gift of Mr. and Mrs. Stanley M. Freehling,
1985.1

Eduardo Paolozzi
Figure, circa 1964–1965 (?)
Cast bronze, h. 11⅜ (28.8)
The Joel Starrels, Jr. Memorial Collection,
1974.187

Hubert Dalwood
British, born 1924
Open Square, 1959
Cast aluminum, 16⅝ x 13 x 4¾ (42.2 x 33 x 12)
The Joel Starrels, Jr. Memorial Collection,
1974.188

Dame Barbara Hepworth
British, 1903–1975
Landscape Figure, 1959
Alabaster, h. 10¾ (27.3), l. 9½ (24.1)
Hodin 255
The Joel Starrels, Jr. Memorial Collection,
1974.143

Dame Barbara Hepworth
Curved Form (Wave II), 1959
Painted cast bronze with steel strings,
6/7, h. 15¾ (40), l. 18 (45.7)
Hodin 264
The Joel Starrels, Jr. Memorial Collection,
1974.195

Dame Barbara Hepworth
Serene Head (Thea), 1959
Cast bronze, edition of 7, h. 13¼ (33.7)
Hodin 269
The Joel Starrels, Jr. Memorial Collection,
1974.142

Magdalena Abakanowicz
Polish, born 1930
Structure Black, 1971–1972
Woven dyed sisal, h. 128 (325.1)
Gift of John Deere and Company, 1981.93

DECORATIVE ARTS

* German, Berlin, Royal Porcelain
Manufactory
Plate, circa 1810–1815
Hard-paste porcelain with overglaze
enamel and gilt decoration,
diam. of rim 9⁷⁄₁₆ (24)
Purchase, Gift of Mrs. Lois Bader
Adelman, 1979.51

English, Shelton, Shorthose &
Company (?)
Tea Caddy, circa 1815–1822
Porcelain with blue transfer-printed
decoration, h. with lid 5½ (14)
Gift of Mrs. Leo Zimmerman, 1984.5

English, Worcester (?),
for Mason & Sons Factory
Rococo Revival Plate, circa 1835
Ironstone with overglaze gilt decoration,
diam. of rim 8½ (21.6)
Gift of Kelvyn G. Lilley, 1974.118

French, Sèvres Factory
Sauce Boat (from Tuilleries Service),
1861–1863
Porcelain with overglaze gilt decoration,
l. 10½ (26.7)
Gift of Kelvyn G. Lilley, 1977.10

English, Old Hall Earthenware
Company Ltd.
Christopher Dresser, designer
Scottish, 1834–1904
Sauce Boat Tray, circa 1886
Earthenware with hand-enameled
transfer-printed ("Persian" design)
and overglaze gilt decoration, l. 8¼ (21)
Gift of Kelvyn G. Lilley, 1983.95

French
The Pen (La Plume), after a design
by Alphonse Mucha, circa 1900
Cast bronze plaque with gilt and
polychromed decoration, 19⅝ x 7⅛
(49.8 x 18.1)
Purchase, Gift of Dr. Burton J. Grossman,
M.D. '49, in memory of his beloved mother,
Neva Grossman, 1980.53

French
The Primrose (La Primevère), after a design
by Alphonse Mucha, circa 1900
Cast bronze plaque with gilt and
polychromed decoration, 19⅝ x 7⅛
(49.8 x 18.1)
Purchase, Gift of Dr. Burton J. Grossman,
M.D. '49, in memory of his beloved mother,
Neva Grossman, 1980.54

French, Nancy
Emile Gallé, designer
French, 1846–1904
Vase, circa 1900
Cased cameo-cut and acid-etched colored
glass, h. 10 (25.4)
Gift of Miss Margaret Walbank, 1975.22

Austrian, Vienna, Loetz' Witwe Factory
Vase, circa 1900
Cased blown iridescent glass, h. 6¼ (15.9),
diam. of mouth 4¹⁵⁄₁₆ (12.5)
Gift of Dennis Adrian, A.B. '57, in honor of
Professor Edward A. Maser, 1980.41

* Gustave Serrurier-Bovy, designer
Belgian, 1858–1910
Fireplace Surround, circa 1902–1905
Brass, copper, wrought iron, mahogany,
mirror, glazed porcelain tile by Boch
Frères, La Louvière, 98 x 56 (249 x 142.2)
Gift of Seymour Stein, 1984.20

German, Wächtersbach,
Wächtersbacher Steingut
Neureuther, designer
Cake Tray, 1906
Glazed earthenware with copper border
and handle, diam. without handles
13½ (34.4)
Marcia and Granvil Specks Collection,
1986.169

Vilmos Huszár
Hungarian, lived in Holland, 1884–1960
Maquette for a Sidechair, circa 1918–1919
Painted pine, h. 11½ (29.2)
Purchase, Unrestricted Funds, 1988.80

Austrian, Vienna, Wiener Werkstätte
Josef Hoffmann, designer
Austrian, 1870–1956
Vase, 1918–1920
Hammered brass, h. 7⁹⁄₁₆ (19.2)
Purchase, Gift of the Friends of the Smart
Gallery, 1982; 1982.4

Czechoslovakian, Karlsbad,
Ludwig Moser & Söhne
Amazon Vase, circa 1920
Cut, acid-etched, and gilded purple glass,
h. 8¾ (22.2)
Gift of Mrs. Benita Livingston, 1982.41

Emile Decoeur
French, 1876–1953
Vase, n.d.
Porcelain, h. 4¾ (12.1)
Gift of Mr. and Mrs. William G.
Swartchild, Jr., 1974.9

Emile Jacques Ruhlmann, designer
French, 1869–1933
Dining Chair, n.d.
From the ocean liner *Ile de France*
Fruitwood with (replacement) fabric seat,
h. 36 (91.4)
Gift of Bud Holland, 1987.5

Marcel Breuer, designer
Hungarian, 1902–1981
B35 Lounge Chair, circa 1929 (design),
manufactured in early 1930s
Chrome-plated tubular steel, painted wood,
and (original?) braided rattan, h. 33½ (85.1)
Gift of E. L. Menger, 1986.2

Gertrude Waehner-Schmidt
Austrian, 1900–1979
Writing Desk, circa 1930
Stained wood, closed 55¾ x 39½ x 19⅜
(141.6 x 100.3 x 49.2)
Gift of E. L. Menger, 1986.6a-c

French, Limoges
Camille Fauré, designer
French, active circa 1900–1950
Vase, circa 1930
Enameled and silvered beaten copper,
h. 9¼ (23.5)
Purchase, Gift of the Friends of the Smart
Gallery, 1979; 1979.17

Wilhelm Kåge
Swedish, 1889–1960
Bowl, 1930
Glazed stoneware (Farstaware), h. 3¾ (9.5),
diam. of mouth 8⅜ (21.3)
Gift of Mr. and Mrs. William G.
Swartchild, Jr., 1974.14

Franz Singer, designer
Austrian, 1896–1954
Pair of Dining Chairs, circa 1933
Designed for the residence and surgery of
Dr. Joseph Deutsch and Dr. Ella Deutsch,
Vienna
Fruitwood, ebonized wood, and original
caning, each h. 30 (76.2)
Gift of Hanne Deutsch Sonquist and John
Sonquist, and Stephen and Elizabeth
Deutsch in memory of their parents, Dr.
Joseph Deutsch and Dr. Ella Deutsch,
1988.19 and 1988.20

Bernard Leach
British, 1887–1979
Covered Jar, n.d.
Earthenware with Tenmoku glaze with
resist decoration, h. with lid 6⅝ (16.8)
The Duffie Stein Collection, 1976.50

Nineteenth Century and Modern: The Americas

PAINTING

Thomas Sully
American, 1783–1872
Portrait of George Washington,
after Gilbert Stuart, n.d.
Oil on canvas, 30¼ x 25⅛ (76.8 x 63.8)
Gift of Mrs. Phillip D. Sang in memory
of her husband, Phillip D. Sang, 1983.44

* **William Merritt Chase**
American, 1849–1916
Portrait of a Man, circa 1875
Oil on wood panel, 45½ x 30½ (115.6 x 77.5)
Gift of Mrs. Robert B. Mayer, 1974.49

George Inness
American, 1825–1894
Landscape, circa 1880–1890
Oil on canvas, 20 x 30 (50.8 x 76.2)
The Harold H. Swift Bequest, 1962; 1967.8

George Inness
The Coming Shower, 1892
Oil on canvas, 29 x 44 (73.7 x 111.8)
The Harold H. Swift Bequest, 1962;
1978.202

* **Childe Hassam**
American, 1859–1935
*On the Lake Front Promenade,
Columbian World Exposition*, 1893
Oil on canvas, 17⅝ x 23⅝ (44.8 x 60)
The Harold H. Swift Bequest, 1962;
1976.146

Arthur B. Davies
American, 1862–1928
The Three Graces, 1907
Oil on canvas, 20½ x 18¼ (52.1 x 46.4)
The Martin A. Ryerson Bequest, 1967.3

Arthur B. Davies
Enchanted Woods, 1915
Oil on canvas, 22 x 17 (55.9 x 43.2)
The Martin A. Ryerson Bequest, 1967.4

Rockwell Kent
American, 1882–1971
A Low-lying Landscape, 1926
Oil on wood panel, 15½ x 19½ (39.4 x 49.5)
Bequest of Joseph Halle Schaffner in
memory of his beloved mother,
Sara H. Schaffner, 1973.139

* **Guy Pène du Bois**
American, 1884–1958
Four Arts Ball (Bal des quatres arts), 1929
Oil on canvas, 28¾ x 36½ (73 x 92.7)
Gift of William Benton, 1980.1

* **Raphael Soyer**
American, born in Russia, 1899–1987
Two Girls, 1933
Oil on canvas, 24 x 30¼ (61 x 76.8)
The Mary and Earle Ludgin Collection,
1982.72

Raphael Soyer
In the Studio, 1947
Oil on masonite, 21⅜ x 11⅜ (54.3 x 28.9)
The Mary and Earle Ludgin Collection,
1985.109

Stanton MacDonald-Wright
American, 1890–1974
Still Life with Buddha Head, circa 1945
Oil on canvas, 36 x 25 (91.4 x 63.5)
Gift of William Benton, 1980.2

Hyman Bloom
American, born in Latvia, 1913
The Rabbi, 1947
Oil on canvas, 49 x 35 (124.5 x 89.9)
The Mary and Earle Ludgin Collection,
1982.68

* **William Baziotes**
American, 1912–1963
Waterflowers, 1947
Oil on canvas, 16⅛ x 12⅛ (41 x 30.8)
Gift of Mr. and Mrs. William G.
Swartchild, Jr., 1974.37

Roberto Matta Echaurren, called **Matta**
Chilean, active in U.S.A., born 1911
Untitled Study, 1952–1953
Oil on panel, 23½ x 31⅜ (59.7 x 79.7)
Gift of Allan Frumkin, 1974.306

* **Larry Rivers**
American, born 1923
Portrait, 1956
Oil on canvas, 21 x 26 (53.3 x 66)
Gift of Lindy Bergman in memory of
Edwin A. Bergman, 1986.14

Larry Rivers
Spirit of Chicago, 1967
Oil and collage on canvas, 47 x 56½ x 7
(119.4 x 143.5 x 17.8)
Gift of Mr. and Mrs. Richard Selle, 1986.167

Gertrude Abercrombie
American, 1909–1977
Doors (3 Demolition), 1957
Oil on canvas, 18 x 24 (45.7 x 61)
Gift of the Gertrude Abercrombie Trust,
1979.14

Leon Golub
American, born 1922
Head VII, 1957
Oil on canvas, 27³⁄₁₆ x 17¹⁄₁₆ (69 x 43.4)
Gift of Mr. and Mrs. Edwin A. Bergman,
1982.1

Kenneth Noland
American, born 1924
Untitled, 1958
Oil on canvas, 36 x 42⅞ (91.4 x 108.9)
Gift of Mr. and Mrs. Hart Perry, 1977.135

Joan Mitchell
American, born 1926
Untitled, 1961
Oil on canvas, 18⅛ x 15 (46 x 38.1)
Gift of Katharine Kuh, 1968.3

Pinchas Burstein, called **Maryan**
American, born in Poland,
lived in France and Israel, 1927–1977
Personage, 1962
Oil on canvas, 44⅞ x 45 (114 x 114.3)
Gift of Robert A. Lewis in memory of
Martha A. Schwarzbach, 1983.37

* **Mark Rothko**
American, born in Russia, 1903–1970
Untitled, 1962
Oil on canvas, 81 x 76 (205.7 x 193)
Gift of Mrs. Albert D. Lasker, 1976.161

Jack Youngerman
American, born 1926
Tondo, 1964
Acrylic on canvas, 58 x 58 (147.3 x 147.3)
Gift of Mr. and Mrs. Solomon Byron
Smith, 1975.21

Grace Hartigan
American, born 1922
Henderson, The Rain King, 1965
Oil on canvas, 72 x 80 (182.9 x 203.2)
Gift of the artist to the University in honor
of Saul Bellow and Harold Rosenberg,
1966; 1967.117

Paul Georges
American, born 1923
Portrait of Dennis Adrian, 1965
Oil on canvas, 72 x 56¼ (182.9 x 142.9)
Gift of Allan Frumkin, 1977.20

* **Philip Pearlstein**
American, born 1924
Portrait of Allan Frumkin, 1965
Oil on canvas, 60 x 48 (152.4 x 121.9)
Bowman 259
Gift of Allan Frumkin, 1976.73

Philip Pearlstein
American, born 1924
Portrait of Jean, 1966
Oil on canvas, 50 x 44 (127 x 111.9)
Bowman 268
Gift of Allan Frumkin, 1982.76

Sam Gilliam
American, born 1933
Rim, 1970
Oil and epoxy on unstretched canvas,
60 x 80 (152.4 x 203.2)
Gift of Debra and Robert N. Mayer from
the Robert B. Mayer Memorial Loan
Collection, 1983.45

John Clem Clarke
American
Abstract 20, 1971
Oil on canvas, 61 x 89½ (154.9 x 227.3)
Gift in memory of Elaine Sammel
Palevsky, Class of 1944; 1989.4

Sylvia Sleigh
British, lives in U.S.A.
*Nancy Spero, Leon Golub and Sons Stephen,
Phillip and Paul*, 1973
Oil on canvas, 72 x 96¼ (182.9 x 244.5)
Gift of Leon Golub and Nancy Spero,
1988.6

Jules Olitski
American, born in Russia, 1922
First Dooja, 1974
Acrylic on canvas, 96 x 45¾ (243.9 x 116.2)
Gift of Mrs. Thomas Dittmer, 1979.23

Art Green
American, lives in Canada, born 1941
A Clean Break, 1975
Oil on canvas, 54 x 54 (137.2 x 137.2)
Gift of Baxter Travenol Laboratories,
1979.39

Ron Gorchov
American, born 1941
Lure, 1976
Oil on linen on shaped stretcher,
34 x 56 x 14 (86.4 x 142.3 x 35.6)
Gift of Mr. and Mrs. Gerald Silberman,
1982.74

Daniel Smajo-Ramirez
American, born 1941
TL-P 2.151, 1977
Latex, acrylic on raw canvas, four panels,
overall 96 x 118 (243.8 x 299.7)
Gift of Mr. and Mrs. Herman Ramirez,
1981.52

DRAWINGS, WATERCOLORS, AND
PAINTINGS ON PAPER

John LaFarge
American, 1835–1910
Sketchbook, 1866–1867
Bound sketchbook with pencil, brush and
ink, crayon on laid paper with forty-one
folios (one loose), each full sheet
4⅞ x 7½ (12.4 x 19.1)
University transfer from the Joseph
Regenstein Library, Special Collections,
Gift of the Department of Education,
1976.41

John Frederick Peto
American, 1854–1907
Nine Books, n.d.
Oil on paper mounted on wood panel,
6 x 9 (15.2 x 22.9)
The Mary and Earle Ludgin Collection,
1981.95

Abraham Walkowitz
American, born in Russia, 1880–1965
Standing Figure, 1906
Charcoal on wove paper, 12½ x 6⅛
(31.7 x 15.6)
Gift of Dr. and Mrs. Joel Bernstein, 1977.23

John Marin
American, 1870–1953
Clouds Overhanging Issy, 1908
Watercolor, pencil on laid paper,
10¹³⁄₁₆ x 8¾ (27.5 x 22.2)
Bequest of Joseph Halle Schaffner in
memory of his beloved uncle and aunt,
Hiram J. Halle and Julia Halle, 1973.100

Frederick Waugh
American, 1861–1940
Geometric, 1921
Pencil, watercolor, gouache on Japanese
paper, 20½ x 13¾ (52.1 x 34.9)
Lulu M. Quantrell Bequest, 1986.18

Rockwell Kent
American, 1882–1971
Twilight of Man, 1926
Watercolor, pencil on laid paper,
10¼ x 14¼ (26 x 36.1)
Bequest of Joseph Halle Schaffner in
memory of his beloved mother,
Sara H. Schaffner, 1973.97

José Clemente Orozco
Mexican, 1883–1949
Nude, circa 1930
Charcoal on laid paper, 24⁹⁄₁₆ x 18¹³⁄₁₆
(62.4 x 47.8)
Anonymous Gift, 1973.36

Carlos Mérida
Mexican, born in Guatemala, 1895
Abstraction, Mayan Theme, 1934
Pen and ink, watercolor and/or gouache,
pencil on wove paper, 13½ x 9⅞
(34.3 x 25.1)
Gift of Katharine Kuh, 1968.2

Norman Rockwell
American, 1894–1979
*Scene from "Tom Sawyer" by Mark Twain:
Whitewashing the Fence*, n.d.
Charcoal, pencil on paper, 20¹⁵⁄₁₆ x 17¾
(53.2 x 45.1)
Gift of Encyclopeadia Britannica, Inc.,
1975.7

Morris Graves
American, born 1910
Bird Calling Down a Hole, n.d.
Ink, wash on laid paper, 12¹¹⁄₁₆ x 9½ (32.2 x
24.1)
Gift of Mr. and Mrs. William G.
Swartchild, Jr., 1974.36

* **Franz Kline**
American, 1910–1962
Untitled, circa 1950
Ink, paint on wove paper mounted on
rag board, 7½ x 7½ (19 x 19)
Gift of Katharine Kuh, 1969.2

Theodore Roszak
American, born 1907
Fledgling No. 6, 1953
Ink, wash on wove paper, 30 x 22³⁄₁₆
(76.2 x 56.3)
Gift of Mr. and Mrs. Edwin A. Bergman,
1976.70

David Smith
American, 1906–1965
Untitled, 1954
Tempera on paper (compositions on recto
and verso), 15½ x 20⅛ (39.4 x 51.1)
Gift of the Friends of the Smart Gallery,
1976; 1976.64

Willem de Kooning
American, born in Holland, 1904
Black and White Study, 1960
Brush and ink on wove paper, 16⅞ x 13¾
(42.9 x 34.9)
Gift of Mrs. Robert B. Mayer from the
Robert B. Mayer Memorial Loan
Collection, 1986.191

Jack Beal
American, born 1931
Landscape—For Carol, n.d.
Felt-tip pen, collage on graph paper,
8⁷⁄₁₆ x 10¹¹⁄₁₆ (22.5 x 27.1)
Gift of Mr. and Mrs. Richard L. Selle,
1978.117

Jack Beal
Rex Begonia, 1967
Pencil on paper, 9 x 12 (22.9 x 30.4)
Gift of Dr. and Mrs. Irving Forman, 1985.28

*__Jim Nutt__
American, born 1938
Steping [sic] off the Room, 1971
Acrylic on paper, 13 x 11 (33 x 27.9)
Gift of Gerald Elliott in memory of
Leona Etta Spar, 1985.4

PRINTS AND PHOTOGRAPHS

James Abbott McNeill Whistler
American, lived in England and France,
1834–1903
The Millbank, 1861
Etching, plate 4 x 4⁷⁄₈ (10.2 x 12.4)
Kennedy 71 (serving as an announcement
for his first one-person exhibition, this
impression signed and inscribed in pencil
by the artist to the editor of the English art
journal, *The Critic*)
Gift from the Children of Leopold and
Birdie Metzenberg, 1985.81.104

Attributed to **Matthew B. Brady**
American, 1823–1896
*Brady's Photographic Outfit in Front of
Petersburg*, circa 1864
Albumen print on original mount, vintage
impression, image 7¼ x 9³⁄₁₆ (18.4 x 23.3)
Gift of David C. Ruttenberg, 1978.125

Winslow Homer
American, 1836–1910
The Life Line, 1884
Etching, plate 17½ x 22¼ (44.4 x 56.5)
Lulu M. Quantrell Bequest, 1986.23

Winslow Homer
Saved, 1889
Etching, plate 16⁷⁄₈ x 27¹³⁄₁₆ (42.9 x 70.6)
Lulu M. Quantrell Bequest, 1986.24

Lewis Hines
American, 1874–1940
Foreman in a Steel Plant, n.d.
Silver gelatin print, vintage contact
impression, sheet 5 x 6¹⁵⁄₁₆ (12.7 x 17.6)
Gift of Joel Snyder, 1980.150

Nathan Lerner
American, born 1915
Child and Mask, 1936
Silver gelatin print, image 10¹³⁄₁₆ x 8½
(27.4 x 21.6)
Gift of Joel Snyder, 1981.87

Walker Evans
American, 1903–1975
Begging Couple, 1941
Silver gelatin print, vintage impression,
sheet 7¾ x 7¼ (19.7 x 18.4)
Gift of Arnold Crane, 1978.137

Aaron Siskind
American, born 1903
Jalapa (Mexico) 46, from the
Homage to Franz Kline series, 1974
Silver gelatin print, image 10⅛ x 10⅛
(25.7 x 25.7)
Gift of the artist, 1975.46

SCULPTURE

*__Margaret F. Foley__
American, 1827–1877
Portrait of Jenny Lind, 1865
Marble relief tondo, diam. 16½ (41.9)
Gift of Dr. and Mrs. Isadore Isoe, 1973.35

Alfonso Iannelli
Italian, lived in U.S.A., 1888–1965
Frederick Stock, n.d.
Modeled plaster, h. 30 (76.2)
Gift of Scott C. Elliott in memory of
Alec Sutherland, 1985.27

Alfonso Iannelli
John L. Lewis (Man of Iron), circa 1940
Painted modeled plaster, h. 19½ (49.5)
Purchase, Gift of the Friends of the Smart
Gallery, 1985; 1985.26

John Frederick Mowbry-Clarke
American, born in Jamaica, 1869–1953
Untitled (An Embracing Couple), 1918
Cast bronze, h. 13¼ (33.6)
Bequest of Joseph Halle Schaffner in
memory of his beloved mother,
Sara H. Schaffner, 1973.126

Seymour Lipton
American, born 1903
Carnivorous Flower, 1953 (?)
Welded nickel-silver on steel, h. 28 (71.1)
The Mary and Earle Ludgin Collection,
1982.73

*__Isamu Noguchi__
American, lived in France, Japan,
and U.S.A., 1904–1988
Iron Wash (Okame), 1956
Cast iron, h. 9½ (24.1)
Botnick and Grove 421
The Joel Starrels, Jr. Memorial Collection,
1974.183

Roberto Matta Echaurren, called **Matta**
Chilean, active in U.S.A., born 1911
Couple I, 1959–1960
Cast bronze on original wood base,
3/6, 29½ x 22¼ x 18½ (74.9 x 56.5 x 47)
Gift of Allan Frumkin, 1977.137

Richard Hunt
American, born 1935
Organic Construction #10, 1961
Partially painted welded aluminum,
h. 23¼ (59)
The Joel Starrels, Jr. Memorial Collection,
1974.166

*__Richard Hunt__
Winged Hybrid Figure No. 3, 1965
Welded steel, h. 27³⁄₁₆ (69.2)
Gift of Mr. and Mrs. Edwin A. Bergman in
honor of Charles and Hanna Gray, 1982.3

*__John Chamberlain__
American, born 1927
Untitled, 1963
Welded painted and chromium-plated steel
automobile body parts, 36 x 50 x 53
(91.4 x 127 x 134.6)
Sylvester 172
Gift of Mr. and Mrs. Richard L. Selle,
1972.3

Claire Zeisler
American, born 1903
Triptych, 1967
Knotted and tied dyed wool, each panel
59½ x 28¾ (148.6 x 73)
Gift of Mr. and Mrs. Joel Starrels, Sr.,
1973.213

Robert Irwin
American, born 1928
Untitled, 1969
Acrylic paint on cast acrylic disk, four
incandescent spot lights, diam. of acrylic
disk 46 (116.8)
Gift of Mr. and Mrs. Solomon Byron
Smith, 1975.29

Karl Wirsum
American, born 1939
The Phantom of Hackle Park, 1982
Painted wood, h. 24½ (61.6)
Purchase, Illinois Arts Council Matching
Grant and Unrestricted Funds, 1984.129

DECORATIVE ARTS

Louis H. Sullivan, designer
American, 1856–1924
Dankmar Adler, designer
American, 1844–1900
*Exterior Architectural Ornament for
Window*, 1884
Designed for the Scoville Building, Chicago
Unglazed terracotta, h. 28 (71.1), l. 53 (134.6)
Gift of the General Services
Administration, 1977.97

Louis H. Sullivan, designer
Elevator Enclosure Screen, circa 1894
Designed for the Chicago Stock Exchange
Painted cast and wrought iron, 73½ x 29½
(186.7 x 74.9)
Gift of Kenneth Newberger, 1967; 1967.96

**American, New York, Tiffany Glass
and Decorating Company**
Vase, circa 1896–1902
Blown and crimped Favrile glass,
h. 4⅛ (10.5)
Gift of Miss Margaret Walbank, 1975.24

American, New York, Tiffany Studios
Candlestick with Globe, circa 1905
Cast bronze and blown Favrile glass,
h. 18½ (47)
Gift of Ruth McCollum in memory of
William Wright McCollum and Napier
Wilt, 1977.105

American, New York, Tiffany Studios
Vase, circa 1915–1920
Blown Favrile glass, h. 11¾ (29.8)
Purchase, The Cochrane-Woods
Collection, 1980.146

George Grant Elmslie, designer
American, born in Scotland, 1871–1952
Balustrade, circa 1899–1901 or 1903–1904
Designed for Louis H. Sullivan for the
Schlesinger and Mayer Department Store
(now Carson Pirie Scott & Company),
Chicago
Bronze-plated and painted cast iron,
h. 34½ (87.6)
Gift of Carson Pirie Scott & Company
through the courtesy of The Art Institute
of Chicago, 1967.111

Frank Lloyd Wright, designer
American, 1867–1959
Armchair, 1900
Designed for the B. Bradley House,
Kankakee, Illinois
Oak, h. 34½ (87.6)
University transfer, Gift of Mr. Marvin
Hammack, Kankakee, 1967.66

* **Frank Lloyd Wright**, designer
Dining Table and Six Chairs, 1907–1910
Designed for the Frederick C. Robie
Residence, Chicago
Table: oak, leaded colored
and opaque glass, ceramic,
55⅝ x 96¼ x 53½ (140 x 244.5 x 135.9)
Chairs: oak, leather, h. 52⅜ (132.8)
University transfer, 1967.73–1967.79

Frank Lloyd Wright, designer
Window, 1909–1910
Designed for the Frederick C. Robie
Residence, Chicago
Clear and colored leaded glass in original
painted wood frame, 47⅞ x 38⅝
(124.5 x 76.8)
University transfer, 1967.89

**American, Syracuse, New York, Gustav
Stickley Company** or **United Crafts**
Gustav Stickley, designer
American, 1858–1942
Armchair, circa 1901
Oak and original leather, h. 37 (94)
University transfer, 1967.50

George Mann Niedecken, designer
American, 1878–1945
Armchair, 1909–1910
Designed for the Frederick C. Robie
Residence, Chicago
Oak and laminated oak, h. 39½ (100.3)
University transfer, 1967.66

American, Cincinnati, Rookwood Pottery
Kataro Shirayamadani, painter
Japanese, lived in U.S.A., 1865–1948
Vase, 1908
Earthenware with slip-painted decoration
under a matt vellum glaze, h. 15¾ (40)
Gift of Mr. and Mrs. Leon Despres,
1974.134

American, Cincinnati, Rookwood Pottery
Attributed to Lorinda Epply, painter
American, 1874–1951
Low Fluted Bowl, 1928
Glazed porcelain, diam. of mouth 24 (61)
University transfer, 1980.145

American, Ironrite, Inc.
Herman A. Sperlich, designer
American, dates unknown
Health Chair, 1938
Enameled bent and molded steel,
h. 27 (68.6)
Gift of Barry Friedman, 1984.36

Glen Lukens
American, 1887–1967
Bowl, circa 1940
Partially glazed earthenware, h. 4¾ (12),
diam. of mouth 6½ (16.5)
The Duffie Stein Collection, 1976.52

**American, Los Angeles,
Evans Products Company**
Charles Eames, designer
American, 1907–1978
Leg Splint, 1942
Molded plywood, h. 42 (106.7)
With original paper wrapping and label
Gift of Barry Friedman, 1984.28

American, Herman Miller, Inc.
Charles Eames, designer
Dining Chair, 1946
Molded walnut plywood, steel rods, and
rubber shockmounts, h. 29½ (74.9)
Gift of Mr. and Mrs. Ernest R. Frueh,
1973.178

* **Peter Voulkos**
American, born 1924
Covered Jar, 1956–1957
Stoneware with negative stencil relief, iron-
oxide and cobalt slips, and thin transparent
glaze; h. with lid 8½ (21.6)
The Duffie Stein Collection, 1976.162

Gertrud Natzler
Austrian, lived in U.S.A., 1908–1971
Otto Natzler
Austrian, lives in U.S.A., born 1908
Bowl, 1960
Glazed earthenware, h. 3½ (8.9),
diam. of mouth 9½ (24.1)
Gift of Mr. and Mrs. Leon Despres, 1974.131

* **Gertrud** and **Otto Natzler**
Bowl, circa 1960
Earthenware with uranium-based glaze,
h. 5⁷⁄₁₆ (13.9), diam. of foot 2⅛ (5.3),
diam. of mouth 7¹⁄₁₆ (18)
Gift of Mr. and Mrs. Leon Despres, 1975.47

ORIENTAL ART

Chinese

PAINTING

Artist Unknown, Zhe School
Chinese, Ming dynasty
*The God of Longevity and Three Immortals
under Pine Trees*, circa 1500–1550
Hanging scroll, ink and light color on silk,
51¹³⁄₁₆ x 37½ (130 x 95.3)
Purchase, Gift of Mr. and Mrs. Gaylord
Donnelley, 1974.103

Guo Xu
Chinese, 1465–circa 1530
*Storing Garments of the Husband in Far
Away Territory*, 1500–1530
Hanging scroll, ink and color on silk,
45³⁄₁₆ x 22 (115.3 x 55.9)
Purchase, Anonymous Gift, 1974.84

Wen Jia
Chinese, 1501–1583
Landscape, 1561
Hanging scroll, ink and color on silk,
46¹⁵⁄₁₆ x 17⅜ (119.2 x 44.1)
Purchase, Anonymous Gift, 1974.82

Qian Gu
Chinese, 1508–after 1578
The Red Cliff, 1575
Handscroll, ink and color on silk,
painting panel 10¹⁄₁₆ x 49¹⁄₁₆ (25.6 x 124.6),
text panel 10 ⅝ x 53⅝ (27 x 136.2)
Purchase, Anonymous Gift, 1974.90

Song Xu
Chinese, 1525–after 1605
Drifting Mountains in Fog (after Wu Zhen),
1603
Hanging scroll, ink on silk, 62⅜ x 17⁹⁄₁₆
(158.4 x 44.6)
Purchase, Gift of Mr. and Mrs. Gaylord
Donnelley, 1974.94

Chen Guan
Chinese, born 1563, active 1610–1640
Landscape, circa 1620
Hanging scroll, ink on silk, 71⁹⁄₁₆ x 17½
(181.8 x 44.5)
Purchase, Gift of Mr. and Mrs. Gaylord
Donnelley, 1974.93

* **Mi Wanzhong**
Chinese, circa 1570–1628
*Among the Fragrant Snowy Mountains of
Lan Garden*, 1621
Hanging scroll, ink on satin, 73¹¹⁄₁₆ x 19⅛
(187.2 x 48.6)
Purchase, Gift of Mr. and Mrs. Gaylord
Donnelley, 1974.92

Zhu Qizhen
Chinese, active mid 17th century
Landscape, 1633
Hanging scroll, ink and light color on silk,
67¹³⁄₁₆ x 17⅛ (172.2 x 43.5)
Gift of Jeannette Shambaugh Elliott,
1987.12

Lan Ying
Chinese, 1585–after 1664
Landscape (after Li Cheng), circa 1630–1650
Hanging scroll, ink and color on silk,
62¹⁄₁₆ x 19¼ (158.1 x 48.9)
Purchase, Anonymous Gift, 1974.83

* **Lan Ying**
Landscape (after Huang Gongwang),
circa 1637–1638
Handscroll; frontispiece, ink on paper,
23¹⁄₁₆ x 40⁵⁄₁₆ (58.7 x 102.4); painting, ink
and color on silk, 23¹⁄₁₆ x 379⅛ (58.7 x 1014.7)
Gift of Jeannette Shambaugh Elliott in
honor of Professor Harrie A. Vanderstappen,
1987.56

Lan Ying and
Sun Di
Chinese, died 1651
Bamboo and Rocks, circa 1640–1650
Hanging scroll, ink on silk, 64⅞ x 22⁹⁄₁₆
(164.8 x 57.3)
Purchase, Anonymous Gift, 1974.89

Wu Da
Chinese, dates unknown
Summer Pavilion (after Zhao Danian), 1675
Hanging scroll, ink and color on satin,
42⅛ x 18³⁄₁₆ (107 x 46.2)
Purchase, Gift of Mr. and Mrs. Gaylord
Donnelley, 1974.91

Luo Mu
Chinese, 1622–after 1706
Landscape, 1689
Hanging scroll, ink on satin, 79³⁄₁₆ x 19⅛
(201.1 x 48.6)
Purchase, Anonymous Gift, 1974.87

Huang Ding
Chinese, 1660–1730
Clouded Mountains, 1724
Hanging scroll, ink on silk, 48½ x 22⅜
(123.2 x 56.8)
Purchase, Anonymous Gift, 1974.80

Zhang Pengzhong
Chinese, 1688–1745
Jade Hall in Autumn Mountains, 1744
Hanging scroll, ink and color on paper,
26⅜ x 25 (67 x 63.5)
Gift of Mitchell Hutchinson, 1984.97

Hua Yan
Chinese, 1682–1756
Paths and Cliffs Beautiful under Clouds, 1746
Hanging scroll, ink and color on silk,
49⁹⁄₁₆ x 24½ (125.9 x 62.2)
Purchase, Anonymous Gift, 1974.79

Tong Yu
Chinese, 1721–1782
Plum Blossom, n.d.
Hanging scroll, ink on paper, 33½ x 10¾
(85.1 x 27.3)
Gift of Richard and Mali Edmonds, 1988.6

Zhai Dakun
Chinese, died 1804
Landscape (after Wang Fu), circa 1790–1800
Hanging scroll, ink on gold-flecked paper,
61⅝ x 18 (156.5 x 45.7)
Purchase, Anonymous Gift, 1974.85

Gu Haoqing
Chinese, 1766–circa 1830
Rain View, circa 1810
Hanging scroll, ink and color on paper,
55¼ x 14⁵⁄₁₆ (140.3 x 37.2)
Purchase, Anonymous Gift, 1974.81

Zhu Xuan
Chinese, active circa 1790–1820
Plum Blossoms, 1819
Hanging scroll, ink on silk, 34¹⁵⁄₁₆ x 13¹¹⁄₁₆
(88.7 x 34.8)
Purchase, Gift of Mr. and Mrs. Gaylord
Donnelley, 1974.96

Yun Xiang
Chinese, died 1827
Orchids, 1824
Handscroll, four painting panels and
colophon panel, ink on paper; painting
panels 13¼ x 37 ¹¹⁄₁₆ (33.7 x 95.7), 13¼ x 37¾
(33.7 x 95.9), 13¼ x 37¾ (33.7 x 95.9),
13¼ x 37⅜ (33.7 x 94.9); colophon panel
13¼ x 107½ (33.7 x 273.1)
Gift of Warren G. Moon, Ph.D. '75, in
behalf of Harrie Vanderstappen, 1983.9

Chen Yizhou
Chinese, circa 1800–after 1850
Birds and Pine Tree, 1848
Hanging scroll, ink and light color on
paper, 66⅞ x 33¾ (169.8 x 85.7)
Purchase, Gift of Mr. and Mrs. Gaylord
Donnelley, 1974.97

Tseng Yuho (Mrs. Gustav Ecke)
Chinese, lives in U.S.A., born 1923
Landscape, circa 1947–1948
Ink and light color on paper, 11 x 18¹¹⁄₁₆
(27.9 x 47.5)
Gift of Warren G. Moon, Ph.D. '75, in
memory of Professor Edward A. Maser,
Founding Director of the Smart Gallery,
1973–1983; 1989.12

CERAMIC VESSELS AND SCULPTURE

Neolithic period, Yangshao culture,
Gansu phase, Banshan-Machang style
Bowl with Handles, circa 2500–2200 B.C.
Unglazed earthenware with slip-painted
decoration, h. 3¾ (9.6), diam. of mouth
3¹⁄₁₆ (7.8)
Gift of Mrs. Geraldine Schmitt-Poor and
Dr. Robert J. Poor in honor of Professor
and Mrs. T. H. Tsien, 1989.21

Neolithic period, Yangshao culture,
Gansu phase, Banshan-Machang style
Bowl with Handles, circa 2500–2200 B.C.
Unglazed earthenware with slip-painted
decoration, h. 3¼ (8.3), diam. of mouth
3¼ (8.3)
Gift of Mrs. Geraldine Schmitt-Poor and
Dr. Robert J. Poor in honor of Professor
and Mrs. T. H. Tsien, 1989.22

Neolithic period, Yangshao culture,
Gansu phase, Banshan-Machang style
Bowl, circa 2200 B.C.
Unglazed earthenware with slip-painted
decoration, h. 4¼ (10.8), diam. of mouth
5⅜ (13.7)
Gift of Mrs. Geraldine Schmitt-Poor and
Dr. Robert J. Poor in honor of Professor
and Mrs. Herrlee G. Creel, 1989.2

Neolithic period, Yangshao culture,
Gansu phase, Banshan-Machang style
Bowl with Handles, circa 2200 B.C.
Unglazed earthenware with slip-painted
decoration, h. 5 (12.7), diam. of belly
5⅝ (14.3)
Gift of Mrs. Geraldine Schmitt-Poor and
Dr. Robert J. Poor in honor of Professor
and Mrs. Herrlee G. Creel, 1989.3

Late Shang-Western Zhou dynasty
Li (Tripod Cooking Vessel), circa 1000 B.C.
Unglazed earthenware with beaten
cord-pattern decoration, h. 5⅝ (14.3),
diam. of mouth 5 15/16 (15.1)
Anonymous Gift in honor of the
Divine Word Missionaries, 1989.1

* **Tang dynasty**
Tomb Guardian Figure, circa 650–700
Molded and modeled unglazed earthenware
with cold-painted decoration and partial
gilding, h. 27¼ (69.2)
Purchase, Gift of Gaylord Donnelley,
1981.55

Liao dynasty
Vase, 10th–11th century
Partially glazed earthenware, h. 11½ (29.2)
Gift of Dr. Maurice Cottle, 1977.127

Southern Song dynasty
Bowl, 12th–13th century
Stoneware with "hare's fur" glaze
(Jian ware), diam. of mouth 4⅞ (12.4)
Gift of Cora Passin, 1988.81

Qing dynasty, Export Ware
(English Market)
*Armorial Plate (with Arms of Lee
Quartering Astley)*, circa 1730
Porcelain with overglaze enamel and gilt
decoration, diam. of rim 8 15/16 (22.7)
Gift of Mrs. Chauncey Borland, 1976.62

METALWORK AND DECORATIVE ARTS

Shang dynasty, late Erligang-early
Anyang period
Ding (Ritual Cooking Vessel),
14th–13th century B.C.
Cast bronze, h. 6⅝ (16.8),
h. without handles 5 9/16 (14.1)
Inscribed inside bowl: Xiu
Gift of Mr. and Mrs. Isaac S. Goldman,
1976.163

Shang dynasty, Anyang period
Ding (Ritual Cooking Vessel),
13th–12th century B.C.
Cast bronze, h. 8 (20.3),
h. without handles 6 9/16 (16.7)
Gift of Prof. and Mrs. Herrlee G. Creel,
1986.328

Shang dynasty, Anyang period
Jue (Ritual Wine Vessel),
late 13th–early 12th century B.C.
Cast bronze, h. 6⅝ (16.8)
Inscribed under handle with an
undeciphered graph
Gift of Prof. and Mrs. Herrlee G. Creel,
1986.329

* **Shang dynasty**, Anyang period
Gu (Ritual Wine Beaker),
late 13th–early 12th century B.C.
Cast bronze, h. 12 (30.5),
diam. of mouth 6¼ (15.9)
Inscribed inside foot: Jing
Gift of Prof. and Mrs. Herrlee G. Creel,
1986.330

Late Shang dynasty, Anyang period
Gu (Wine Beaker), late 13th–12th century B.C.
Cast bronze, h. 8 11/16 (22.1),
diam. of mouth 5¼ (13.3)
Gift of Prof. and Mrs. Herrlee G. Creel,
1986.331

Shang dynasty, Anyang period
*Fragment of a Spatula with Carved Taotie
Decoration*, 13th–11th century B.C.
Bone, l. 2 9/16 (6.5)
Gift of Prof. and Mrs. Herrlee G. Creel,
1986.361

Shang dynasty
Hairpin, n.d.
Bone, l. 5 1/16 (12.9)
Gift of Prof. and Mrs. Herrlee G. Creel,
1986.356

Shang dynasty
Hairpin, n.d.
Bone, l. 4 15/16 (12.6)
Gift of Prof. and Mrs. Herrlee G. Creel,
1986.357

Shang dynasty
Ge (Socketed Dagger-axe), n.d.
Cast bronze, l. 8 (20.3)
Inscribed on tang: Yue
Gift of Prof. and Mrs. Herrlee G. Creel,
1986.332

Shang dynasty
Ge (Socketed Dagger-axe), n.d.
Cast bronze, l. 9⅜ (23.8)
Gift of Prof. and Mrs. Herrlee G. Creel,
1986.333

Shang dynasty
Ge (Dagger-axe), n.d.
Cast bronze, l. 8½ (21.6)
Gift of Prof. and Mrs. Herrlee G. Creel,
1986.334

Shang dynasty
Ge (Dagger-axe), n.d.
Cast bronze, l. 10 (25.4)
Gift of Prof. and Mrs. Herrlee G. Creel,
1986.335

Shang dynasty
Ge (Dagger-axe), n.d.
Cast bronze, l. 11⅜ (28.9)
Gift of Prof. and Mrs. Herrlee G. Creel,
1986.336

Shang dynasty
Ge (Dagger-axe), n.d.
Cast bronze, l. 9½ (24.1)
Gift of Prof. and Mrs. Herrlee G. Creel,
1986.337

Late Shang dynasty
Ge (Dagger-axe), n.d.
Cast bronze, l. 10 1/16 (25.5)
Gift of Prof. and Mrs. Herrlee G. Creel,
1986.338

**Late Western Zhou dynasty/
Western Han dynasty**
Luan (Chariot Jingle), n.d.
Cast bronze, h. 7 (17.8)
Gift of Prof. and Mrs. Herrlee G. Creel,
1986.348

Tang dynasty
Mirror with Lion-and-Grapevine Motif, n.d.
Cast bronze, diam. 5⅜ (13.7)
Gift of Prof. and Mrs. Herrlee G. Creel,
1986.349

Japanese

PAINTING

Kanō Tan'yū
Japanese, 1602–1674
Landscape, n.d.
Hanging scroll, ink on silk, 15 13/16 x 48½
(40.2 x 123.2)
Gift of Mr. and Mrs. Bertold Regensteiner
in memory of Professor Bachhofer, 1983.3

Donkei Toshitsu
Japanese, died 1668
Children Playing in the Garden, n.d.
Hanging scroll, ink and color on paper,
45⅝ x 18 (115.9 x 45.7)
Gift of Jeannette Shambaugh Elliott in
honor of Professor Harrie Vanderstappen,
1987.54

* **Nittō**, Head Priest of Ikegami Honmonji
(Temple)
Japanese, 1652–1733
Nichiren's Nirvana,
late 17th–early 18th century
Hanging scroll, ink and color on silk,
42⅝ x 31⅞ (108.1 x 80.7)
Purchase, Gift of Mr. and Mrs. Gaylord
Donnelley, 1974.101

Ikeno Taiga
Japanese, 1723–1776
Magnolia Blossoms, circa 1740–1750
Hanging scroll, ink and color on paper,
53⁵/₁₆ x 21¾ (135.4 x 55.2)
Purchase, Gift of Mr. and Mrs. Gaylord
Donnelley, 1974.99

Ikeno Gyokuran
Japanese, 1727/28–1784
Bamboo, circa 1760
Hanging scroll, ink on paper, 32 x 7⅞
(81.3 x 20)
Purchase, Gift of Mr. and Mrs. Gaylord
Donnelley, 1974.105

Nagasawa Rosetsu
Japanese, 1754–1799
Waterfall, circa 1770
Hanging scroll, ink on paper, 57½ x 13¹¹/₁₆
(146 x 34.8)
Purchase, Gift of Mr. and Mrs. Gaylord
Donnelley, 1974.102

Yōsen'in (Kanō Korenobu)
Japanese, 1753–1808
Triptych, circa 1794
Three hanging scrolls, ink and color on
silk, each panel 46¼ x 16¾ (117.5 x 42.5)
Gift of Daniel Jeremy Silver, 1983.174 a,b,c

Artist Unknown
Japanese, Edo period, colophon inscribed
by Priest Taiden
Portrait of Priest Yogetsu Ryosaku,
18th century (colophon 1795)
Hanging scroll, ink and color on silk, 41¹/₁₆
x 16½ (104.3 x 41.9)
Gift of Jeannette Shambaugh Elliott in
honor of Professor Harrie Vanderstappen,
1987.55

Artist Unknown
Japanese, Edo period
Bamboo, late 18th century
Ink on paper, 51 ⅜ x 11⅝ (130.5 x 29.5)
Purchase, Gift of Mr. and Mrs. Gaylord
Donnelley, 1974.100

Kameda Bōsai
Japanese, 1752–1826
Landscape, circa 1807–1808
Hanging scroll, ink and color on silk,
38¹¹/₁₆ x 13¼ (98.3 x 33.7)
Purchase, Gift of Mr. and Mrs. Gaylord
Donnelley, 1974.98

Kinoshita Itsuun
Japanese, 1799–1866
Landscape (in the Manner of Mi Youren),
circa 1850
Hanging scroll, ink on satin, 11 x 17¹/₁₆
(27.9 x 43.3)
Purchase, Gift of Mr. and Mrs. Gaylord
Donnelley, 1974.104

PRINTS

Suzuki Harunobu
Japanese, 1724–1770
Komurasaki in Komusō Attire
(*The Girl in White*), n.d.
Color woodblock (*hashira-e*), sheet 27 x 4¾
(68.6 x 21.1)
Gift of Mr. and Mrs. Gaylord Donnelley,
from the Frances Gaylord Smith
Collection, 1972.4

* **Torii Kiyonaga**
Japanese, 1752–1815
Women Resting above the Kamo River
(central panel from a triptych, *Cooling Off
in the Evening at Shijō Rivershore*), circa 1784
Color woodblock (*ōban*), sheet 15⅛ x 10¼
(38.3 x 26)
Gift of Warren G. Moon, Madison,
Wisconsin, in honor of Professor Harrie
A. Vanderstappen, 1984.8

Kitagawa Utamaro
Japanese, 1753–1806
*Taking Shelter from a Sudden Summer
Shower under a Huge Tree*, early 1790s
Color woodblock triptych of *ōban* panels,
each sheet 14⅞ x 9¾ or 10 (37.8 x 24.8 or 25.4)
Gift of Mr. and Mrs. Gaylord Donnelley,
from the Frances Gaylord Smith
Collection, 1972.14

Utagawa Toyokuni
Japanese, 1769–1825
Untitled, n.d.
Surimono woodblock, sheet 8⁹/₁₆ x 7⅜
(21.7 x 18.7)
Gift of Mr. and Mrs. Gaylord Donnelley,
from the Frances Gaylord Smith
Collection, 1974.68

Katsushika Hokusai
Japanese, 1760–1849
Untitled (*Two Women Beating New Silk*), n.d.
Surimono woodblock, sheet 7¹³/₁₆ x 11¹⁵/₁₆
(19.1 x 30.3)
Gift of Mr. and Mrs. Gaylord Donnelley,
from the Frances Gaylord Smith
Collection, 1974.67

Katsushika Hokusai
Parody on the "Rokkasen"
(*Six Immortal Poets*), n.d.
Surimono woodblock, sheet 7¹⁵/₁₆ x 10⅞
(20.2 x 27.6)
Gift of Mr. and Mrs. Gaylord Donnelley,
from the Frances Gaylord Smith
Collection, 1974.66

Utagawa (Andō) Hiroshige
Japanese, 1797–1858
*Evening Vista of the Eight Views of
Kanazawa in Musashi Province*, 1857
Color woodblock severed triptych of *ōban*
panels, each sheet 14⁵/₁₆ x 9⅞ or 10
(36.4 x 24 or 25.4)
Gift of Mr. and Mrs. Gaylord Donnelley,
from the Frances Gaylord Smith
Collection, 1972.7

Ohara Shōson (Koson)
Japanese, 1877–1945
Snow on Willow Bridge, 1927
Color woodblock, block 14¼ x 9⅜
(36.2 x 23.8)
Gift of Mr. and Mrs. Gaylord Donnelley,
1974.63

Shikō Munakata
Japanese, 1903–1975
*Goyū, Station Thirty-six from the Tōkaidō
(Eastern Sea Road)*, n.d.
Black woodcut, 5/10, block 13⅝ x 17¹³/₁₆
(34.6 x 45.2)
Gift of Mr. and Mrs. William G.
Swartchild, Jr., 1974.28

Sadao Watanabe
Japanese, born 1913
The Three Magi, 1962
Color stencil print, 18/50,
image 17¹³/₁₆ x 19⅞ (45.2 x 50.5)
Gift of Mr. and Mrs. William G.
Swartchild, Jr., 1974.34

Kiyoshi Saitō
Japanese, born 1907
Garden Tenryuji, Kyoto, n.d.
Color woodcut, 3/80, image 23¼ x 17¹¹/₁₆
(59 x 44.9)
Gift of Mr. and Mrs. Sigmund Kunstadter,
1975.35

Hideo Hagiwara
Japanese, born 1913
Fantasy in Red (2), 1962
Color woodcut, 14/30, sheet 26³/₁₆ x 38
(66.5 x 96.5)
Gift of Mr. and Mrs. William G.
Swartchild, Jr., 1974.33

Mabuchi Thoru (Tōru)
Japanese, born 1920
Still Life with Figs and Other Fruits, 1962
Color woodblock from constructed block,
image 10⅞ x 22½ (27.6 x 57.2)
The R. Branson Frevert Memorial
Collection, 1971.29

Yōzō Hamaguchi
Japanese, born 1909
Hamaguchi's Original Six-color Mezzotints,
1978
Portfolio of six prints, each individually
mounted, with an English and French
introduction, in a suede box
Color mezzotint, edition of seventy-five
with fifteen artist's proofs, proof set
dedicated "To the museum of The
University of Chicago" ("Pour la musée de
l'université de Chicago"), each plate
4½ x 4½ (11.5 x 11.5)
Gift of Nantenshi Gallery, Tokyo,
1979.56–1979.61

CERAMICS

Shōji Hamada
Japanese, 1894–1978
Square Bottle, n.d.
Glazed stoneware with "bamboo-sprout"
pattern, h. 9 (22.9)
With original box with poem by Hamada
The Duffie Stein Collection, 1976.48

Shōji Hamada
Covered Jar, n.d.
Salt-glazed earthenware with comb
decoration, h. with lid 3½ (8.9)
Gift of Mr. and Mrs. William G.
Swartchild, Jr., 1974.7

Korean

CERAMICS

Koryŏ dynasty
Bowl, 12th–13th century
Stoneware with celadon glaze, h. 2⅞ (7.3),
diam. of mouth 6⁵⁄₁₆ (16)
Gift of the Estate of Ethel Behncke, 1986.153

Koryŏ dynasty
Bowl, 12th–13th century
Stoneware with celadon glaze and carved
decoration, h. 3⁵⁄₁₆ (8.4), diam. of mouth
6⁹⁄₁₆ (16.7)
Gift of the Estate of Ethel Behncke, 1986.154

Koryŏ dynasty
Bowl, 12th–13th century
Stoneware with celadon glaze and incised
and molded decoration, h. 2¾ (7),
diam. of mouth 6¹⁵⁄₁₆ (15.1)
Gift of the Estate of Ethel Behncke, 1986.155

Koryŏ dynasty
Cup, 12th–13th century
Stoneware with celadon glaze and incised
decoration, h. 2¼ (5.7), diam. of mouth 3¼
(8.3)
Gift of the Estate of Ethel Behncke, 1986.165

Koryŏ dynasty
Wine Cup with Stand, circa 1300
Stoneware with celadon glaze and carved,
incised, and black and white inlaid
decoration, with gold lacquer repairs, cup:
h. 2¾ (6.9), diam. of mouth 3 (7.6), stand:
h. 2 (5), diam. of tray 5 ½ (13.9)
Gift of John F. Peloza, 1988.2a, b

Southeast Asian

DRAWINGS AND PAINTINGS

Indian, Mughal
Profile Head of a Woman, 17th century
Pen and ink, light color, gold on paper,
9 x 5³⁄₁₆ (22.8 x 13.2)
Gift of Dr. and Mrs. Sherman E. Lee,
1974.135

** **Indian, Orissa**
Kṛṣṇa and Brahmā,
late 19th century–early 20th century
Folio from the tenth book of a manuscript
of the *Bhāgavata Purāṇa*
(*Ancient Story of God*)
Tempera, ink on wove paper,
9⁷⁄₁₆ x 15³⁄₁₆ (24.6 x 38.8)
Purchase, Gift of Mr. Harris J. Fishman
through the Alumni Fund, 1974.62

SCULPTURE

Gandharan, Pakistan
Head of a Man, circa 3rd–5th century
Schist, h. 2¼ (5.7)
Gift of Mr. Reuben Frodin, 1982.30

Gandharan, Pakistan
Head of a Woman, circa 3rd–5th century
Schist, h. 2 (5.1)
Gift of Mr. Reuben Frodin, 1982.31

**Khmer, Kampuchia (People's Republic
of Cambodia)**
Śiva Liṅga, 7th–11th century
Sandstone, h. 17¼ (43.8)
Purchase, Gift of Gaylord Donnelley,
1982.20

CERAMICS

Annamese, Vietnam
Guan-shaped Jarlet, 14th–15th century
Stoneware with underglaze blue
decoration, h. 2⅞ (7.3)
Gift of Michael Willis, 1985.40

DECORATIVE ARTS

Indian, Mughal
Necklace, late 18th century
Rose-cut diamonds, pearls, *champlève*
enamel, fabric, l. 8 (20.3)
Gift of Mildred Othmer Peterson, 1987.50

INDEX OF ARTISTS